LANCHESTER LIBRARY, Coventry University
Gosford Street, Coventry CVI 5DD Telephone 024 7688 7555

This book is due to be returned not later than the date and
time stamped above. Fines are charged on overdue books

WOMEN ON STAGE IN STUART DRAMA

Women on Stage in Stuart Drama provides a 'prehistory' of the actress, filling an important gap in established accounts of how women came to perform in the Restoration theatre. Sophie Tomlinson uncovers and analyses a revolution in theatrical discourse in response to the cultural innovations of two Stuart queens consort, Anna of Denmark and the French Henrietta Maria. Their appearances on stage in masques and pastoral drama engendered a new poetics of female performance that registered acting as a powerful means of self-determination for women. The pressure of cultural change is inscribed in a plethora of dramatic texts that explore the imaginative possibilities inspired by female acting. These include plays by the key royalist women writers Margaret Cavendish, Duchess of Newcastle, and Katherine Philips. The material explored by Tomlinson illustrates a fresh vision of theatrical femininity and encompasses an unusually sympathetic interest in questions of female liberty and selfhood.

SOPHIE TOMLINSON is a Senior Lecturer in English at the University of Auckland, New Zealand. She has published essays on female performance and women's drama in early modern England, and has edited John Fletcher's comedy *The Wild-Goose Chase* for the forthcoming Revels Companion Library volume of *Three Seventeenth-Century Plays on Women and Performance*.

WOMEN ON STAGE IN STUART DRAMA

SOPHIE TOMLINSON

CAMBRIDGE
UNIVERSITY PRESS

CAMBRIDGE UNIVERSITY PRESS
Cambridge, New York, Melbourne, Madrid, Cape Town, Singapore, São Paulo

Cambridge University Press
The Edinburgh Building, Cambridge CB2 2RU, UK

Published in the United States of America by Cambridge University Press, New York

www.cambridge.org
Information on this title: www.cambridge.org/9780521811118

First published 2005

Printed in the United Kingdom at the University Press, Cambridge

A catalogue record for this book is available from the British Library

ISBN-13 978-0-521-81111-8 hardback
ISBN-10 0-521-81111-2 hardback

For Pamela,
and for John

Contents

Illustrations

Acknowledgements

In writing this book I feel fortunate to have received stimulus and support from many friends and colleagues, to all of whom I offer sincere thanks. For their longstanding guidance I am indebted to Peter Holland, Martin Butler and Juliet Fleming. Lorna Hutson has shaped my thinking both near at hand and at a distance, while the influence of Michael Neill will be apparent to anyone familiar with his teaching and writing. My ideas have been fuelled by conversations with Hero Chalmers, Susan Wiseman and Mark Houlahan, and my travails eased by the attentive friendship of Sarah Shieff, Janine Barchas and Rebecca Hayward.

For their careful reading of portions of the manuscript I am grateful to Martin Andrew, Mark Dawson, Stephanie Hollis, Mark Houlahan, Aorewa McLeod, Mercedes Maroto Camino, Claudia Marquis and Don Smith. The exacting appraisals of two readers for Cambridge University Press helped me hone a book from a PhD thesis. My editors, Victoria Cooper and Rebecca Jones, were patient and painstaking in eliciting the manuscript and seeing it to the press; I am especially grateful to Victoria Cooper for the book's straightforward title. Libby Willis was a tactful and meticulous copy-editor. Barbara Ravelhofer kindly liaised with the municipal gallery in Bologna to obtain a copy of the *Circe* painting which had riveted my attention several years before. Thanks to Mary Kisler and Erin Griffey for talking with me about the painting. To my tender husband, Peter Haynes, I tender thanks unlimited. The book is dedicated to the memory of my parents, each of whom in their different ways nurtured in me a love of performance.

The project was generously assisted by a Marsden grant from the Royal Society of New Zealand, and by the University of Auckland, which allowed me several periods of sabbatical. Material in Chapter 2 is reproduced from 'Theatrical Vibrancy on the Caroline Court Stage: *Tempe Restored* and *The Shepherds' Paradise*' in Clare McManus (ed.), *Women and Culture at the Courts of the Stuart Queens* (Basingstoke: Palgrave

Macmillan, 2003), pp. 186–203. An earlier version of Chapter 5 appeared as '"My Brain the Stage": Margaret Cavendish and the Fantasy of Female Performance' in Clare Brant and Diane Purkiss (eds.), *Women, Texts and Histories 1575–1760* (London: Routledge, 1992), pp. 134–63. The same chapter reworks a paragraph which appeared in my essay on 'Drama' in Anita Pacheco (ed.), *A Companion to Early Modern Women's Writing* (Oxford: Blackwell, 2002), pp. 317–35. Material in Chapter 6 is reproduced from 'The Sources of Female Greatness in Katherine Philip's *Pompey*' in Jo Wallwork and Paul Salzman (eds.), *Women Writing 1550–1750*, a special issue of *Meridian*: The La Trobe University English Review, vol. 18, no. 1 (2001), pp. 179–90. Parts of the Introduction and Chapter 3 appeared in 'Too Theatrical? Female Subjectivity in Caroline and Interregnum Drama', *Women's Writing* 6 (1999), 65–79. I am grateful to all the publishers for their permission to reuse these materials.

Note on procedures

Unless otherwise stated, quotations from Shakespeare refer to the compact Oxford edition of *The Complete Works*, edited by Stanley Wells and Gary Taylor (1994). I have quoted Webster from the old-spelling critical edition of David Gunby, David Carnegie and Anthony Hammond (1995). In the case of Walter Montagu's *The Shepherds' Paradise* I have used as my primary text the abridged Tixall Manuscript of the play, edited by Sarah Poynting for the Malone Society (1998). Where a variation between Poynting's edition and the longer printed edition of 1659 has a significant bearing on my discussion, quotations are cross-referenced to the relevant pages, or line numbers, of the respective edition. One hopes that the complete text of Montagu's play, Acts 1–3 of which have been edited by Poynting in her Oxford DPhil thesis (1999), will soon find a publisher. In cases of texts using old spelling, I have altered 'i' to 'j' and 'v' to 'u', and expanded elided words and ampersands. Old-style dates have been altered to conform with the modern calendar. Unless otherwise stated, dates in parentheses following play titles derive from the third edition of Alfred Harbarge's *Annals of English Drama 975–1700*, revised by Sylvia Stoler Wagonheim.

Abbreviations

Jonson	C. H. Herford and Percy and Evelyn Simpson (eds.), *Ben Jonson*, 11 vols. Oxford: Clarendon Press, 1925–52.
Revels History IV 1613–1660	Philip Edwards *et al.* (eds.), *The Revels History of Drama in English, IV 1613–1660* London: Methuen, 1981.

Introduction: shifting sisters

'Sisters are doin' it for themselves' ran one feminist mantra of the 1980s.[1] Every student of Elizabethan drama learns that, contrariwise, the female roles in Shakespeare's theatre were played by boys and young men whose voices had not yet broken, usually from the ages of about ten to eighteen. Students of Restoration drama discover that in 1660 women began representing themselves on the public stage. How did this cultural transformation come about? And what was the impact on the audience, and on English drama, when 'the woman's part' was indeed performed by a woman? Recent revisionist contributions to English theatre history have overturned the long-held assumption that the Elizabethan public theatre grew out of, and sustained until 1660, a performance tradition that was exclusively male.[2] While the convention of male transvestite performance has received considerable attention, much less interest has been shown in those works, scripted for and by women, in which female theatrical representation is at issue.[3] In this book I wish to widen the range of evidence currently used to guide the questions we ask about 'women and drama' in early modern England. My aim is to investigate the relationship between the idea of the actress in drama and her incarnation on a variety of stages between 1603 and 1670. Rather than viewing the appearance of the professional actress as a decisive change from the past, I demonstrate the literary and theatrical continuities which made her appearance possible. Specifically, I show that the advent of women on the professional stage in 1660 was the outcome of a vigorous debate conducted in the drama and theatrical entertainments of the early Stuart period.

The advent and public acceptance of actresses in the professional Restoration theatres has been seen as a consequence of the familiarity of Charles II and his courtiers with female performance in France, Spain, Italy and Germany, where there was a tradition of women acting in public theatres.[4] In her study *The First English Actresses*, Elizabeth Howe accounts for the welcoming of women on to the public stage by claiming

that the audiences were similarly exclusive at the Caroline court theatre and the Restoration playhouses: 'It was within the select atmosphere of a particular social group that the first English actresses were introduced and flourished.'[5]

In an earlier, influential essay, Katharine Maus offered a conceptual explanation for the acceptance of women into the professional theatre. Maus argued that the seventeenth century witnessed a major shift in attitude on the part of the playgoing public towards the ideology linking feminine sexuality and the theatre, from condemnation to celebration, accompanied by a shift from a hierarchical to a polar model of sexual relations.[6] While acknowledging the partial validity of these arguments, my study shows that the actress's arrival is part of a much broader shift in the ways women are represented, and are beginning to represent themselves, in the course of the seventeenth century. If we take a long view of the sixty-year period leading up to the Restoration, it is possible to chart changes of attitude towards the idea of the actress in English society, culminating in the experimental operatic productions of William Davenant in the late 1650s in which women sang on a semi-public stage. These changes can be shown to have originated in the innovative theatrical performances of the Danish Queen Anna and the French Queen Henrietta Maria at the early Stuart courts. These two foreign queens were consorts respectively to James VI of Scotland, who ruled England as James I from 1603 to 1625, and his son Charles I, whose reign began in 1625 and culminated in 1642 in the outbreak of the English Civil War. In his cultural biography *Anna of Denmark* Leeds Barroll makes a crucial point about the altered royal situation in England following the forty-five-year reign of the unmarried Elizabeth I. In the case of a married monarch, Barroll writes, the Crown comprised 'a royal duality – theoretically two regal figures, and two courts'.[7] This political division has consequences for the cultural agency exercised by the two queens consort who figure in this study, in particular for their theatrical performances. Elizabeth I conceived of herself as an actor, commenting in 1586, 'We princes, I tell you, are set on stages, in sight and view of all the world.'[8] But no matter how artfully devised the roles Elizabeth played, she remained first and foremost the monarch; her political role was all-pervasive.

By contrast, early in the Jacobean reign the Privy Council expressed strong reservations about the King's proposal for his wife to take part in a masque, alleging 'it were the ready way to change the mirth of Christmas, to offer any conditions where her Majesty's person is an actor'.[9] Underpinning this objection to the Queen's masquing is a patriarchal notion of

the royal spouse, in which Anna's body or 'person' remains subordinate to her husband as head. The fact that Anna performed in Jonson's *Masque of Blackness* notwithstanding the Council's demurral shows the pliability of patriarchal ideology when faced with what Jonson names in *Blackness* as 'her majesty's will'.[10] A royal marriage meant a doubling of the royal prerogative, which in turn opened up possibilities both for marital insubordination and for the activation of the political aspirations of 'a number of ambitious and talented women'.[11]

Hitherto critics have focused on the sociopolitical function of women's masque performances. For the purposes of this book, the importance of the Stuart masque lies in the newly significant and signifying role accorded to female theatrical performance. Hence the first two chapters trace the development of what I call a poetics of female performance in Stuart masques and pastoral entertainments. I argue that these works inaugurate a shift in the conception of female subjectivity, which is represented in drama of the time as fluid, shifting and, most importantly, emergent. Caroline drama demonstrates a new attitude towards female theatricality, previously a focus of ambivalence in Renaissance drama and English culture in general. In this new disposition, the theatrical woman is viewed sympathetically, her outward identity seen either as socially imposed or as a ruse to protect her emotional self. Interestingly, this depiction of femininity as theatrical informs Lady Mary Wroth's prose romance, the *Urania* (1621). Heather Weidemann argues that in the *Urania* Wroth represents women 'not so much as spectacles as revelatory subjects; their appearances often point to a subjective female identity which is hidden but nonetheless authentic'.[12] Weidemann distinguishes the enabling potential of this new identity from the misogynist equation of women and duplicity, one *locus classicus* of which is Hamlet's berating of Ophelia in the nunnery scene, 'I have heard of your paintings too, well enough. God hath given you one face, and you make yourselves another' (3.1.145–6). By contrast, in the Stuart literature I examine, female theatricality has a rhetorically productive ambiguity, facilitating both satiric and idealized representations of women. Nonetheless, I argue that one result of women's increasing cultural visibility was a manifest concern on the parts of amateur and professional dramatists with issues of liberty and civility that derive from a sympathetic interest in female selfhood.

My project is therefore a revisionist one, which shares something in common with feminist modes of 'prehistory' or 'counterhistory'. Margaret Ezell has shown how a notion of literary tradition which privileges print technology and professionalism has helped shape an early modern

canon which marginalizes the work of women who wrote as amateurs within a system of manuscript circulation. In a study which similarly redirects our critical attention, Karen Raber maintains that 'within the genre loosely defined as closet drama . . . women find the dramatic voice they do not achieve in genres intended for the professional theater'.[13] My argument about the occlusion of the actress depends on an expanded notion of Stuart drama, encompassing court and provincial masques, closet plays and pastoral tragicomedies, as well as drama performed in the commercial London theatres. This diversity of forms 'serve[s] to complicate what we understand as the spaces and opportunities for performance, and intellectual engagement with the concept of theatre, that existed for women, and men, in the seventeenth century'.[14]

The inclusiveness of that last phrase is important. For the evidence suggests an openness to change on the part of a sector of English men and women ranging from courtiers to gentlemen travellers to amateur and professional dramatists. Even James's Privy Council, having boldly expressed their misgivings at the idea of the Queen's acting, proceeded to urge James to mount the masques in which Anna would appear at his own expense, simultaneously countenancing the Queen's theatrical performance and registering 'the increased political relevance of royal masquing'.[15] Thirty years later, Sir Lucius Cary, son of the dramatist Elizabeth Cary, expressed his enthusiasm for Queen Henrietta Maria's performance in Walter Montagu's pastoral drama *The Shepherds' Paradise* (1633): 'I must say this, both of it and the great actresse of it, that her action was worthy of it, and it was worthy of hir action, and I beleeve the world can fitt neither of them, but with one another.'[16]

Cary's comment, with its gender-specific term 'actress', reflects an elite culture much more at ease with the active participation of women than the Jacobean court. Even before the controversy fuelled by William Prynne's attack on women actors as 'notorious whores' in his voluminous *Histrio-Mastix* (1633), the topic of female actors is represented as a fashionable talking-point in Caroline drama. As David Scott Kastan has argued, Prynne's tract was 'less the culmination of the [Puritan] attack on the stage . . . than an anachronism at the time of publication'.[17] A resignation to change is evident in John Chamberlain's comment upon Henrietta Maria's acting in Racan's pastoral *Artenice* in 1626: 'I have knowne the time when this wold have seemed a straunge sight, to see a Quene act in a play but *tempora mutantur et nos.*'[18] 'Times change and so do we', says Chamberlain philosophically. His remark supports Michael Shapiro's suggestion that, rather than being anomalous in its retention of

an all-male public theatre (as Stephen Orgel has argued), England, a Protestant island nation detached from continental Europe, may simply have been slow to change.[19]

This book investigates the relationship betwen female theatricality and women's subjectivity or selfhood as it is represented in early Stuart drama, on stage and in social behaviour. The material I discuss testifies to 'an increased self-consciousness about the fashioning of [female] identity as a manipulable, artful process', accompanied by 'a new stress on the executive power of the [female] will'.[20] My study shares elements in common with diverse explorations of early modern women's self-fashioning and their ambivalent status as subjects.[21] The image of the actress converges with the idea of the female subject to the extent that a vocal woman transgressed the patriarchal ideology which worked to keep women out of the public view, discouraging them from speaking, taking the floor or making spectacles of themselves. The conduct book writer Richard Braithwait's injunction to English gentlewomen to 'make your Chamber your private Theatre, wherein you may act some devout scene to God's honour' illustrates this code of confinement in its Caroline form.[22] As a monarch, even Elizabeth I was not immune from moralistic prohibitions on women's self-display, as is clear in this excerpt from Sir Francis Osborne's *Historical Memoires on the Reigns of Queen Elizabeth and King James* (1658): 'Her Sex did beare out many impertinencies in her words and actions, as her making Latin speeches in the Universities, and professing her selfe in publique a Muse, then thought something too Theatrical for a virgine Prince.'[23]

Osborne constructs Elizabeth's theatricality as conflicting with her femininity, or her status as a 'virgine Prince'. Elizabeth's display of her learning and presentation of herself as a muse are forms of assertiveness which Osborne represents as 'impertinencies' in respect of the Queen's gender. At the same time, Osborne's account of Elizabeth suggests a subtle shift of response towards this performative femininity: the Queen's behaviour he writes, was '*then* thought something too Theatrical for a virgine Prince'. His remark testifies to a shift of attitude, and an alteration of circumstance taking place between Elizabeth's reign and the time of Osborne's writing, shortly before the Stuart Restoration. While Elizabeth was extolled as a phoenix, authoritative female self-fashioners of the Stuart generation are more numerous: Queens Anna and Henrietta Maria,

Margaret Cavendish, Duchess of Newcastle, and Katherine Philips, 'the matchless Orinda', come immediately to mind. In their theatrical and literary self-representations, these women steered a path through the female subjection enshrined in biblical and legal writings. Thomas Edgar, the putative author of *The Lawes Resolutions of Womens Rights* (1632), explains the situation of women as wives in early Stuart England. After his citation of God's cursing of Eve in the third chapter of *Genesis*, Edgar adds the following comment:

See here the reason . . . that Women have no voyse in Parliament, They make no Lawes, they consent to none, they abrogate none. All of them are understood either married or to bee married and their desires or [are] subject to their husband, I know no remedy though *some women can shift it well enough*.[24]

The modification 'some women can shift it well enough' suggests a gap between patriarchal ideology and women's lived experience. As both verb and noun the word 'shift' suggests physical effort, an action or attitude to which one is forced by particular circumstances. How well women could 'make shift', or perform in their given situation, depended, among other things, on their socioeconomic and educational backgrounds. The 'poor shifting sisters' invoked by Middleton and Dekker's Moll Cutpurse share a vulnerability to sexual and financial exploitation with 'distressed needle-women and tradefallen wives'.[25] Conversely, the idea of a shift in the sense of a theatrical expedient or stratagem offsets Margaret Cavendish's pessimistic appraisal of women's status. Noting the exclusion of women from political office, Cavendish comments, 'if we be not citizens in the Commonwealth, I know no reason we should be subjects in the Commonwealth: and the truth is, we are no subjects, unless it be to our husbands, *and not always to them, for sometimes we usurp their authority, or else by flattery we get their good wills to govern*'.[26] Cavendish theorizes the possibility of a wife becoming what Shakespeare's Orsino calls '[her] master's mistress' (5.1.323) either through outright 'usurpation' or by the more subtle shift of flattery. Such attribution of agency to women is facilitated in Stuart literature by the discourses of Neoplatonism and *honnêteté*, about which I say more later in this Introduction. The distinctiveness of Stuart representations of female identity and agency derives from their simultaneous embracing of and recoiling from women's use of theatrical arts.

Feminist scholars have observed that 'the notion of the husband's legal right to a woman's body and mind was . . . being contested in the [early modern] period'.[27] Evidence of a woman's ability to 'shift it', or to

secure a space for herself strategically in her domestic relationships, is found in the speech and actions of Maria, the heroine of *The Woman's Prize, or The Tamer Tamed* (1611), John Fletcher's Jacobean riposte to Shakespeare's *The Taming of the Shrew* (1592). Maria counters her sister's attempt to dissuade her from withholding her sexual delights from Petruchio with words which seriously undermine the concept of wifely subjection:

> A weaker subject
> Would shame the end I aime at: disobedience?
> You talk too tamely: By the faith I have
> In mine own Noble will, that childish woman
> That lives a prisoner to her husbands pleasure,
> Has lost her making, and becomes a beast,
> Created for his use, not fellowship.

Buttressed by the Protestant ideal of equality in the state of marriage, Maria asserts a sense of herself as an independent being, encapsulated in the phrase 'mine own Noble will'. The epilogue added for the 1633 revival of the play at the Blackfriars and the Caroline court elaborates Fletcher's intention as 'to teach both Sexes due equality, / And as they stand bound, to love mutually'.[28] This instruction resonates with the representation of the marriage between Charles I and Henrietta Maria in their early masques. As Roy Strong remarks, 'Charles and Henrietta Maria are the first royal couple to be glorified in the domestic sense.'[29] The presentation of their marriage in idyllic terms followed a strife-torn first five years soured by the King's dismissal of a large part of the Queen's extensive Catholic retinue in 1626. After the assassination of Charles's close friend George Villiers, Duke of Buckingham, in 1629, Henrietta moved to secure first place in her husband's affections. The first extant Caroline masque, Jonson's *Love's Triumph through Callipolis* (1631), mythologizes the royal marriage as a compound of 'heroic love' and ideal beauty, stressing that 'where love is mutual, still / All things in order move'.[30] The language of Henrietta's favoured form of Christian Neoplatonism is evident in the emblem of 'Beauty and Love, whose story is mysterial' (184). Henrietta Maria has recently been described as 'one of the most . . . intellectually driven women of her day'.[31] As the Catholic bride to a Protestant king, she bore the responsibility of pursuing the cause of Catholics in her adopted country. Her masques may be seen as 'stratagems of persuasion', to use Alison Shell's term, indirectly promoting her faith through dramatizing 'the all-conquering power of a feminised religious love'. Shell notes the consistency of this project with the Pauline

injunction for wives of the true faith married to unbelieving husbands to 'use indirect means to convert them', adding, 'to call this feminist is misleading; but, paradoxically, it counts among the incentives that prompted early modern women towards finding a voice'.[32]

Less paradoxical, in terms of providing inspiration for women actors and authors, was Henrietta's performance in and sponsorship of a feminized pastoral drama. The influence of this cultural trend may be seen in the Interregnum dramatic writings of the Cavendish women: the sisters, Lady Jane Cavendish and Lady Elizabeth Brackley, and their stepmother, Margaret Cavendish, née Lucas. In *The Concealed Fancies*, the household drama composed in the mid-1640s by the Cavendish sisters, theatrical self-fashioning works simultaneously in the service of female fantasy and of a shrewd domestic pragmatism. One of the claims this book makes is that the performative culture of the Stuart courts created a sphere in which elite women exerted influence and authority; that culture was profoundly inspiring for literary and theatrically minded women.[33]

This book's primary aim is to explore the literary and social ramifications of the new status of women as actors and patrons of theatrical culture at the early Stuart courts. The rest of this introduction outlines in greater detail the contexts and premises of the book's arguments. As part of that, it is necessary to sketch more closely the cultural pursuits and personal styles of the two histrionic women who functioned as royal figureheads throughout the period I examine.

THE CULTURAL INFLUENCE OF THE STUART QUEENS CONSORT

As natives, respectively, of Denmark and France, Queens Anna (1574–1619) and Henrietta Maria (1609–69) acted as conduits for the transmission of European baroque culture to early Stuart England.[34] It is worth remembering that at this time, for English writers, musicians and artists, continental travel and employment was a staple of their professional development: the lutenist and composer John Dowland was resident in Denmark between 1598 and 1606; the architect Inigo Jones toured extensively in Italy and France, while the courtier dramatist Walter Montagu heard Monteverdi conduct his own works in Venice and twice visited the artist Artemisia Gentileschi in Sicily.[35] Thus, in fostering female performance, and in their further artistic patronage, Anna and Henrietta Maria were accelerating a process of cultural exchange and transformation which was already underway.

For Anna of Denmark artistic patronage arguably provided a substitute for the political intriguing in which she had engaged in Scotland.[36] In England, with a strong consensus of nobles supporting James's rule, her options for political engagement were limited. However, she formed strong links with 'the Essex circle' which clustered around the figure of Lucy Russell, Countess of Bedford, whose husband was one of three earls who rode with Robert Devereux, second Earl of Essex, in his abortive rebellion of 1601. At the accession of James I in 1603, Russell won the privileged place of lady of the Bed Chamber to Queen Anna; as well as dancing in masques, her prominence as a theatrical patron is reflected in her role as dedicatee of two Jacobean women's masques, Samuel Daniel's *The Vision of the Twelve Goddesses* (1604) and Robert White's *Cupid's Banishment* (1617). The poet Daniel held the position of groom of the Privy Chamber in Anna's household, as did the linguist John Florio. The patronage orbit of the Essex group included the playwrights Ben Jonson and George Chapman and the poet John Donne; the group comprised other female patrons such as Susan de Vere, who in 1621, as Countess of Montgomery, received the dedication of the *Urania*, the prose romance authored by Lady Mary Wroth, the daughter of Robert Sidney, a poet and Anna's Lord Chamberlain.

Barroll ambitiously describes Anna as 'the important precipitant of that "atmosphere" of high cultural patronage which we associate with the early Stuart court' (Figure 1).[37] Anna's success in establishing herself as a cynosure on a par with, or rivalling, James may be gauged by a reference in a letter of John Chamberlain to the palace of Somerset House on the Strand as 'Quenes court'.[38] Chamberlain's letter reports the marriage at Somerset House of Anna's lady-in-waiting Jane Drummond to the Earl of Roxborough in February 1614, an occasion which was graced by Daniel's pastoral *Hymen's Triumph* (pub. 1615), commissioned by Anna to celebrate the completion of renovations to the building.[39] This performance postdated Anna's active masquing career, which lasted some eight years from 1603 to 1611; during this period she performed in six extant masques, but after the death of Prince Henry in 1612 she ceased participating as a masquer. However, Anna maintained her interest in performance until the end of her life; in 1617 she was entertained with a *ballet de cour* by her French musicians, and in the same year she was the chief spectator and addressee of White's *Cupid's Banishment*, a masque performed at her Greenwich court by young schoolgirls.[40]

Clare McManus posits the innovation of female masquing speech in *Cupid's Banishment* as the culmination of tendencies manifested within

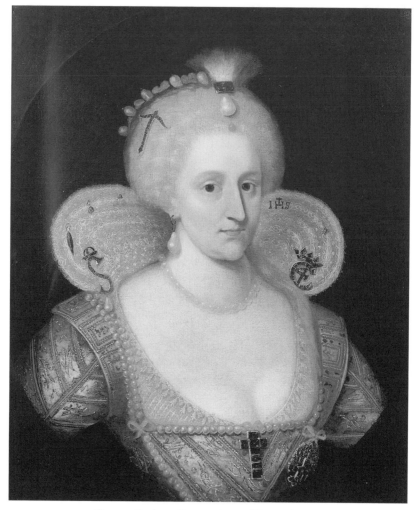

Figure 1. Paul van Somer, *Anna of Denmark*, 1617.

earlier Jacobean queen's masques and she argues that 'Anna's court performances stood as a significant precedent for the development of courtly and professional female performance in the Caroline court'.[41] Using the framework employed by Malcolm Smuts to describe the emergence of a royalist court culture in early Stuart England, we may characterize the years of Anna's influence as a transitional period,

initiating theatrical practices and modes which were consolidated and extended in the subsequent reign.[42] Henrietta Maria's staging of Racan's *Artenice* in 1626 caused shockwaves not just on account of the Queen's acting, but also because some of the participants 'were disguised like men with beards'. Female transvestism was one of the carnivalesque aspects of Henrietta Maria's entertainments; the device persisted in the performance of *The Shepherds' Paradise*, where nine out of the thirteen actresses played masculine roles.[43] Simultaneously, in Henrietta Maria's masques and in courtier drama there emerged the figure of the warrior woman; this development also had an avatar in the Jacobean reign, in Anna's appearance as the martial goddess Pallas-Athena in *The Vision of the Twelve Goddesses* and in Jonson's heroic *Masque of Queens* (1609). Such continuities should not blind us to the differences in style of the queens consort and in the conduct of relationships between women and men at the two courts. Henrietta Maria's youth (she was not quite sixteen when she arrived in England in 1625), her French background and her personality combined to introduce a new gaiety and sophistication to court culture. In the words of her most recent biographer, she had 'immense vitality and an instinctive flair for chic' (Figure 2).[44] The French Queen made her mark as much through her dress sense and her private supper parties as she did through her Catholicism and her cult of Platonic love. Together Henrietta Maria and Charles presided over a court where feminine beauty was transformed into political and intellectual power, and in which, as one ambassador remarked, 'many negotiations [were] conducted through women'.[45] This formed a contrast with the marriage of the homosocially inclined James and Anna, who after the death of her sixth child, Mary, in 1607, departed from Whitehall to set up her own court at Somerset (or Denmark) House.[46] Moreover, Henrietta Maria's enthusiasm for drama spurred her to visit commercial theatres; in the 1630s she attended four separate performances at the Blackfriars, and on a fifth occasion she and Charles attended a special performance of Thomas Heywood's *Love's Mistress, or the Queen's Masque* (1634, pub. 1636) at the Phoenix theatre, home to Queen Henrietta's Men. While Anna was an enthusiastic sponsor of professional drama, Henrietta Maria's visits to commercial theatres signal her urbanity, and demonstrate the greater cross-fertilization between the cultures of the court and the metropolis in the Caroline period.[47]

The increased visibility of female cultural agency in the 1630s may be gauged by the satirizing of Henrietta Maria's social fashions in Caroline drama. The protagonist of James Shirley's *The Humorous*

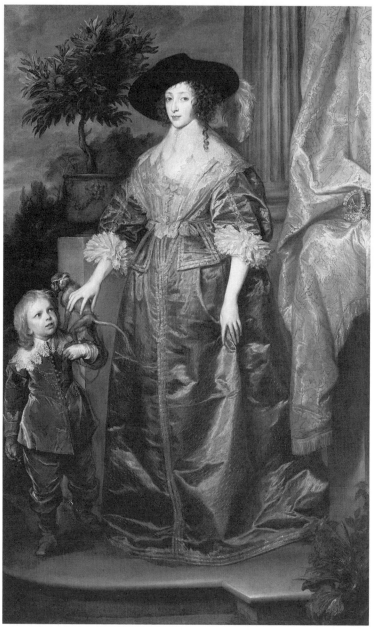

Figure 2. Van Dyck, *Queen Henrietta Maria with Sir Jeffrey Hudson*, 1633. Hudson, the Queen's dwarf, performed in several court masques.

Courtier (1631, pub. 1640) rails against the indignities inflicted on men by 'a womans court':

> Ile choose
> Any employment rather then to heare
> A lady utter perfum'd breath, or see her
> Advance in her masculine garbe, in her
> New mimicke posture.[48]

As the last phrase shows, Shirley was aware of the shock of the new, and its pulling power. His comedy *The Ball* (1632) questions but ultimately vindicates the genteel fashion of social dancing associated with the Queen; the play features a French dancing-master named Monsieur Le Frisk who is ridiculed as a foreign artisan. As Sandra Burner points out, the court coterie for whom Shirley was writing 'demanded wit, ingenious plotting, and even the satiric treatment of its own exaggerated manners and fashions'.[49] Shirley's association with Henrietta Maria's circle demonstrates the latitude afforded by court patronage, as Martin Butler and Kevin Sharpe have argued.[50] His tragicomedy *The Bird in a Cage* (1633) crystallizes the uneasy accommodation of female performance within the political and commercial pressures that bore upon the professional playwright. Originally titled *The Beauties*, Shirley published the play under its new title in 1633 with a mock dedication to Prynne, who was in prison awaiting trial after his denunciation of women actors had been construed as an attack on the Queen's performance in *The Shepherds' Paradise*. Shirley, it seems, saw the chance to reap a political advantage with his play, which showcased women actors. In the dedication Shirley confesses with heavy irony that the comedy lacks

much of that ornament which the stage and action lent it. For it comprehending also another play or interlude, personated by ladies, I must refer to your imagination the music, the songs, the dancing, and other varieties, which I know would have pleased you infinitely in the presentment.[51]

By so dedicating *The Bird in a Cage*, Shirley manifested his support for the crown; his affiliation was further spelled out by his description on the title-page of the quarto edition as 'Servant to her Majesty', alluding to his recent appointment as *valet de chambre* to Henrietta Maria. Yet there is no clear correlation between Shirley's gestic championing of the Queen and his ambiguous representation of women actors within the play itself. What is notable is that, concurrent with the Queen's innovations, female acting becomes a topic of dramatic discourse in the Caroline period, giving rise to new literary representations and fostering cultural debate.[52]

LITERARY RAMIFICATIONS OF FEMALE PERFORMANCE

Chief among the literary consequences of women's status as actors and patrons of theatre at the early Stuart courts was a new sexual realism in works performed by and associated with both queens. At its most rudimentary, this element was expressed by the sheer novelty of women's bodies on stage, but this aspect of feminine embodiment is apparent also in titles such as Daniel's pastoral *Hymen's Triumph*. The intensive concern with female subjectivity in Stuart drama is accompanied by a new focus on female expressiveness and a woman's articulation of sexual desire. My second chapter examines the interest in women's 'naked hearts' in two entertainments performed at the Caroline court, Aurelian Townshend's masque *Tempe Restored* and Montagu's *The Shepherds' Paradise*. By juxtaposing these works' representation of theatrical femininity with the role of the Lady in Milton's *Masque performed at Ludlow Castle*, I show how the latter masque revises and complicates a Neoplatonic construction of female virtue. The works by Townshend and Montagu inaugurate a sexual rhetoric attached to the woman's body on stage, which has been analysed in depth by Elizabeth Howe in relation to Restoration drama. Howe proposes that 'in the outstanding plays of the [Restoration] period the sexual realism provided by the actress helps promote a fresh, sensitive, and occasionally even a radical consideration of female roles and relations between the sexes'.[53] The sympathetic exploration of women's position in Restoration drama is foreshadowed in Montagu's play, which shines a spotlight on the divisions and discontinuities informing Caroline female subjectivity. Moreover, Montagu's *précieux* dialogue is permeated by the language of liberty and prerogative, which anticipates the focus on women's plight within marriage in Restoration comedy.

Secondly, the prominence of women in Caroline court culture produced an enhanced recognition of female invention, ingenuity and wit in drama written for both the court and the professional stages. My third chapter scrutinizes the literal and figurative freedom to act accorded women in three Caroline comedies by Ben Jonson, James Shirley and William Cartwright. These comedies pursue in vigorous fashion the potential social and political significances of women's liberty and theatricality. The figure of the stateswoman, vocal in political matters, is common to the work of all three playwrights. It is possible that this literary focus on women as active, political subjects was triggered by the

intense controversy provoked by female performance in Charles's reign. However, in assessing this dramatic trend, we should also note the currency in England of feminist ideas drawn from Neoplatonic philosophy, and the French social trend of *honnêteté*, which simply translated means 'civility'. Cartwright's *The Lady-Errant* satirizes arguments that were gaining ground in French *honnête* literature, such as Du Bosc's *L'Honnête Femme* (1632), which urged upon women 'le courage de rentrer dans leur droits' (the courage to discover their rights). In his translation of Du Bosc's text as *The Accomplished Woman* (1632?, pub. 1656), Walter Montagu argues that 'It is a Tyranny and a Custome that is not lesse unjust than ancient, to reject Women from Publick and Particular Government, as if they were fit for nothing but to spin: Their Wit is apt for more elevated actions.'[54] These sentiments took root in English drama via the heroicizing portrayal of women like Cleopatra in Fletcher and Massinger's *The False One* (1620), discussed in Chapter 6, and Cleora and Pulcheria, the heroines respectively of Massinger's tragicomedies *The Bondman* (1623, pub. 1624) and *The Emperor of the East* (1631, pub. 1632). In discussing the satiric portrayal of the actress as politician in *The Lady-Errant*, I employ an argument made by Mary Beth Rose about tragicomedy as a transitional form which at once transforms and critiques chivalric heroism and reconfigures private life.[55]

My fourth chapter explores the notion of sexual realism in relation to the representation of women in Caroline tragedies by John Ford, James Shirley and the Puritan dramatist Nathanael Richards. In casting women as sirens, these tragic dramatists highlight qualities of feminine sensuality, passion and eloquence. In her study *Woman and Gender in Renaissance Tragedy*, Dympna Callaghan remarks that 'woman can be said to be constructed as a "shifting" subject', chiefly through her polarised representation as alternatively a transgressor and a saint.[56] Caroline tragedy inherits and reflects the misogynous view of women in Renaissance drama; however, it also sustains the intensive focus on women's shifts or contrivances that I demonstrate in my chapter on comedy. Thus in this chapter I am concerned not just with the fundamentally unstable representation of woman as a 'shifting subject', but also with the performative strategies of desire, madness and death through which Caroline dramatists register a heightened conception of woman as histrionic. I argue further that these plays articulate subversive views of monogamy, and manifest sympathy for the woman trapped in an arranged marriage.

WOMEN AS AUTHORS OF DRAMA

An interchapter analysing the role of women singers in William Davenant's Protectorate opera forms a bridge to my last two chapters, which examine the persistence of female theatricality as a motif in women's drama of the Interregnum and early Restoration periods. Unlike earlier women writers of closet drama, such as Mary Sidney and Elizabeth Cary, the minds of the women to whom I give centrestage, Margaret Cavendish and Katherine Philips, were shaped by the efflorescence of Caroline court culture. Certainly, the closet dramas of Sidney and Cary, together with Lady Mary Wroth's pastoral *Love's Victory*, form an antecedent to the dramatic writing of Cavendish and Philips. This earlier Renaissance drama by women is preoccupied with female voices: Sidney's and Cary's plays are charged with a sense of mouths and tongues as agents of eroticized speech, while Wroth's play, as I show in Chapter 2, is enmeshed with anxieties about female voicing and expression.

However, the shifts in theatrical conditions and cultural patronage which this book charts make a substantial difference to the material purchase of a woman's 'public voice' as represented by Elizabeth Cary in her Jacobean *Tragedy of Mariam* (1602–4, pub. 1613) and women's speaking 'upon the publick Stage' as represented in the closet drama of Margaret Cavendish, composed during the 1650s and published after the Restoration.[57] Women's voices were heard at the Caroline court in ways they were not during James's reign, as actors and sponsors of plays. In the epilogue to his comedy *The Court Begger* (1640, pub. 1653), Richard Brome gives an index of the cultural sway exercised by female courtiers, alleging that 'the great and curious Poets' are 'by [the ladies'] powerfull voyces . . . cry'd up wits o' Court'. As Karen Raber has shown, the closet drama of noblewomen such as Cary and Mary Sidney thrived upon its disassociation from the public stage.[58] After Henrietta Maria had both acted in plays, and attended performances in public theatres, this detachment of the female aristocrat from the theatrical profession was undermined. As the practices of court theatre begin to colonize the public stage in the mid-seventeenth century, the relationship to theatre of women like Cavendish (who was nonelite in origin) and the middle-class Philips also changes. Through their personal relationships and cultural situations, these writers display a knowledge of and affinity with theatrical culture which is absent from the work of Cary and Sidney. As a result, in their drama acting and performance become potent, ambiguous metaphors, facilitating female agency and expression, but simultaneously

rendering the female self vulnerable to charges of improper display and assertiveness.

It is no longer tenable to situate Cavendish and Philips as marking a transition between a culture in which female authorship remains eccentric or private, and the culture of the Restoration theatre in which women such as Aphra Behn and Mary Delarivier Manley competed openly with men as professional playwrights.[59] The conservative feminism which blossomed in the 1630s saw women as capable of 'elevated actions', and during the Civil War and Commonwealth periods such actions encompassed literary and musical composition. In the 1650s Cartwright's 'younger disciple' Philips used the theory of the unsexed soul to buttress women's claim to the province of friendship, attributing their exclusion from 'friendship's vast capacity' to men's 'partial tyranny'.[60] Cartwright was a major influence on Philips, whose earliest foray into print was her commendatory poem, 'In Memory of Mr Cartwright', published in the posthumous collection of Cartwright's *Comedies, Tragicomedies, with other Poems* (1651). Raber proposes that Philips's translations of Corneille may be seen as closet drama recuperated for stage performance; yet this characterization does not do justice to the extent to which Philips was wired into a theatrical culture, remarking in a letter from Dublin to Charles Cotterell, 'We have a new Playhouse here, which in my Opinion is much finer than D'AVENANT'S, but the Scenes are not yet made.' It was this custom-built theatre in which her own *Pompey* was produced in February 1663.[61]

Philips's letters display a veneer of modest self-effacement, yet at the same time they show her discriminating appraisal of the work of her male contemporaries and indicate her aspirations to recognition from a particular 'public'. By contrast, Cavendish openly courted 'an extraordinary fame' through the publication of her many, disparate writings and the 'singularity' of her dress and behaviour.[62] Whereas Cavendish's plays were acted only in the blazing world of her imagination, Philips achieved the distinction of having her version of Corneille's *Pompey* performed on the Dublin, and possibly the London, stages. The modifications of attitude and shifts of discourse which facilitated women's appearance on the public stage similarly worked to make possible women's public expression as authors. As the introduction of actresses opened up a new range of conventions and attitudes, so the metamorphosis of the female wit into the woman playwright brought an enlarging of dramatic perspectives. This two-fold expansion of literary and theatrical possibilities forms the subject of this book.

'Magic in majesty': the poetics of female performance in the Jacobean masque

In his *History of Great Britain* (1653), the Puritan dramatist Arthur Wilson described the Jacobean court as:

A continued *Maskerado*, where [the Queen] and her Ladies, like so many *Sea-Nymphs* or *Nereides*, appeared often in various *dresses* to the *ravishment* of the beholders . . . But the *latitude* that these high-flying *fancies*, and more speaking *Actions* gave to the lower World to judge and censure even the Greatest with *reproaches*, shall not provoke me so much as to stain the innocent Paper.[1]

Wilson's image of the Jacobean court as a 'continued *Maskerado*' is in one sense misleading, for, as Leeds Barroll has pointed out, the intermittent masques were 'the proverbial tip of the iceberg' of Queen Anna's cultural activity and patronage.[2] Yet if masques formed only one part of Anna's broader interests, they were certainly the most conspicuous part, and it was not only Wilson who emphasized their authority. In an account of Queen Anna written in 1607, the Venetian ambassador stated, 'She likes enjoyment and is very fond of dancing and fêtes.'[3] The courtier Arbella Stuart describes how she was drawn into verbal games or 'childe-playes remembred by the fayre ladies' while with the Queen at Winchester in 1603, commenting drily, 'I was even perswaded by the princely example I saw to play the childe againe.' She adds, 'Thear was an enterlude, but not so ridiculous (as ridiculous as it was) as my letter.'[4] The theatrical playfulness encouraged by the Queen attained formal artistic expression in the 'high-flying fancies, and more speaking *Actions*' of the court masque.

The phrase 'speaking actions' captures the signifying potential of the masque as a theatrical genre. Recent criticism focused on women's performance in Stuart masques has explored the capacity of the masque to resonate with meanings other than the legitimation of male monarchy and royal power. In his cultural biography of Anna of Denmark, Barroll

focuses on the masques in which she performed as 'prestigious socio-political events' through which Anna achieved a 'self-centering' as the queen consort. The monograph by Clare McManus, *Women on the Renaissance Stage,* broadens the concept of female performance to encompass coronations and royal baptisms, attributing to Anna 'a career of oppositional political engagement, cultural agency and dissident performance'.[5] These two substantial studies effect a shift of focus from the published scripts of the masques to the political and performance texts constituted by the female body in space and the social bodies of the Queen's and King's courts as participants in and spectators of these entertainments. One dimension of Stuart masques which these contextualising approaches do not consider is their generative relationship with later drama and literature. Assuming such a long view, this chapter focuses on the masques' representation of women's persuasive agency, figured through a dynamic language of action and motion. I argue that the conventions of female performance created by the masque texts themselves involve a bold affirmation of femininity. This affirmation sits alongside, and at times troubles, the masques' mythic idealization of kingship.[6] The tension and ambiguity inherent within the Queen's masque as an entertainment performed for the King becomes more pronounced in masques marked by the monarch's absence; in examining several such masques I demonstrate the potential of the masque form to refashion concepts of gender, and of virtuous action, through the 'lively motion' of performance.[7]

The masques written for Queen Anna by Samuel Daniel and Ben Jonson simultaneously embody and animate a poetics of female performance. In this new theatrical form, the female body is central, becoming 'the locus of action and meaning'.[8] The poetry of Jonson's masques, in particular, suggests that in Queen Anna he found a collaborator whose instincts for the unusual and exotic were in sympathy with his own sense of the masque form as something 'rich and strange', sounding to present occasions but able to 'lay hold on more removed mysteries'.[9] At the end of the text of his wedding masque *Hymenaei*, performed at Whitehall in January 1606, Jonson articulates the capacity of the masque to ravish the viewers in the manner evoked by Wilson: 'Such was the exquisite performance, as . . . that alone . . . was of power to surprise with delight, and steal away the spectators from themselves' (522–6). The terms in which Jonson describes the masque highlight its movement. The performance is

impossible to recapture for it 'cannot by imagination, much less descrip-
tion, be recovered to a part of that spirit it had in the gliding by' (530–2).
This language resonates with Wilson's phrase 'fluent *Elegancies*', suggest-
ing a form that is insubstantial, fleet of foot, barely touching the ground.
The quality of the Queen's masques as theatre inhered especially in the
power of the female performer to move the spectator, or as Iris, in
Daniel's *Vision of the Twelve Goddesses* puts it, to 'work the best
motions'.[10] In the context of the masque, this phrase would have sug-
gested not just the power of feminine beauty to transport the viewer but
women's ability to perform the 'motions' or dances which were the chief
component of the masque as spectacle. It is women's 'moving' in this
compound sense of performance and persuasion that is celebrated in a
lyric from Jonson's *Masque of Beauty* (1608), which was sung as an
interlude during the dancing of the female masquers:

> Had those that dwell in error foul,
> And hold that women have no soul,
> But seen these move, they would have then
> Said women were the souls of men.
> So do they move each heart, and eye
> With the world's soul, true harmony.
> (307–12)

The song describes women's dancing in Neoplatonic terms, presenting
their movement as an image of heavenly concord and beauty.[11] The
Neoplatonic convention in which women act as an inspiration to heav-
enly rapture is a paradigm of the queen's masque as developed by Jonson,
complementing its function as 'a triumphal celebration of the king's
majesty'.[12] This depiction of female action as inspiring a heightened
emotional and spiritual state mirrors the idealized portrayal of the female
musician in Elizabethan literature. Linda Austern documents the associ-
ation between feminine beauty and music which led to 'the development
of stock literary situations in which female musicians either caused
spiritual fulfillment or physical destruction'.[13] There is a crucial differ-
ence, however, between women's persuasive action as it is celebrated in
Jacobean masques and the female musical enchantment analysed by
Austern. Whereas all the literary musicians Austern analyses are singers,
the performance of women in court masques was silent (with the import-
ant exception of Robert White's 1617 masque at Greenwich, *Cupid's
Banishment*, which I discuss later). Wilson's phrase 'speaking *Actions*' is
an oxymoron: what the actions of the court masque spoke of to Wilson, as

to many other critics, was unseemly extravagance. The fact that women in masques were mute meant that the power of their performance lay chiefly in their sumptuous appearance and physical movement. Women's ability to 'work the best motions' therefore depended on a 'silent rhetoric' similar to the virtuous influence attributed to the elite female audience.[14] The potency of such mute feminine eloquence is shown in Shakespeare's *Coriolanus* (1608) in the moment when Volumnia, after pleading with Coriolanus to spare Rome, falls silent. The stage image, in which Coriolanus *'holds her by the hand, silent'* (5.3.183.1) resonates with the emotional charge of the bond between mother and son. Coriolanus speaks, and yields, while Volumnia remains silent for the rest of the scene, yet the theatrical power is all with her. The masquer's silence in no way lessened the theatricality of her or his role; indeed, combined with the vizards which customarily obscured their faces, the masquers' silence must have heightened the initial mysteriousness of their appearance. As we shall see, the texts of Jacobean masques invest women's performance with an expansive range of meanings and emotional affects.

SONGS WITHOUT WORDS: JONSON'S MASQUES 'OF BLACKNESS' AND 'OF BEAUTY'

The 'characters'[15] of women in Jonson's twinned masques *Of Blackness* and *Of Beauty* derive from two paradoxes: the one of a luminous blackness; the other of a constant beauty perpetually in motion. The overarching conceit of the masques was framed by Jonson in response to Queen Anna's mandate: 'because it was her majesty's will to have them blackamores at first, the invention was derived by me, and presented thus' (18–19). Jonson acknowledges the fusion between the Queen's commissioning 'will' and his poetic 'invention'. This creative fusion feeds into *The Masque of Blackness* where the idea of women's will and the erotic overtones of feminine blackness are realized in Jonson's conception of the twelve masquers as water nymphs, daughters of the River Niger.

Jonson used 'the Queen's fancye' as the basis for a new theatrical language in which female performance, and dancing, is represented as a vehicle of meaning.[16] In explaining to Oceanus the reason for his traversal of the globe from East to West, the presenter figure Niger identifies his daughters as the propulsive force of the masque. Succumbing to the fables of poets who extoll fair skin over black, the nymphs 'wept such ceaseless tears into [his] stream / That it hath thus far overflowed his shore / To

seek them patience' (146–8). The women's desire to be beautified has propelled Niger westward; moreover, we hear that they have hurled 'volleys of revilings' (149) at the sun for scorching their cheeks. While the masquers remain silent, their vocal force is animated within the script. The character of the nymphs is amplified by the discovery of the moon 'in the upper part of the house, triumphant in a silver throne' (186–7). The radiance of 'Great Aethiopia' (196) has been foreshadowed by Niger's account of how the nymphs, as they were bathing, saw in the lake 'a face, all circumfused with light', inscribed with mystical writing directing them to seek out a land ruled by a sun greater than 'bright Sol' (159, 166). Aethiopia's revelation of her identity to Niger introduces an aspect of mirroring which suggests her maternal role in relation to his daughters: 'I was that bright face / Reflected in the lake in which thy race / Read mystic lines' (204–7). The nymphs read the riddle containing the key to their fantasized transformation in Aethiopia's reflected light. As Aethiopia provides an empowering self-image for the nymphs, she also holds out the promise of a more complete identity. Her maternal function is enhanced by the fact that as an Eastern moon goddess she resembles 'a Cynthia made alien'.[17] It is no coincidence that Cynthia was one of the names by which poets including Jonson in his early, masque-like play, *Cynthia's Revels* (1600) figured Queen Elizabeth I. The subsequent naming of Aethiopia as Diana, Roman goddess of chastity and the moon, allows us to read this composite deity as figuring the women masquers' ambiguous likeness to, but difference from, Elizabeth I.[18] In her aspect as a moon goddess, and as a source of 'pure, auspicious light' (195), Aethiopia summons echoes of Elizabeth.

The sense of ancestry and feminine lineage brought to the masque by Aethiopia intensifies the paradoxical iridescence of the Ethiopian nymphs.[19] Stephen Orgel describes as a paradox the appearance of the noble masquers in a disguise which 'to the Elizabethans was a synonym for ugliness'.[20] However, the discovery of the masquers under the aegis of Aethiopia argues a contrary case. Floating in 'a great concave shell' (46), reminiscent of the scallop shell bearing Botticelli's Venus, the nymphs are heralded by their sea train as a 'beauteous race, / Who, though but black in face, / Yet are they bright, / And full of life and light' (81–4). This refashioning of blackness as luminous is enhanced by the masque's aquatic symbolism, focused in the masquers' personae as water nymphs. The nymphs' fluidity fuses the elements of poetry and dance. As they approach the British shore, Aethiopia directs the nymphs to 'indent the land with those pure traces / They flow with in their native

graces' (230–31). The image of liquid grace is visually evoked as the masquers '*dance on shore*' and echoed in the hieroglyphics on the fans each couple presents to the audience, with their associations of water, purity and fertility.[21]

McManus argues that in Jonson's first masque for Queen Anna, 'the female masquer appears to have been aligned only . . . with the physical aspects of the masque', that part which in the preface to *Blackness* Jonson names the 'carcass' as opposed to the 'spirit' of the work.[22] There is undoubtedly a tension between the idealizing discourse of the hieroglyphs and the masquers' black painted faces and arms, which McManus reads as emanating a 'dangerous and open sexuality'.[23] Yet, importantly, this tension is *already* embedded within the masque text, in the two songs which intersperse the mixed dancing of the revels. The allure of the women's movement is evoked firstly in a 'charm' recalling the nymphs to sea '*as they were about to make choice of their men*' (265–6). The nymphs are told:

> If you do not stop your ear,
> We shall have more cause to fear
> Sirens of the land, then they
> To doubt the sirens of the sea.
>
> (271–4)

The image of the women's dangerously open ears represents the social dancing of the revels as a form of erotic congress. By depicting male and female dancers alike as sirens, the song suggests a mutual enthralment arising from their entwining in dance. The captivating power of the nymphs is imaged further in the Echo song at the end of the revels.[24] The song depicts the earth and water as literally out of step through the '*double echo*' which issues '*from several parts of the land*' (277). The peals of the land frustrate its attempts to entertain further the 'daughters of the subtle flood' (279). Betrayed by its own utterance, the land can only echo its 'little hope, to gain you . . . the more you flee' (285, 290). Poetry and music combine to evoke the elusiveness of the nymphs, conjuring a soundscape to match their fleet-footed dancing.

By representing the elements of earth and water as irreconcilable, Jonson's Echo song creates a poetic rationale for the nymphs' return to the sea. At the same time, the song weaves a spell of enchantment about the nymphs' lingering presence. The magic of female performance is represented as a dangerous seductiveness which causes the earth dwellers to 'follow [the nymphs] the more [they] flee'. Interestingly, this line is

grafted from George Chapman's mythological poem *Ovid's Banquet of Sense* (1595), where Ovid watches his mistress Corynna singing a paean to women's art of love:

> It is our grace and sport to see,
> Our beauties sorcerie,
> That makes (like destinie)
> Men followe us the more wee flee.[25]

The song expresses delight at the seductive power of women's beauty, which transforms the allegorical figure of 'wisdome' (114) to folly in his effort to justify sensual indulgence. The overt sensuality of Chapman's naked Corynna imports an undertow of active danger to the Echo song, addressed as it is to the 'daughters of the *subtle* flood'.[26] This epithet forms a poetic corollary to the women's dancing which visually challenges the ideal of a stable identity.[27] The multiple associations of the masquers as water nymphs supplants the image of female fixity voiced by Niger's disgruntled view of his daughters' 'settled thought[s]' (153), and their vanity, which has caused him to track halfway around the world in search of a beauty treatment.

The artistry of Jonson's Echo song encompasses an evocation of 'decorous coition' in the word 'entertain' used in the opening stanza.[28] This potential meaning is sustained by the glimpsing of sexual possession in the second stanza: the sirens of the sea afford their land counterparts only '[this] little hope to gain [them]'. These erotic resonances must have been heightened by the appearance of the six-months-pregnant Queen, whom McManus describes as 'an embodiment of consummated sexual passion'.[29] Yet rather than the climax of coition, there is a specifically feminine pleasure evoked in the song's sonic effects of ripples and waves.

Although the quest paradigm underpinning *Blackness* posits the nymphs' physical transformation as the telos of the masque, Jonson forgoes this poetic and theatrical climax.[30] Instead, the fluidity figured through song and dance is arrested by Aethiopia, who tells the masquers, 'Enough, bright nymphs, the night grows old' (300). Her account of the rites the nymphs should perform to remove 'this veil the sun hath cast / Above your blood' (306–7) links their perfecting with the soothing source of water and with Aethiopia herself, the governess of change. The parting song again simulates female speech by exhorting the nymphs to 'shout with joy of favor, [they] have won' (335), a 'favor' which derives ultimately from King James's grace, and which foreshadows the nymphs' change of

favour, or countenance, that will be effected by his 'sciental' light (226). That transformation, however, belongs to the future; within the present the song suspends the nymphs in the syncopated rhythms of the sea: like the ebbing waves, they move backwards, but the image of their 'forward grace' (333) keeps their return tantalizingly within view. At the end of the masque, the nymphs are unchanged, yet still in motion, 'full of [a] life' which cannot be refashioned into beauty's likeness.

Recent commentaries on *The Masque of Blackness* have focused on the implications of the women's blackface disguise and costumes as part of an interpretation privileging 'the twin concerns of patriarchy and imperialism' as they converge in the text.[31] The '*bodily part*' (71) of the masque created by Inigo Jones formed a brilliant complement to Jonson's conception of the masquers as Niger nymphs. The women's dresses and mantles were coloured azure and silver, highlighting the darkness of their skin and hair. Their exotic costume, topped by a feather headdress, was accentuated by lavish jewellery, 'of the most choice and orient pearl' (60). Jones's design shows a dress with filmy half-sleeves, leaving the masquer's darkened arms bare to the elbow, her upper arm perceptible through the transparent gauze (Figure 3).

Jones's costume design is such a stunning analogue to Jonson's script that one might almost say the costumes played by themselves.[32] However, the critical focus on the material dimension of the masque has occluded the richness of Jonson's poetic figuring of femininity. The mixture of the bizarre and the beautiful embodied in the visual side of the masque forms a corollary to the drama of feminine seductiveness elaborated in the text. Each element, visual and poetic, involves an element of danger. As we have seen, Jonson images the water nymphs as 'sirens', evoking the potential of feminine beauty to 'ensnare[s] both soul and body'.[33] The risk of the masquers' costumes entailed the open avowal of sexuality connoted by black skin, and by face-painting, each of which were associated in Renaissance culture with seductive and potentially unsettling figures, the African and the courtesan.[34] The links between the masque and the courtesan were precariously close: each was inherently seductive, each employed painting and artful discovery; moreover, the masque drew its very name from the courtesan's symbol.[35] The association between masquing and prostitution surfaces in Dudley Carleton's remark that the masquers' costumes in *Blackness* were 'too light and curtisan-like for such great ones'.[36] Rather than the dresses themselves, it was most probably the exposure of the women's blackened faces, necks and arms which provoked Carleton's disapproval.[37]

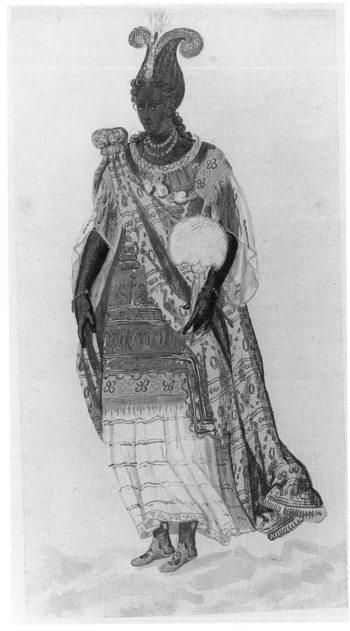

Figure 3. Inigo Jones, *Nymph of Niger.*

The sensuality of women's arms (to which Westerners have become dulled) is beautifully captured in Van Dyck's *Portrait of a Girl as Erminia* (Figure 4). The painting evokes the scene in Tasso's Christian epic *Jerusalem Delivered* (1581, trans. 1600) in which Erminia dons the armour of her friend Clorinda in order to enter Jerusalem and find the wounded Tancred.[38] Erminia rests one hand on a helmet, while with the other she raises her voluminous sleeve, displaying the length of her arm to a point above the elbow. The painting highlights the contrast between her steel breastplate, her softer smock and her even softer flesh. This image provides a potent analogue to the fifteenth-century admonition of the Italian Francesco Barbaro, 'It is proper . . . that not only the arms but indeed also the speech of women never be made public; for the speech of a noble woman can be no less dangerous than the nakedness of her limbs.'[39] Rejecting such prohibitions, both Van Dyck's painting and *The Masque of Blackness* engage in a form of risk-taking comparable to the courtly ideal of *sprezzatura*, or 'recklessnesse', described by Castiglione in *The Book of the Courtier*.[40]

Possibly, the transgressive embodiment and self-fashioning of the masquers in *Blackness* are encompassed by the term Jonson placed on the title-page to the 1608 Quarto, a word which reappears at the end of the text. There Jonson states that the masque '*had that success in the nobility of performance as nothing needs to the illustration but the memory by whom it was* personated' (338–9, emphasis mine). Dympna Callaghan suggests that in this instance '*personate* has more the force of "bearing the character of" . . . than the active characterization we associate with mimesis, where a character, not the actor's own, has to be "brought to life" onstage'.[41] Nonetheless, it is intriguing that with particular reference to *Blackness*, Jonson uses a term which had recently come to be applied to the new style of character impersonation taking hold in the professional theatres.[42] This mode of acting was linked with powerfully individualized male protagonists such as Marlowe's Tamburlaine and Doctor Faustus, Kyd's Hieronimo and Shakespeare's Othello; the latter play, subtitled *The Moor of Venice*, was performed at the Jacobean court in the autumn of 1604, several months before the performance of *Blackness*. Although in the Jacobean court masque female performers remained silent, they are referred to several times as 'actors' in contemporary accounts. For example, John Pory wrote of the performance of *Hymenaei*, 'Both Inigo, Ben, and the actors men and weomen did their partes with great commendation.'[43] The performance of courtiers in masques may be thought of as hovering somewhere between rhetorical and theatrical notions of

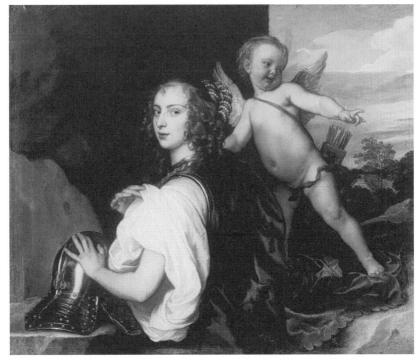

Figure 4. Van Dyck, *Portrait of a Girl as Erminia, attended by Cupid.* This sensuous painting resonates with the depiction of the *femme forte*, or heroic woman, in Stuart masques and drama.

acting, between inhabiting and feigning a role.[44] A masquer's disguise was 'a representation of the courtier beneath'; yet, as Pory's choice of words suggests, the adoption of that disguise implied playing a part.[45] From this angle, Jonson's use of 'personate' with reference to the masquers in *Blackness* captures his masque's audacious theatricality.

The use of *'presented'*, rather than 'personated', in the published text of *The Masque of Beauty* conveys the temperate spirit of Jonson's second queen's masque. The plot of *Beauty* skilfully accommodated the contingencies of a two-year delay in its production and Queen Anna's request for Jonson to incorporate four more performers, raising the number of masquers from twelve to sixteen (4–6). The Queen's paramount requirement was that the masquers should appear, in Jonson's discreet phrase, with 'their beauties varied' (5), completing the diptych of femininity initiated in *Blackness*. Jonson dramatizes the threatening aspects of blackness in the Spenserian figure of Night, an antagonist to Aethiopia and

King James. As recounted by the north wind, Boreas, Night's 'malice, and
. . . magic' (70) undermine the very basis of the masque form, namely
orderly motion.[46] Night's actions effect both stasis and movement for the
female masquers. She has imprisoned on a floating island four siblings of
the African nymphs, who had set out for Britannia after witnessing the
transformation wrought upon their sisters. Their twelve siblings, alone
able to free the four with the sight of their blanched countenances, 'in
piety moved, and kind, / Straight put themselves in act the place to find'
(76–7), so falling prey to Night who 'ever since hath . . held / Them
wand'ring in the ocean' (80–1). This maritime imagery, and the witchcraft
represented by Night, evoke Queen Anna's stormy sea voyage from
Denmark to Scotland in 1590, which was later rumoured to have been
cursed by Danish and Scottish witches.[47]

Reading *Blackness* and *Beauty* alongside the romance quest motif
elaborated in the Stirling celebrations for the baptism of Prince Henry
in 1594, McManus notes the reversal of the King's position effected by
these masques: 'where once he had been depicted as the heroic lover,
warrior and prince, in *Blackness* and *Beauty* James I became the goal of a
female quest led by the queen he had previously purported to rescue'.[48]
The directorial role of the Queen is acknowledged in the speech of the
west wind, Vulturnus, who recounts how, Night's charms having been
broken by Aethiopia, 'their queen / Hath raisèd [the nymphs] a throne
that still is seen / To turn unto the motion of the world' (110–12). The
discovery of the masquers on this revolving Throne of Beauty, lighted
by Cupids sitting on steps which turned in a contrary motion, the throne
erected on an island propelled by a forward motion, formed a spectacular
climax. Jonson writes that the throne '*seemed to be a mine of light struck
from their jewels, and . . . garments*' and describes how '*with these three
varied motions . . . the whole scene shot itself to the land*' (216–17, 222–3). His
pleasure in the scene's virtuosity is echoed in the Venetian ambassador's
remark that 'the apparatus and the cunning of the stage machinery was a
miracle'. That *Beauty* set the seal on Anna's appropriation of the court
masque as a vehicle of self-aggrandizement is implied by the ambassador's
praising of her as 'the authoress of the whole' and his observation that 'she
reaped universal applause'.[49]

Jonson's early masques for Queen Anna map a delicate balance be-
tween feminine strangeness and serenity. I have used the phrase 'songs
without words' to describe their theatrical representation of women
(drawing an analogy with Mendelssohn's lyrical pieces for piano), for
notwithstanding the masquers' wordlessness, the texts endow them with a

persuasive power akin to song. It is true that in both *Blackness* and *Beauty* 'the benificent magic of whiteness . . . is the magic of masculine and patriarchal authority': in *Beauty* the 'attractive beams' (326) of King James as Albion call forth the entire celebration.[50] Yet alongside the power of the King, these masques assert and animate a 'magic in [female] majesty'.[51] As King Leontes stands in wonder before the statue of his dead queen Hermione in Shakespeare's *The Winter's Tale*, he begins to perceive signs of 'warm life' in the image (5.3.35), exclaiming that 'the fixture of her eye has motion in't' (5.3.67). What Leontes experiences as magical is the lifelikeness of Hermione. Of course, on the professional stage, Hermione's 'silent rhetoric' was enacted by a boy. How much more magical was the theatrical representation of femininity when animated by women themselves? Or perhaps the question should be, how dangerous? Although both *Blackness* and *Beauty* depict women within an idealizing philosophical framework, both masques encompass a view of women's theatricality as potentially disrupting, rather than consolidating, masculine identity and authority. In *Beauty* this countercurrent is represented in one of the songs which punctuated the masquers' dances, which raises the anxiety that the Ethiopian dames 'mean surprise' (293) upon the men. This fear of feminine seduction is allayed by an answering song's assurance that the Loves (the live Cupids acting as the masquers' torchbearers) are not of the fickle kind and that the flames issuing from the women's eyes are 'pure . . . [and] fixed' (300). Jonson's focus on the possibility of women's deception demonstrates that even, or perhaps especially, in the masque genre 'the female body ultimately cannot exhaust its signification'.[52]

While in *Beauty* the Cupids are '*armed with bows, [and] quivers*' (202), subsequent masques, such as Jonson's *Queens* and Davenant's *Salmacida Spolia* (1640), arm their female performers with weaponry, making theatrically explicit the 'bravery' of female masquing. In addition to the sense of 'courageous', the word 'brave' connotes an ostentation which might be construed as too visible depending on the rank, or gender, of the performer.[53] In 1618 a masque of nine ladies planned by Lucy Percy Hay and her sister Dorothy was cancelled by royal behest. John Chamberlain wrote to Dudley Carleton that the participants 'had taken great paines in continuall practising, and were almost perfet and all theyre implements provided, but whatsoever the cause was, neither the Quene nor King did like or allow of it and so all is dasht'.[54] Precisely what prompted the royal displeasure cannot be guessed, but the information that Lady Hay was to appear as 'Quene of the Amazons' is suggestive of the controversy

that might attach to the 'bravery' of female masquing. The mythical Amazons lived apart from men, employing their time in wars and archery, in the pursuit of which they burnt off their right breast so that they might better draw the bow. In the Renaissance the image of the Amazon might convey connotations of sexual licence as well as the 'unnatural' usurpation of masculine valour and a rejection of female submissiveness within marriage.[55] Significantly, in a masque which was successfully presented to James by the daughters of Sir John Croft several years later, the masquers are presented as heeding the call of 'Moderation vertues freind'.[56] The next section examines how Jonson handles the threat of excess embodied in the Amazon or militant woman.

FEMALE SOVEREIGNTY IN JONSON'S 'MASQUE OF QUEENS' AND DANIEL'S 'TETHYS' FESTIVAL'

Queen Anna's creative will and her theatrical instinct for variety continued to influence Jonson's ongoing shaping of the court masque. In *The Masque of Queens* (1609) he presented the Queen and her ladies as martial women from the classical past. He attributes the antimasque to the Queen's command for 'some dance or show that might precede hers and have the place of a foil or false masque' (11–12). Jonson therefore 'devised that twelve women in the habit of hags or witches, sustaining the persons of Ignorance, Suspicion, Credulity, etc., the opposites to good Fame, should fill that part, not as a masque but a spectacle of strangeness, producing multiplicity of gesture' (14–18).

The masque thus becomes a vehicle for discriminating between two types of female actor: the malefic and the martial; the witch and the heroine. The contrast between grotesque and noble womanhood is intensified by the transvestite performance of the witches who were represented by male professionals.[57] By choosing as his theme 'a celebration of honorable and true fame bred out of virtue' (6), the poet deals a preemptive blow to those detractors disposed to seeing female performance as inherently infamous. Through the witches he incorporates and subjugates these hostile elements, simultaneously giving voice to powerfully negative aspects of female agency and expression.

This negativity is encapsulated in the witches' stated intention to undermine James's patriarchal government: thus their leader, Dame Mischief, declares, 'I hate to see these fruits of a soft peace, / And curse the piety gives it such increase' (132–3). Jonson animates their subversion by portraying the witches' ceremony as the inverse of the 'true fame'

represented by the aristocratic masque occasion (6). His grotesque women pit their 'rites profane' (225) against the stately ritual of the main masque, deploying their spells, sounds and movements to subvert its aesthetic order. Their appearance is characterized by a copious physicality in their 'multiplicity of gesture' and '*strange fantastic motions of their heads and bodies*' (18, 331–2).[58] The witches' key weapon is disorderly sound. They emerge from the hell mouth '*with a kind of hollow and infernal music*', armed with '*spindles, timbrels, rattles . . . making a confused noise*' (25–6, 29–30). This description hints at the polarities of difference and uniformity, discord and harmony, upon which *The Masque of Queens* makes its bid for structural coherence.

The question 'when is saying something doing something?' is peculiarly relevant to the witches' rampant vocality.[59] Jonson's dozen witches 'do' very little, notwithstanding their threats of subversion. As Ruth Little writes, 'the witches protest too much and their intentions are wasted, rather than gathered, in language'.[60] Not only is Dame Mischief late in arriving, but once present, her attempts to summon satanic forces prove impotent. As the fiends and furies on whom they call fail to appear, the sisters abandon their charms for sheer aural aggression – 'Hoo! Har! Har! Hoo! – while Mischief melodramatically wounds her arm with 'a rusty knife' (307, 292). Their raging effects nothing, however, for in the heat of their '*magical dance*' is heard '*a sound of loud music, as if many instruments had given one blast; with which not only the hags themselves but the hell into which they ran quite vanished, and the whole face of the scene altered, scarce suffering the memory of such a thing*' (334–7).

Music provides the point of contact between the antithetical sections of the masque as Fame's apocalyptic blast eliminates all trace of the witches.[61] The stylized chaos of the witches' appearance, language, music and motion is dispelled by the architectural and poetic order of the transformation scene with its monumental House of Fame bearing the twelve queens, topped by the classical hero, Perseus.

Jonson writes that the altered scene '*scarce* suffer[ed] the memory' of the witches' coven (emphasis mine), prompting a reading in which the subversive forces the witches embody are not wholly eliminated from the masque.[62] Instead of effecting a clean division between the witches' and the masquers' revelry, the music and dancing of the main masque harness the witches' ebullience.[63] The theatrical energy of the warrior queens is imaged in Jonson's characterization of Fame in the first song: 'And as her brows the clouds invade, / Her feet do strike the ground' (485–6).[64] This image of Fame as a female Colossus forms a backdrop

to the queens' progress about the stage in chariots drawn by eagles, griffins and lions, their female foes bound before the chariot wheels. The masquers' silence is insignificant alongside the 'full triumphant music' which accompanies the procession, the martial aura of which is evoked by the image of Fame's trumpet (478–9, 446).[65] Fame's feet which 'strike the ground' prefigure the queens' dancing which mobilizes this heroic spectacle, their first dance performed to the music of cornets. The feet of the queens bring to life the women they represent: 'Swift-foot Camilla', 'Victorious Thomyris', 'Bold Valasca' (376–7, 385). Jonson testifies that the masque dances *'seemed performed with no less spirits than of those they personated'* (491–2). In the martial arena, the dancing of the queens suggests, action is eloquence.

As in *The Masque of Blackness,* it is the aesthetic of 'strangeness' which subverts the symbolic division between antimasque and masque. The 'strangeness' of *Queens* is epitomized by the music and dancing of the witches, but in the text Jonson cites as part of 'the strangeness and beauty of the spectacle' 'the masquers' habits . . . the going about of the chariots, the binding [of] the witches, the turning machine with the presentation of Fame' (463–8). This acknowledgement of the simultaneity of strangeness and splendour in the main masque supports my suggestion of a closer relationship between the witches and queens than is implied by the structural opposition between masque and antimasque. The visual image which most corresponds to this aesthetic is Jones's sketch of the costumed figure of 'Penthesilea, the brave Amazon' (375), presented by Lucy Harrington Russell, Countess of Bedford (Figure 5). Clad in a voluptuously plumed helmet, one hand resting on her sword hilt, the other arm elegantly akimbo, the figure encapsulates an attitude of 'bravery' which one can imagine the other masquers seeking to emulate. The sketch evokes the female masquer's capacity for self-transformation, empowered by the arts of poetry, music, dance and design.[66]

Barroll astutely observes that in *The Masque of Queens* Anna 'for the first time employed the court masque not to symbolize but to *signify* her queenship'.[67] While Jonson mines classical history and literature to recount the 'great actions' of the 'renownèd queens' (370, 435), his portrayal of 'Bel-Anna' as 'Queen of the ocean' (391–2) creates a contemporary myth. As the masque celebrates the fame of 'the queen of Great Britain', it is appropriate that Jonson lays special emphasis, not just on Anna's 'sacred modesty' but on her 'princely virtue', in which, he writes, she is 'safe . . . against the good or ill of any witness'.[68] In his animadversion on Queen Anna's masquing, Arthur Wilson suggested that the

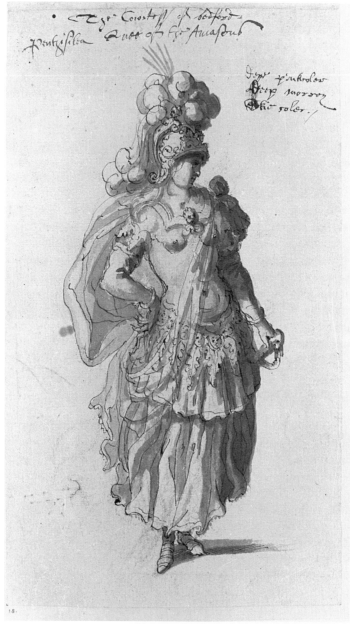

Figure 5. Inigo Jones, *Penthesilea, Queen of the Amazons.*

actions of princes are always subject to critical scrutiny: 'Princes, by how much they are greater than others, are looked upon with a more *severe eye*; if their *Virtues* be not suitable to their Greatness, they lose much of their *value*.'[69] *The Masque of Queens* is Jonson's counterblast in this particular war over royal manners; a work in which Fame's trumpet 'sounds [the] Honor' (372) of Bel-Anna and attests the nobility of her 'speaking actions'.

Or does it? A debate has emerged in readings of *Queens* over the extent to which the masque subordinates Anna's virtue to James's and Jonson's combined patriarchal politics and poetics, figured in the hypermasculine Perseus bearing the shield of Pallas, on which is depicted the head of the slain Medusa, an image – according to one recondite Renaissance source – of 'artful eloquence'.[70] However, within the theatrical space of the masque, the dancing queens themselves embody heroic virtue and the figure of Perseus may appear correspondingly 'static, verbose but essentially weak'.[71] As Lewalski observes, 'these militant Queens whose force is directed against Kings and husbands need, and find, a female referent in Queen Anne, not in King James'.[72] Pace Orgel, the theatrical spectacle *is* one of female empowerment.[73] The warrior queens, who harbour husband-slayers in their midst, pose a threat of their own to patriarchal government: the spectacle they present animates their brave spirits which resound beyond the containing myth into which they are incorporated by Jonson.[74]

Together, Jonson's masques *Of Blackness* and *Of Beauty* and his *The Masque of Queens* defined a pattern for female performance in the Jacobean masque. In these masques the image of the King as prime mover was complemented by an emphasis on women's persuasive action. This paradigm differs from the Caroline masques performed by Charles I and Henrietta Maria. Inducted into theatrical performance under Queen Anna, as an adult Charles (unlike James) saw the political virtue of acting in masques rather than watching them from the royal state. The masques composed for Charles and Henrietta Maria, whether featuring one or both of them, project their marriage as an image of the polis, highlighting the importance of love to good government. It is perhaps too easy, given our knowledge of James's affections for men, to project into the Jacobean masques hints of marital dysfunction, or 'female resistance to Jacobean patriarchy'.[75] Jonathan Goldberg has identified James's rhetoric of kingship in his treatises and pronouncements with the historian

Lawrence Stone's model of the 'restricted Patriarchal Nuclear Family' prevalent in the early Stuart period. Goldberg links the patriarchal model informing Jacobean family portraits to the rhetoric of Jonson's *The Masque of Queens* in which 'the patriarch absorbs female creativity', as did the King when he described himself in *Basilikon Doron* as a 'loving nourish-father' to his kingdom.[76] Yet Margaret Ezell has shown the elasticity with which the patriarchal family functioned in early modern England; while husbands were the notional heads of their wives and children, in practice there was considerable scope for maternal influence, especially in relation to the children's upbringing and marital partners.[77] The success or failure of women in exercising power in the familial realm depended, to paraphrase Barroll, on 'the fixedness of [women's] will'. A case where the Queen's will won out is the ongoing conflict between Anna and James over the guardianship of their eldest son, Henry. Through her 'aggressive interventions', Anna succeeded in bringing the nine-year-old Prince with her from Scotland to England in 1603, foiling James's intention for Henry to remain in the guardianship of the Earl of Mar during his minority.[78]

One Jacobean masque which accords Anna powerful influence as a parent is Daniel's *Tethys' Festival* (1610). Anna's relationship with her son was the moving force behind this masque, which celebrated Henry's investiture as Prince of Wales and heir apparent to the throne. Performed before James and Henry as its chief spectators, Daniel's masque was very much a family entertainment, which achieved a nobly aggrandizing representation of Anna as Tethys, Queen of the Ocean. Anna was joined on stage by her daughter Elizabeth, representing 'the lovely nymph of stately Thames', with twelve more ladies as nymphs representing English rivers and her younger son Charles, Duke of York, who impersonated the west wind, Zephyrus.[79] Daniel's text glows with family pride and unity, expressing Tethys' joy in the honour bestowed on Meliades (Prince Henry) and 'her affection and her zeal' to the 'great monarch of Oceanus', King James (190–1).

Tethys' Festival strikingly foregrounds Anna's parental authority and her regency over the ocean. With the King's approval, maternal influence reigns supreme for the Queen is accorded the epithets of 'mighty' and 'imperial Tethys' (151, 373) and is depicted as 'that intelligence which moves the sphere / Of circling waves' (150–1). In *The Vision of the Twelve Goddesses* Daniel had similarly represented the Queen as prime mover; there the descent of the goddesses to Britain is brought about 'by the motion of the all-directing Pallas, the glorious patroness of this mighty

monarchy' (406–7). In Daniel's later masque for Anna the autonomy and agency of Tethys are made vividly immediate through the deployment of active, present tense verbs: Tethys 'resolves', 'summons', 'sends' and 'wills'; these verbs dramatize her capacity for judgement and action and indicate her direction of other participants in the masque.

By choosing the role of Pallas in her first court masque, Anna identified herself with the independence of Elizabeth I, and this 'neo-Elizabethan imagery' occurs also in several of her portraits.[80] In *Tethys' Festival* a connection to Elizabeth is evoked through the representation of Tethys as 'a mother of the nation'.[81] The masque's maternal aspect involves Tethys counselling Prince Henry towards the pacific stance of King James, specifically with regard to English foreign policy in respect of Catholic Spain. Tethys' 'message' (147) is mediated by a Triton who delivers her presents to James and Henry, respectively a trident signifying James's rule over the triple kingdoms of England, Scotland and Wales, and a sword sacred to Astrea, the goddess of justice, imaging Henry's potential for military action in a just cause. In Jonson's *Prince Henry's Barriers*, performed earlier in 1610, Henry had donned the persona of Meliadus, performing as 'the militant Protestant chivalric hero'.[82] In Daniel's masque Henry's martial urges are circumscribed by the additional gift of a scarf signifying 'the zone of love and amity' (200). Uniquely among Jacobean masques, the Triton ventriloquizes Tethys/Queen Anna's vocal 'charge' (214): 'Herewith, says she, deliver him . . . this scarf . . . wherein he may survey / Enfigured all the spacious empery / That he is born unto another day' (199–203).

Not simply maternal, the figuring of Henry's future inheritance on the embroidered scarf has a matriarchal resonance. Visually, the masque blazons the feminine fecundity found 'within the large extent / Of [Tethys'] waves and watery government' (209–10). The moment of discovery reveals Tethys on a 'great aquatic throne' (255), surrounded by the river nymphs 'in their several caverns gloriously adorned' (228–9); the nymphs' costumes display their bare breasts, while their wide skirts swell voluptuously about the hips, where the material was 'wrought with lace, waved round about like a river, and on the banks sedge and seaweeds all of gold' (296–8).[83] Tethys' maternal bounty assuages the desire for imperial conquest linked with Henry's faction, for, as the Triton ventriloquizes, within her demesnes 'will be . . . more treasure, and more certain riches got / Than all the Indies to Iberus [Spain] brought; / For Nereus will by industry unfold / A chemic secret, and turn fish to gold' (210–13). Disdaining the example of Spain with its colonial booty, Tethys promises that the British will reap substantial profit 'from fishing home waters'.[84]

Tethys' Festival is unencumbered by the weight of explanation which accompanies Daniel's *Vision*, where the effortfulness of artistic innovation is felt both in Daniel's authorial voice and the voice of Iris. It is Iris who explains for the audience the allegorical use of the female form; for women, she says, 'work the best motions, and best represent the beauty of heavenly powers' (268–9). In the later masque Daniel has sublimated this 'rationalizing tendency' and his doubts about the masque as a medium of substance find expression in two songs which alternate between the masquers' first and second dances.[85] The first song encapsulates the simplicity of a performance which comprises 'sounds and words and motion', expressive of the participants' 'joy' (327, 326). The confidence expressed in the power of visual and aural harmony to make manifest 'devotion' (329) is offset by the second song's emphasis on the transience of such effects: 'Glory is most bright and gay / In a flash, and so away' (353–4). These lines correlate with Daniel's repeated use of the word 'suddenly' to describe the vanishing and appearing of the masquers, a technique which enhances the wondrous effect of these transformations.[86] The masque's last 'show' (367) makes manifest the notion of theatrical incarnation: the Triton informs the audience that Tethys will 'restore / Them to themselves whose beauteous shapes they wore' (376–7), while Tethys and her nymphs will in turn 'shift those forms' they have assumed (375). The Triton's speech holds in balance the Queen's political and theatrical personae, making her shape-shifting visible to the audience. As much as Daniel's masque exalts Anna as life-giving mother and political adviser to her son, *Tethys' Festival* celebrates most vividly 'Anna's remarkable talent continually to reinvent herself'.[87]

WOMEN WITHOUT MEN: 'CUPID'S BANISHMENT' AND THE COLEORTON MASQUE

As I indicated in the introduction, Anna's withdrawal from active masquing after 1611 did not put a halt to her symbolic representation within the masque. Two masques from the end of the 1610s, *Cupid's Banishment* and the wedding masque performed at Coleorton, marry female bravery and virtue in a manner very different from the court masques for women performed under the aegis of King James. Both these works reactivate issues voiced in Jonson's masques for the Queen, while introducing new ideas and concerns made possible by the King's absence. This section examines the diverse ways these two works appropriate the masque as a vehicle of advocacy for women.

The memory of royal women's performance forms a touchstone for the defence of chaste female revels in *Cupid's Banishment*, a masque presented to Queen Anna and her ladies-in-waiting on 4 May 1617 by 'young Gentlewomen of the Ladies Hall In Deptford at Greenwich'. The manuscript was dedicated to the Countess of Bedford by its author Robert White, 'in regard of the honourable furtherance and noble encouragement your Lady gave us in presenting our masque to Her Majesty'.[88] White, who acted the presenter role of Occasion, was probably the schoolmaster of Ladies Hall, one of London's growing number of 'smart private academies in the metropolitan suburbs'.[89] C. E. McGee characterizes the masque as 'unusual in blending the customary revels of the school with the lavish display of the court masque'.[90] White describes the revels in the Dedication: 'the ground of our plot is, choosing of a king and queen by Fortune's doom, which is a sport our little ladies use on Candlemas night'. The celebration of this 'chaste combination' within a court presided over by the goddess Diana creates a 'mirroring of majesties':[91] as the nymphs' sport is enacted in the 'sacred place' (53) of Diana's domain, so the masque performance takes place '[within] the circle of [this] sacred sphere' (17) defined by the Queen and her 'stars of women' (326).[92] My concern is with White's moulding of the masque as an instrument of self-assertion for his young female charges. I shall focus on two Ovidian myths of metamorphosis which are central to this: the stories of Actaeon and Philomel. These myths featured as part of the discourses of femininity and absolutism in Renaissance literature and art; they were also employed in drama written for the professional stage.[93] The following discussion explores how White's 'homespun' muse (332) modulates Ovid for juvenile female performance.

Cupid's Banishment presents the dynamic interaction of chastity and lust through Cupid's repeated encroachment on the coronation and marriage which make up the women's revels. This structure leads to an anomaly noted by Enid Welsford, in that, rather than their visual discovery forming the theatrical climax of the masque, the masquers 'were revealed at the beginning of the proceedings, and remained in full view of the audience until the end'.[94] The exposure of the masquers to Cupid's and the audience's gazes is spelled out in Cupid's remonstration to Occasion that his presence is required 'where such a chorus / of lovely nymphs as these shall stand before us' (49–50). By berating the boy's 'blind intrusion' and rejecting his 'wanton subject and lascivious Muse' (52, 67), Occasion revokes the voyeurism which Cupid's attitude implies. In Ovid's *Metamorphoses* the hunter Actaeon stumbles upon Diana and

her nymphs bathing naked in the forest while he is pursuing the chase. In White's masque the speaking part of Diana was played by a boy actor, Richard Browne.[95] Unsurprisingly, Diana's nakedness is not represented. Instead, Cupid's interference prompts Diana to reveal herself, '*in her arbour, attired all in white . . . a very rich girdle about called the zone of chastity, to shew her defiance to CUPID and to signify their chaste meeting*' (69.1–6). Diana's deliberate self-display (the text reads '*she shews herself*') reverses Ovid's narrative of illicitly glimpsed divinity. However, Actaeon's violation of the goddess's sanctuary is recalled in Diana's rebuking of Cupid's 'rash access without our high command' (73) and her assertion that neither she nor her nymphs are 'in the compass of [his] bow' (76). Notwithstanding Diana's defiance, the song of two of her nymphs summoning Hymen to the ceremony acknowledges Cupid as an insinuating presence who 'fills our hearts with deep annoy' (129). By depicting Cupid's power to overtake the heart the masque suggests subtly that chastity is an emotional, rather than a physical, condition.

The presence of a myth which has at its centre an act of male voyeurism provokes the concern with defining and representing chastity in *Cupid's Banishment*. An ineffable virtue on a par with Jonson's 'removed mysteries', chastity can only be manifested in Cupid's absence. The masque requires a second, more decisive confrontation between Diana's nymphs and Cupid, who returns under the protection of the wine god Bacchus, having been disarmed by Jupiter. Cupid's refusal to accept his assigned role of spectator calls forth an expression of Diana's will: 'Thou shalt find and see / Lust can never conquer Chastity' (215–16). The banishment of Cupid is effected through a dance which enacts an archetypal metamorphosis inflicted on the male who trespasses upon female virtue. In a dynamic sequence a further eight wood nymphs with darts in their hands '*rush out of a grove adjoining to [Diana's] Mount*', four from either side, and encircle Cupid in a dance figure, at the end of which they '*chase him forth into the woods by violence*' (218.2, 18–19). The full freight of menace underlying this confrontation is encapsulated in the wood nymphs' action of crowning Cupid with Actaeon's head, or the head of a stag. In Ovid's tale Diana punishes Actaeon by transforming him into a stag; he is then torn to pieces by his own hounds. A generic precedent for the nymphs' routing of Cupid exists in an Elizabethan masque performed in 1560 which featured a Huntress, her nymphs and the hounds by which Actaeon was dismembered. Actaeon's fate was more graphically rendered than in White's masque for his garments were 'all . . . cutt in small panes and

steyned with blood'.[96] Avoiding this tragic register, the wood nymphs'
action displays their bravery to advantage: their mimed menacing of
Cupid encompasses 'many pretty figures' or dance steps; moreover, they
present an image of unconstrained feminine beauty, attired in green
garments with loose 'dishevelled' hair, bare shoulders and 'half-naked'
arms.[97] The nymphs' appearance is appropriate to followers of the hunt-
ress Diana, who was associated 'not only with female chastity and spiritual
purity but also with matter, in the shape of wild nature'.[98] The descrip-
tions in the text stress that the costumes of Diana and the masquers signify
their 'defiance' of Cupid, proclaiming their power of self-definition. In
this manner White suggests that chastity is as much a way of seeing as the
cupidity which the women's acting has banished.

Two further images of metamorphosis illustrate how the masque uses
images of deviant and damaged women as part of its proclamation of
feminine integrity. The first occurs when Cupid, enraged at his exclusion,
threatens to transform Diana's nymphs from 'coy dames' to 'beldames',
making them 'rave [and] . . . tear [their] hair' (208–9). Cupid's pledge to
make the nymphs 'curse their coyness' evokes the frenzied behaviour of
the witches in *Queens*, or the delirious violence of the Bacchantes, the
priestesses of Bacchus who tore the musician Orpheus to pieces (a fate
resembling Actaeon's). The notion of women succumbing to savage
passion and violence is the antithesis of the ideals of graceful and modest
accomplishment espoused by the masque. Strikingly, the picture of gro-
tesque womanhood conjured by Cupid's threat is quelled by an 'antic'
performance which is itself a stylized image of feminine violence.

The second image of female metamorphosis underlies the nymphs'
song expressing joy at the routing of Cupid:

> Hark, hark, how Philomel
> Whose notes no air can parallel;
> Mark, mark, her melody.
> She descants still on chastity
> The diapason of her song is Cupid's gone.
> (219–23)

White's use of 'descants' and 'diapason' suggest that he may have read
Shakespeare's poem *The Rape of Lucrece* (1594), where the violated Roman
matron invites the nightingale Philomel to join her in lamenting her
plight.[99] Strategically, White eliminates all trace of pathos from Philomel's
story. Ovid's *Metamorphoses* recounts Philomel's transformation into a
nightingale after she was raped by her brother-in-law Tereus, who then

cut out her tongue.[100] In White's most innnovative stroke, Philomel is co-opted as an unparalleled musician and as a female survivor with whom the nymphs joyfully unite to celebrate their freedom from Cupid's 'tyranny'. Their triumph of female action ensures their safety from the 'lust and rape and foul incestuous acts' (64) which the masque firmly exiles with Cupid.

The myth of Philomel represents the ambivalence attached to women's speech; the raped and tongueless woman transformed into a songbird is at once an image of muteness and inarticulacy and of feminine eloquence.[101] *Cupid's Banishment* breaks from the norm of female silence in the court masque on three occasions when Diana's nymphs sing, and in the speech of the goddess Fortune, welcoming Mercury and Hymen to the women's revels (139–46). Like several earlier Elizabethan and Jacobean entertainments performed away from the court, *Cupid's Banishment* 'press[es] upon generic boundaries' in its assignment of both speech and song to its youthful female performers.[102] In the next chapter I explore Milton's expansion of the masque form to accommodate female speech and song in *Comus*, where the Lady's musical invocation of Philomel acquires more dramatically complex resonances than in White's masque.

We may compare the triumph of chastity in *Cupid's Banishment* to John Lyly's mythological drama *Galatea*, played before Queen Elizabeth at Greenwich in 1588 by the choirboys of Saint Paul's.[103] In this earlier boy-acted drama, Cupid vows revenge on a scornful nymph of Diana, determining to prove his mighty godhead. He makes Diana's nymphs enamoured of the seeming boys Galatea and Phillida, who are in fact two young women in the habits of men. In revenge, the goddess takes Cupid captive, setting him to unpick the amorous tales sewn in her tapestry. However, in Lyly's play Cupid's capture by Diana is temporary: the dispute between Diana and Venus for possession of Cupid is resolved by the sea god Neptune, whose quinquennial demand for a Lincolnshire virgin to be sacrificed has dictated the disguising of Galatea and Phillida by their fathers. When Neptune promises 'for ever [to] release the sacrifice of virgins', Diana yields Cupid to Venus, still asserting that 'chastity is not within the level of his bow' (5.3.75, 87).[104]

It is this purity of heart which paradoxically persuades Venus to assist Galatea and Phillida by changing the sex of one of them. The girls' 'constant faith', their unspotted love, wins the goddess's sympathy (5.3.140). The marriage enabled by the play has the endorsement of both goddesses, presenting an image of love and chastity combined. Yet, as G. K. Hunter remarks, 'the ending of the quarrel must still be seen as an agreement to differ rather than a sharing of opinions'.[105] In the

epilogue Galatea conjures all ladies to yield to Cupid, testifying that 'love conquereth all things but itself, and ladies all hearts but their own' (12–13).

This play performed before the virgin Queen by professional boy actors presents a wryly ambiguous accommodation between chastity and love, combining 'naturalistic exemplum [in the story of Galatea and Phillida] and mythic fable'. As Joel Altman makes clear, the immunity granted to virgins by Neptune (which encompasses Diana's nymphs *and* the Lincolnshire community) stems from the fact that 'virgins, though they desire to be chaste, may still suffer the pangs of desire'.[106] In White's rhetorically simpler masque, it is this insinuating power of desire, combined with the modesty of the performers, which dictates the decisive routing of Cupid. The descriptive text of *Cupid's Banishment* is at pains to assert *'that their revels did wholly tend to Chastity, being a sport the goddess and her nymphs did use in bowers and retired places without prejudice to virginity or scandal to any entire vow'* (195.6–9). At the same time, Diana predicts that the 'chast scene' (281) of the young women will 'charm hearts and eyes with never-ending pleasure' (284). Female chastity precludes neither pleasure nor eroticism; it is simply that Cupid represents the wrong kind of pleasure. It is Anna's 'royal resolution / Of female worth' (2–3) which provides the ground for the masque's realization of a feminized theatre. The closing address to the Queen as 'Bright Pallas and royal mistress of our muse' (313) locates her as the sponsor of chaste female revels.[107] By picturing Anna in the role she performed in *The Vision of the Twelve Goddesses*, *Cupid's Banishment* makes the Queen's masquing history the linchpin in its defence of female performance.

In contrast to the victory of chastity over lust in *Cupid's Banishment*, the masque performed at Coleorton in Leicestershire on 2 February 1618 presents a more closely fought contest between masculine and feminine virtues.[108] In this regard this masque, too, reflects its conditions of address. It was presented to Lady Frances Devereux and Sir William Seymour in celebration of their marriage by a group of masquers including Frances's brother, Robert Devereux, third Earl of Essex, and his friend, Sir Thomas Beaumont, of Coleorton Hall, the masque's sponsor. Devereux was the unfortunate bridegroom whose marriage to Lady Frances Howard was celebrated in Jonson's *Hymenaei*. Their teenaged union was later annulled on the grounds of nonconsummation to enable Howard to marry the King's favourite, Robert Carr, Earl of Somerset.[109] While indebted to the themes and structure of *Hymenaei*, the Coleorton masque clearly signals its difference from the grand ceremonial masques performed at the Jacobean court. Absent from the text are elaborate

descriptions of scenery and the masquers' costumes. Indeed, the lavish dress of women forms a target of the antimasque, which is concerned with the decline of country hospitality. The spirits Bob and Puck bemoan the wasteful vanity typified by an *arriviste* madam 'whose father's sheep ha' farted her into a ladyship' (44–5). The desire for upward mobility is rendered through a discourse of the female grotesque: 'Then her scurvy hair must be curled and powdered, the chamber stink of bawds and midwives. This wood falls to make her a forepart in a farthingale. Th' hard arable land shall be converted into loose gowns, and the meadows fly up in petticoats. This robs both buttery and kitchen' (47–51).

Even as this passage recycles commonplace satire on women's extravagance, there is a covert appreciation of the literal 'animatedness of clothes' in the proximity of 'petticoats' and 'fly up'.[110] The misogynist tone is also evident in a paean to Frances Seymour as 'Beauteous woman . . . (And what's true, though wondrous rare, / Th' art as good, as thou art fair)' (317–19). Contrary to the Neoplatonism of the court masque where woman represents ideal beauty, these lines reflect the truism that women's beauty masks moral vice. Nonetheless, as a wedding tribute from a brother to a sister the Coleorton masque privileges female will; in this respect it dovetails with Jonson's *Blackness* where 'her Majesty's will' is represented as the galvanizing force.

The discourse of sexual contest familiar from comedies such as Fletcher's *The Woman's Prize* is established when the customary order of a mixed masque is reversed 'to show the precedency of female virtue'.[111] Representing Jupiter and Juno are Favonius, the west wind, and Iris, the rainbow. Favonius readies the audience for a masque of 'six brave virtues masculine'; however, when the music sounds '*the scene opens and discovers six women masquers*' (140, 174). This usurpation of the masquing stage is presented as part of a legendary marital dispute between Juno and Jupiter in which the goddess, to deflate men's presumption, has imprisoned Jove's masque in a cloud and substituted her own. The paralysis of the male masquers recalls Night's transfixing of the daughters of Niger on the floating island in *The Masque of Beauty*, but whereas Night's malignant hold is broken by Aethiopia, Juno and Iris keep the men enthralled until the female masquers have performed their dance. Sexual contest is therefore expressed theatrically as Iris proclaims, 'lest this should turn to faction, / They [the women] shall prove my words in action' (207–8).

The female assertiveness which is graphically depicted by having women dance 'first on foot' (219) is linked by Favonius to Jacobean

society. In response to Juno's subversion of the male masque he wonders, 'what have we here? A metamorphosis! Men transformed to women! This age gives example to the contrary' (176–8). In 1620 the phenomenon of women transformed to men was inveighed against from London pulpits by clergy who had 'expresse commaundment from the King' to preach 'against the insolencie of our women', in particular their wearing of masculine fashions. Indeed, as has been noted, the Coleorton masque was 'penned at the apex of the pamphlet controversy over women's roles'.[112] Favonius's allusion to contemporary masculine women is amplified in Iris's song accompanying the women's descent to dance their entry. By invoking 'brave Amazonian dames' (238) as examplars of female freedom, the song presents a more militant picture of feminine virtue than the masque figures previously named by Iris as 'Meekness', 'Simplicity', 'Truth-in-Love', 'Modesty', 'Silence' and 'spotless Chastity' (199–202). The dancing and lyrics mutually realize the images of women's 'strength' and 'active spirits' which the song presents as 'tame[d]' and 'smothere[d]' by men's domination. The song's conclusion envisages a utopian social and sexual arrangement:

> Learn, virgins, to live free.
> Alas, would it might be,
> Women could live and lie with one another.
> (244–6)

It seems that the local auspices of entertainments such as the Coleorton masque, whose authors and sponsors had strong Protestant affiliations, allowed for glimpses of radical sexual and political alternatives like the same-sex relations wistfully glimpsed here; we shall find a similarly revolutionary moment in Milton's *Comus*. The song's stress upon women's need to find freedom from 'men's overawing' echoes the dialogue between a Nymph and a Shepherd spoken at the departure from Ashby of Alice Stanley, Dowager Countess of Derby, at the end of a sojourn during which she was the recipient of an 'Entertainment' (1607) scripted by the playwright John Marston. The Nymph in Marston's eclogue is adamant that woman is best 'to keepe hir owne' or to maintain her autonomy outside marriage. The humanist debate about the state of virginity versus marriage is concentrated in a couplet: [Shepheard] 'She senceles lives without affection / [Nimph] yett happye lives without subjection.'[113] Such sceptical questioning of marriage formed an integral part of many wedding entertainments. What is striking about the stand-off between the sexes in the Coleorton masque is the way its author uses the medium of

dance to instruct the masquers in sexual equality. Here, too, the masque diverges from the mixed dancing of *Hymenaei* where the chaste love symbolized by the women is depicted as 'tempering' (100) the 'humours and affections' (255) embodied by the men. In the sexually combative Coleorton masque, the male masquers, once released from their cloud, are told to

> mix
> Themselves in pace with yonder six,
> And there in *lively motion* show
> Who the other shall outgo.
> (254–8, emphasis mine)

Discord is at once enacted and resolved through the 'motions' of a mixed dance whose 'equal paces' (285) decree that victory can be awarded to neither sex. The masque shifts from its championing of women to urging them in its concluding song to 'forsake / Your coyness, scorn, and proud disdain' (288–9). This quashing of the collective claim to female preeminence is offset by the address to Frances Seymour 'At the Going Away', which presents her as the epitome of mingled virtues and graces (326–9). The compliment recalls the image of united virtues embodied in the final dance and opens up the radical possibility of viewing Lady Frances as the epitome of masculine and feminine virtues. The idea of mutuality and exchange between the sexes is supported by lines in the valediction praising the Earl of Essex in terms which evoke chastity as a male virtue: 'Thou, whose tempered soule is white, / Pure and free, as morning light' (334–5). These last metamorphoses imaged in the Coleorton masque suggest the dynamic potential of the masque form to refashion concepts of virtuous action through the 'lively motion' of performance.

As a wedding celebration the Coleorton masque maps a provocative, 'equal' relationship between the sexes, repudiating the orthodoxy of female submission through the medium of performance. As I show in later chapters, drama and dialogue expand the potential for representing transformations of sexual identity and meaning opened up by the masque. In both *Cupid's Banishment* and the Coleorton masque, marriage is a metaphor for 'collaborative meaning creation between the genders'.[114] The temporary stand-off between the sexes in the Coleorton masque concentrates theatrically the contention between Truth and Opinion over the claims of marriage and virginity which concluded *Hymenaei*. Jonson's animating of this humanist topos forms a bridge between representations

of women in his masques and in Stuart drama. Appearing as two ladies, identically attired, Truth challenges Opinion to debate the motion that marriage 'doth far exceed th' insociate virgin life' (642), declaring 'whosoe'er thou be, in this disguise, / Clear Truth anon shall strip thee to the heart, / And show how *mere fantastical* thou art' (648–50, emphasis mine). While as a creator of masques Jonson was obliged to heed 'the Queen's fancye', this opposition reflects the satirical portrayal of feminine fancy in Jonsonian drama. Like the author of the Coleorton masque, Truth stresses mutuality between the sexes, arguing that 'the self-loved will / Of man or woman should not rule in them, / But each with other wear the anadem' (678–80). Opinion depicts Truth's reciprocity as a one-way traffic, with wives as tumblers performing tricks at their husbands' bidding. The fighting of the male champions is halted by the apparition of an angel who hails the arrival of heavenly Truth to settle the contest in favour of marriage and to reconcile the warring parties. Significantly, it is King James as 'royal judge' (845) to whom Truth appeals for vindication; as in Jonson's masques, his 'piercing splendour' (853) is represented as the fount of all meaning. In this patriarchal symbolic order Truth's manifestation entails the discovery of Opinion as a counterfeit lady. Thus Truth reveals Opinion in her false colours:

> And princes, see, 'tis mere Opinion,
> That in Truth's forcèd robe for Truth hath gone!
> Her gaudy colours, pieced with many folds,
> Show what uncertainties she ever holds.
>
> (835–8)

The revelation of 'adult'rate Truth' (839) forms a paradigm of the dichotomous representation of women within a symbolic order in which purity is offset by a sexualized, rhetorically 'uncertain' femininity. The opposition between painted Opinion and transparent Truth, whose 'heart shine[s] through her breast' (709), finds an echo in the Coleorton masque's contrast between the gaudy colours of Iris and the luminosity of Lady Frances, 'child of light' (316). These polarities, between aggressive Opinion and serene Truth, painted ladies and angelic actors, will resonate throughout the following chapters.

'Naked hearts': feminizing the Stuart pastoral stage

'Lord, how like a torrent love flows into the heart when once the sluice of desire is opened!'
Lady Brute in Sir John Vanbrugh's *The Provoked Wife* (1697)[1]

Lady Brute's declaration of sexual passion is the epitome of what the reforming critic Jeremy Collier viewed as the immorality and profaneness of the Restoration stage.[2] Her exclamation forms part of *The Provoked Wife*'s vigorous questioning of marriage, a bond the authority of which had been weakened through legal measures put in place during the mid-century English revolution, and through the sexual licence of the Restoration court under Charles II. To Collier, as to William Prynne sixty years earlier, the court-sponsored theatre was a hotbed of sexual, moral and religious depravity, a Vanity Fair of scurrilous and obscene representation. The gusto of Lady Brute's expression, at once revelling in and wondering at the experience of physical desire, emerges from a theatre that had undergone a revolution of representation over the course of the century.

I proposed in the Introduction that the explosive sexual realism made possible by the admission of women to the Restoration stage was foreshadowed in the pastoral drama tailored to the tastes of Queen Anna and Queen Henrietta Maria. Since the Italian poet Torquato Tasso's *Aminta* (pub. 1581, trans. 1591), pastoral drama had been explicitly concerned with sexual ethics, and with the constraining power of 'Onor' or Chastity, that 'tyran[t] of the minde'.[3] During the Jacobean period the genre of pastoral tragicomedy launched by the poet Giambattista Guarini's influential *Il Pastor Fido* (pub. 1590, trans. 1602) had been adapted to female concerns, if not to women's stage presence. At the same time as Daniel and Jonson were developing the Queen's masque, they, and other playwrights such as John Fletcher in his *The Faithful Shepherdess* (1608), were experimenting with dramatic pastoral. Daniel's *The Queenes Arcadia* (1605) and *Hymen's Triumph* (1614), both written for Queen Anna, speak

sympathetically to the sexual dimension of female experience.[4] This pastoral drama geared towards a female audience and readership is pre-occupied with the problem of how women may chastely testify their love.

In *The Queenes Arcadia*, performed by male students of Christ Church College before Anna and her ladies during the royal visit to Oxford in 1605, this question is explored through a focus on the female body as a text which displays the signs of overpowering emotion. The climax of the play is the spectacle of the heartstruck Cloris, a scornful shepherdess who early in the play vows to remain immune to men's treacheries. In the manner of neoclassical drama, where action is narrated rather than represented, the shepherd Mirtillus recounts the 'new appearing of [Cloris's] naked heart' which is moved to affection by the sight of her suitor Amyntas lying apparently senseless on the ground.[5] Roused by Cloris's supplications, Amyntas fixes her with a look which elicits a 'convulsion of remorse and grief' issuing in Cloris's shriek, 'O deere, O my deere heart', followed by a thunderburst of tears (5.2.105–6). Mirtillus's speech recreates the drama of feminine desire at the moment of conception: he describes Cloris's heart not merely as 'naked' but as 'new conceiving' (5.2.110). The conception of love is imaged as phallic penetration of the female heart, but Mirtillus's speech gives equal weight to the 'silent rhetoricke' of bodily starts, blushes and tears which signal Cloris's new responsiveness (5.2.119).

Mirtillus's account of Cloris's actions offers sentimental testimony of authentic female feeling. The shift in Cloris's portrayal from a 'piersive' wit to an empathetic lover is conveyed by Mirtillus's exclamation, 'Ah, would to God Dorinda had bene there / T'have seene but Cloris acte this wofull part' (5.2.144–5). This designation of Cloris as an actress of pathos shows Daniel's interest in women as the subjects of love's 'powerfull force of moving' (5.2.114). Women do not simply incite the emotions and reactions of men in Daniel's drama; rather, his 'imaginative sympathy' prompts him to explore female subjectivity, and the ways women express, or are inhibited from expressing, their feelings.[6] This feature aligns Daniel's drama with the Jacobean pastoral tragicomedy of Lady Mary Wroth, *Love's Victory* (*c.* 1620), and with Walter Montagu's Caroline pastoral, *The Shepherds' Paradise*.

Seventeenth-century English drama travels a vast distance between the narratorial discovery of Cloris's 'naked heart' in Daniel's play and Lady Brute's forthright voicing of her sexual desire. Yet without the earlier Stuart drama's testing of the boundaries of female expression, I contend, later plays of the calibre of Vanbrugh's *The Provoked Wife* and William

Congreve's *The Way of the World* (1700) could not have been written. Daniel's evocation of Cloris's 'naked heart' is an early example of a sexual rhetoric attached to the female body on stage, albeit that in his pastoral female bodies were represented by men, and Cloris's emotion is conveyed through the speech of a male character. The development and ramifications of this sexual rhetoric in the genre of Stuart pastoral forms the subject of this chapter.

I take as my focus three pastoral entertainments of the 1630s which constitute a sustained exploration of the musical, dramatic and theatrical possibilities opened up by female performance: Aurelian Townshend's court masque *Tempe Restored* (1632), Walter Montagu's comedy *The Shepherds' Paradise* (1633) and John Milton's *A Masque presented at Ludlow Castle* [*Comus*] (1634). These three works differently embrace the innovation of the female voice embodied on stage. Together they cover the spectrum of attitudes to women's use of theatrical arts, depicting women as celestial and sensual sirens, who alternatively draw men up to heaven by their 'sweet compulsion' or lead them astray with what Prynne, in *Histrio-Mastix*, calls '*the plague of the voyce*'.[7] Each of these works is strikingly experimental. *Tempe Restored* juxtaposes a male with a female singer, both of whom represent a female role. The audience is thus offered the chance to compare a naturalistic and an illusionistic performance of gender. The leading actors of *The Shepherds' Paradise* assume multiple identities, and the play reverses the cross-gender casting common to the professional English stage, in the playing of male roles by women. Montagu explores the very anxieties about female discourse and display that agitated Prynne; moreover, he approaches these questions with a hitherto unrecognized comedy and subtlety. The experimentalism of Milton's masque is both theatrical and literary: like White's *Cupid's Banishment*, *Comus* departs from custom to enable the school-age children for whom it was written 'to display their abilities in speech and song'.[8] Milton's masque radically revises the ideals of chastity and eloquence, focused in its fifteen-year-old female performer.

ACCOMMODATING THE FEMALE VOICE

The previous chapter illustrated the portrayal of female action in Jacobean masques as effecting both the consolidation, and the subversion, of masculine virtue and identity. The presence of women as singers, and as speaking actors, greatly expands the imaginative scope with which female

agency may be represented. In scripted drama women cannot simply 'work the best motions'. Once women perform as characters on stage, those characters must manifest signs of human feeling, of themselves being moved. 'A woman moved is like a fountain troubled,' declares Kate to her frowardly sister Bianca and the Widow at the end of *The Taming of the Shrew* (5.2.147). But the proposition hinges on the type of feminine emotiveness in question. At this point in Shakespeare's comedy, Kate has been moved by Petruchio to wield her rhetorical gift in the form of 'womanly persuasion' as distinct from her earlier performance of shrewishness as unwomanly defiance (5.2.125). The 'woman moved' may eloquently promulgate the Renaissance ideal of wifely obedience. Authors and audiences alike know that a woman like Shakespeare's Roman Octavia, of 'a holy, cold and still conversation' (2.6.122–23), yields little dramatic excitement.

In asking how works scripted for female performance newly represent women, we must note that in Renaissance culture the power or magic of theatre is already represented as feminine. In his antitheatrical tract *The Schoole of Abuse* (1579) Stephen Gosson describes the dangerous allure of poetry and plays through the metaphor of 'Circe's cup'.[9] Thus when Townshend casts a professional singer-actress in the role of Circe in *Tempe Restored*, he intensifies an already potent metaphor of feminine theatricality. Crucially, in this masque Circe exists not merely as a text or trope, but as an animated character. Authors such as Townshend and Milton would have been familiar with the depiction of Circe in Homer's *Odyssey*, where she appears as a formidable goddess, gifted in the art of magic, and of surpassing beauty, most especially beauty of voice. Rather than inhabiting an island, as in the *Odyssey*, in Townshend's masque Circe has usurped the pastoral valley of Tempe in ancient Greece, the haunt of the muses and their followers. In this Arcadian setting Townshend shows Circe not simply as a woman who moves others, but as a woman who is moved: the masque portrays Circe as at once enchantress and victim.[10]

The figure of Circe represented a powerful icon of the theatrical woman in Renaissance and seventeenth-century Europe. Circe featured as the protagonist of the French *ballet de cour*, the *Balet Comique de la Royne* by Balthasar de Beaujoyeulx (1581, pub. 1582), a work to which *Tempe Restored* is indebted both for its allegory and for its featuring of female singers. In the *Balet Comique* the enchantress Circe is at once an emblem of 'natural', unrestrained passion and a figure for the religious strife between Catholics and Protestant Huguenots which had beset

France in the second half of the sixteenth century.[11] In England, with the coming of the Protestant reformers, the pagan image of Circe as a figure of intemperance was supplemented by an association between Circe and the biblical Whore of Babylon with her golden cup. This image of the Apocalyptic Circe sharpens the political edge of the *Masque performed at Ludlow Castle*, which takes as its allegorical hinge Milton's invention of the magician Comus as Circe's son.[12]

Circe's influence also reached to the visual arts. In the Pinacoteca at Bologna there is an extraordinary painting entitled *La Maga Circe*, by the seventeenth-century Bolognese artist Lorenzo da Gerbieri (1588–1655), (Figure 6). The magician Circe is depicted on the point of executing a spell; in one hand she holds an amphora, in the other her wand. Her brow is knitted, her eyes piercing in their intensity, she looks as if in the grip of a prophetic frenzy. To the modern viewer this is a woman concentrating on her art; she is about to make something happen. To the Renaissance spectator the image would have connoted the dangers of feminine creativity and knowledge. Stuart drama has its own versions of this dynamic, potentially dangerous figure: Shakespeare's Paulina, Fletcher's Clorin and Delphia, and, in her infernal incarnation, Marston's astonishing, man-eating enchantress, Erichtho.[13] None of these parts, however, was written for a female performer. In what follows I analyse the aesthetic, intellectual and sentimental pleasures afforded the elite audience by the representation of the female singers and actors in the three works under discussion. I shall argue that, in diverse ways, these entertainments participate in and promote the debate about female performance in England in the 1630s.

<center>'TEMPE RESTORED'</center>

Tempe Restored was presented by Queen Henrietta Maria and fourteen ladies to King Charles on Shrove Tuesday 1632. Its chief theatrical innovation was the performance of two female singers, the Frenchwoman Madame Coniack, as the enchantress Circe, and a Mistress Shepherd, who, as the personification of Harmony in the main masque, ushers in Divine Beauty, who was danced by Henrietta Maria.[14]

We now have convincing evidence that Madame Coniack was a French singer employed by the Queen as one of her chapel musicians. Coniack was the subject of an immensely popular poem by Thomas Randolph, which was printed with the title 'Upon a very deformed Gentlewoman, but of a voice incomparably sweet'. Randolph's poem survives in no less

Figure 6. Lorenzo da Gerbieri, *La Maga Circe*. The viewer of this portrait is placed in the
position of Circe's victim, on whom she is casting a spell.

than thirty-two manuscript copies, with various titles, describing their
subject as 'the French woman . . . that singes in Masques at Court', or
more specifically as 'one of the Queenes Chapple'.[15] Whether Mistress
Shepherd had a similar role as a court musician remains unknown, but

it is worth noting that her singing role is as substantial as Madame Coniack's.

Harmony's role is to conduct on to the stage the fourteen Influences of the stars, and to direct the audience's attention towards the visual music represented by the Queen and her masquers. The first words she sings, 'not as myself', accentuate her status as the voice of Divine Beauty.[16] In contrast, the part of Circe is decidedly histrionic. Townshend uses the singing and acting abilities of Madame Coniack to produce a compelling image of female passion and enchantment. The casting of an accomplished singer-actress as Circe invests the masque with an entirely new emotionalism and theatrical excitement.

The 'Song of Circe'

The masque presents Circe's sensual magic in counterpoint with the Divine Beauty represented by Henrietta Maria. The centrepiece of the antimasque is the 'Song of Circe' which, together with its attendant action, makes audible and visible Circe's power of enchantment.[17] In the 'Allegory' written by Inigo Jones, Circe's power is equated with 'desire in general, the which . . . being mixed of the divine and sensible, hath diverse effects, leading some to virtue, and others to vice'. The allegory locates Circe's power specifically in her 'extraordinary beauty, and sweetness of her voice' (298–304).[18]

The reference to Circe's 'sweetness of . . . voice' suggests that the action of *Tempe Restored* evolved partly in response to the English novelty of a female singer in a histrionic role. In this respect the masque differs from its French source, the *Balet Comique*, in which Circe symbolizes the horrors of civil war. As well as singing a lament for her escaped lover, which forms the highlight of the first *intermedium*, the French Circe delivers a spoken harangue in which she claims to embody the principal of change. The French Circe was played by a courtier, Mademoiselle de Sainte Mesme. The fact that she both sings and speaks indicates the contrasting lack of restrictive protocol governing women's histrionic performance at the French court.

Symbolically, Townshend's Circe represents a neutral force; however, the action of the masque shows Circe's tempestuous and tyrannical authority subdued by the radiant influence of Divine Beauty. The necessity of containing Circe's power hints at the danger and threat posed by the display of the woman singer, which Lucy Green defines as 'an element

of active control which is invested in the power of the lure'.[19] Stephen Orgel remarks that *Tempe Restored* 'makes its moral point far more significantly through Jones's engineering than through the action of Circe and her erstwhile lover'.[20] I would go further and suggest that the masque's moral imperative, the triumph of Divine Beauty and Heroic Virtue, symbolized by the seated King Charles, is subverted by Circe's potent theatricality.[21]

Circe's initial impact is made physically as she enters in a whirlwind of passion, enraged at '*the escape of the young gentleman her lover*' (96). The dynamic action continues as Circe '*traverse[s] the stage with an angry look*' and '*sings to her lute*' the song beginning, 'Dissembling traitor, now I see the cause' (97, 99). The song shifts from rage to 'a lamentation or love passion' (10):

> And he is gone (ay me) is stol'n from hence,
> And this poor casket of my breast hath left
> Without a heart . . .
> O most inhuman theft!
>
> (105–108)

By introducing Circe through an air sung '*to her lute*' (97), Townshend enhances the image of Circe as an enchantress with the specific power of music and song to seduce.[22] In England, the twin forces of musical and sexual allure were especially associated with foreign women such as Madame Coniack. Witness Thomas Coryate's vivid description of the singing of a Venetian courtesan: 'She will endevour to enchaunt thee partly with her melodious notes that shee warbles out upon her lute, which shee fingers with as laudable a stroake as many men that are excellent professors in the noble science of Musicke; and partly with that heart-tempting harmony of her voice.'[23]

Marston exploits this image in his comedy for the Children of the Queen's Revels, *The Dutch Courtesan* (1605), where Franchischina's singing to her lute clinches the violent affection which overcomes the Puritan Malheureux. It is not just the spectacle of the female musician which makes possible the theatrical excitement generated by Circe's song. The emotional pleasure afforded the audience by Circe's song is complex: she is at once tyrant and victim, so that her song conveys both potency and pathos. Townshend makes Circe's song a *tour de force* of dramatic representation by revealing in turn the attitudes of lovelorn woman, seductress and defiant sovereign.

Circe as sovereign

The song ends with Circe rallying her court:

> Then take my keys, and show me all my wealth!
> Lead me abroad! Let me my subjects view!
> Bring me some physic, though that bring no health,
> And feign me pleasures, since I find none true.
>
> (111–14)

After the song Circe sits in her '*chair of state*' (79) and watches the antimasques of '*Indians and Barbarians*' and the men she has '*half transformed into beasts*' (121–2). This imperial tableau inverts the visual norms of the Jonsonian masque, in which the monarch's gaze is paramount.[24] At this point in the masque, Circe's gaze usurps the gaze of the spectator-king: it is her act of observation that is the thing observed by the audience.

Moreover, this *Gestus* conflicts with the expectation raised earlier by Circe's 'Fugitive Favourite' that Circe will be subdued by King Charles's virtue. The masque opens with the speech of the Fugitive Favourite (played by the court page, Thomas Killigrew) whose reason has compelled him to flee after the enchantress capriciously transformed him to a lion and then back to his human shape. Safe in the vicinity of the royal state, the Favourite envisages that Circe will be cowed by Heroic Virtue, 'in whose awful sight / She dares not come but in a mask, and crouch / As low as I did, for my liberty' (72–4). Through the disparaging phrase 'but in a mask' the Favourite attempts to transfer on to Circe the demeaning aspect of his own theatrical experience. But the moral subordination which he ascribes to Circe is not, at this point of the masque, borne out by the action. Rather than fawning before the King, Circe confronts his gaze as she sits in dominion over the men she has subjugated and transformed. It is a potent emblem of the mythological struggle between Venus and Mars.

The gentle transition from antimasque to main masque in *Tempe Restored* suggests the interdependence of Circe and Divine Beauty as earthly and heavenly Venus. In contrast to the forcible expulsion of non-courtly evil, found in, for instance, the dispelling of the witches by the female warriors in Jonson's *Queens*, Circe's departure from the scene is not coerced; she and her nymphs '*retire towards the palace from whence she came, and the scene returns into the vale of Tempe*' (138–40). After the dance of the fourteen Influences, ushered by Harmony, the scene again changes '*into an oriental sky*' (171) in preparation for Divine Beauty's appearance.

Inigo Jones created a stunning visual effect as the Queen descended in a golden chariot, accompanied by eight musicians representing the spheres, and fourteen female masquers as attendant stars. This feat of engineering, combined with the dancing of the main masquers, suggests the capacity of Divine Beauty and Harmony to pacify Circe's unruliness; here the Queen performs as an agent of patriarchal control. Yet Circe does not yield without a fight, as we see and hear in the final *intermedium* where, after the main masque dance, she returns to the stage to take part in a debate with the Olympian gods about her possession of Tempe.

This part of the action differs markedly from the *Balet Comique* where Circe attempts to flee, is stunned by a thunderbolt from Jove and is finally led in triumph around the hall by Minerva. In *Tempe Restored* the conflict is resolved in a civilized manner, as together Divine Beauty and Heroic Virtue (figured by the seated King) '*dissolve the enchantments, and Circe voluntarily deliver[s] her golden rod to Minerva*' (324–5). Jones's allegory describes the masque's symbolism in Neoplatonic terms, whereby Circe's submission illustrates '*the harmony of the irascible and concupiscible parts obedient to the rational and highest part of the soul*' (327–9). But dramatically, the sung dialogue between Cupid, Jupiter, Pallas and Circe shows the martial goddess Pallas yielding to Circe. At issue is Circe's 'acting of a tyrant's part' (256), her tormenting of thousands of lovers, for which, Cupid and Jupiter allege, Circe must cede sovereignty over Tempe. Circe sings cheekily, 'The Gods more freedom did allow, / When Jove turned Io to a cow' (264–5). Her bold reference to Jupiter's history of seductions triggers a contention between Pallas and Circe in which, upbraided by Pallas for her presumption, Circe flings at Pallas the insult, 'Man-maid, begone!' (268).

This is an unprecedented moment in masquing history, in which Circe asserts herself as an actress and female performer.[25] On stage were Cupid, Jupiter, Pallas and Circe: two gods, one goddess and a nymph. It is conceivable that this line-up represented four distinct vocal registers and tone colours: a boy treble for Cupid, a bass for Jupiter, a tenor or countertenor for Pallas, and a soprano, or mezzosoprano for Circe. By spurning Pallas with the epithet 'Man-maid', Circe distinguishes herself from the ambiguously gendered transvestite actor and singer. Her proud femininity reveals this masculine Pallas as a fraud. It is a richly comic moment, which may have encompassed the French soprano's derision of the English (counter)tenor's vocal timbre.[26]

Pallas responds to Circe, 'Though I could turn thee to a stone / I'll beg thy peace' (269–70). Pallas alludes to the petrifying power of the Medusa

whose head she bore on her shield. Freud famously interpreted the decapitated head of Medusa as a symbol of the female genitals, the sight of which he believed inspired in small boys 'a terror of castration'.[27] Here, in a curious inversion of that idea, the male actor playing Pallas threatens to disable his theatrical rival by turning femininity's disruptive force back upon itself. But the goddess makes and withdraws her threat in the same moment, and is anyway rebuked by Jupiter. Pallas's threatening of Circe indicates to the actress her undesirability, but her withdrawal of that threat shows Pallas, and the male actor's, impotence; it is as though, when faced with the redoubtable Madame Coniack, the actor playing Pallas accepts his shortcomings as a female impersonator. The concession made by Pallas is complemented by Circe's shrewd anticipation of Jove's 'gift' by bestowing the vale of Tempe upon the 'matchless pair' (273) of Charles and Henrietta Maria. Circe's application of the epithet 'matchless' to the royal couple demonstrates her politically accommodating stance. Melinda Gough has proposed that *Tempe Restored* celebrates to an extent unprecedented in the English masque tradition 'the prerogatives of elite and nonelite women alike to participate centrally in the social, political and increasingly theatrical functions of majesty'.[28] We must include as part of this innovativeness the masque's dramatizing in Circe the traits of a diva, and a diplomat.[29]

It is hard to imagine that the conflict staged in *Tempe Restored* between the hermaphroditic Pallas and female Circe does not also arise in the masque's juxtaposition of sensual and divine Beauty.[30] Specifically, the mute and comparatively static Henrietta Maria may have had trouble matching the spell cast by Circe's voice. In her next court appearance in Montagu's pastoral comedy *The Shepherds' Paradise* the Queen chose to demonstrate her musical capacity more actively than the sublime harmony of Divine Beauty allowed.

'THE SHEPHERDS' PARADISE': THE FEMININE PASTORAL SCENE

The Shepherds' Paradise struggles with the doubts and dilemmas of female subjectivity in a wholly new theatrical context. To appreciate this we must distinguish between the professional performance of Madame Coniack as the heartstricken Circe, and the delicacy surrounding female characterization in a play written to be acted by the Queen and her ladies. The unabashed emotional display of Circe's song was not feasible in Montagu's play. Instead the play makes drama out of the uncertainties

surrounding female acting and expression; its theatrical *frissons* derive from scenarios in which femininity is placed in jeopardy.

The role of 'Bellessa' played by Henrietta Maria in *The Shepherds' Paradise* is in essence a dramatic refashioning of her role as Divine Beauty in *Tempe Restored*.[31] Bellessa, alias Saphira, the Princess of Navarre, is the newly elected queen of the Shepherds' Paradise, an order devoted to the ideals of beauty and chastity. Male and female initiates of the 'Society' (750) must take a vow of chastity and single life; an outlet is allowed at the annual election of the queen when members may resign from the order expressly to marry. As well as offering a haven for aristocrats, the pastoral retreat provides a strictly controlled environment in which the sexes may meet and discuss questions of ethics and etiquette in love. These discussions form the body of the play, which as Sarah Poynting remarks, is best read 'as a prose romance which happens to be written entirely in dialogue'.[32]

While the mode of *The Shepherds' Paradise* strikes the modern reader as static and untheatrical, contemporary reports help recreate the play's performative dimension. In the several months before the intended performance on 19 November 1632 (the King's birthday), while the Queen and her ladies were learning their parts and Inigo Jones was constructing the scenery, we learn from John Pory that 'Taylour the prime actor at the Globe, goes every day to teach them action.'[33] The costume design for Prince Basilino, played by Mary, Marchioness of Hamilton, shows the stylized gesture which suited the play, and indicates how youthful maleness was depicted through a short, loose dress, plumed hat and sword (Figure 7). The histrionic aspect of the performance is stressed in the report of the Florentine ambassador, who wrote that Henrietta Maria 'with her new English and the grace with which she showed it off, together with her regal gestures and actions on the stage outdid all the other ladies, though they acted their parts too with the greatest variety'.[34] It is the performative dimension of the text with which I am concerned, for this is the first play written for women actors in English. The following discussion focuses on moments in which the issues of female acting and expression are taken up as part of the dialogue.

'Glowing heat': the disclosure of feminine desire

One of the key questions of *The Shepherds' Paradise*, for both the characters and the audience, is whether Bellessa is in love with Moramante, the assumed name of the disguised Prince Basilino. Acts 4 and 5 circle around

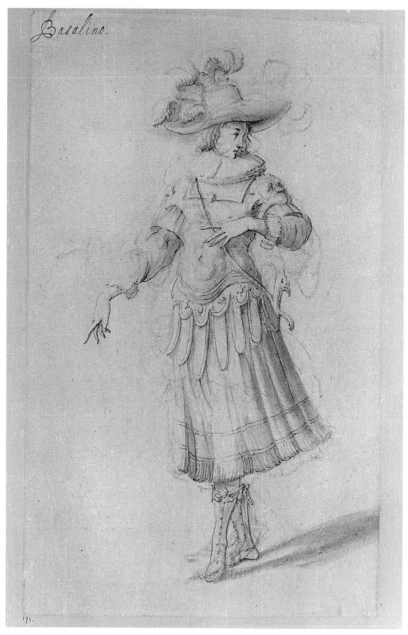

Figure 7. Inigo Jones, *Basilino, Prince of Valentia.*

the burning question, 'does the Queen love?', engaging in an elaborate teasing game with the audience. The game is advanced when Bellessa twice has recourse to 'a privacy' (2965): on the first occasion she confesses her love for Moramante in song; on the second, in a wood known as 'loves Cabonett' (3296), she consults with Echo as to whether she should discover her love to Moramante. Both scenes prepare the audience for an intimate revelation, an expectation enhanced by the song's opening line, 'Presse me noe more kind love, I will confesse' (2986).

Rather than an outright confession, Bellessa's song is a negotiation with Cupid about the terms on which she may disclose her emotion. While admitting that love is 'strong enough to make me speake', she sets her spontaneous expression against the regulatory force of 'the virgin shame'. Only on the understanding that she may be 'safely free' does she admit to an apprehension of chaste desire:

> I find a glowing heat that turnes red hott,
> My heart, but yet it doth not flame a jott:
> It doth but yet to such a Colour turne,
> It seemes to me rather to blush then burne,
> You would perswade me that a flaming light
> Riseing will change this Colour into white,
> I would faine in this whity inference:
> [I would fain know if this whites inference, 1659: 112]
> Pretend pale guilt or Candid Innocence.
>
> (2994–3001)

The song functions as a mirror in which Bellessa reads and interprets her own complexion. Her anxious self-scrutiny contributes a novel twist to an early modern theatrical discourse in which, more usually, male characters note and interpret a woman's body as a legible sign.[35] These particular lines symbolize a form of bodily speech, enacting the distillation of a blush. They make vividly theatrical Brabantio's image in *Othello* of Desdemona's motion 'blush[ing] at herself' (1.3.96).

As young women are taught, 'horses sweat, men perspire, ladies only glow'. The 'glowing heat' that kindles Bellessa's heart subtly expresses both her emotion and her physical desire. Her conflict between love and shame suggests the onset of passion, offset by chastity. The eroticism of the blush is captured in Shakespeare's *Antony and Cleopatra* by Enobarbus's description of the Egyptian queen on her barge, fanned by Cupids whose wind 'did seem / To glow the delicate cheeks which they did cool' (2.2.210–11). However, like Congreve's Restoration heroines, Montagu's queen is conscious that 'a blush may spell disaster', notwithstanding the

fact that she is alone.[36] Hence her desire to know from Cupid whether her complexion should be read as implying 'pale guilt or Candid Innocence'.

Bellessa's concern about disclosing her love has an interesting antecedent in Mary Wroth's Jacobean pastoral drama, *Love's Victory*, which, like Montagu's play, was designed for a coterie audience.[37] *Love's Victory* dramatizes a moment of feminine apprehensiveness about the treacherously expressive body, a body that speaks in spite of its owner's will. The heroine Musella has declared her love for Philisses, but their private conference is threatened by the approach of Rustic, the man Musella's father has ordained she must marry. Musella wishes Rustic were absent:

> For though that he, poor thing, can little find,
> Yet I shall blush with knowing my own mind.
> Fear and desire, still to keep it hid,
> Will blushing show it when 'tis most forbid.[38]

Musella attributes her anticipated blush to a combination of factors: firstly, her preference for Philisses over Rustic, a knowledge which encompasses sexual desire; secondly, her 'fear' or anxiety about whether her blushing cheeks will betray her desire to Rustic. While Musella links her body's response to her psychological confusion, Philisses locates the source of the blush in bodily pleasure, or *jouissance*: 'kind desire makes you blushing know / That joy takes place, and in your face doth climb / With leaping heart like lambkins in the prime' (4.1.132–4).

Significantly, it is Philisses who speaks ingenuously of sexual desire, while Musella expresses that knowledge only in terms of what is forbidden to women. By making Musella's blush the subject of a spoken exchange between a woman and a man, Wroth pinpoints the repressive effect of the Renaissance prohibition upon women displaying sexual feeling. The word 'kind', in Philisses's phrase 'kind desire', carries the sense of 'natural', as it does in Bellessa's addressing of Cupid as 'kind love' (*OED* kind, *a.* 1). But Musella's predicament illustrates that women more usually experience desire as unkind, or unnatural; for them it proves a source of confusion and distress.

The convergence between Wroth's and Montagu's dramatizing of feminine desire confirms Gary Waller's suggestion that *Love's Victory* anticipates the pastoral plays sponsored by Henrietta Maria in the late 1620s and 1630s.[39] Waller characterizes these feminized pastorals in terms of an 'attractive languidness';[40] but one imagines both the scenes discussed above having a particular piquancy for their female audience or reader. In Montagu's comedy this piquancy is intensified by the gestic

quality of Bellessa's song, and the fact that, while dramatically she is alone, she is surrounded by the courtly audience. Bellessa introduces her song as a civil entertainment of Cupid (2984); yet, through its musical register, the entertainment extends beyond Cupid as the song's immediate addressee. What is spelled out as a private moment of introspection carries a public dimension by virtue of the theatrical performance. Montagu flaunts this fact by having Bellessa appeal to Cupid at the beginning of the song 'Not to bring me to witnes it [her love] to men' (2989). The song, however, does just that, with the qualification that there were not only men but women in the audience for whom the song may have aroused a sympathetic pleasure.

By stressing Bellessa's quandary over how her body will be read, the song neutralizes the potential immodesty in the Queen's physical display and vocal utterance. However, the rest of the scene dramatizes the tensions arising from the actress's visible, audible presence. Overcome by 'a gentle drowsynes' (3004), Bellessa falls asleep. Moramante enters, drawn by the sound of Bellessa's voice, and seeing her sleeping, 'stands wondring' (3010). Moramante feels himself carried towards Bellessa by an 'earthynes' (3020), but approaching nearer he declares himself 'all soule' and kisses Bellessa's hand not once but twice, causing her to awake.

This scene reaps exquisite comedy from Moramante's dilemma over the feeling aroused in him by the sight of Bellessa sleeping. Before he sees her, Moramante perceives Bellessa's singing as a source of heavenly music. When confronted by Bellessa asleep, however, he is unable to resist his urge to touch her. His involuntary transportation towards her makes comically literal the Neoplatonic idea of the 'motions' worked by women. The scene plays out the sexual allure and vulnerability of women which became a constant image on the Restoration stage, but in a gentler key.[41] Such a scene was made possible by the privacy and decorum governing the performance of the pastoral; when it was printed belatedly in 1659, the title-page spelled out that it was '*Privately* Acted before the Late King Charls [*sic*] by the Queen's Majesty, and Ladies of Honour' (emphasis mine).

Some of the fascination of this scene in performance must have stemmed from its dramatizing of an erotic encounter with the young married Queen at its centre. For connoisseurs of drama in the court audience, Moramante's stolen kisses might have recalled the scene from Guarini's *Il Pastor Fido* in which Mirtillo narrates how he stole a kiss from Amarillis.[42] Montagu's daring may be gauged by the fact that his scene enacts what is merely narrated in Guarini's pastoral. In the acting, the

erotic dynamics of *Il Pastor Fido* undergo a subtle modulation. Guarini's Mirtillo is a man dressed as a woman to steal a kiss from his beloved. The theatrical context of *The Shepherds' Paradise*, in which all the actors are women, resembles the ironic all-female game which the cross-dressed Mirtillo invades. Montagu's feminine theatre allows women to act out the rituals of heterosexual courtship in a manner that we shall see appropriated within the context of closet drama by Margaret Cavendish. Bellessa relishes her erotic power over Moramante in a manner identical to Cavendish's heroines. Here she punishes Moramante's transgression by banishing him from her company, but she later remits her sentence with the intention of torturing him 'upon the racke of Hope' (3102), a flirtation suiting with the prerogative of a Platonic mistress.

Wording love: Bellessa and Echo

Bellessa's song gives a definitive answer for the audience, but not as yet for the play's characters, to the question of whether the Queen is moved by love. Her trepidation over expressing her desire surfaces several scenes later when Bellessa consults with Echo in Love's 'Cabinett' (3353).[43] Whereas Bellessa's song to Cupid may have carried overtones of religious confession, the Echo scene summons political resonances stemming from Charles I's recent institution of a 'cabinet council'.[44] The scene theatricalizes the tutelage Bellessa receives from a series of male figures: Cupid, Moramante, her 'Tutour' in love (3288), and here the interestingly masculine figure of Echo, a 'Councellor' whom Bellessa describes ironically to Moramante as 'old, and a litle deafe' (3360, 3364). Alone in the wood at first, Bellessa tells Echo, 'I will trust you soe as to take Councell of you, in the discovery of my love' (3305–6). In his fragmented manner, Echo counsels her to 'Speake', 'Word love' and 'Doe', reassuring her of Moramante's 'Constancy' and their mutual 'Content'. When Moramante finds her alone, Bellessa tells him to speak to Love's 'Councellor' if he has any suit. To Moramante's query, 'doth Bellessa Love?', Echo replies in the affirmative, '*Love*'. When Moramante declares, 'it is to[o] great a miracle to beleive but from any voice but yours' (3371–2), Bellessa affirms, 'It is my voyce Moramante and I have lett it loose from mee: that it might not have somuch as modesty to hold it back, beleive it, for if you put me to take it into me againe, I have a virgin cold that will not let it speake soe cleere' (3373–7).

As in her song to Cupid, the monitory force of virgin modesty intervenes to inhibit Bellessa's expression of her desire. In order to

speak clearly of her love to Moramante, therefore, Bellessa mediates her voice through Echo. Here she represents her voice as emanating from elsewhere, as divided in the very act of utterance. Moreover, Montagu doubly alienates Bellessa from her own voice by making Echo masculine.

In Ovid's *Metamorphoses* Echo is a figure of frustrated female speech and desire, subject to an unrequitable love for the beautiful youth Narcissus. This is the myth depicted in Poussin's *Echo and Narcissus* (Figure 8), contemporary with Montagu's play, where an etiolated Echo gazes with unfulfilled longing at a Narcissus who lies turned away from her, his gaze fixed on his own watery image. By gendering Echo as masculine, Montagu avoids splitting the dramatic focus of the scene between two female characters. Instead, his Echo acts as an adviser to the Queen, the chief minister of Love's Cabinet. Bellessa conveys her love to Moramante through a political mediator, as a queen communicates her decision to a subject.

Furthermore, Echo's changed gender distances Montagu's play from the urgent nature of the Ovidian Echo's sexual desire. In George Sandys's translation of the *Metamorphoses*, Echo's loss of voice is a punishment imposed by Juno after the 'vocall Nymph' distracts her from Jove's adulteries with 'long discourses'.[45] The passage describing the kindling of Echo's love for Narcissus conveys the sexual scope of the word 'glow', the erotic connotations of which I observed in my discussion of Bellessa's song. Sighting Narcissus out for the hunt, Echo

> *forth-with glowes,* and with a noyselesse pace
> His steps persues; *the more she did persew,*
> *More hot (as neerer to her fire) she grew.*[46]

Echo's eager desire, verbalized in her rejoinders to the hunter's calls to his companions, proves distasteful to Narcissus, who spurns her as a 'light Nymph'. Ovid's rebuffed Echo suffers a sobering fate, 'withering into the ghostly voice of pure reflectivity'.[47] By modifying Ovid's Echo, Montagu avoids confronting the symbolic freight connoted by the mythological figure, namely, the dangers inherent in a woman's frank expression of sexual desire. The ventriloquism of Montagu's Echo scene suggests a specifically courtly response to the trauma over female self-expression registered in Bellessa's song. When Moramante pleads with Bellessa to reingest her voice – 'give me leave to begg for this kinde voyce . . . that you would now take it into you againe' (3380–1) – Bellessa replies with her fullest testimony of feeling:

Figure 8. Nicolas Poussin, *Echo and Narcissus* 1629–30. In *The Shepherds' Paradise* Montagu alters the customary image of Echo as feminine, seen in Poussin's painting, by making his Echo a masculine counsellor, 'old, and a little deafe'.

I have had long a sence well fitted, to your sufferings; and the first thought I did allow your love, was soe civill as it brought me [many] in returne of it, and by this exchange stor'd me with thoughts which were soe cleere, as they seem'd glasses for vertue to dresse her selfe by not shadowes to draw over her, Therefore I have continued the enterteinment of your love. (3387–91)

This speech condenses many of the crucial ideas in Montagu's play, including the vital relationship between sense and virtue, and the idea, broached by Bellessa's song to Cupid, of love as a mode of civil entertainment. The word 'entertainment' may connote both the reception of a guest, and the employment of a servant, encompassing both equality and difference of social status (*OED n.* 2a, 13).[48] Wedded to the key concept of 'civility', the idea of 'entertainment' offers a template for the relationship of Bellessa and Moramante, a relationship which, as Sarah Poynting has shown, is modelled upon that between queen and courtier-favourite.[49]

Bellessa sees her relationship with Moramante as having developed through a process of mental and emotional reciprocity and exchange. Her account of their relationship makes an interesting comparison with that offered by the shepherdess Camena, in a passage omitted from the Tixall manuscript, but present in the quarto edition of 1659. Camena's speech forms part of a debate with her shepherd-lover Melidoro about the extent to which women are moved by the passions they raise in their lovers: 'I cannot think [Bellessa] voyd of sense, but I beleeve it sinks no deeper then the face of that civility, where men do see it set, and make a returne to *Moramente*.'[50]

From Camena's perspective, civility properly limits the degree to which Bellessa is sensible of, and returns, Moramante's feelings. Her understanding of civility is contradicted by Melidoro, who retorts that 'civility and freedome of discourse' are the 'outworkes' of the heart, and that, in the course of his approaches to Bellessa, Moramente has 'taken these outworks'.[51] Melidoro's linking of 'civility' to a metaphor of amorous siege gestures towards a more expansive meaning of 'civility', and the word 'sense', with which 'civility' is linked in both Bellessa's and Camena's speeches. Camena attributes to Bellessa a 'sense' that remains on the 'civil' side of sensuality, but as we have seen, the play is not shy of exploring the sensual aspect of Bellessa's and Moramente's experience. As Poynting rightly observes, 'Camena is actually wrong about Bellessa's feelings', which indeed run deeper than the reciprocating courtesy Camena describes.[52] Bellessa's song testifies to her consciousness of her sensual response to the man with whom she has been engaged in civil conversation about love. The 'glowing heat' which Bellessa contemplates in her

song may have been produced by her thoughts about Moramante's 'person' (2979) in the soliloquy which precedes it. In her speech before her consultation with Echo, Bellessa reflects on the overwhelming force of love in language which anticipates the torrents and sluices of Lady Brute's desire: 'Love in that instant that it is let in, falls under our wills, and like an Innundation all it findes – portable it rayseth upp and carryes with it' (3285–7). What is critical, as both Camena and Bellessa perceive, is the manner in which Bellessa's actions are witnessed and interpreted by others.

The extent to which a queen's conduct forms a cynosure of the people's gaze is suggested both by Camena's phrase 'where men do see it set', and by Bellessa's image of her thoughts as 'glasses for vertue to dresse her selfe by'. This conceit echoes Antonio's 'character' of the Duchess in John Webster's *The Duchess of Malfi* (1614), which similarly represents the exemplary royal woman as 'th'observed of all observers': 'Let all sweet Ladies breake their flattring Glasses, / And dresse themselves in her.'[53] Webster's use of the pastoral convention of an Echo provides a further link with *The Shepherds' Paradise*. In a ruined graveyard Antonio and his friend Delio are arrested by an echoic intimation of the murdered Duchess's presence. Antonio's recognition of his wife's accents prompts Echo to declare, '*I, wifes-voyce*' (5.3.26). The pun on 'I/Ay' affirms the Duchess's human role as Antonio's wife, complementing her dying assertion of her royal status.[54]

The juxtaposition of Montagu's Bellessa with the Duchess of Malfi is a fertile one because of the way that both plays stress 'the dramatic and self-conscious playing of parts'.[55] Elizabeth Harvey instances Webster's play as a paradigmatic example of the early modern orchestration of voice by an 'invisible' author, and more particularly, as an example of what she terms 'transvestite ventriloquism', or a male author's creation of a feminine voice.[56] As Harvey points out, 'the disjunction between speaking and gender' consequent on a male writer's representation of feminine speech is intensified by the acting conventions of the English transvestite stage.[57] Thus in the wooing scene of Webster's play, when the Duchess of Malfi places Antonio's hand on her heart and tells him, 'This is flesh, and blood, (Sir,) / 'Tis not the figure cut in Allablaster / Kneeles at my husbands tombe', the illusion of a passionately sentient woman is potentially disturbed by the discontinuity between the dramatic character and the gender of the actor by whom that character is voiced.[58] At the same time, it is lines such as these which bear out Catherine Belsey's view of *The Duchess of Malfi* as a play 'poised between the emblematic tradition of

the medieval stage and the increasing commitment to realism of the post-Restoration theater'.[59] Belsey reads Webster's Echo scene as an example of the reduction of the Duchess to an emblem, an emblem signifying both innocence and sorrow, 'the inevitable experience [of innocence] in a fallen world'.[60] Harvey's reflections upon transvestite ventriloquism, and Belsey's reading of the emotional-moral impact of Webster's emblematic Echo, form a pertinent backdrop against which to judge Bellessa's ventriloquizing of her love for Moramante.

As a male dramatist Montagu inhabits women's voices; however, in the Queen's performance of his play those voices were articulated by women, not men. One result of this heightened realism, I suggest, is Montagu's *précieux* focus on the inherently theatrical nature of Bellessa's identity, and by extension, that of other elite women. In the printed text, at the point at which she provisionally accepts Moramante as her lover, Bellessa appears to discard her queenly role: 'Rise *Moramente*, unless you wish an answer from a Queen, and not *Bellesa*' (1659: 137). Her ensuing speech explains the condition of doubleness which her discarding of queenliness attempts to dissolve: 'I have had long a sense well fitted to your sufferings, and I have beleeved so well of you as I did not feare the seemingnesse of my indifferency would divert you from a meritorious persistency.' The periphrasis, 'the seemingnesse of my indifferency', forms an oblique acknowledgement by Bellessa of the deceptiveness of her former re-strained manner towards Moramante. In this matter of a queen's appro-priate response to a suitor or lover, Montagu does not represent Bellessa as exceptionally privileged, as beyond her sex. On the contrary, her behav-iour is interpreted by Camena as a model of correct conduct for all women.

In another of the sparring dialogues between Camena and Melidoro omitted from the abridged text of the play, Camena justifies Bellessa's emotional neutrality to Melidoro: 'If women at first be but so civill as an *Eccho*, 'tis enough if she but shew that she did hear' (1659: 125).[61] Camena's assertion anticipates Bellessa's intimating of her love to Mor-amante through Echo, and her subsequent reciprocation of Moramante's declaration of love. Especially interesting are the reasons Camena adduces in support of Bellessa's initial withholding of an avowal of love from Moramante: '''Tis but a year since [Moramante and Bellessa] knew one another, and that is scarce time enough for a woman to make all her objections against loving of a man, much lesse to be so satisfied, as to resolve to give herself away' (1659: 126). The dangers attendant upon romantic and marital relations for a woman are of equal concern to

Bellessa, as she makes clear when, in dialogue with Echo, she expresses her fear of Moramante proving either vain or inconstant (1659: 135). In her speech accepting Moramante's love, Bellessa admits that her thoughts 'have been studying you all this while, with this advantage to[o], of your not knowing it. So they have informed themselves of your nature streghtly in it self, without the ply it takes, bent by designe' (1659: 137–8). In this intriguingly complex architectural figure, Bellessa signals that she has surmounted her fears of Moramante's dereliction from merit through patient, unbiased scrutiny of his behaviour.[62] By means of a paradox, Bellessa justifies her studied indifference as a means of ensuring the virtuous transparency of Moramante's character: her concealing of her feelings was in aid of judging Moramante's uprightness, unwarped by the 'ply', or fold, of his anterior knowledge or 'design'.

The reversals rung in this speech on the moral complexities of concealing, or feigning, bear out Poynting's argument that such artistic and architectural metaphors 'are not merely decorative but an integral part of the play's anti-Platonism', its problematizing of the notion expounded in the Caroline masque that 'sight leads to knowledge'.[63] We must include as part of this anti-Platonism the refusal of *The Shepherds' Paradise* to propound essentialist notions of female identity. For, far from eliding the gap between 'the gender of the [feminine] body and the voice that speaks it',[64] Montagu's pastoral shines a spotlight on the divisions and discontinuities which inform Caroline female subjectivity. At the same time, in a *précieux* style which complements and contrasts with the representation of female desire on the professional Stuart stage, the play reveals its women characters as made of flesh and blood.

It would be anachronistic to ascribe to Montagu a belief in the performative aspect of gender and identity *avant la lettre*. I have discussed elsewhere how the ambivalence attached to feminine self-concealment is played out in the subplot where Fidamira, the original mistress of Prince Basilino (called Moramante), disguises herself as the Moor, Gemella.[65] Yet while Montagu's play registers a traditional unease with ideas of dissembling, its action and language continue to draw attention to the doubleness of its female protagonist. The scene I have been examining defers the fruition of the new understanding forged between Bellessa and Moramante owing to the hidden nature of both partners' identities. Bellessa asserts that Moramante's love 'hath proposed that which I cannot answer yet, because it knowes not who it speakes to' (1659: 138). A valid 'agreement' (1659: 139) between the pair cannot take place until the final

unveiling of all the initiates in the Shepherds' Paradise with which the play concludes. Yet even at this point, Bellessa/Henrietta Maria cannot stop acting the Queen's part. At the denouement, Bellessa miraculously produces a new queen of beauty by pulling off Gemella's scarf.[66] This transformation from blackness to beauty harks back to Jonson's twin masques *Of Blackness* and *Of Beauty*, with their embodying of feminine strangeness and serenity. Bellessa's revelation of Fidamira's beauty likens her role to that of the monarch in the Jonsonian masque, the ultimate transformative power.[67] Thus it is the true French Princess, Henrietta Maria of Bourbon, who reaps the crowning glory of theatrical transform-ation. At the same time as she relinquishes her title, Bellessa's discovery of Fidamira confirms her as the prime actress and leading celebrant of Montagu's pastoral drama.

'A MASQUE PRESENTED AT LUDLOW CASTLE' ['COMUS'] (1634)

The Shepherds' Paradise struggles with women's expression of sexual feeling with a fastidiousness which suggests the novelty of the theatrical situation for the original audience. In this respect Montagu's play makes a fruitful comparison with Milton's Caroline masque which was similarly written for particular persons and a specific occasion. Performed on 29 September 1634 to celebrate the Earl of Bridgewater's assumption of his new office as President of Wales, the masque took the innovative step of presenting three of the Earl's children in acting and singing roles, together with their music master, the court musician and composer Henry Lawes, who played the Attendant Spirit. Milton's masque had the appearance of 'a children's entertainment', an inoffensive piece designed to delight and instruct.[68] Yet the timing of the masque commission, in the year after Prynne's imprisonment following the publication of *Histrio-Mastix*, makes Milton's acceptance of the commission and writing of the masque in themselves political acts.[69]

Prynne had argued that for both actors and audiences, plays had the effect of '*enervating and resolving the virility and vigor of their mindes*'.[70] As a counterview to Prynne, Milton's work for the stage demonstrates the ennobling, fortifying power of poetry and music. Moreover, Prynne had alleged that women actors were 'notorious whores'. At the time of composing *Comus*, Milton was engaged in a period of intensive private study paid for by his father, who expected that his son would be ordained as an Anglican minister. Milton was also a burgeoning poet, exceptionally

responsive to the sensual, natural world. The debate between purity and pleasure dramatized in _Comus_ was one that Milton felt in his pulses.[71] The dialogic mode of Milton's masque enabled him to speak in both a feminine, and what his contemporaries would have called an effeminate, voice, inhabiting at one and the same time the personae of the Lady and Comus.[72]

A Masque presented at Ludlow Castle both responds to, and differentiates itself from, earlier court entertainments in which its actors had participated. Lady Alice Egerton, and her younger brother John, Lord Brackley, had danced as Influences in _Tempe Restored_. In February 1634 the eleven-year-old John and his nine-year-old brother Thomas danced in Thomas Carew's court masque, _Coelum Britannicum_. Like _Tempe Restored_, Milton's masque counterpoints a celestial and a sensual siren. The reveller Comus is the son of Circe by the wine god Bacchus, but he 'excels his mother at her mighty art' (63). In Townshend's masque the opposition between Circe and Divine Beauty remains symbolic; Milton engineers a dramatic confrontation between his singing virgin and the god of pleasure. Unlike the exemplary contest of White's _Cupid's Banishment_, Milton depicts chastity as an ideal that may be imperilled by forces outside human control. His masque draws on the vulnerability of the young Alice Egerton, presenting her as a Lady Errant lost in a wild wood who falls prey to an enchanting seducer. Milton challenges courtly, Neoplatonic conventions of theatricality by limiting the magical efficacy of feminine virtue. Simultaneously, he strikes back at Prynne by making his prime actress the spokeswoman of 'a sage and serious doctrine',[73] transforming the virtue of chastity into a vehicle for philosophical argument.

The power of female song in A Masque

Commentators on Milton's masque have noted its 'recurrent emphasis on music rather than visual spectacle'.[74] The centrality of musical performance in the masque is complemented by an emphasis on aural perception as an index of virtue. The moral imperative to hear truly exercises actors and audience alike, a point driven home in the epilogue where the Spirit addresses the audience, 'List mortals if your ears be true' (996). Responding to his sibling's fear for the welfare of their sister, from whom they have become separated in the wood, the Elder Brother argues that she is guarded from danger by the 'hidden strength' of chastity (414), which he figures through a metaphor of spiritual perception:

So dear to heaven is saintly chastity,
That when a soul is found sincerely so,
A thousand liveried angels lackey her,
And . . .
Tell her of things that no gross ear can hear.

(450–7)

These lines recall the depiction of the music of the spheres in *Arcades* as inaudible to those of 'gross unpurged ear'.[75] Questioning the Elder Brother's idealized perspective, Milton foreshadows in the antimasque action the formidable nature of the Lady's ordeal by showing the subtlety of Comus's senses. In the shady wood the Lady is reliant on her sense of hearing: 'This way the noise was, if mine ear be true, / My best guide now' (169–70). The 'sound / Of riot' which the Lady reluctantly follows is amplified in the autograph manuscripts' description of the measure danced by Comus's rout of monsters, 'in a wild, rude and wanton antick'.[76] Comus's strength as a potential assailant is imaged in his preternatural sensitivity to the Lady's approach: 'Break off, break off, I feel the different pace, / Of some chaste footing near about this ground' (145–6). In his working copy of the masque, Milton originally had Comus '*hear* the different pace' of the Lady's step.[77] In the performed and printed versions, 'hear' became 'feel', heightening Comus's power of divination.

In Milton's strikingly original fallen masque world, the Lady's purportedly superior hearing is no bulwark against the threatening inner soundscape which besets her amidst the 'single darkness' and silence of the wood (203):

What might this be? A thousand fantasies
Begin to throng into my memory
Of calling shapes, and beckoning shadows dire,
And airy tongues, that syllable men's names. . .

(204–7)

The Lady's song to Echo is an attempt to hold at bay this chaos of undifferentiated sound. It is a vocal complement to her inspiring vision of Faith, Hope and Chastity, concentrating and communicating her 'new-enlivened spirits' (227). The further grace of modesty makes the Lady introduce her song as an alternative to a masculine 'hallo[o]':

I cannot hallo to my brothers, but
Such noise as I can make to be heard farthest
I'll venture.

(225–7)

These lines distinguish between the Lady's femininity and the masculine realm of hunting, to which hallooing was appropriate.[78] Far from representing 'a self-limiting decision',[79] the song that follows represents a mustering of the Lady's inner resources. She seeks sustenance from a community of female vocalists: Echo, 'sweet queen of parley' (240), and the 'love-lorn nightingale', Philomel, who 'nightly to [Echo] her sad song mourneth well' (233–4). In my discussion of *Cupid's Banishment*, I showed how the masquing nymphs enlist Philomel as the overseer of their expulsion of Cupid. Precipitating the Lady's encounter with, and capture by, Comus, her song to Echo enacts no such simple victory; instead, the song forms part of the 'dramatization of moral uncertainty and danger' by which Milton questions the philosophical certainties of the court masque.[80]

I suggested above that, in *The Shepherds' Paradise*, Montagu's representation of Echo as an aged male counsellor makes safer – both for the actress and her audience – the potentially scandalous issue of women's sexual desire. Milton, however, is not interested in strategies of avoidance. In her attempt to discover the whereabouts of her brothers, the Lady appeals to tragic women from classical myth: Ovid's Echo, condemned to repeat fragments of others' speech, and Philomel, whose rape by Tereus triggered a spiral of retributive violence which was terminated by her transformation to a songbird. Thyrsis, the Attendant Spirit, will later depict the Lady as 'poor hapless nightingale', summoning overtones of sexual danger buried within the epithet 'love-lorn'.[81] Bereft of her family, and empathizing with Echo, it seems the Lady 'would be content with the protection of invisibility'.[82] But as William Shullenberger argues, the very 'act of singing paradoxically accomplishes the Lady's differentiation from and "translation" of Echo'.[83] Through the beneficent act of 'translation' which the Lady's song envisages, Echo is transformed into a celestial siren, participating in and confirming the cosmic music: 'So mayst thou be translated to the skies, / And give resounding grace to all heaven's harmonies' (241–2). From a personification of 'fragile pathos', Echo becomes 'a newly discovered imaginative and moral resource'.[84]

Critically, this resource remains inward; for in contrast with Bellessa's addressing of Echo in *The Shepherds' Paradise*, the Lady's invocation of Echo receives no reply. The comparison throws into relief what Cedric Brown calls 'the "tragic" novelty of this echo song, in which there is no immediate answer, only . . . the savage irony of being overheard, answered, by the very evil [the Lady] would avoid.[85] Comus's evil, however, is briefly suspended by the Lady's song. He accords the Lady's

'raptures' (246) a transformative power exceeding the sensual captivation of Circe's and the Sirens' insinuating harmonies:

> How sweetly did they float upon the wings
> Of silence, through the empty-vaulted night
> At every fall smoothing the raven down
> Of darkness till it smiled.
>
> (248–51)

The Lady's musical art does not render Comus brutish; on the contrary, her singing moves him to a momentary apprehension of goodness, a 'sober certainty of waking bliss' (262).[86] As befits her status, the Lady denies any sophistication of performance in her courteous rebuking of Comus's idolatrous reaction to her singing: 'Not any boast of skill, but extreme shift' (272) moved her to song. Nonetheless, Comus's wondering response, and Lawes's 'beautifully expressive setting' of the Lady's appeal allow the audience to experience the illusion of 'a soul communing with heaven'.[87]

The beauty of the Lady's song, and its fleeting impact on Comus, foreshadow the special power of music and poetry manifested in Thyrsis's later addresses to the river nymph Sabrina, and in Sabrina's reciprocating song and releasing charm. In its immediate effects, this first encounter between Comus and the Lady troubles the Caroline masque's moral assumptions. Beauty and virtue are not invincible in Milton's masque. While temporarily disarmed by the Lady's singing, Comus regains command through his impersonation of a humble shepherd. Like Eve listening to Satan, the Lady is beguiled through the ear, unable to detect the 'glozing' beneath Comus's 'honest-offered courtesy' (321).[88]

'Vocal and articulate power': the visionary potential of female speech[89]

In her first encounter with Comus, Milton represents the Lady's eloquence as a benign natural force, while also showing that she remains vulnerable to the sorcerer's deceptions. In the scene of her imprisonment in Comus's palace, Milton contrasts the Lady's human weakness with her rhetorical strength. The appearance of the Lady 'fixed and motionless' (818) in the enchanted chair suggests the extent to which she is caught within a controlling dichotomy of virtue as pleasure's antithesis. Her immobility contrasts with the emphasis of the court masque on female motion and movement. Yet Milton gives the Lady a 'motion' of a different sort, in the argument with which she rebuts Comus's insistence that humans should wantonly consume nature's resources. In the

prolegomenon to her oration, the Lady evokes the equation between women's chastity and their silence:

> I had not thought to have unlocked my lips
> In this unhallowed air, but that this juggler
> Would think to charm my judgement, as mine eyes
> Obtruding false rules pranked in reason's garb.
>
> (755–8)

These lines emphasize the Lady's corporeality, 'making it difficult to idealize her virginal body too completely'.[90] Indeed, the lines follow upon Comus's reference to the Lady's physical 'gifts': her 'vermeil-tinctured lip', 'love-darting eyes' and 'tresses like the morn' (751–3). In a context where women's eyes are perceived as Cupid's agents, the Lady's speaking becomes an act of bravery, a venturing of feminine self. Her ringing denunciation of luxury and riot expands the imaginative reach of female eloquence, even while her words fall on deaf ears (but surely not those of the masque's audience). Comus, the Lady avers, 'hast nor ear, nor soul to apprehend / The . . . high mystery . . . of virginity' (783–6).

In the discourse of the Lady, Milton fuses intellectual passion with a young woman's enthusiasm for the Christian notion of chastity as sacred.[91] The Lady's assertion of the immunity of her 'judgement' to Comus's rhetoric highlights the fact that, as portrayed by Milton, her self-definition is anchored in her mind, memory, reason and imagination, rather than in her outward appearance. This confidence in her intellectual identity, together with her conviction of her 'pure cause', fuels the Lady's boast to Comus of the transformative effect of her 'sacred vehemence' should she undertake to convince him of chastity's power:

> Dumb things would be moved to sympathize,
> And the brute Earth would lend her nerves, and shake,
> Till all thy magic structures reared so high,
> Were shattered into heaps o'er thy false head.
>
> (795–8)

Here the Lady's speech takes on the tone of prophecy, a discourse by definition convinced of its own truth.[92] Arguably, the Lady has no need of rhetorical proofs, for her apocalyptic language makes Comus apprehend her higher meaning: 'She fables not, I feel that I do fear / Her words set off by some superior power' (799–800). Comus moves to force the Lady to drink his magic cordial, but his gesture is thwarted by the entrance of the Brothers, who shatter his glass and drive out his disorderly retinue.

At the beginning of their contest, the Lady defies Comus's sexual threats by asserting her spiritual inviolability: 'Fool do not boast, / Thou canst not touch the freedom of my mind' (661–2).[93] Comus's move to overcome the Lady's resistance by force leaves unresolved the troubling question of virtue's 'freedom' in the face of physical assault. Would the Lady's chastity be impaired were she made the victim of Comus's force? Her invocation of cosmic power remains an invocation only: after Comus's escape she is left root-bound and silent, notwithstanding her virtue. Possibly, the Lady's skirmish with Comus has the psychological effect of a physical assault: her immobility and speechlessness suggest a state of trauma, as much as the lingering effect of Comus's charms. While the Brothers' impetuous attack succeeds in driving off Comus and his rout, the release of the Lady from Comus's spell requires the healing agency of the river nymph Sabrina, invoked by Thyrsis in 'warbled song' (853).

Throughout the masque the Lady's isolation is compounded by the masculine gender of her fellow actors.[94] Mitigating this effect, Sabrina's singing, and her sprinkling of pure water drops on the 'Brightest Lady' (909), produce a mirroring of the women as immaculate virgins. Her watery ministrations recall the marine rites prescribed by Aethiopia for the Niger nymphs in Jonson's *Masque of Blackness*. In contrast to Aethiopia as a mediatrix of King James, Sabrina is an emphatically Welsh pastoral genius; swaying 'the smooth Severn stream' (824), she is a presence identified with the Earl of Bridgewater's power. As a 'guiltless damsel' who narrowly escaped her vindictive stepmother's rage, Sabrina is perfectly poised to 'listen for dear honour's sake' (863). Dissolving with her 'chaste palms' the 'gums of glutinous heat' (916–17) which sully the chair in which the Lady sits, Sabrina restores the Lady to her virginal self.[95]

Milton's masque leaves no doubt that the victory of chastity and youthful ardour is a qualified one. Thyrsis's urging of the children to 'fly . . . Lest the sorcerer us entice / With some other new device' (938–40) represents Comus's baits as powerfully tempting and ever-present. Yet the Brothers' ability in disputation, and the Lady's vision of a better ordered society augur well for their moral development. The 'victorious dance' (973) performed by the Egerton children is the coda to a masque whose emphasis is on 'moral struggle rather than courtly resolution'.[96] At the same time, the dance vindicates the children's action, affirming their performance as part of the 'princely lore' (34) in which they have been educated.

CONCLUSION

In her essay on women's roles in court masques from the Jacobean and Caroline periods, Suzanne Gossett interprets *Tempe Restored* as forming the climax and the end of Henrietta Maria's theatrical experiments.[97] My discussion of *Tempe Restored* in the company of *The Shepherds' Paradise* and *Comus* demonstrates instead a sustained exploration of the ramifications of female performers within the genres of pastoral and masque. Both Townshend and Montagu highlight the drama of feminine desire; both writers invest their theatrical works with an element of comedy which derives from the presence of women performers. Together, *Tempe Restored* and *The Shepherds' Paradise* signal an encroaching sexual realism in the English theatre. One consequence of this in Montagu's play is a forensic attention to female discourse and display, the very issues which so agitated Prynne. Montagu uses the concept of 'civility' as a way of circumventing the social prohibition of women's sexual expression. Civility is a key idea in Montagu's play, applying both to the relationship between female sovereign and subject and to that between mistress and lover. Arguably, the notion of civility is implicit in Wroth's Jacobean pastoral in the distinction between the lovers' courteous, accomplished conversation and the lack of those qualities manifested by Rustic. But the absence of the word from Wroth's play points to a difference in sensibility between Jacobean and Caroline court cultures.[98]

I argued that in *Tempe Restored* Circe's emotionalism and her potent theatricality destabilize the masque's moral intentions. In his experimental masque Milton deliberately unsettles the court masque's moral and symbolic framework by limiting the magical efficacy of feminine virtue. The Lady is subjected to Comus's gaze and charms, but the threat Comus poses is offset by the Lady's burgeoning 'vocal and articulate power' which Milton makes an integral part of the masque. In the Lady's impassioned speech, Milton gives a new theatrical embodiment to Jonson's image of naked Truth, whose 'heart shines through her breast'. The Lady's discourse constitutes an expansion of women's intellectual identity, centred in 'a learned Protestant virgin'.[99] These three works, in diverse ways, participate in and promote the debate about female performance that flourished in England in the 1630s. At the same time, they represent new forms of feminine self-consciousness. The extended mapping of female selfhood in Caroline comedy forms the subject of my next chapter.

'Significant liberty': the actress in Caroline comedy

In her study of the impact of actresses upon Restoration drama, Elizabeth Howe concludes that 'the introduction of actresses . . . brought about the stronger expression of an exclusively female viewpoint in comedy'. Lest we automatically align that privileged female viewpoint with women dramatists, Howe reminds us that ' "feminist" writing in the [Restoration] period is by no means limited to female writers'.[1] This book contends that Caroline drama authored by men deserves greater recognition both as spotlighting 'the social relations of women', and for its energetic engagement with the figure of the actress.[2] In the previous chapter I showed how in *The Shepherds' Paradise* Montagu explores the weddedness of theatricality to feminine identity. The play's attitude towards this topic is by no means consistent. In one respect *The Shepherds' Paradise* represents femininity as inherently theatrical by making Bellessa express her love for Moramante through an act of ventriloquism. Yet traces of the ambivalence attached to a feminine theatricality which entails self-concealment hover about the romance between Bellessa and Moramante. Consider this question put by Melidoro to Camena: 'Do you not beleeve . . . that *Bellesa* doth act the Queens part more then her own, in this distancing of her selfe from any sense of *Moraments* love?'[3] Here Montagu spins gentle irony from the situation of coterie performance, the meshing of royal image with dramatic role. Melidoro suggests that in this case, for Bellessa/ Henrietta Maria to 'act the Queen's part' is disingenuous; the Queen is adhering too much to her political persona. His hint of Bellessa's subtlety (in the serpentine sense) is ironed out in Camena's answering praise of the Queen: 'Methinks she hath so equall and significant a liberty, as it speakes all things that she doth naturall, as I beleeve her the perfection of our sex.'[4] Viewed through Camena's idealizing gaze, Bellessa's artfulness (in Melidoro's eyes) becomes a model of decorum and naturalness. Noting that paradox, this chapter will consider the wider resonances of Bellessa's 'equall and significant . . . liberty' on the Caroline comic stage.

79

In the context of *The Shepherds' Paradise*, the 'equal liberty' Camena ascribes Bellessa relates foremost to the ethics of courtship, connoting Bellessa's liberal and generous demeanour towards her admirers.[5] However, the word 'liberty' as used by Camena also harbours political and theatrical dimensions. *The Shepherds' Paradise* dramatizes the distinctive liberty of a female monarch elected solely by women whose laws are intended to protect feminine virtue. The staging of Montagu's play further signals women's seizing of the freedom to act, an 'equal and significant liberty' embodied in the courtier actresses' theatrical performances.[6] These political and theatrical connotations of female liberty coalesce in a passage from Fletcher's comedy *The Wild-Goose Chase* (1621, revived 1632), spoken by Lillia-Bianca, one of the two 'airy' daughters of the French gentleman, Nantolet. Lillia-Bianca apologizes to her suitor Pinac for her earlier impulsive behaviour:

> Some hours we have of youth, and some of folly;
> And being free-born maids we take a liberty,
> And to maintain that, sometimes we strain highly.[7]

Lillia-Bianca posits a connection between her independent demeanour and her status as the daughter of a 'free-born' man, that is, a man possessing land in 'freehold' to the minimum value of 40 shillings, or its French equivalent.[8] (It is clear from the play that Nantolet's daughters are heirs to a rich estate.) This profession of a relationship between women's social privilege and their free behaviour is ironized by the fact that Lillia-Bianca's tritely penitent attitude is a disguise assumed for the end of gaining revenge upon Pinac, as part of *The Wild-Goose Chase*'s 'dance of wit' between the sexes.[9] The liberty which Lillia-Bianca proclaims, and pretends to regret indulging, is embodied by her perpetration of a clever, winning deception upon Pinac.

This example of Lillia-Bianca's theatrical agency accords with Kathleen McLuskie's characterization of the milieu of Fletcherian comedy as 'a world of competitive individualism which was liberating for those women with the wit and the resources to survive within it'.[10] The three Caroline comedies I discuss in this chapter press further the important question McLuskie raises of just how far-reaching the shifts in the representation of women in Fletcherian drama were. The plays expand the potential significance of women's liberty, and theatricality, far beyond the connotative range of those concepts as broached in *The Shepherds' Paradise*. They are Jonson's late comedy, *The New Inn* (1629, pub. 1631), Shirley's sparkling social comedy, *Hyde Park* (1632, pub. 1637) and a little-discussed

tragicomedy by William Cartwright, *The Lady-Errant* (1633–5?, pub. 1651). Each play engages vigorously with issues of power and authority, especially in relation to women's freedom to fashion their identities through performance and role-play. At the same time, these plays raise questions about women's legal and political status in early modern England, the comedies by Jonson and Shirley in particular highlighting women's loss of liberty upon marriage and their dependent status as daughters and wives. In the previous chapter we saw how Milton endows the Lady of his masque with an absolute conviction of 'the freedom of [her] mind'. The strength and variety of female characters in the plays I discuss here form a comic corollary to that certitude. This drama testifies to a newly awakened perception of women's abilities as actors and artists in the Caroline period, and to a fresh valuation of their intellectual and moral qualities.

'THE NEW INN' AND THE PURPOSE OF FEMALE PLAYING

In his late comedy *The New Inn*, Jonson embraces female theatricality as a fertile source of dramatic complication and emotional affect. His engagement with shifting women in this play is apparent in its stunning array of five female roles, all of which involve literal or figurative disguise.[11] A woman's shift lies at the heart of *The New Inn*'s romance plot. The last scene of the play reunites Lord and Lady Frampul, a husband and wife who have been separated for seven years. The cause and circumstances of their separation are differently reported by various characters, but the key trigger is stated by Jonson in 'The Argument', which describes how Lord Frampul, one of many 'green husbands . . . given over to . . . peccant humours', deserted his wife during 'the time of her lying-in of her second daughter'.[12] He spent some time roaming the 'shires of England' (5.5.93) with gipsies and itinerant entertainers before setting up as the keeper of the New Inn at Barnet, eleven miles north of London, where he goes under the pseudonym 'Goodstock'. This male desertion, which initiates the break-up of Lord Frampul's household, points to the unique way that Jonson moulds the materials of Shakespearean comedy which underpin the romantic plot of *The New Inn*. The Frampul family's 'strange division' (1.5.75) is not a catastrophe caused by arbitrary Fortune, the force responsible for the riven families of *The Comedy of Errors, Twelfth Night* and *Pericles*. Instead, Jonson explores the implosion of an early modern family from within. The quitting of wife and children by a diffident patriarch ('The Argument' tells us that Lord Frampul was 'married young',

line 2) is followed by the departure from home of Lady Frances. She is described in 'The Argument' as an 'over-loving wife', whose 'hurt fancy' construes the birth of her second girl as explaining 'her husband's coldness in affection' (lines 7–11). Returning to steal away her younger daughter, Laetitia, Lady Frampul resorts to a drastic shift to ensure her and her child's survival: disguised as a one-eyed Irish beggar, she sells Laetitia as a boy to a charitable innkeeper named Goodstock. Employed by him as the boy's nurse, she later discovers that Goodstock is her truant husband.

One aspect of this scenario which is strikingly Jonsonian is the way that 'humorous' or habitual behaviour is demonstrated as causing considerable frustration and anguish. This insight binds the romantic and realistic parts of the plot, for the paralysed relationship between Lady Frances Frampul and her suitor, Lord Lovel, is due in large measure to each person's perverse enthralment to their egos. A second notable feature of the scenario I have outlined is Jonson's sympathetic focus on the situation of a solo mother warding off poverty. Having divorced herself from both her home and the family income, Lady Frampul clearly encountered the hardship of a 'poor shifting sister'. Her explanation of her actions to her master, Goodstock, is an astonishingly candid voicing of a biological mother's feelings and experience:

> Forgive the lie o' my mouth, it was to save
> The fruit o' my womb. A parent's needs are urgent . . .
> But you relieved her and me too, the mother,
> And took me into your house to be the nurse.
>
> (5.5.20–4)

This speech's juxtaposition of maternal fruitfulness with deceit ('the lie o' my mouth') is echoed by Lady Frampul's subsequent affirmation, when responding to her newfound husband's confession that he had given her up as lost: 'So did I you, / Till stealing mine own daughter from her sister, / I lighted on this error hath cured all' (5.5.108–10). The 'error' to which Lady Frampul refers comprises her absconding with her daughter and her misrepresentation of Laetitia's gender. Her interpretation of her 'error' as a 'cure' is mirrored at large within Jonson's comic plot, which, in an unorthodox show of wish-fulfilment and dramatic engineering, contrives to turn social transgression and sexual inversion into familial and marital harmony. The jury is still out on whether *The New Inn* should be judged an artistic and theatrical success.[13]

By giving the mother who is so absent from the bulk of Elizabethan drama an eloquent voice, *The New Inn* expands the boundaries of

dramatic female subjectivity.[14] The shifts to which the Frampul mother and daughter are put form part of the comedy's broader representation of theatrical femininity. Women's shifting, in the senses of moving from one state to another, and pretending, informs the main action of the play at every point. The process is galvanized by the festivity initiated at the sign of the 'Light Heart' by Lady Frances Frampul and her chambermaid Prudence. Frances is a noblewoman of fortune who arrives at Goodstock's fashionable drinking-house with her train of gallants, intent on passing several days in 'society and mirth' (1.6.37). In a carnivalesque inversion of status, Pru has been elected 'sovereign / Of the day's sports' (1.6.43–4) by Lady Frances and her followers. The subject of female dissembling is raised in Pru's interview with the Host and his melancholy guest, Lovel, in which she invites Lovel to participate in the day's merriment. Lovel refuses on the grounds that Lady Frances 'professeth still / To love no soul or body but for ends / Which are her sports' (1.6.54–6). As the sly coupling of body and soul suggests, Lady Frances has deliberately fash- ioned a risqué public self-image; she is a woman who desires to be noticed. According to Lovel, her habit of surrounding herself with 'a multitude of servants' (i.e., lovers) calls Lady Frances's 'honest[y]', that is, her chastity, into question with 'some prying, narrow natures' (1.5.53–6). Lovel's objection evokes an image of Lady Frances as 'a high-spirited *précieuse*', a woman who adopts 'an intellectual rather than an emotional attitude towards love'.[15] Pru, however, assures Lovel, 'O, Master Lovel, you must not give credit / To all that ladies publicly profess, / Or talk o' th' volley unto their servants: / Their tongues and thoughts oft-times lie far asunder' (1.6.60–3). Jonson here puts a contemporary gloss on the prover- bial idea that 'A woman's heart and her tongue are not relatives'.[16] This idea of a divorce between women's social and inner selves fuels the main action of *The New Inn* in which sovereign Pru institutes a Court of Love where Lady Frances must 'entertain', or engage, Lovel as a 'principal servant' for 'a pair of hours', rewarding his service after each hour with a kiss (2.6.161, 159). Pru participates in these revels as director, actor and judge.

Anne Barton proposes as one of the Shakespearean dimensions of *The New Inn* the way that 'acting converts itself into truth' for the central characters.[17] But there is more at stake than self-realization in Jonson's portrayal of the transaction between actor and audience during the scenes of Pru's Court of Love. The transformations wrought by acting a part are highlighted in the Host's response to Lovel's first oration, delivered in response to his lady's command that he define the nature of love:

all those brave parts of your soul awake
That did before seem drowned and buried in you.
That you express yourself as you had backed
The Muses' horse, or got Bellerophon's arms –
(3.2.266–9)

In the same way that the Host interprets Lovel's 'vively' acting ('The Argument', line 66') as enhancing his prowess and virility, so the Court of Love scenes exploit the notion of a histrionic female personality as a source of dramatic tension and sexual excitement. At a key moment Lady Frances declares herself converted from Love's heretic to his disciple:

How am I changed! By what alchemy
Of language or love am I thus translated!
His tongue is tipped with the philosophers' stone,
And that hath touched me thorough every vein.
I feel that transmutation o' my blood,
As I were quite become another creature.
(3.2.170–5)

This profession draws Pru's knowing plaudit, 'Well feigned, my lady: now her parts begin', to which Lord Latimer, one of Lady Frances's 'servants', adds, 'And she will act 'em subtly' (3.2.177–8). The sympathetic female auditor is a common figure in Renaissance drama: witness Marlowe's Dido moved to pity by Aeneas' tale of the fall of Troy or Desdemona devouring Othello's discourse 'with a greedy ear'. In tragedy, as Marianne Novy points out, the women auditors' role is often confined to 'mediating the offstage audience's sympathy' for the hero.[18] *The New Inn* reflects the greater centrality of women to Shakespearean comedy by focusing on Lady Frances as both auditor and actor.

In the first hearing of the Court of Love, Jonson casts doubt on the authenticity of Lady Frances's response via the remarks of Pru and Latimer.[19] Her metaphor of alchemy expresses the symbiosis beteween actor and audience, the process by which the listening spectator is caught up in, and becomes a part of, the world of performance. This quickening process is visible in the rapt language Lady Frances employs as she begins to relish the role of a lover, showing off her modish reading: 'Who hath read Plato . . . / Sidney, D'Urfé, or all Love's fathers, like him? / He's there the Master of the Sentences / . . . And breathes the true divinity of Love!' (3.2.204–8). At the same time, through the phallic figure of 'the philosophers' stone' Jonson represents Lady Frances's excited responsiveness as irremediably sexual; her 'blood' is suggestively aroused by the finesse of Lovel's 'tongue', which has 'touched [her] thorough every vein'.[20] Her

'greedy ear' is evidenced in her wish to 'let mine ear / Be feasted still, and filled with this banquet', while the ribald connotations of 'the banquet of love' assert themselves in her exaggerated fantasy of performing penance to Venus by offering 'a wax candle / As large as the town maypole' (3.2.200–1, 221).[21] The 'bravery' or histrionic virtuosity of Lady Frances's conversion is marked by Pru's exclamation, 'Excellent actor, how she hits this passion!' (3.2.209).

It is significant that Pru's praise echoes the character of 'An excellent Actor' ascribed to John Webster and published in the sixth impression of Sir Thomas Overbury's *Characters* (1615). Jonson convincingly dramatizes the fluidity between Lady Frances's imaginative and emotional engagement with Lovel's discourse, making her reveal to the audience, 'I could begin to be in love with him' (3.2.232). But at the same time as this private confession suggests the imminent crystallizing of a personal 'truth', the sexual dimension of Lady Frances's performance points up her transgressive encroachment upon the public territory of the male actor. As a way of stabilizing the heroine's modesty, already called into question through her unconventional behaviour, the episode between the first and second hours of the Court of Love presents to the inn's patrons and the audience an unmistakeable actress-whore figure, in Pinnacia Stuff.

Pinnacia focuses the audience's attention on women's shifts in the most literal of senses. Before she appears our attention is drawn to Pinnacia's undergarments by the inn's chamberlain, Jordan, who admires the 'stately gown, / And petticoat' worn by the new visitor (4.1.22–3). The coachman, Barnaby, remarks on Jordan's eye for sartorial detail: 'You're a notable peerer, an old rabbi, / At a smock's hem, boy' (4.1.24–5). The phrase 'smock's hem' represents woman metonymically *as* an undergarment.[22] It emerges that Pinnacia's husband, Nick Stuff, Lady Frances's tailor, has a penchant for dressing his wife in the richest of his clients' garments, then transporting her by coach to various watering holes outside London and making love to her in the garb of the footman. When Pinnacia enters she is clothed in the new suit ordered by Lady Frances for Pru to wear as Queen of the revels, the nonarrival of which furnishes the stagebusiness between mistress and maid at the start of Act 2: as Pru struggles into a substitute gown of her lady's, she is told briskly, 'Thou must make shift with it. Pride feels no pain' (2.1.5).

It is inappropriate pride on the part of the aspiring *nouveau riche* which Jonson satirizes in the Stuffs, together with 'the sexual fetishism of the suburbs'.[23] The topsyturvydom of their marriage is demonstrated by Pinnacia's railing upon Stuff inbetween being fought over by two of the

inn's patrons, Captain Glorious Tipto and Hodge Huffle, and being invited to a room upstairs to meet Lady Frances's company. With an hauteur befitting the title of 'Countess' which she has assumed, Pinnacia orders her husband, whom she names her 'Protection',

> Here, tie my shoe and show my vellute [velvet] petticoat
> And my silk stocking! Why do you make me a lady,
> If I may not do like a lady in fine clothes?
>
> (4.2.85–7)

'Doing' or acting like a lady is the substance of Pinnacia's social transgression, whereby she 'ape[s] the conspicuous display of fine company'.[24] The sexual sense of the verb 'to do' is brought home in her husband's rejoinder, 'Sweet heart, you may do what you will with me' (4.2.88). This indecorous 'doing' is sexual and linguistic: Pinnacia not only usurps the clothes of her social superiors, she dares to speak of sex, describing the 'trick' she performs for her husband with a candour which appalls Lady Frances: 'Peace, thou immodest woman! / She glories in the bravery o' the vice' (4.3.74–5). Latimer's punning quip, ''Tis a quaint one!', demonstrates the extent to which Pinnacia's presence signifies sex, both in her physical bulk – she is described as a 'giantess' and a 'succuba'– and her promiscuous appetite – she tells both the tapster, Pierce, and the Host that she would 'go with' [have sexual intercourse with] them, were they 'a little finer' (4.2.104–5, 109–110).[25]

As theatrical women Lady Frances and Pinnacia differ in degree rather than kind. Indeed, the severity of Pinnacia's treatment is partly explained by the fact that, dressed in what Lady Frances describes to Pru as 'our gown', she presents the female aristocrat with a grotesque mirror image. Pinnacia shares with Lady Frances a reckless linguistic exuberance, illustrated in her explanation of her and her husband's disguises: 'Nay it shall out, since you have called me wife, / And openly dis-ladied me: though I am dis-countessed, / I am not yet dis-countenanced' (4.3.60–2). Each of these boldly verbal women is, in her own way, an actress. But the play's overdetermined designation of Pinnacia as *the* actress-whore signals a concern on Jonson's part to distinguish between the genuine lady and the simulacrum. For, while Lady Frances's coquetry lays her open to scandal, Pinnacia's brazen persona is interpreted by the characters as an infallible sign of her unchastity. Before she has spoken a word, Pinnacia is heralded by 'Quartermaster Fly' as 'a very *bona-roba*, and a bouncer / In yellow, glistering, golden satin!' (3.2.271–3).[26] Both her size and her

garrulity associate Pinnacia with lower-class women, or prostitutes. When she boasts of her dress that it is 'as new as day', Lord Latimer sneers, 'she answers like a fishwife' (4.3.31). The meretriciousness of Pinnacia's imposture is further spelled out in the derivation of her name from 'pinnace', a small boat, or 'a light bark given to sexual deviations from a straight course'.[27] When Lady Frances asks lividly of both the Stuffs, 'what show is this that you present us with?' (4.3.49), her language identifies the inappropriately bedecked couple with the fairground. The Stuffs are served a punishment that aligns them with the common people; Nick Stuff is tossed in a blanket, while at the order of Lady Frances and the Host, Pinnacia is 'stripped like a doxy' ('The Argument', line 94), and sent home in a cart, with her husband beating a basin before her – the treatment allotted to common whores. The episode starkly pinpoints the privilege of Lady Frances in living 'to [no] other scale than what's my own' (2.1.59). In Jonson's world, freedom of action is not open to everyone.

The dismissal of the Stuffs' social pretensions is offset by Jonson's bold elevation of Pru, a menial chambermaid, who at the end of the play accepts an offer of marriage from Lord Latimer.[28] The plot relies upon Pru's 'dexterity and wit' in instituting and overseeing the Court of Love ('The Argument', line 60). Her wise judgement and enforcement of her own decrees earn her the accolades of 'a she-Trajan' and 'a rare stateswoman' from the Host and Lord Latimer (2.6.132, 252). Jonson adventurously locates in a domestic servant what Louis Montrose calls 'a dramatistic conception of [female] life', namely 'the complex, adaptive, or inquiring self, created and discovered in performance'.[29] Pru more than 'makes shift' with her borrowed dress, she comports herself in her new role with dignity and aplomb. Moreover, in addition to affording her this creative impersonation, Jonson endows Pru with a Shakespearean-derived understanding of theatre's potential to illuminate. For, upon discovering the source of Lovel's dis-ease in her mistress's ignoring him, Pru pledges 'to hold the glass up to [Lady Frances], / To show her ladyship where she hath erred, / And how to tender satisfaction' (1.6.76–8). Like Hamlet's account of 'the purpose of playing', the *mise-en-scène* of Pru's Court of Love enables Lovel to display his unrecognized virtue and shows a scornful lady her own image.

Pru's knowledge of matters both intimate and learned proves critical to the plot, and interestingly, proved critical to the contemporary failure of Jonson's play. I suggested earlier that Jonson exploits the theatricality of Lady Frances as a source of dramatic and sexual tension. The dilation

of the comic plot through a 'strategically induced *uncertainty*' was an element of Terentian comedy which Lorna Hutson argues Shakespeare and Jonson appropriated and developed in their comedies.[30] The importance of a space for error in relation to Lady Frances's profession of herself as Love's apostle, rather than his heretic, is highlighted at the end of Act 3 when the Host urges the doubting Lovel, 'Cheer up, noble guest, / We cannot guess what this may come to yet; / *The brain of man, or woman, is uncertain*' (3.2.255–7, emphasis mine). At the end of Act 4, the undecidability of Lady Frances's feelings for Lovel issues in a crisis. The question of whether women speak what they feel, upon which Pru had pronounced so confidently to Lovel, wreaks havoc on the relationship between maid and mistress. After the second session, when Pru pronounces the 'play ended', Lovel is overcome by despair and exits railing at 'the craft of crocodiles, women's piety / And practice of it, in this art of flattering / And fooling men' (4.4.274–6). Pru's failure to perceive Lady Frances's passion for Lovel leads Lady Frances to damn her as an 'idiot chambermaid' (4.4.314). In accounting for her mistress's demeanour to Lovel, Pru had said that women's 'tongues and thoughts oft-times lie far asunder'. Attempting to justify her earlier refractory behaviour, Lady Frances has recourse to the same argument: 'frowardness sometime / Becomes a beauty, being but a visor / Put on. You'll let a lady wear her mask, Pru!' In her defence Pru points to the difficulty of judging the mask: 'But how do I know when her ladyship is pleased / To leave it off except she tell me so?' (4.4.294–8). Through the metaphor of the mask Jonson reiterates the disjunction between women's thoughts and tongues, between subjective feeling and outward appearance. Pru's protest, 'I thought you had dissembled, madam, / And doubt you do so yet' (4.4.311–12), reveals the intrinsic unreliability of those means of 'looks and language' to which Lady Frances appeals when upbraiding Pru for her deficient observance (4.4.299–300). Jonson here 'assigns theatrical femininity a positive value', but from a formalist, rather than a feminist perspective, as a means of complicating and heightening the drama.[31]

It may be a measure of Jonson's responsiveness towards a private theatre audience in which women were newly prominent that he makes female artifice the stuff of an emotive argument between women rather than a witty dialogue between men, as in the earlier boys' company satire *Epicene*. Lady Frances links her refusal clearly to submit to Lovel ('to come in first') to her honour, telling Pru, 'You knew well / It could not sort with any reputation / Of mine to come in first, having stood out / So long without conditions for mine honour' (4.4.303–6). By featuring the

terms 'honour' and 'reputation' in the dialogue between Lady Frances and Pru, Jonson gestures to the prohibitive force of these feminine ideals. This detail of Jonson's characterization foreshadows Restoration drama, where women's appeal to their honour and reputation is axiomatic, and with the growth of satirical sex comedy such as Wycherley's *The Country Wife* (1675), comes to be mocked as hypocritical. There is indeed a disingenuous element in Lady Frances's appeal, not squaring with her professed disregard for the 'prying, narrow natures' whom Lovel earlier describes as querying her honesty. The ambiguity of Jonson's portrayal of Lady Frances culminates in her plea to Pru to bring her together with Lovel, the two women having arrived at an 'uneasy peace':[32]

> My fires and fears are met; I burn and freeze,
> My liver's one great coal, my heart shrunk up
> With all the fibres, and the mass of blood
> Within me is a standing lake of fire
> Curled with the cold wind of my gelid sighs
> That drive a drift of sleet through all my body
> And shoot a February through my veins.
> Until I see him, I am drunk with thirst
> And surfeited with hunger of his presence.
>
> (5.2.46–54)

The speech, with its Petrarchan hyperbole, forms an instructive comparison with Bellessa's descanting on her red and white in *The Shepherds' Paradise*. The sensual language ('liver', 'heart', 'blood', 'body', 'veins') is at once comically demeaning of a lady, and a compelling expression of feminine ardour. Jonson's representation of the 'woman's part' here treads a fine line between sympathy and satire. The tonal instability created by this speech's suggestion of Lady Frances's 'disposition to have sex' is suspended by the onset of the comic catastrophe, as Goodstock announces the mock-marriage of Lord Beaufort to his son.[33]

Criticism of *The New Inn* commonly notes Jonson's redeployment of the romance of origin motif in the confusion surrounding Lady Frances's lost sister Laetitia, whom the audience first sees dressed as the Host's adopted son, 'Frank'. Martin Butler traces the plot's framing action to Terence's *Andria, or The Woman of Andros*, 'in which a lost daughter is hidden under an assumed identity'.[34] Jonson complicates matters by grafting on to his New Comedy source the cross-dressed boy player motif that furnished Elizabethan playwrights with opportunities for ingenious variation, and which he had used to great effect in both *Epicene* and *The Devil Is an Ass*. Moreover, in the figure of 'Frank', as also of Pru, Jonson

draws attention to the all-male stage in a manner that sets off the contrastingly fictive status of the acting by the play's women. On Frank's first appearance, Lovel's servant, Ferret, tells his master that 'he prates Latin / And 'twere a parrot or a play-boy' (1.3.4–5). Frank's verbal facility is instanced by Pru in support of her proposal to dress 'him' as a kinswoman of Lady Frances, both 'to raise a little mirth', and to provide her mistress with a female companion of her own rank during the day's sports. When Lady Frances enquires, 'is he bold enough, / The child, and well assured?', Pru's reply glances at the several levels of playing comprised in the action: 'As I am, madam, / Have him in no suspicion more than me' (2.1.79–81). Within the play both Pru and Frank assume roles apparently at odds with their real natures; but both are also 'play-boys', boy actors impersonating women.

Jonson's use of the cross-dressing device in *The New Inn* stresses the theatrical dexterity of the boy actor but to a far greater extent his own 'sheer dramaturgical ingenuity'.[35] The dressing of the Host's 'pretty boy' as a lady, on whom Lady Frances bestows the name of her sibling, 'Laetitia', perpetrates a double cross-gender disguising. Unlike Shakespeare's handling of Rosalind's disguises in *As You Like It*, Jonson withholds from his audience until the end of the play the knowledge that Frank really *is* Laetitia Frampul.[36] The palimpsest represented by Frank-Laetitia begs the question of sexual identity: after living as Goodstock's son to an age at which she is considered marriageable, does Laetitia feel herself to be that which she is or that which she plays? Tellingly, the question is not one to which Jonson accords any attention. This is because as a figure of mirth, or as Pru says, 'what you will', Laetitia is an embodiment of the 'error' through which Jonson heightens the confusion and mistakings of the plot.[37]

Thus, in the catastrophe, or 'knitting up of everything' ('The Argument', line 100), the emotional ambiguity attached to Lady Frances is displaced by the visual enigma represented by Frank-Laetitia. Jonson draws on the Terentian motif of clandestine marriage in the abduction of Laetitia by the amorous Lord Beaufort, a straying 'servant' of Lady Frances. Beaufort's physical attentions to Laetitia during the Court of Love have drawn protests from Frank's Irish Nurse, Sheelee-nien Thomas, alias the elder Lady Frampul. When the Nurse slips into a drunken stupor, Beaufort seizes the moment to steal offstage with Laetitia, the Host advising him, 'away with her, my lord, but marry her first'. The audience anticipates the hilarity of a same-sex marriage, such as that perpetrated upon Morose in *Epicene*. But after the Host's revelation of Laetitia as his son, the farcical

union metamorphoses into a clandestine marriage, through the Nurse's claim that the shorn waif standing on stage is 'my daughter'. In the same moment, 'Laetitia' proves the shifting sister to Frances Frampul. When Lady Frampul removes the eye-patch she has worn for almost seven years, having vowed 'never to see light / Till such a light restored it as my children' (5.5.78–9), she symbolically dissolves the 'metaphorical "blind spot"' through which Jonson has prolonged the family's misrecognition of its members.[38] As she expresses to her newfound husband, in stealing one daughter from her sister and in disguising that daughter as a boy, Lady Frampul 'lighted on [the] error hath cured all' (5.5.110) To her joy, and the wonderment of the beholders, what seemed a desperate action proves the means of the recovery and reconciliation of her family.

What, then, may we conclude of Jonson's experimentation with shifting women in *The New Inn*? The strongest articulation of female subjectivity in the denouement belongs to the elder Lady Frampul, who, speaking 'as an incensèd mother' challenges Beaufort's equation of her and Laetitia's poverty with 'inherent baseness' (5.5.64, 62), in his attempt to cast his new wife off as a beggar. Laetitia's own feelings on the matter of her marriage to Beaufort remain unspoken.[39] Her sister Frances is similarly silent when her father, Lord Frampul, bestows her upon Lovel. We may read into her silence evidence of a Shakespearean freedom 'to learn from experience, to metamorphose [oneself] and change';[40] her inundation by love induces the 'froward, frampul lady' to feel a sense of humility, and she accepts Pru's advice henceforth to 'use [her] fortunes reverently' (5.2.58). The singing of Lovel's poem, which he calls his 'dream of beauty' (5.5.149), stands in place of a resolution of his relationship with Lady Frances.[41] First read aloud by Lovel to Frances between his two hours of audience, and finally sung by Lovel's boy in the spirit of an epithalamion to 'light us all to bed', the poem is the product of the creative suspense induced in Lovel by Lady Frances's acting. In *The New Inn*, what female acting produces, in one sense, is an enhancement of male poetic accomplishment.

The female character for whom acting does prove transformative in a material sense is Prudence. By renaming as 'Prudence' the character originally called 'Cecily' or 'Cis', Jonson highlights the exceptional qualities of judgement and discretion which equip this chambermaid to play a queen.[42] In contrast with pastoral romances like Shakespeare's *The Winter's Tale*, or Montagu's *The Shepherds' Paradise*, there is no fold in the plot which reveals Pru as the orphan of a prince. By creating her 'egregious Pru' (2.6.158), Jonson gives dramatic embodiment to the 'subversive idea' propounded by Ovid in Chapman's *Ovid's Banquet of Sense*

that 'Virtue makes honour, as the soul doth sense, / And merit far exceeds inheritance.'[43] Pru's merit derives solely from the strong individuality which the Host applauds in his line, 'Still spirit of Pru!' One hopes it is as much for this spiritedness as for 'her virtue and manners' that Lord Latimer offers himself, and his title, to Prudence. It is significant that the same characterization which a modern audience views as progressive clearly lacked credibility for some of Jonson's contemporaries. In his reply to Jonson's 'Ode to Himself', provoked by *The New Inn*'s poor reception at the Blackfriars, Owen Feltham criticized Jonson's 'la[ying] / Before a chambermaid / Discourse so weighed as might have served of old / For schools, when they of love and valour told'.[44] This reaction indicates that Jonson's decision to make Pru a player-queen presiding over a courtly debate was indeed, for its time, a 'significant liberty'.

WOMEN'S WIT AND THEATRICAL PLEASURE: THE AMBIVALENCE OF 'HYDE PARK'

James Shirley has long been recognized as a transitional dramatist, whose comedies of London society anticipate many features of Restoration comedies of manners.[45] In his edition of *The Lady of Pleasure*, Ronald Huebert notes that Shirley's long life (1596–1666) spans the opening of the Swan playhouse in Elizabethan London and the actress Nell Gwyn's infiltration of the Restoration stage.[46] This particular shift, from a theatre of boy actors to a theatre of female performers, is one that Shirley's drama foreshadows. Shirley was sufficiently interested in the figure of the actress to devote a portion of his comedy *The Bird in a Cage* to a representation of women actors that is both mocking and appreciative. The theatrical aptitude of women such as Donella and Eugenia in *The Bird in a Cage* is figured more broadly throughout Shirley's London comedies in women of outstanding wit and moral intelligence – the two qualities not always cohabiting.

In his comedy *Hyde Park* Shirley juxtaposes three women, 'each of whom speaks out boldly in order to assert her identity and values. The most vigorous voice of the three belongs to Mistress Carol, who was described by the Caroline clergyman Abraham Wright as 'an excellent part for a shee-wit, a jesting witty gentlewoman'.[47] Critics and actors have rightly viewed the part of Mistress Carol as 'a link between Beatrice in *Much Ado About Nothing* and Millamant in *The Way of the World*'.[48] Yet Carol's name, which chimes with 'Carolus', the Latin for Charles, marks her out as a distinctive product of the Caroline age. In her satirical mode Carol offers a critical perspective on courtship conventions and the legal

plight of the married woman, or *femme couverte*. Her characterization sits provocatively beside the publication in 1632 of the updated and emended *The Lawes Resolutions of Womens Rights*, which sets out clearly and sympathetically women's status and rights under English common law. The fact that *Hyde Park* was licensed and probably performed in the same year that this important treatise was published shows the topicality of the play's concern with legal issues concerning women.

In Shirley's era the word 'carol' meant not the Christmas song that it commonly designates today, but a dance tune. In medieval times a carol was a ring-dance accompanied by a song, often performed by maidens in springtime. Thus the name 'Carol' additionally conjures up a festive dimension of song and dance, merrymaking and sexual love.[49] This is the spirit captured by the carol 'It was a lover and his lass', sung for Touchstone and Audrey in Shakespeare's pastoral comedy *As You Like It*. Shirley draws upon the festive associations of Carol's name in ways that have gone unnoticed in critical discussions of the play. In *Hyde Park* the comic imperatives of love, sex and procreation are bounded within an urban green world. In the reign of James I, when Hyde Park was both a royal game preserve and an exclusive leisure resort, the park had acquired a reputation as a site for illicit trysts. Shirley draws on this image for the plot in which the gentlewoman Julietta entertains and reforms a lascivious 'sprig of the nobility', Lord Bonvile.[50]

By the 1630s Hyde Park had become associated with the conspicuous self-fashioning of London's leisured gentry and nobility.[51] Shirley's targeting of that elite audience is suggested by the probable timing of his play's production to coincide with the park's springtime opening, and by his dedicating the comedy to the park's noble patron, Henry Rich, Earl of Holland.[52] In the play's third plot, involving the merchant Bonavent, presumed lost at sea, his wife, Mistress Bonavent, and her suitor, Lacy, Hyde Park forms the literal turf upon which the values of gentility and propriety are disputed. Here Shirley dramatizes the role played by women in upholding Caroline ideals of conjugal loyalty and civility.[53]

* * *

The most critical character for a reading of the intersection of female subjectivity with theatricality in *Hyde Park* is Mistress Carol. Her charisma as the heroine of the comedy's main plot is posited in the opening scene when one of her suitors, Rider, compares her to Cleopatra. Brandishing '*a chain of pearl*' at his rival, Venture, Rider declares, 'Were it more rich than that / Cleopatra gave to Antony, / With scorn I would

return it' (1.1.170–2). Rider's gesture prompts the revelation that, in the same way Carol juggled the diamond ring she bestowed upon Venture, so the pearl she bestowed upon Rider was Venture's original gift to her. In a literal 'shift', Carol has turned back on her suitors the ritual of gift-giving which anticipates the exchange of women as commodities in marriage. The 'amorous tokens' by which Rider and Venture sought to buy Carol's favour have been transformed by her into derisory symbols of men's speculation on women as marital prospects. Carol's sleight of hand realizes Venture's description of Carol as a shifting woman at the outset of the play: 'The needle of a dial never / Had so many waverings.' Moreover, her witty jest makes a mockery of Venture's boast to his companion, Trier, 'I am her pole' (1.1.54–5, 57). In this manner the opening scene of *Hyde Park* sets up as a challenge for some winning suitor the heroic task of bringing Carol's infinitely mobile mind to a point of stasis. Carol's subversion of her two suitors' desire to score a public victory over their rival hints at her position as 'the supreme gamester' of the play and whets an audience's appetite to meet a woman of such manifest wit.[54]

The following scene presents Carol in a different guise, as counsellor-orator, to her third suitor, Mr Fairfield, and her kinswoman, Mistress Bonavent. Carol's 'wildness' (1.2.131), or her professed hostility to love and marriage, echoes the satiric stances of Shakespeare's Beatrice, Marston's Crispinella and subsquent 'scornful ladies', but Shirley gives Carol's spurning of Fairfield's suit topical punch through her debunking of his perfunctorily Neoplatonic language.[55] When Fairfield purports to love Carol's face 'as heavenly prologue to [her] mind', she draws attention to his misrecognition of her active intelligence:

CAROL: If it be the mind you so pretend
 To affect[,] my wonder of your folly,
 For I have told you that so often.
FAIRFIELD: What?
CAROL: My mind, so opposite to all your courtship
 That I had rather hear the tedious tales
 Of Holinshed than any thing that trenches
 On love. (1.2.65–71)

Unlike Beatrice, Carol's misogamy does not stem from a wounded heart or a belief that 'men were deceivers ever'. Rather, what Fairfield terms Carol's 'new doctrine' (1.2.85) is buttressed by her belief in what she calls 'the nobleness of [men's and women's] birth and nature', an integrity Carol thinks men abuse by 'servile flattery of this jigging, / And that coy mistress'. Hence she tells Fairfield, 'keep your privilege, / Your masculine

property' (1.2.89–92). In his reading of *Hyde Park*, Butler glosses the word 'privilege' as meaning 'man's freedom to be his dignified self', and suggests further that 'the term "property" here is close to Denzil Holles's notion of "propriety" . . . meaning that which is proper to each man, his by right of possession (with all its attendant political suggestions)'.[56] This political shading to Carol's speech is given added resonance by an exchange from *The Shepherds' Paradise*, which was performed at court the year after *Hyde Park* was licensed for the professional stage. Melidoro and his mistress Camena debate the question of whether marriage entails a form of ownership or 'propriety' which weakens 'Love's prerogative'. While Melidoro maintains that marriage enlarges each partner's self-possession, Camena is wary of the self-loss that 'nuptiall bonds' entail for women: 'I cannot yet resolve to abate soe much from what I love soe well, my selfe, *as to submit to a propriety*'.[57] Montagu's Camena articulates her resistance to marriage in the same politicized language with which Carol deflects Fairfield's courtship. The playwrights' shared focus is on the integrity of feminine and masculine selfhood; Carol tells Fairfield, 'you [men] neglect / Your selves' (1.2.88). The selves in question are differently compromised, however, by men's temporary submissive attitude as servants to a deified mistress, and a woman's permanent subjection to a husband who is both her head and ruler.

The idea of personal integrity and property going hand in hand acquires a feminist emphasis in Carol's speech castigating Mistress Bonavent for her decision to marry the gentleman, Lacy, after she has waited seven years for the return of her husband from sea. Carol's extended admonishment of her cousin, presumed a widow, 'you have / Too, too much liberty' (1.2.167–8), exhibits a satirical vim reminiscent of Marstonian comedy, and consolidates the lawyer's attitude which Fairfield picks up earlier by asking her, 'do you give all this counsel without a fee?' (1.2.130). Indeed, Carol might have been reading 'The Womans Lawier', for her discourse is designed to convince Mistress Bonavent of just how much a gentlewoman in command of her own estate and household stands to lose 'when husbands come to rule'. With a similar intent the author of *The Lawes Resolutions* appeals to wives newly liberated from their husbands: 'Why mourne you so, you that be widdowes? Consider how long you have been in subjection under the predominance of parents, of your husbands, *now you may be free in liberties, and free* proprii iuris *at your owne law.*'[58]

The debate over the respective merits of widowhood and marriage had a complement in literary disputes between figures representing virginity

and married life, as in the dialogue following Jonson's wedding masque, *Hymenaei*. While Carol finds Holinshed tedious, it appears she has a taste for Erasmus, whose colloquy 'The Girl with no Interest in Marriage' (1523) debates the pros and cons of a young woman entering a convent. In the dialogue Catherine is advised by her 'good counseller', Eubulus, to 'consider how many advantages you lose along with your freedom'. The liberties Eubulus describes pertain to a life of domestic female piety, all of which freedoms, he alleges, 'do most to draw you to true godliness'.[59] Carol's berating of her cousin reworks this passage of Erasmus's colloquy in a secular key. In contrast to his devout emphasis, the freedoms Carol spells out for Mistress Bonavent highlight the independent woman's social status: 'you have a coach . . . and a Christian livery to wait on you to church' (1.2.171–2), with religion accorded a suggestively irreverent nod:

> You have the benefit
> Of talking loud and idle at your table,
> May sing a wanton ditty and not be chid,
> Dance, and go late to bed, say your own prayers,
> Or go to heaven by your chaplain.
>
> (1.2.180–4)

Whereas the humanist Eubulus urges Catherine 'to marry a husband of similar tastes and establish a new community at home', Carol's satirical mimicry represents marriage as a constricting prison: 'And will you lose all this? For "I, Ciceley, take thee, John / To be my Husband"?'[60] Conversely, the household made up of the husbandless Mistress Bonavent and her kinswoman Carol takes on the aura of a female utopia. Carol's assumption of the privileged position of good counsellor, and her challenging of Mistress Bonavent's unquestioning acceptance of the marital status quo, trouble the patriarchal order of her society.[61]

The antipathy to marriage voiced by the comedy's most engaging woman character forms a stark contrast to the seriousness with which Christian marriage is handled in the Bonavent/Lacy plot. Unlike Carol, Mistress Bonavent conceives her identity in terms of relationship; thus, while she expresses her willingness to wait a further seven years for her husband were there hope he was still alive, she feels compelled to reward Lacy's constant courtship with her hand. Bonavent's return in disguise allows him to vet his wife's loyalty, and her chastity. In seeking to gauge the latter, he provokes an altercation with Lacy in the park, where Lacy and his bride have gone with their friends to celebrate their marriage. A potential duel is averted by the joint intervention of Lord Bonvile and Mistress Bonavent, who upbraids Bonavent for his 'injurious' action,

invoking the Christian and common law view of man and wife as one flesh or 'one person': 'Could any shame be fastened upon [Lacy], / Wherein I have no share?' (4.3.280–1). In attempting to reconcile the two men, Mistress Bonavent appeals to Bonavent as a gentleman, pleading, ''Las, I am part of [Lacy] now, and between / A widow and his wife, if I be thus / Divorced –' but she is relieved in her distress by Bonavent's promising, 'I'll be his servant' (4.3.329–31).[62] Mistress Bonavent is 'between a widow and [Lacy's] wife' because her marriage to Lacy, solemnized that morning, remains unconsummated. Her plea to Bonavent not to bring about her premature 'divorce' from Lacy by mortally injuring him shows her perception of her identity as deriving from her marital status. Should Lacy die, Mistress Bonavent would be doubly widowed, and – as she has not yet slept with Lacy – wife to no man. Bonavent now has his wife's word (which he lacked earlier) that both her marital chastity, and his personal honour, are unblemished. This explains why he yields to Mistress Bonavent's request that he conclude his differences with Lacy, though it seems likely, too, that he has been moved by his wife's evident distress.[63]

By intervening to stop the men from duelling, Mistress Bonavent performs the role of a peacemaker, restoring the bonds of civility which the culture of *honnêteté* saw women as especially equipped to maintain.[64] At the end of the play, after Bonavent has reclaimed her from Lacy in a theatrical ritual that asserts his preeminence, Mistress Bonavent reassigns her affections to her former husband. There is no reason to disbelieve her final profession of happiness.

* * *

Shirley's social vision thus incorporates the conservative feminism of Mistress Bonavent alongside the satirical feminism of Mistress Carol. The remaining plot of *Hyde Park* expands the intellectual and moral focus of the other two, juxtaposing conflicting ethical conceptions of male and female liberty. Shirley reworks the dramatic convention of the man testing his mistress by having Trier secretly introduce Julietta to the libertine Lord Bonvile as a lady of pleasure. The novel twist is that Shirley affords Julietta reciprocal testing rights. In response to Trier's fifth-act plea that his sexual manoeuvring was 'but a trial, and may plead for pardon' (5.2.22), Julietta asserts her equal right to try, and judge, him: 'I pray deny me not that liberty: / I will have proof, too, of the man I choose / My husband' (5.2.23–5). Her riposte to Trier's assertion that he has found her 'perfect gold' is palpably damning: 'And I have . . . found you dross; nor do I love my heart / So ill, to change it with you' (5.2.9–11).

Julietta's claiming of an 'equal liberty' in her showdown with Trier is of a piece with her formative, extended dalliance with Lord Bonvile in Hyde Park. Julietta parries Bonvile's suave addresses by wielding the terms and values appropriate to her gentle, and his noble, station: 'If I did think your hono[u]r had a thought / To venture at unlawful game, I should / Ha' brought less confidence' (4.1.22–4). It is confidence, melded with 'plain humility' (3.1.8), which Julietta demonstrates in the purposeful *révérence*, or curtsy, by which she attempts to instruct Bonvile of the appropriate distance between them:

> As you are a person, separate and distinct,
> By your high blood . . .
> *Thus low I bend* . . .
> It is my duty, where the king has sealed
> His favo[u]rs, I should show humility,
> My best obedience, to his act.
>
> (5.1.109–18, emphasis mine)

Julietta's curtsy is a gesture that marks her subordinate role within the ordained social hierarchy. In response Bonvile pointedly sexualizes her theme of social obligation: 'So should / All handsome women that will be good subjects'. Julietta's amplification on the theme of virtue redefines Bonvile's notion of a good female subject, building to a ringing assertion of selfhood:

> I must
> Be bold to tell you, sir, unless you prove
> A friend to virtue, were your hono[u]r centupled . . .
> Yet I, I in such infinite distance, am
> As much above you in my innocence.
>
> (5.1.130–40)

Julietta both assumes and defends the liberty of 'speak[ing for her]self' (5.1.141–2). Her pleading for virtue, and herself, is a form of advocacy especially significant in a society where women 'make no Lawes, they consent to none, they abrogate none'.[65] As yet, her rhetoric has little impact; Bonvile offers only a delayed conversion 'upon condition you and I may have / One bout tonight' (5.1.151–2). It requires Julietta's picturing of Bonvile's decrepit old age, and the small comfort offered by the memory of 'the sins of [his] wild youth', to startle the lord into a consciousness of his own degradation: '[*Aside*] If this be true, what a wretched thing should I / Apppear now, if I were anything but a lord? / I do not like myself' (5.1.175–7) Notwithstanding this perfunctory response, Julietta's moral ministry works its effect. Bonvile's reconciliatory

gesture, 'give me thy hand . . . be honest' (5.1.178–9), looks forward to his enlisting himself as a servant to Julietta's virtue 'in noble ways' at the end of the play (5.2.127).[66]

The developing relationship between Julietta and Lord Bonvile explores the tension between women's sociability and their sexual reputations which was at the forefront of Shirley's concerns in comedies such as *The Ball* (1632) and *The Lady of Pleasure* (1635). As principal dramatist to the Queen's Men, Shirley had an interest in representing elite women as persuasive moral agents. Yet as an heir to the Jonsonian tradition of satiric comedy, Shirley was also obliged to scrutinize the deeds and language of men and women with an impartial eye. Notably, in the speech discussed above, Julietta conceives her moral utterance as a new and powerful expression of her identity: 'tis the first liberty / I ever took to speak myself'. The theatricality of her discourse is similar to the performance code governing the Stuart masque where the idealized role customarily affirmed, rather than concealed, the masquer's identity. Shirley juxtaposes Julietta's self-affirmation with the satirical tone of the main plot, in which the subversiveness of Carol's 'new woman' stance is palliated by its being interwoven with a Jonsonian comedy of feminine shifting and dissimulation.[67]

'A very tyrant over men' (Hyde Park, 1.1.53)

From the outset of the play, Shirley politicizes Carol's determined independence. He does this by making Carol avow a libertine creed that privileges sport and gameplaying above human relationships.[68] Presuming to dictate Mistress Bonavent's conduct of her personal affairs, Carol professes absolute power over her suitors in the interests of her own diversion:

> CAROL: Keepe him [Master Lacy] still to be your servant;
> Imitate me . . . I
> Dispose my frownes, and favo[u]rs like a princess;
> Deject, advance, undo, create again;
> It keeps the subjects in obedience,
> And teaches 'em to look at me with distance.
> MISTRESS BONAVENT: But you encourage some.
> CAROL: 'Tis when I have nothing else to do for sport. (1.2.186–94)

Butler uses this passage as a basis for aligning Carol with the court, arguing that her avoidance of commitment 'involves a tyranny of personal will'.[69] But Carol's position is never that fixed. This becomes clear when her tyrannical exercise of her prerogative is countered by Fairfield's imposition of control over her speech and behaviour, in a ruse whereby

he makes Carol swear never to love him, nor to desire his company. Fairfield effects his coup by requesting that Carol 'swear to perform truly what /[He] shall desire', with the proviso that Carol first 'except whate'er [she] would deny [him]' (2.4.63–6). The ensuing listing of liberties by Carol takes on the hue of a petition of female rights. Significantly, the freedom of speech to which Carol drew her cousin's attention features prominently in her catalogue of provisos: 'I will not have my tongue tied up, when I've / A mind to jeer my suitors . . . For I must have my hu-[mo[u]r' (2.4.124–7). Carol's abuse of the right of free expression is precisely the exorbitant humour which Fairfield's 'physic' is designed to 'cure' (2.3.1–3). By imposing on Carol a negative oath, Fairfield binds her to desist from her custom of initiating, and monopolizing, social dialogue. Her confinement to a position from which she is unable to speak to Fairfield, or seek him out, cuts at the heart of her social agency, and she chafes at this restriction in expressly political terms: 'Although I never meant to think well on him, / Yet to be limited and be prescribed, / I must not do it, – 'twas a poor trick in him' (2.4.159–61). In the space of three scenes, the positions of Carol and Fairfield oscillate between the autocracy of an overbearing monarch, and the dependent subject (or constitutional ruler) whose position and rights are circumscribed.

The ramifications of the pact between Fairfield and Carol traverse the brilliantly choreographed third and fourth acts, where the action shifts from the predominantly interior settings of the exposition to the pastoral arena of Hyde Park. Having sworn to heed Fairfield's charge at the end of Act 2, Carol is left wriggling on his hook, unable to shake off her itch to be in his presence. The theatrical pleasure afforded the audience by the spectacle of the female-conqueror-turned-victim is extravagant. At the same time, Shirley nurtures an audience's sympathy for Carol through asides which divulge the keenness of her newly awakened desire: on the first occasion when she sees Fairfield in the park with a woman she does not know (in fact, his sister, Julietta), 'Keep in, great heart'; and a little later, 'I must speak to him, / To ease my heart; I shall burst else'(3.1.142, 181–2). The hauteur which formerly allied Carol with Cleopatra has become akin to the consuming passion of Antony in Shakespeare's tragedy, which threatens to burst his constraining armour. As in Shakespeare's play, these hints at the poignancy of Carol's feelings tread a fine line between emotional intensity and burlesque. This affective quality was expertly captured by Fiona Shaw in the production of *Hyde Park* by the Royal Shakespeare Company in 1987. Shaw played Carol as a Bloomsbury-inspired new

woman, her touch of Woolfian camp perfectly matching the histrionic edge of Shirley's character.[70]

Shirley thus limns a dimension of female subjectivity by laying bare to the audience Carol's concealment of her embryonic love for Fairfield. Subsequently, the concept of disguise becomes the focus of the interview Carol engineers with Fairfield after spotting him in the park with Julietta. Shirley whets the audience's appetite for Carol's potential humiliation by showing her momentary discomfiture on being left alone with Fairfield: 'I am ashamed to think what I must say now' (3.2.12). The possibility of Carol losing face is frustrated, however, by her lightning-quick denial that she summoned Fairfield, which she caps with some thrilling mimicry, ridiculing Fairfield as a despairing lover. Carol's affected outrage provokes Fairfield to accuse her of overacting:

> O woman!
> How far thy tongue and heart do live asunder! . . .
> A little peevishness to save your credit
> Had not been much amiss, but this over-
> Over-doing the business, – it appears
> Ridiculous.
>
> (3.2.51–9)

Fairfield's berating of Carol pivots on the same point that Pru drives home to Lovel in *The New Inn*: 'women's tongues and thoughts oft-times lie far asunder'. However, as we saw, Pru's conspiratorial wisdom about the female psyche is undermined by her inability to recognize Lady Frances's sincere profession of love. In *Hyde Park* the dramatic cliché of women's dissembling is similarly troubled by Fairfield's disingenuousness. For, having accused Carol of overacting, Fairfield goes on to suggest that, after all, a soupçon of bashfulness is desirable in women.[71] Fairfield's speech enacts a conventional gesture of unmasking that panders to male fantasies of knowing women to the core: 'Come . . . off with this veil . . . I do tell thee, / I see thy heart, and every thought within it.' He ends with patronizing forgiveness, 'wenches must ha' their ways' (3.2.53–5, 62).

This initial clash of wit between Fairfield and Carol burgeons in the rest of the scene into a virtuoso struggle for power. The theatrical gameplaying of these two characters is so acutely drawn that even the apology for acting which Carol offers in response to Fairfield's upbraiding her may be yet another shift.[72] The issues of female autonomy, and the conscious performance of self converge when Carol volunteers to contract herself to Fairfield in front of a witness. Her offer proves a ruse, for when

Fairfield produces his friend, Trier (whom he had hidden as audience to the encounter), Carol blasts Fairfield's expectations of victory by inexplicably asking Trier how much money he wishes to borrow. Carol's posing as a creditor shows off her independence as a woman of means; her monies, she tells Trier 'are all abroad, yet, upon good security . . . I will speak / To a friend of mine', and she offers Trier 'fifty pounds for forty weeks' (3.2.110–15). Carol's demonstration of her solvency may reflect women's active role in credit networks in early modern England.[73] When viewed in the light of her earlier warning to Mistress Bonavent about a wife's lack of legal redress after marriage, this display of self-sufficiency – in place of a betrothal – appears a calculated gesture warning Fairfield against abusing the future 'privilege' he will enjoy as Carol's husband. In Act 1, scene 2, Carol had cautioned her kinswoman:

> You will join issue presently, without your council,
> You may be o'erthrown; take heed, I have known wives
> That have been o'erthrown in their own case, and after.
> Nonsuited too, that's twice to be undone.
>
> (1.2.160–3)

This passage puns cleverly on a wife's 'join[ing] issue' as signifying both joining together with her husband in marriage, and in the marital bed, and becoming joint opponents in a law suit. Carol hits on the crucial weakness of wives' legal position in the phrase 'without your council / You may be o'erthrown', referring to the inability of English women to sue in their own name under the law of coverture. Owing to coverture, a wife had no rights independent of her husband, and therefore could have no independent legal 'counsel'.[74] The equation between the legal act of 'nonsuiting', and women's 'undoing' or rape by the masculine law, powerfully drives home the legal vulnerability of married women.[75] The speech provides a critical insight into women's legal predicament, in language that is rife with sexual innuendo: 'o'erthrown', 'nonsuited', 'case', 'undone'.[76] Such ambivalence highlights the difficulty of claiming for Shirley's drama any form of 'protofeminism', or empathy for women, when Carol's mode of assertiveness is overlaid with sexual meanings aimed at men's theatrical pleasure.

Mistress Bonavent opts not to heed Carol's advice, marrying her suitor Lacy later in the morning. Under the law of comedy, Carol, too, must eventually dispose of herself, and her property, to Fairfield. But at their meeting in the park she is at pains to drive home to Fairfield the unreasonableness, and the unattractiveness, of his presuming ownership

of her – what Camena, in *The Shepherds' Paradise*, terms a 'propriety'. Hence Carol's goading mimicry of Fairfield's triumphalism, after Trier has exited in scorn: 'You know my heart, and every thought within it! . . . do I not melt like honey / I'the dog-days?' (3.2.122–4).

The scene ends in an emotional impasse when Fairfield, intent upon leaving, shoots at Carol, 'y' are a fine may game' (3.2.145). His metaphor expresses the souring of the festive raillery in which Carol has indulged, and marks a shift in tone on Fairfield's part, from good-humoured toleration of Carol's abuse, to disillusionment. Locked in her jeering mode, Carol finds herself hamstrung amid emotive language she has hitherto disdained: 'I shall fool too much . . . by all the faith and love of womankind, / Believe me now – [*Aside*] it will not out' (3.2.146–8). Unlike Julietta, who frankly 'speaks herself' to Lord Bonvile, at the critical moment when Carol would 'fain speak kindly to [Fairfield]', she is without words (3.2.142). Her speechlessness acquires a poignant symbolism when the play's springtime setting intrudes in the form of a nightingale's call. In responding to the bird, Carol seeks to assuage the hurt she has done Fairfield: 'Hark, sir, the nightingale; there is better luck / Coming towards us' (3.2.150–1). Fairfield's derisory reaction lumps Carol and the bird together as 'talking' creatures, and opens up a vein of sexual aggressiveness usually reserved by Shirley for his tragedies: 'stay you and practise with the bird; / 'Twas Philomel, they say; and thou wert one, / I should new ravish thee' (3.2.156–8). His menacing allusion to Philomel calls up the image of the raped and tongueless woman of classical myth whose muteness is reborn as the songbird's eloquence.[77] The bird imagery also calls to mind a further meaning of the noun 'carol' as the joyous warbling of birds (*OED* 2). Shirley plays against this meaning of Carol's name by having her depart the scene in the direction of her coach, where she goes to weep, a response brought about not just by the thought that she may have lost Fairfield, but by the harshness of Fairfield's verbal violence.

THE PERFORMANCE OF FEMININE DESIRE IN STUART COMEDY: READING FORWARDS

While Carol's wildness has free rein in the play, her coltish habit of breaking away is finally curbed in her concluding interview with Fairfield, where she is pricked to confess her love by Fairfield's threat to geld himself. Clearly Carol is more interested in Fairfield's 'masculine property' than she

initially lets on! Shirley's scripting of Carol's speech after her declaration, 'I do love you', is instructive (5.1.287).

> My thoughts
> Point on no sensuality; remit
> What's past, and I will meet your best affection.
> I know you love me still; do not refuse me.
> If I go once more back, you ne'er recover me.
> (5.1.294–8)

The difference between Carol and Cleopatra, to whom Rider compared her, could not be more striking. While she shares the Egyptian Queen's histrionic caprice, Carol's love comes modestly girded. In marked contrast with the comedies of Montagu and Jonson I have discussed, in Shirley's comedy for the public stage feminine sensuality is suppressed in the interests of decorum. The ideal union in *Hyde Park* is chaste and witty, with the volatility of a horse race and the elegance of a dance.

<p style="text-align:center">* * *</p>

I have been arguing that the figure of Carol combines female autonomy with a compulsive theatricality, and that this heady mix is a response to contemporary perceptions of women in Caroline England. At the same time, Shirley provides glimpses of Carol's subjective consciousness – her desire – which are marked as authentic, and work to draw an audience's sympathy. We have seen that the image of the mask is fundamental to Lady Frances's and Carol's feminine identities. The mask, both literal and metaphoric, forms a central motif in subsequent representations of witty women in Restoration comedy, such as Etherege's Harriet and Congreve's Millamant. In *The Way of The World* the adulteress, Marwood, delivers a speech to Millamant which engages many of the theatrical tropes I have explored in this chapter. Her worldly perspective, tinged with sexual jealousy, demonstrates a key difference between the early Stuart public stage, and a theatre in which women's roles were performed by women. Marwood responds to Millamant's wishing that, like worn clothing, a lady could dispose of fools to her chambermaid:

'Twere better so indeed. Or what think you of the Play-house? A fine gay glossy Fool, shou'd be given there, like a new masking Habit, after the Masquerade is over, and we have done with the Disguise. For a Fool's Visit is always a Disguise; and never admitted by a Woman of Wit, but to blind her Affair with a Lover of Sense. If you wou'd but appear bare fac'd now, and own *Mirabell* . . . for the

Town has found it: the secret is grown too big for the Pretence: 'Tis like Mrs. *Primly's* great Belly; she may lace it down before, but it burnishes on her Hips.[78]

Marwood's variation on Millamant's fanciful conceit echoes an exchange between Lady Frances and Prudence in *The New Inn*, in which Lady Frances advises Pru to pass on to the players the dress she borrows from her mistress to play the queen: "Twil fit the players yet / When thou hast done with it, and yield thee somewhat' (2.1.35–6).[79] But at the same time that Congreve reworks the feminine tropes of Stuart comedy, Marwood's likening of Millamant's desire to 'Mrs. *Primly's* great [pregnant] Belly' belongs to an altered public theatre where the actress's body and sexuality are visibly present on stage. Such a vivid representation of female desire, and its outcome, could only be spoken by a carnally knowing woman like Marwood, whose character is irrevocably tainted by her sexual actions. The women who intend to survive in Restoration drama, and who are held up for the audience's admiration, must suppress their physical passions and practise emotional containment. To a greater degree than Shirley's Carol, when speaking of love to men, 'modesty forbids / [They] should use many words' (5.1.289–90). So Millamant expresses her ardour not to her lover, Mirabell, but, ironically, to his former mistress, Mrs Fainall: 'If *Mirabell* shou'd not make a good Husband, I am a lost thing; – for I find I love him violently.'[80] Millamant's 'a lost thing' is as stark a definition as one may find of a seventeenth-century woman trapped in a loveless marriage. Poised to 'dwindl[e] into a Wife', as Mirabell puts it, Millamant makes light of the role's restrictiveness: 'my dear Liberty, shall I leave thee? . . . must I bid you then Adieu?'[81] The subject of women's liberty could be invoked with such insouciant irony only in the wake of its contestation in comedies like *The Shepherds' Paradise* and *Hyde Park*.[82]

'THE LADY-ERRANT': THE ACTRESS AS POLITICIAN

The New Inn and *Hyde Park* are comedies which reflect the social ascendancy of women within Caroline culture, yet each of them illustrates this theme's satirical scope. The writing of the poet, playwright and Anglican divine William Cartwright similarly shows the tonal variety which could inform a royalist outlook. In *Theatre and Crisis* Butler analyses Cartwright's *The Royal Slave* (1636) as part of a school of romantic Platonic drama encompassing plays as various as *The Shepherds' Paradise* and Massinger's *The Bashful Lover* (1636). Butler finds that

Cartwright's treatment of Platonic love in *The Royal Slave* yields 'surprisingly democratic implications', as well as an emphasis on female heroism and women's political strategizing.[83] Upon its first performance by students during a visit of the King and Queen to Oxford, *The Royal Slave* won especial favour with Henrietta Maria, who requested a repeat performance by the King's Company at Hampton Court.[84] Yet Henrietta Maria's approval of Cartwright's play need not betoken his exclusive identification with her religious and political concerns. As well as addressing poems to the Queen, Cartwright penned a panegyric to her political rival, Lucy Hay, in which he images her as a '*Heroïna*', and asserts that 'in your great Endowments Church and Court / Find what t'admire'.[85] His scepticism towards the Queen's fashions generated one of his best-known lyrics, 'No Platonic Love'. The play I discuss in this section, *The Lady-Errant*, bears out Cartwright's penchant for satire in its parody of the martial woman, and the sabotaging of a feminist insurrection by women themselves. In this play women are associated both with the subversive potential of plot and intrigue and with its conservative, ordering power. In debating women's relationship to power and political authority, *The Lady-Errant* opens up a rich vein of topicality, and, as a tragicomedy, manifests 'a relation to the future as well as to the past'.[86]

* * *

One of the ways *The Lady-Errant* manifests a relationship to the future is in its vindication of women's theatrical performance. Evidence for this derives from the prologue, which indicates that the original production was distinguished by its unusual distribution of parts:

> Yet if you will conceive, that though
> The Poem's forc'd, We are not so;
> And that each Sex keeps to it's Part,
> Nature may plead excuse for Art.
>
> As then there's no Offence
> Giv'n to the Weak or Stubborn hence,
> Being the Female's Habit is
> Her owne, and the Male's his . . .
>
> (21–8)

Uniquely among Caroline drama, these verses refute the 'Weak or Stubborn' opponents of female actors, such as William Prynne, by arguing for the naturalism of mixed-sex performance. The natural ordering of parts between men and women gestured at here is plausible in the context

of an elite private staging of Cartwright's play. This is supported by a reference to the 'Presence . . . [of] choice Beauties' in the second stanza, which envisages the audience as an alternative court: 'it may under Question fall, / Which is more Court, This, or *White-Hall*' (10–16). Reading the prologue in conjunction with the epilogue's braving of the pastoral prowess emanating from 'the Neighbouring Plain' (1), G. Blakemore Evans construes the play's mode of performance as an intended corrective from the Oxonian Cartwright, directed at the Queen's gender-bending performance of *The Shepherds' Paradise*, written by the Cantabrigian Montagu. Blakemore Evans suggests a date of between 1633 and 1635 for *The Lady-Errant*, when the prologue's topical allusions 'might still be fresh enough to be caught by the audience'.[87]

This hypothesis of a provenance for *The Lady-Errant* is all the more attractive in light of the play's satirical theme, which is sexual subversion. Cartwright's prologue points a contrast between the absence of transvestism in performance, and the transgressive aspect of the play, the comic plot of which depicts women aspiring above their sex in an effort to usurp power from men. By distinguishing between the perverse content of the play, and its unforced presentation – 'The Poem's forced, *We* are not so' – the prologue states loudly that here there is no erring in the acting. In this performative stance *The Lady-Errant* legitimizes the woman-actor *who keeps to her part*, while the action of the play silences her symbolic threat.

A genuine threat to patriarchal order is patently not presented by the titular heroine, Machessa. Her character is a burlesque of virgin knights such as Spenser's Britomart in *The Faerie Queene*, and perhaps owes something to Beaumont's grocer-errant, Rafe, from *The Knight of the Burning Pestle*, whom she resembles in her enthralment to 'fancy'. The etymology of her name suggests a female warrior, from the Latin 'machaera', meaning 'armed'.[88] Accoutred with a helmet, scarf, falchion and lance and accompanied by the pint-sized Philaenis as her page, Machessa has two ambitions: to 'disobleige [her] Sex' (419) from knights-errant by rescuing men in distress, and to achieve the title of Queen of the Amazons. In pursuit of the latter aim she is enlisted by 'Three busie factious Ladies' ('The Persons') in an attempted *coup d'état* while the men of Cyprus are away fighting a war with the Cretans. In the event the wily Eumela, acting for the Cyprian Queen and Princess, dissuades Machessa from assisting the rebellious women and confounds the plot by sending the rebels' contributory wealth to the King and his army in Crete.

Notwithstanding the female faction's defeat, a bias towards women's interests in *The Lady-Errant* is signalled by the dominance of female characters (of the nineteen named characters, ten are women) and the sophisticated antagonism between the sexes. Unusually for Caroline drama, the action opens upon three female courtiers, Cosmeta, Pandena and Rhodia, '*busily discoursing in the Myrtle Grove*'. Karen Newman writes of 'the talking woman' in English Renaissance culture that 'whenever women's talk removed to public spaces it became a threat . . . it became dangerous, even seditious'.[89] Here the subversive aspect of the trio's conversation is highlighted by its taking place against the pastoral back-drop of a 'Myrtle Grove', the plant sacred to Venus. These factious ladies are talking of politics, rather than love, which the play marks out as women's proper sphere. With the entrance of three male courtiers whom the Dramatis Personae describes as 'left at home', we witness a battle fought out between men and women in language. Wishing to secure their support for the female plot, the women move aside to eavesdrop on the men's conversation. As Rhodia predicts, the men talk of women, specific-ally the female population's desperation for male company. When the men's slanders implicate the eavesdropping women personally, the trio come out into view, upbraiding the courtiers for cowardice in staying home and avoiding military conflict. The men retaliate by deflecting each conversational gambit of their opponents with insinuations of the wo-men's sexual desire: 'say what e're you will / You shall not reason me to your Bed-side' (143–4). Cosmeta accurately analyses this rhetorical strat-egy as the men verbally 'discharg[ing] the sin on us' (150), or as Rhodia elaborates:

> You're got
> Into a safe field of Discourse, where you
> Are sure, that Modestie will not suffer us
> To answer you in a direct line.
> (167–70)

These opening scenes of *The Lady-Errant* depict the instrumentality of language in the battle for power between the sexes. To speak directly of sex is offlimits for women; therefore the men can thwart the women's superior arguments, their 'reason', by descending to sexual innuendo. If speech is dramatized by Cartwright as a battleground, so, too, is written discourse. The possession or lack of literacy is highlighted in Cosmeta's enumeration of women who have subscribed to the 'Rowl of the Asserters / Of Female Liberty' (273–4), a stage prop which the actress '*puls out*' and

flourishes before her companions (29.1–2). The list includes court ladies, country ladies, city wives and 'Countrey Gentlewomen, and their eldest daughters, / More than can write their Names' (36–7). In marked contrast to those illiterate, but still assertive women, Cosmeta threatens to use writing and poetry as offensive weapons to ensure the men's submission to the 'Female *Covenant*': 'we will . . . write Satyrs, and make Libels of 'em, put 'em / In Shows, and Mock-Shows, Masques, and Plaies, present 'em / In all Dramatique Poetry' (205, 199–202).

This invocation of a vigorous female literary culture is one of the forward-looking features of *The Lady-Errant*. The years 1640–60 saw a marked increase in the number of women making use of the medium of print, either in literary publications or to express religious and political opinions.[90] This 'enhanced female self-confidence' may be seen variously in Katherine Philips declaring of a political enemy in a poem addressed to her husband, 'Let verse revenge the quarrel'; in the polemical pamphlet *The Women's Sharp Revenge*, described on the title-page as '*performed* by Mary Tattle-well and Joan Hit-him-home' (1640); or in 'the increasingly large and militant groups of women who petitioned Parliament throughout the 1640s and early 1650s'.[91] Women Levellers petitioning for the release of John Lilburne in 1649 were described in language which echoes the title of Cartwright's play: one newswriter dubbed them 'the Ladyes-errants of the Seagreen Order'.[92] In the female characters' calculated use of poetry and theatre, *The Lady-Errant* both reflects and anticipates a world in which women's literacy functions as a means of cultural and political empowerment.

Contrasting with the factious ladies, the role of Eumela exhibits the proper agency of women in romantic and political intrigue. Her acting is ambiguous, for she moves between the comic and romantic plots, 'mingl-[ing] Counsels' with both loyal and rebellious parties (538). As confidante to Princess Lucasia she is asked by her lover Olyndus to convey a letter from his Cretan friend Charistus to Lucasia 'with all the speed and secrecy you may' (369). In this respect Eumela functions as an agent of Venus, the deity of Cyprus, who, with Apollo, presides over the play's action. As a tactician Eumela achieves success through her mastery of rhetoric. We hear her in operation in a scene where the women of Cyprus are represented 'sate as at Parliament' (4.1.02). As 'Mistris Speaker', Eumela supplies proofs supporting the opening address of Queen Adraste, in which, pretending to advance the women's plot, Adraste urges the Cyprian women to 'Assert your selves into your Liberty' (1196). In her oration Eumela derives women's political astuteness from their acting ability, or skill in the cosmetic arts:

He that saies Woman is not fit for Policy,
Doth give the Lie to Art; for what man hath
More sorts of Looks? More Faces? Who puts on
More severall Colours?

(1214–17)

In her immediate situation of affecting allegiance to the female cause, Eumela exemplifies her own argument. She displays the histrionic flair that Queen Adraste accords women collectively when she addresses the female parliament with the words, 'My Lady Martiall [a nod to Machessa] and the rest *Mercuriall*' (1163). As the god of thieves Mercury was associated with oratory and deceit; the epithet 'mercurial' summons up the qualities of quickwittedness and instability that Eumela claims for women as a sex: 'wee'l now / Shew [men] our Passions are our Reasons Edge, / And that, which they call Lightness, only is / An Art to turn our selves to severall Points' (1227–30). This 'Art' is deftly exhibited in Eumela's reasoning with Machessa to bring her over to the Queen's side. She allays Machessa's concern that sabotaging the subversive plot entails breaking her faith to Cosmeta and her companions by insisting that, while it may be against Machessa's Order to deceive, ''tis more against your Order to assist / Rebellious Persons 'gainst their King' (1384–5). Eumela further appeals to the integrity of Machessa's self-definition:

Doth not your Oath enjoyn you to relieve
Distressed men? Who more distressed now
Than is the King, and th'Army? *fear not words;*
You are not Treacherous unto them, but *faithfull*
Unto your self.

(1386–90, emphasis mine)

In treating words as a pliable medium, Eumela shows her kinship with shifting sisters such as the adulterous Alice Arden in *Arden of Faversham*, who tells her lover Mosby, 'Oaths are words, and words is wind / And wind is mutable.'[93] But where Alice's duplicity leads to her death, *The Lady-Errant* celebrates Eumela's theatrical aptitude, representing it as one aspect of her loyal political 'service' (1887). Cartwright's innovative characterization of Eumela shows that female imposture and rhetorical contrivance may be represented as licit or illicit depending on the ends to which they are directed.

This proposition is substantiated by the play's consistent condemnation of the histrionic abilities of the factious ladies. Their 'busie' nature is accompanied by the pride, vanity and surreptitious lust that misogynist discourse attributes to the talking woman. The trio's subversive femininity

is clinched in an exchange with the loyal male courtiers masquerading as Cretan 'embassadours', prior to the courtiers' discovery of the news that the King has landed. When Cosmeta expresses surprise that the Cretan state cannot furnish 'three Female Agents', Iringus explains his master's reluctance 'to commit / His Kingdom's secrets to a peece of Chrystall; / That were not to Negotiate, but Betray' (1995–8). The chrystal metaphor suggests the idea of woman as man's mirror, and the weaker vessel: frangible, and hence leaky.[94] Rejecting Iringus's insinuation that women will leak state secrets, Pandena retorts, 'You shall meet Women here, that are not Chrystal, / Those that will find out you, and hide themselves' (1999–2000). This particular image of woman as probing and self-concealing is negatively weighted, for in Pandena these traits are allied with treasonous intentions. However, such 'Silent, and Close' (1899) behaviour is vindicated in Eumela's withholding from Queen Adraste her knowledge of Lucasia's growing love for Prince Charistus of Crete. When Adraste objects to Eumela, 'you ne'r knew / That I destroy'd true vertuous Loves' (1890–1), Lucasia defends her friend, adducing ''tis more Injustice / To betray secret Love, than to make known / Counsels of State. *Cupid* hath his Cabinet' (1901–3).

Even as Lucasia's defence posits the sphere of love as transcending politics, her juxtaposition of the two realms bespeaks their interconnectedness. Cartwright's play shares the humanist aesthetic of court masques scripted by Jonson, Davenant, Carew and Townshend in which the language of love and marriage provides a pattern for political relationships.[95] In the final scene King Dinomachus of Crete asks Apollo's forgiveness for misinterpreting his oracle, and declares that what the god spoke, '*Venus* hath perform'd' (2102). Dinomachus attributes the peace between Cyprus and Crete to the romantic union of the two heirs apparent, Charistus and Lucasia. In the Cyprian King's confirmation of that view – 'Affection brings about / What Counsell cannot' (2107–8) – we glimpse an attitude to political conflict that culminates in the wishful thinking of the last Caroline masque, Davenant's *Salmacida Spolia*.

Thus far I have dealt with the political threat posed to the Cyprian monarchy by the factious women. The romantic plot counterpoints this threat to the state by representing, in Aristotelian fashion, disruptions within the 'little state of man'. In their personal relationships Eumela and Lucasia act as moderating influences, working to effect emotional harmony. On first receiving the letter of Charistus, who has defected from the war in order to see her, Lucasia tells herself, 'I must refine his Passion' (604). Using Olyndus as her emissary, Lucasia tells Charistus he must

return to Crete and 'do Honourably' in the battle of their two countries: 'Get him a Name, and Title upon *Cyprus*' (815, 818). When Charistus hears that Lucasia has appointed Olyndus her proxy-lover, he conceives a jealousy which issues in 'an ornamentally bloody encounter', after which the two friends '*lye groveling, and embracing*' (1012.1).[96] The men's conflict fires a dispute between Lucasia and Eumela over the worth of their beloveds, each of them decrying her lover's opponent as ignoble. In the course of the argument, Eumela claims a significant freedom of speech, challenging Lucasia's assertion that Charistus is 'fairer' because he is loved by a princess:

> I must
> Tell you that Love's a Princess too in me,
> And stamps as much Heroick Majesty
> Upon my Thoughts, as Birth hath done on yours.
>
> (1094–7)

Appealing to Nature, Eumela represents Love as a levelling power who effects an equality among lovers, irrespective of 'Births, / Fortunes, and Titles' (1115–16). Eumela's conviction means that for a moment she fails to recognize Lucasia's political authority: when Florina admonishes her, "Tis the Princess speaks', Eumela rejoins, 'Nor Prince, nor Subject speaks, but Love in both' (1120).[97]

Eumela's boldness in challenging her royal mistress is vindicated when in the next scene Lucasia reveals herself persuaded of Eumela's argument. While Eumela asks Lucasia to impute her folly to her passion, Lucasia replies:

> Call't not Passion,
> 'Twas Reason to Contest: Love's Kingdom is
> Founded upon a Parity; Lord, and Subject,
> Master, and Servant, are Names banish'd thence;
> They wear one Fetter all, or, all one Freedom.
>
> (1149–53)

Lucasia, therefore, has been convinced by Eumela's vision of love as sufficiently strong and magnanimous to eliminate distinctions of rank. Eumela's persuasive efficacy typifies the 'moderate . . . feminism' associated by Erica Veevers with *honnête* writers, and the court plays sponsored by Henrietta Maria, such as Cartwright's *The Royal Slave*.[98] In the romantic plot Eumela's histrionic agency works in the interests of a love conceived in terms of 'reall friendship' between men and women (242). The play foregrounds Eumela's artistic abilities in the form of music,

poetry and theatre: in Act 1, scene 4 she sings an ode to her lute to cheer the spirits of two exemplary ladies, 'sadly bearing the Absense of their Lords' ('The Persons'). The same ladies complain of Eumela's theatrical hoaxes:

> Thy bringing in my Father's Dwarf
> With Bow and Wings, and Quiver at his back,
> Instead of *Cupid*, to conveigh us Letters
> Through th'Air from hence to *Crete* was but a trick
> To put away our sadness.
>
> (319–23)

Later, in a reprise of Paulina's presentation of the statue of Hermione in *The Winter's Tale*, Eumela surprises the grieving ladies by revealing statues of their lords that prove flesh and blood. Her homespun theatre is indebted to Shakespeare, and the Stuart masque.[99] While the play condemns the factious women's plotting, it condones, even promotes, Eumela's rhetorical and theatrical talent. This is because her artifice is harnessed to such laudable ends as aiding the path of romantic love and averting treason. The play thus reiterates the gesture of the prologue, which presents 'natural', mixed-sex performance as offsetting the political transgression of women within the text. Eumela represents those ladies 'that would willing / Keep their own Sex and not turn Lords' (220). Her 'keeping her part' functions as a reproof to the actresses who impersonated men in Montagu's pastoral, and to intrepid women who extended this symbolic sexual inversion further into the seventeenth-century world.[100]

CONCLUSION

All three of the comedies I have considered in this chapter represent theatricality as a crucial component of women's identity. Feminine theatricality is doubly productive in Caroline drama: the female characters' manipulation of language functions both as a means of self-empowerment and a source of dramatic instability. Taken together, the plays envision an expansion of women's social and political agency, whether it be in Jonson's portrayal of the chambermaid Prudence as a 'rare stateswoman', in Carol's trenchant criticism of patriarchal marrige, or in Eumela's rhetorical prowess as 'Mistris Speaker'. Rather than using a gathering of women as an excuse to satirize their reputedly boundless sexual appetite,[101] Cartwright's female parliament tackles head-on women's lack of

political representation, challenging their age-old exclusion from 'Councels and Senates' (1172). *The Lady-Errant* shows that the vital, 'politic' power of ratiocination is the preserve of no single gender. Eumela's argument to the female parliament that women's 'Passions are [their] Reasons Edge' is especially interesting because it represents women's supposedly humoral, histrionic characteristics as assets which, under the control of reason and wit, may be turned to political advantage. In this respect Cartwright's play forms a provocative analogue to the recent work of feminist historians who have argued that 'women's supposed humoral characteristics – their slippery, liminal qualities – rendered them useful when normal rules of male political negotiation did not apply, as in the chaos of the mid-1640s'.[102] As the example of petitioning women Levellers who were represented as 'ladyes errants' suggests, female errancy is a resonant concept in mid-seventeenth-century England.

We have seen that the types of liberty ascribed to, or claimed by, women in Caroline comedy extend beyond a narrowly political sense of that term. Liberty is a highly nuanced concept in early modern England, often defined reactively against a notion of law, political authority or social restraint.[103] This is illustrated by the 'Frame of Government' for the New English settlement of Pennsylvania drawn up by the Restoration Quaker William Penn in 1682. The preface to this document contains the statement that 'liberty without obedience is confusion; and obedience without liberty is slavery'.[104] The 'liberty . . . to speak myself' attested by Julietta in *Hyde Park*, and strongly endorsed by Shirley's play, belongs precisely to the political discourse that Penn articulates.

At the same time, Julietta's defence of her free speech to Lord Bonvile is testimony to the increased interest in feminine subjectivity evident in Caroline drama, which accompanies the playwrights' new awareness of women as active subjects.[105] We have seen how a concern with the affective dimension of female experience complicates and enhances *The New Inn* and *Hyde Park*. I have suggested ways in which both these plays foreshadow the representation of women in Restoration drama, specifically through their construction of feminine feeling as a dimension of experience which of necessity must be veiled or masked. Professions of liberty by women in Restoration comedy often occur in a context of self-presentation, where feminine conduct is weighed against the measure of what is 'civil'. Thus when Wycherley's Alithea in *The Country Wife* defends her right to 'assume the innocent liberty of the town' to her brother, Pinchwife, she questions him: 'would you not have me be civil? answer 'em [the men of scandalous reputations] in a box at the plays, in

the drawing-room at Whitehall, in St. James's Park'.[106] This evocation of a publicly staged female self reproduces, in an elite social milieu, the stress upon feminine reciprocation of masculine overtures which we saw dramatized in a pastoral context in *The Shepherds' Paradise*.

Of the plays I have discussed in this chapter, the comedy which offers the most complex perspective upon Caroline sexual mores is also the least well known to modern readers, *The Lady-Errant*. However, as I discuss in Chapter 6, Cartwright's play was important to the most famous seventeenth-century woman writer, Katherine Philips, and as a Stuart tragicomedy it should command more of our critical attention. Mary Beth Rose argues that as a hybrid genre, tragicomedy 'can be seen as facilitating processes of artistic change by mediating between future and past dramatic forms'.[107] In its dramatization of the actress as politician, *The Lady-Errant* engages in a two-fold critique and transformation of cultural and theatrical discourses. This process is also apparent in the play's humorous engagement with the cult of female heroism. Unlike her Spenserian forebears, Machessa's delight in adventures bears no trace of the idealism of medieval chivalry; rather, in a mode of feminine self-aggrandizement which we will see embodied in the dramatic writings of Margaret Cavendish, she aims simply to win glory for her sex as their most famous representative. Machessa's eventual rejection of her martial role signals the corrective purpose of the play's satire.

The affectionate and satirical treatment of female heroism in *The Lady-Errant* is in keeping with Cartwright's renown as a rhetorician and with the scope for criticism within panegyric forms such as the court masque. His plays *The Siege* and *The Royal Slave* display enthusiasm for the heroic woman, the latter featuring an Amazonian dance with women in '*war-like habits*' whom Butler imagines 'clashing their swords and shields'.[108] Fuelled by the visual and literary phenomenon of the *femme forte* in France, the heroic woman was embraced as an affirmative image by many seventeenth- and eighteenth-century English women writers.[109] Following the royal unease aroused by Amazon motifs in a proposed masque of 1618, under the aegis of Queen Henrietta Maria, Amazonian iconography again became licit and *de rigueur* in court culture. The glamour and potential erotic charge of martial role-play by women is apparent in Van Dyck's *Portrait of a Girl as Erminia*, discussed in Chapter 1 (Figure 4). A more modern warlike look was presented by Henrietta Maria and female courtiers who appeared in Davenant's *Salmacida Spolia* 'in Amazonian habits . . . with plumed helms, [and] baldrics with antique swords hanging by their sides' (Figure 9).[110]

Figure 9. Inigo Jones, *Henrietta Maria or a Lady in Amazonian Habit.*

Rose argues that it is in the representation of love and sexuality that the process of cultural transformation in which tragicomedy participates is most discernible.[111] She sees tragicomedy as offering 'an alternative conception of heroism that connects public and private life, is symbolized in marriage, and is associated with the future.'[112] The romantic dimension of *The Lady-Errant* calibrates with Rose's view of 'the increasing prestige of private life', traceable in the tragicomic representation of love and sexuality.'[113] Alongside the language of 'spirituall Love' (1412) which dominates the newsprung romance between Lucasia and Charistus, the play represents in a sympathetic manner the eager love of the young married couples, Florina and Philondas, and Malthora and Paestanus. Their love is strongly demarcated by gender: the women express their desire through melancholy yearning for solitude among sublime landscapes of the sort depicted in Katherine Philips's pastoral poetry. The men more actively steal back to Cyprus from Crete, and through Eumela's device of statues that come to life, announce to their wives that they have come 'to fulfil the longing / Of . . . young Novice-Husband[s]' (1490–1). In this manner the play simultaneously evokes and wishes away the destructive impact of war upon private relationships. This is another feature of *The Lady-Errant* which is proleptic of the state of England in the 1640s.

If tragicomedy configures a domain of love and sexuality within which female desire can find fulfilment, Caroline tragedy offers the most intense exploration of the conflicts between women's sexual desires and the patriarchal social order. The next chapter examines the range of responses in Caroline tragedy to the expression, or circumscription, of female passion.

Sirens of doom and defiance in Caroline tragedy

In the previous chapter I explored the fertile significances attached to women's acting in Caroline comedy. Women's dissembling subtends and advances the plots of much Renaissance drama; what has been less remarked is the representation of female acting, notably in plays of the 1620s and 1630s, as an instrument of moral instruction, social harmony and political détente. Of the dramatists discussed in Chapter 4, it is James Shirley whose *oeuvre* reflects most forcefully the new vocality and visibility of women in Caroline culture. A congruent feature of tragedies by Caroline dramatists is their intensive focus on female sensuality and women's sexual desires. This parallels a shift in sensibility at the Caroline court, which 'developed a much more open and uninhibited attitude toward erotic passion than was common in the early seventeenth century'.[1] The shared interest of the playwrights and their audiences in this sensual realm is plainly spelled out in the title of the most renowned tragedy of the period, John Ford's *'Tis Pity She's a Whore*. Ford's title posits women's sexual transgression as a matter for pity, rather than moral abhorrence; when juxtaposed with the titles of Jacobean tragedies such as Webster's *The White Devil* or Middleton's *Women Beware Women*, this hints at a widening of dramatic affect derived from the representation of women within tragic narratives of the Caroline period.

Martin Butler notes that Shirley and Ford 'not only knew one another but wrote for the same playhouse', the Cockpit or Phoenix, and in the parallel titles, themes and tragic designs of Ford's *Love's Sacrifice* and Shirley's *Love's Cruelty* he finds hints of 'a competition or dialogue between two playwrights from the same circle'.[2] Further evidence of the creative friendship between Ford and Shirley is provided by Shirley's congratulatory verses to *Love's Sacrifice*, published in 1633, the same year that the controversy over Prynne's *Histrio-Mastix* erupted.[3] Shirley's first stanza speaks admiringly of the older dramatist's art in rich sensuous language of 'spice' and 'perfumes'. This is followed by a vehement attack

on Prynne, pinpointing the discreet allusion to 'the severity of censurers' in Ford's dedication:

> Look here, thou that hast malice to the stage,
> And impudence enough for the whole age:
> Voluminously ignorant! Be vexed
> To read this tragedy, and thy own be next.[4]

Shirley anticipates his ironic dedication of *The Bird in a Cage* to Prynne by suggesting that Ford's tragedy will aggravate the Puritan ideologue. Theoretically an attack on the immorality of the stage, *Histrio-Mastix* was more specifically 'an attack on the arts associated with the stage at court, on women as a corrupting influence, and on the connection of both with Catholicism'.[5] As Erica Veevers writes, buttressing Prynne's polemic was 'a fear that women, using the arts of love, might be capable of "seducing" men to an alien religion'.[6] In stark contrast to Prynne's Puritan values, the aesthetic sensibility which permeates the tragedies of Ford and Shirley has been seen as Mannerist, Baroque, feminine and neo-Catholic; for the purposes of my argument, what is crucial is that both these playwrights represent charismatically the animation of female passion and eloquence.[7]

We have seen in earlier chapters that, from a Neoplatonic perspective, women's physical 'motions', and their voices, are perceived as channelling divine grace; this attitude is captured in the blissfully lulling music of the 'celestial sirens' in Milton's pastoral entertainment *Arcades*. Simultaneously, the theatrical woman in Stuart drama is figured as the source of man's demise: 'O woman, woman, thy bewitching motion / Fooles wisedom, reason, and blinds all devotion.'[8] One innovative aspect of Caroline tragedy is the playwrights' use of women to represent extremes of emotional harmony and disorder, either through a metaphor, or an animation, of theatrical performance. This especially characterizes the tragedies of Ford, who alone of Caroline dramatists foreshadows Walter Pater's maxim that 'all art constantly aspires to the condition of music'.[9] Two examples from *Love's Sacrifice* and *The Broken Heart* will demonstrate Ford's employment of women to orchestrate scenes of tragic transgression and transcendence.

The feature of *Love's Sacrifice* which would most obviously vex Prynne is the performance of an antic masque by three gentlewomen of the Pavian court. The 'antic' is proposed by the Duke of Pavy's favourite, Fernando, who describes witnessing a similar entertainment in Brussels, 'performed by knights and ladies of [the] court . . . which', he adds, 'for that I ne'er before saw women antics / Was for the newness strange, and

much commended' (3.2.19–22). In the course of the masque the three women stab to death the libertine, Ferentes, who has impregnated them all. The connotations of surprising strangeness in the word 'antic' are borne out by the women's entry '*in odd shapes*' and the ensuing action in which '*they close Ferentes in*', and '*dance about [him] in diverse complimental offers of courtship. At length, they suddenly fall upon him and stab him; he falls down, and they run out at several doors*' (3.2.17.4–12).

This grotesque conflation of love and death is overlaid with a moral dimension that might even have gratified Prynne. Ferentes's dying curses link the women's bizarre performance with their sexual abandon: 'A pox upon your outlandish feminine antics . . . Vengeance on all wild whores, I say' (3.4.18–19, 52–3); his image of the women as whores is realized when the actresses return unmasked, '*every one having a child in their arms*' (3.4.26.2).[10] Ferentes's demise illustrates the sacrifice paid by promiscuous love. The shocking deception of the women masquers also represents in microcosm the gap between female appearance and actuality which is an overriding concern of *Love's Sacrifice*.

Ford's reversed revels functions as a theatrical emblem of social disharmony and moral chaos. Elizabethan and Jacobean tragedians had previously represented women performing in climactic spectacles which disintegrate into murder and mayhem.[11] Ford's refashioning of this convention stresses the distinctive element of female performance, in a manner typical of playwrights of the 1630s. The image of social and personal anarchy embodied in the 'antic' in *Love's Sacrifice* has as its contrary the Renaissance notion of the well-tempered soul. This ideal is expressed by Ithocles in *The Broken Heart* as he cautions himself against aspiring to the love of Princess Calantha: 'Morality applied / To timely practice keeps the soul in tune, / At whose sweet music all our actions dance.'[12]

Ithocles invokes this image of rational composure only to dismiss it as failing to accommodate the vicissitudes of human emotion: 'But this is form of books and school tradition; / It physics not the sickness of a mind / Broken with griefs' (2.2.11–13). The first catastrophe of *The Broken Heart* triumphantly embodies the dictum Ithocles rejects.[13] Leading the revels to celebrate the marriage of the lone happy couple in the play, Calantha continues dancing as three messengers deliver her news of the deaths of her father, friend and lover. What her courtiers construe as a lack of 'female pity' is shortly after belied by her self-willed death, a choreographed ritual which is at once a display of extreme self-control and emotional abandon. Having solemnized her marriage to the dead Ithocles, Calantha divulges the truth underlying her earlier performance:

> O my lords,
> I but deceiv'd your eyes with antic gesture,
> When one news straight came huddling on another,
> Of death, and death, and death. Still I danc'd forward;
> But it struck home, and here, and in an instant.
>
> (5.3.67–71)

The physical referent of Calantha's 'here' is revealed by means of her concentrated command: 'Crack, crack'. Calantha's death is as immaculately staged as Shakespeare's Cleopatra's; the vital difference is the absence of an asp or human agent to bring it about. Ford's heroine dies from sheer intensity of grief: the spectacular breaking of her heart represents inward feeling made outward; female subjectivity made theatrical.

These Fordian moments encompass the gamut of tragic representations of female performance in Caroline drama. There is a precedent for Calantha's agony of emotion in the image of Cordelia smiling through her tears in the quarto text of *King Lear*, upon which the First Gentleman moralizes, 'It seemed she was a queen / Over her passion who, most rebel-like, / Sought to be king over her' (scene 17, 14–16). However, this image of a woman mastering her strong emotion is narrated, while Calantha's conquest over, and submission to, her heart's grief is stunningly enacted. The pressure of cultural change, specifically the imaginative possibilities inspired by female acting, is inscribed both in Ford's modish women antics and Calantha's regal performance. The rest of this chapter takes a thematic approach to Caroline tragedy, exploring how plays by Shirley, Ford and others script 'the woman's part' to achieve effects of heightened eroticism and pathos, thrilling defiance and stoic transcendence. My discussion explores three interlinked themes within which women feature as actors: sexual passion; madness as performance; and masques, ceremonies and the arts of death.

'FIT FOR A LADIES PLEASURE': STAGING SEXUAL PASSION

In *Histrio-Mastix* Prynne relentlessly associates the female voice in the playhouse with sexual arousal and defilement: 'from these songs of Harlots a very flame of lust doth presently set the Auditors on fire'.[14] The contagion of female song, it seems, has infected the women of Caroline England, for in the midst of a passage quoted from Saint Chrysostom bemoaning the celebration of marriages with '*dancing . . . [and] adulterous ribaldry songs*', Prynne opines that participating in such revels is 'a practice too common with our chaunting, dancing blushlesse

females now'.[15] Caroline playwrights repeatedly represent women as sirens; as we have seen, this image was powerfully animated by the performance of the singer Madame Coniack as the enchantress Circe in the court masque *Tempe Restored*. Real singing features in Caroline tragedy where a playwright wishes to convey exceptional sexual confidence on the part of women. In Shirley's *Love's Cruelty* the saucy Clariana sings snatches of a ballad and a popular air while lying in bed following lovemaking with her husband's best friend. The words of the air, 'for he did but kisse her, and so let her go',[16] reflect Clariana's insouciance, and her recklessness, occurring as part of a dialogue in which she extolls to her lover the piquancy of stolen pleasures. Clariana makes light of her adultery by mocking the fearfulness of Hippolito, her lover, who observes 'you are very confident' (p. 42, line 5). The complacency with which Clariana invokes her husband is upset by Bellamente's surprise return; when she falls on her knees his curt words, 'no petitioning, you can sing' (p. 42, line 18), represent his apprehension of Clariana's manipulativeness in terms of her vocal proficiency. However, Bellamente is dissuaded from killing Clariana and Hippolito through the pragmatism recommended by Clariana, who, praising Bellamente for having 'secur'd all shame at home', urges him not to trumpet their combined infamy 'abroad' (p. 45, lines 34, 36). She refers to how Bellamente has whitewashed her adultery by ordering Hippolito into the closet, then showing the informing servant the apparently inviolate marital bedroom, thus forestalling the servant's spreading of domestic scandal.

Bellamente's disdaining of 'bloody sacrifice' in the fourth act allows Shirley to pursue Clariana's obsessive love to a startling tragic conclusion. When it arrives, the catastrophe has a novel twist in that Clariana asserts her propriety in the reformed and about-to-be-married Hippolito (whom she has lured to a meeting) by stabbing him herself, preempting his murder by Bellamente, who, inevitably, surprises the couple for a second time. Clariana's explanation of her initiative in 'begin[ning] / The tragedy' (p. 62, lines 7–8) parallels the driving sexual possessiveness of Ford's Giovanni in *'Tis Pity She's a Whore*, who murders his sister-lover Annabella from a similar impulse:

> I know my fate was not
> To be resisted . . . and
> I would secure no woman after me
> Should boast the conquest of *Hippolito*.
> (p. 62, lines 8–12)

Surprised by Clariana's 'bold hand', Hippolito spontaneously stabs Clariana, and Bellamente expires from grief soon after.[17]

In Clariana, Shirley dramatizes with remarkable psychological insight the fatal sexual attraction of a woman to a man. The grip of physical passion upon Clariana is spelled out in her declaration to Hippolito, 'when first I saw your person I gave up / My liberty' (p. 34, lines 3–4). Clariana's infatuation with Hippolito differs therefore from the rampant libertinism of Messallina, the dynamic protagonist of Puritan-affiliated Nathanael Richards's *The Tragedy of Messallina, The Roman Empresse* (1635, pub. 1640).[18] Gauged for the popular end of the playgoing market, Richards's play makes an appropriate companion piece to the politicized misogyny of Prynne's tract. In their commendatory verses Richards's fellow dramatists make much of the pious aim of his 'Anchorite Muse';[19] nevertheless, the prologue represents the actors as endeavouring to 'feast your sences' (220) with their portrait of voracious feminine lust. Messallina's relish of sex is captured in the image of her 'dancing Lavoltos in the very act' (1577), while her feat of outdoing a courtesan by bedding twenty-five men 'all in the circuit of a day and night' (344) is invoked several times with a fascinated horror as testimony of her stamina, as well as her viciousness. As Butler notes, through its copious metatheatrical devices Richards's tragedy realizes the Renaissance Puritan conception of the world as 'the theatre of god's judgements'.[20] The play underscores the complicity of theatrical performance in Messallina's depravity. The Empress becomes infatuated with the actor Menester by watching him act Troilus, while her seduction of the 'vertuously inclined' (187) Roman knight, Montanus, spotlights the debilitating power of her lustful gaze. The stage direction reads '*Enter Emperesse by degrees, gazing at [Montanus]*' (1524), whose lines convey his gradual overwhelming by irresistible desire: 'She's most bewitching sweet, I feare, I feare, / She will ore come; now I begin to burne, / To scorch, like to coales of Etna' (1530–32).

Richards depicts theatre and dance as exciting sexual desire in a manner that echoes Prynne's fears of the incendiary effects of dancing and watching plays. Messallina commands her 'chief of Counsell', Saufellus, 'Graspe me . . . let's have a sprightly dance, / Swift footing apts my blood for dalliance', after which they 'dance a coranto' (1012–17). Messallina avows a libertine philosophy by stating that women who deny themselves pleasure have 'the minds of sots' (967). More politically transgressive is her confidence that she can sway her husband, the Emperor Claudius, into forgiving her legion sexual betrayals and murders by means of her

'quick-Ey'd sence, and *Syrens* tongue' (2510). Here the histrionic traits that distinguish Eumela in Cartwright's *The Lady-Errant* are amplified to a degree that suggests a parallel between Messallina, *meretrix Augusta* (imperial whore), and 'that other great Whore of Rome, the Catholic church'.[21] Richards's sensational melodrama foreshadows modern popular culture's fetishizing of Messallina's image. In Italy from the late nineteenth century into the early twentieth, Messallina became a byword for 'delinquent female desire', while in the 1970s, through the BBC's serialization of Robert Graves's novel, *I Claudius*, an image of Messallina as 'the embodiment of a transgressive femininity against whose treachery all men . . . need warning' reached living rooms worldwide.[22] Modern scholars discern beneath the sexual depravity of the classical narratives a woman's 'shrewd political intelligence'.[23] Maria Wyke observes that in the *Annals* of Tacitus, the most influential of ancient sources for all later Messallinas, the Empress's voracious sexual desire 'is given an extraordinary dramatic momentum – so much so that Tacitus even admits his account of it may seem "fictional" or, perhaps, "theatrical" (*fabulosus*)'.[24] With a matching shrewdness, Richards sensed and capitalized on the hyperbole of his classical sources.[25]

<p align="center">* * *</p>

In his discussion of Ford's influence upon Shirley, Ronald Huebert comments on both dramatists' 'flair for shocking sexual intimacy'.[26] Modern audiences are accustomed to full nudity on stage; it takes a mental effort to imagine the frisson caused by Shirley's and Ford's presentation of scenes in which adulterous or incestuous couples are discovered '*lying on a bed*'.[27] In Ford's *Love's Sacrifice* a series of nighttime encounters between Bianca, the beautiful lowborn wife of Duke Caraffa of Pavia, and the Duke's 'bosom-partner' Fernando (1.1.150) work at once to create a titillating eroticism and to probe what Kathleen McLuskie describes as the 'gap which [Stuart drama] opens up between what is seen and what can be known about women'.[28] In the first part of the play, Bianca strongly resists Fernando's declarations of love. Her rejection is sustained, for in their first confrontation we learn that this is the third time Fernando has 'pleaded treason to [Bianca's] ear and fame' (2.1.142). After the fourth occasion, when she elicits from Fernando a vow never again to speak of love, in the very next scene Bianca appears beside his bed, '*her hair about her ears, in her nightmantle*' (2.4.0.1–2), and declares herself willing to yield to him, adding that she will kill herself afterwards.

Before she calls to Fernando to rouse him from sleep, Bianca urges herself, 'Resolve, and do: 'tis done' (2.4.1). The affirmation could suggest her steeling herself to the challenge of expressing her desire, yet remaining true to her marital vows, or it may indicate that she 'has "resolved" to "ruin" herself in [Fernando's] arms'.[29] Bianca's declaration of her love to Fernando highlights her self-division:

> With shame and passion now I must confess,
> Since first mine eyes beheld you, in my heart
> You have been only king. If there can be
> A violence in love, then I have felt
> That tyranny.
>
> (2.4.17–21)

It takes Bianca's kneeling and swearing to hold true to her vow to kill herself before Fernando apprehends, and believes, what she calls her 'calamity' (2.4.64); only then does he agree to 'master passion' and rest content with a relationship of chaste love in which he will be Bianca's 'servant' (2.4.85, 82).[30]

Modern critics have been perplexed by the lacuna surrounding Bianca's volte-face from chaste wife to willing lover, as they have been equally hard put to explain Bianca's later defiant avowal to the Duke of her (unconsummated) passion for Fernando. In his valuable essay on the play, Butler comments that Bianca's self-division 'is unseen', but the speech quoted above demonstrates Bianca's subjugation by a violent passion which is at the same time a source of shame.[31] In the introduction to his selection of Ford's plays published in 1888, Havelock Ellis accurately diagnoses the sexual dynamic that Ford explores in *Love's Sacrifice*. Ellis summarizes the plot as 'the story of the youth [Fernando] who falls in love with his friend's wife, and when he has aroused in her stronger nature a passion far deeper than his own, shrinks back realizing his falsehood'.[32] His account of the play's central relationship is borne out subsequent to the couple's pact of chaste love, when Bianca's behaviour towards Fernando becomes daringly seductive. In one scene she wipes blood from Fernando's lip with her handkerchief in the Duke's presence, whispering, 'Speak, shall I steal a kiss? Believe me, my Lord, I long' (3.2.47). Fernando's shocked reply, 'Not for the world' (3.2.48), distinguishes Bianca's erotic recklessness from Fernando's stricter punctilio.[33] In the last of their 'nocturnes',[34] the couple are discovered talking and kissing at a table, shortly before they are surprised by the Duke. Here Bianca puts to Fernando the possibility of their rebelling against 'the iron lawes of ceremony . . . What's a vow? A

vow? / Can there be sin in unity?' (5.1.6–8). Fernando demurs; he
reaffirms his role as Bianca's servant, declaring that he will 'see [her] first,
/ Or widowed or buried'.[35] Less bold than Bianca in entertaining the
possibility of adultery, Fernando looks forward either to dying with her,
or to marrying her only after the Duke's death.

Ford's engagement with the plot and stage images of *Othello* – such as
Bianca's gesture with her handkerchief – provide additional leads for
interpreting his portrayal of Bianca.[36] Shakespeare's romantic tragedy
matches an ardent young Venetian woman with an older black man,
whose anxiety about 'the vices of [his] blood' (1.3.123) leads him to
publicly disclaim 'the palate of [his] appetite' (1.3.262). Othello's testi-
mony of chaste love follows Desdemona's profession of her love for him
to the Venetian senate, in a speech where she adduces her 'downright
violence and storm of fortunes' as evidence of her strength of feeling
(1.3.249). In dramatizing Bianca's equally violent passion, Ford transferred
the discrepancy between Desdemona's and Othello's love on to the
adulterous love of Bianca and Fernando. Bianca's intervention on behalf
of the banished nobleman, Roseilli, is a further 'partial, altered' echo of
Desdemona's efforts on Cassio's behalf.[37] In contrast to Desdemona's
persistent pleading, Ford handles Bianca's suit so as to draw attention to
her clever diplomacy, while at the same time presenting her as acting in
collusion with Fernando. Before the Duke's entrance, when Bianca asks
Fernando to assist her in mediating with her husband, D'Avolos (Ford's
Iago) warns Bianca that Roseilli is dangerous, and that in pleading his
cause she risks angering the Duke. Bianca's response expresses scepticism
at D'Avolos's report: '*If it be so*, I am the sorrier, sir. / I'm loath to move
my lord unto offence, / Yet *I'll adventure chiding*' (1.2.217–19, emphasis
mine). Bianca's risk-taking in the court milieu foreshadows her intrepid
action in 'adventur[ing] to [Fernando's] bed' (2.4.29) in the following
act. The language of heroism which is associated with the sexual agency
of Desdemona and the Duchess of Malfi colours Bianca's similarly
transgressive actions.[38]

Ford accentuates Bianca's pluckiness by providing her with an antagon-
ist in the Duke's sister, Fiormonda, who together with D'Avolos is a 'chief
actor' (4.1.136) in the Duke's murder of Bianca for an adultery of which
she is technically innocent. Bianca evinces her strength of mind by
withstanding the jeers of the patrician Fiormonda, who resents Bianca's
low birth, describing her to the Duke as 'the sallow-coloured brat / Of
some unlanded bankrupt' (4.1.18–19). Bianca parries Fiormonda's hostil-
ity by asserting her control over language, pointing out to Fiormonda,

'you still mistake me' (2.1.48). In making the widowed Fiormonda enamoured of Fernando, Ford creates a contrasting perspective on the woman whose passion moves her to act. Fiormonda woos Fernando in a scene which in gesture and language is modelled on the Duchess of Malfi's wooing of Antonio in Webster's tragedy.[39] The scene diverges from the original in that Fernando's perfunctory praise of Fiormonda is aimed at rebutting her forward charge; thus, when she presents him with her husband's ring, he recoils as politely as possible. Ford rewrites the tensely restrained passion of Webster's scene as a moment that is excruciating merely in its social embarassment: when Fiormonda kisses Fernando, he again demurs, 'What means the virtuous Marquess?' (1.2.157). Fernando's explicit voicing of his detestation of Fiormonda in Act 4, scene 1 reconfirms her malicious intention to 'stir up tragedies as black as brave' aimed at ruining Bianca and Fernando (2.3.127).

Fiormonda's vow to foment tragic disaster leads Butler to liken her to a shadow dramatist, in the manner of Iago.[40] This is apt, for in conversation with Fernando, Fiormonda offers constructions of Bianca which the play also entertains, calling her a 'sorceress' and urging Fernando to 'shun that Circe's charm' (4.1.254, 249). These images are opposed by Fernando after Bianca's death when, in an action that teasingly echoes the denouement of *Othello*, Fernando convinces the Duke that he has murdered a 'spotless wife' (5.2.72). At her funeral the Duke offers 'the sacrifice / Of bleeding tears' before Bianca's tomb, which he terms 'the shrine / Of fairest purity' (5.3.43, 37–8). Having previously addressed her as 'black angel, / Fair devil', his image of his wife now accords with the 'white' signified by Bianca's name (5.1.138–9). *Love's Sacrifice* neither upholds nor rejects these shifting images of Bianca; rather, in a manner reminiscent of the plays of John Fletcher, Ford's dramaturgy puts them 'into play' in such a way that the audience is kept pondering the ambiguity of the heroine's character.[41] This interrogative process reaches its acme in the scene where Bianca unleashes her sexual longing for Fernando after D'Avolos's and Fiormonda's informing leads the Duke to burst in on the lovers' dalliance at the table (5.1.4.1–3).

Bianca's flabbergasting speeches respond to the Duke's arraignment of her as a 'wretched whore', a 'strumpet' and a 'shameless harlot' (5.1.50, 54, 60); interestingly, these are the terms in which Shakespeare's Bianca is misrepresented by Iago and Emilia after the altercation between Roderigo, Cassio and Iago in Act 5, scene 1 of *Othello*.[42] What is riveting about this (false) discovery scene is Bianca's provocative performance as a would-be adulteress. One way of viewing the scene is that in playing the whore to

the hilt, Bianca aims to protect Fernando by attracting the blame to herself. Her 'immodest language' (5.1.86) exalts her passion for Fernando:

> O he's a gallant man. If ever yet
> Mine eyes beheld a miracle composed
> Of flesh and blood, Fernando has my voice . . .
> thank heaven he was so slow
> As not to wrong your sheets; for as I live,
> The fault was his, not mine.
>
> (5.1.97–106)

Ford gives his boy actor a 'star-turn' in executing the shift from chaste but tempted lover to defiantly disloyal wife, scornfully disclaiming the Duke as 'fit for a lady's pleasure' (5.1.76). There is a virtuosity required of both actor and character comparable to the moment in *'Tis Pity She's a Whore* when Annabella, resisting her husand's efforts to discover the name of her lover, switches medium and sings in Italian of the glory of dying for love.[43] Although Bianca renders information, while Annabella withholds it, both scenes depict women whose histrionic performances wantonly incite male violence. Both heroines perform as sirens of defiance.[44] Bianca masochistically embraces the violence with which the Duke threatens her: 'To the point / Of thy sharp sword with open breast I'll run / Halfway thus naked. Do not shrink, Caraffa, / This daunts not me' (5.1.158–61). In baring her bosom Bianca extravagantly realizes the image of the truths inscribed on the heart expressed in her vow at the end of Act 2: 'When I am dead, rip up my heart and read / With constant eyes what now my tongue defines: / Fernando's name carved out in bloody lines' (2.4.93–5).

Her vow, which repeats that made earlier by Fernando (2.3.98–101), expresses metaphorically the image which is literalized in the finale to *'Tis Pity She's a Whore*, where Giovanni enters with his sister's heart impaled on his dagger. Such moments demonstrate the extraordinary pressure brought to bear on female chastity in late Renaissance drama, where, as McLuskie writes, 'the certainties which depend upon [chastity] constantly push the narratives in the direction of a more pressing physical searching of the bodies of their female characters'.[45]

The flagrant sensuality of Shirley's Clariana, Richards's Messallina and Ford's Bianca challenges the Protestant conception of monogamous marriage and anticipates the searching, sympathetic investigation of extramarital love in Restoration drama. In amplifying the minds of their trangressive women, *Love's Sacrifice* and *The Tragedy of Messallina* articulate subversive views of monogamy. Messallina defines conventional

marriage as 'fooles Philosophy' (965), questioning, 'Shall Messallina in her flourishing youth / Like dull and tame, Nobilitie live coopt, / Confin'd and mew'd up singular to one[?]' (962–4). In the context of Richards's popular antityrant play Messallina's libertine manifesto is further damning evidence of her wickedness; nonetheless, her scornful view of the nobility as entrapped in their marriages is suggestive of the slow, intermittent erosion of the Renaissance theory of marriage as divinely sanctioned and absolute over the course of the seventeenth century.[46] Ford's treatment of extramarital love in *Love's Sacrifice* is markedly more sympathetic than Richards's characterization of Messallina, or Elizabeth Cary's portrayal of the similarly bigamous and murderous Salome in *The Tragedy of Mariam*. Bianca's conflation of marital and adulterous love as stemming from 'appetite' has the ring of 'a doctrine of sexual equality', while her image of Fernando as 'a miracle composed / Of flesh and blood' carries a subversive force.[47] Like the Duchess of Malfi's use of the phrase with reference to herself in Webster's tragedy, the words 'flesh and blood' assert the commonality of women and men as sexually desiring beings.[48] The conviction with which Bianca communicates her sexual passion is evidence of a decisively anti-Platonic perspective in Ford's play. The same radical perspective is evinced in Bianca's protesting to Fernando against 'the iron lawes of ceremony'. Her questioning of the binding nature of marriage reflects one aspect of the 'youthful' and 'aspirant' societies delineated in *Love's Sacrifice* and Ford's tragicomedy *The Ladies Triall*, societies which Brian Opie characterizes as 'possessed of the means to act free from the constraints of an older generation'.[49] The changing social and moral parameters evinced in Ford's drama resonate proleptically with the ambiguous freedom to act accorded women within the Restoration theatre, where professional actresses were subject to new ideological constraints of being represented as 'playhouse flesh and blood'. Within this theatre women's enjoyment of sex would be represented more attractively in figures such as Mary Delarivière Manley's Homais and Congreve's Semele, albeit such women are still punished for their indulgence of the pleasures of the flesh.[50]

* * *

If the performance of sexual passion allowed Caroline playwrights to expand the repertoire of theatrical femininity, so, too, did the performance of madness. Carol Thomas Neely suggests that the discourse of madness gained prominence in the early modern period 'because it was implicated in the wider transformation of the notion of what it meant to

be human'.[51] As Neely points out, the section on the 'Symptomes of Maids', Nuns' and Widows' Melancholy' in Robert Burton's *Anatomy of Melancholy* was new to the third edition of the text, published in 1628. The licensing for performance of Ford's first-published play, *The Lover's Melancholy*, in the same year indicates the responsiveness of Caroline dramatists to this cultural preoccupation.[52] Portraits of madwomen in Caroline drama imply that being female at this time could entail experiencing repressed sexual desire, anger, despair, and the wish to inflict violence or death upon others or on oneself. Caroline drama intensifies Jacobean drama's innovative representation of psychologically disturbed women, epitomized in the figures of Shakespeare's Ophelia and the Jailer's Daughter in Fletcher and Shakespeare's tragicomedy, *The Two Noble Kinsmen* (1613, pub. 1634).[53]

The plays I examine build on the expansion of women's histrionic abilities in Jacobean tragedy, in parts where female characters dissemble madness in an effort to advance or obstruct the dramatic narrative. In the subplot of Middleton and Rowley's *The Changeling* (1622, pub. 1653), Isabella, wife to the jealous doctor, Alibius, pretends lunacy to deflect the sexual attentions of the courtier Antonio who has disguised himself as a changeling and entered Alibius's asylum in order to seduce Isabella. Donning the 'habit of a frantic'[54] borrowed from the wardrobe administered by the inmates' keeper, Isabella accosts Antonio with rhapsodic speech and intimidating gestures. In her histrionic 'practising' Isabella adapts the resourcefulness typical of the youthful wife of medieval *fabliaux*, though in contrast to that character type, Isabella's agency is directed to preserving her chastity.[55] Unlike Ophelia's madness, and that of the Jailer's Daughter, which extends through several scenes, Isabella's madness is contained within an aria-like speech which demands a bravura performance from the actor. This early Stuart development anticipates the later theatrical fashion whereby mad scenes, specifically mad songs, came to function as a Restoration actress's showpiece.[56]

FEMALE MADNESS AS PERFORMANCE IN FORD'S
'THE BROKEN HEART'

In Act 4, scene 2 of Ford's *The Broken Heart*, Penthea's appearance with '*her hair about her ears*', weeping, flanked by two maids of honour, presents a familiar stage icon of feminine madness.[57] As she enters, Penthea says, 'Sure, if we were all sirens, we should sing pitifully; / And

'twere a comely music when in parts / One sung another's knell' (4. 2. 69–71). These lines combine a Fletcherian beauty with a psychological, prophetic resonance that is Ford's special contribution to English tragedy. Usually figures whose singing lures men to their deaths, the sirens are imagined by Penthea as agents of *self*-destruction, their singing forming a sonorous tragic antiphon. Indeed, knells will shortly be sung for both Penthea and Calantha.[58] Penthea's self-representation as a siren belongs to a register of feminine madness that is pathetic and picturesque. Yet the image of the siren as sounding a seductive note of doom for men is equally appropriate to the narrative function of Penthea's madness. Married against her will to the jealous nobleman Bassanes, Penthea develops into the most strident of *The Broken Heart*'s emotionally damaged Spartan lovers. Her complaints derive from the action of her brother Ithocles, who, harbouring resentment against the family of Penthea's betrothed lover, Orgilus, compelled her advantageous marriage to Bassanes. In her mad scene Penthea's pointing her finger at Ithocles, accompanied by the words 'that is he', gives Orgilus an unmistakable directive for vengeance: 'She has tutor'd me; / Some powerful inspiration checks my laziness' (4.2.124–5). In what follows I argue that Penthea's performative madness locates her simultaneously as the victim of a powerfully internalized patriarchal culture and as an ambiguous agent of revenge.

One important strain of criticism of *The Broken Heart* reads Ford's play as a 'tragedy of manners'.[59] R. J. Kaufmann proposes that 'nowhere [in the canon of English Renaissance drama] is there the same degree of attention to the problems of constructing and maintaining one's persona, nor the same obsessive regard for the direction and control of the self'.[60] What has not been remarked is the specifically gendered aspect of the imperative, ritualized role-playing which *The Broken Heart* simultaneously anatomizes and exalts. The minor role of Euphrania, sister to Orgilus, clarifies the extent to which all the women in *The Broken Heart* are by definition actors, a fact which distinguishes their theatricality from the more deliberate assumption of a scholar's disguise by Orgilus.

Ford begins the play with a scene which recalls Laertes's leavetaking of Polonius in *Hamlet*. Orgilus appeals to his father Crotolon for permission to go to Athens, not, as with Laertes's return to France, to pursue his own betterment, but 'to free Penthea from a hell on earth' (1.1.80) by preventing the jealousy of Bassanes which would arise from Orgilus's further stay in Sparta. On Euphrania's entrance Orgilus extracts from her a promise 'to pass never [her faith] to any man, however / Worthy . . . till, with our

father's leave / I give a free consent' (1.1.93–5). The prerogative exerted over Euphrania's choice of husband by her brother and father resembles the similar control over Ophelia's romantic life exercised by Laertes and Polonius; ironically, Orgilus seems unaware of how his interest in Euphrania's marriage potentially mirrors the coercive agency of Ithocles in compelling Penthea's marriage to Bassanes. By disguising himself as a scholar, Aplotes, and gaining entry to the school of the Spartan philosopher Tecnicus, Orgilus ensures that he can monitor 'Penthea's usage and Euphrania's faith' (1.3.35). In her subsequent secret meeting with her lover, Prophilus (observed by Orgilus as Aplotes), Euphrania replies to Prophilus's wish to have her as his wife with what she calls 'language suited / To a divided mind' (1.3.66–7). The division, of course, is between 'the law of [Euphrania's] desires' (1.3.75) and the consent of her father and brother which she must obtain before she can accept Prophilus's proposal. Notwithstanding Euphrania's insistence that she obtain her male relatives' consent, the eavesdropping Orgilus responds to the interview's conclusion, which Prophilus seals by kissing Euphrania's hand, with a misogynous assumption of his sister's disloyalty: 'There is no faith in woman' (1.3.90).

This patriarchal constriction of women's behaviour and their sexual choices governs Penthea's tragedy. Her histrionic madness is the apogee of her sustained representation as an actress from early in the play. Long before she becomes 'left / A prey to [words]',[61] Penthea performs the role of affronted chastity by banishing Orgilus from her sight. When Orgilus, disguised as Aplotes, surprises Penthea in a garden walk, she warns that she 'can turn affection into vengeance' (2.3.110) should he persist in his demand 'to possess my wife' (2.3.71). After his departure she reflects on her anger, 'I fear I was too rough' (2.3.128), lamenting, 'Honour, / How much we fight with weakness to preserve thee' (2.3.130–1). For Penthea feminine honour is a mask which disguises what she perceives, echoing Hamlet, as her weakness, her sexual 'frailty' (2.3.114).[62] In patriarchal Sparta, as in Stuart England, femininity is fundamentally performative, for the modest woman is never *not* acting.

The psychological self-divison which Euphrania names as a dormant female condition is exacerbated in Penthea by her forced match to Bassanes. To Orgilus, Penthea describes her marriage as a 'rape done on my truth' (2.3.79), while to her brother she protests that by marrying her to Bassanes he has made her a whore 'in act, not in desires' (3.2.71). Penthea's insistent use of language connoting sexual contamination and rape is replicated by the discourse of Ithocles in the interview between

him and Penthea which forms the fulcrum of the third act. Ithocles's anguished regret at his 'monstrous' action carries hints of defloration:

> My rash spleen
> Hath with a violent hand pluck'd from thy bosom
> A lover-bless'd heart, to grind it into dust,
> For which mine's now a-breaking.
>
> (3.2.82, 43–6)

Penthea's response to Ithocles's remorse is to wish a curse on his heart, praying for 'some wild fires [to] / Scorch, not consume it'. (3.2.47–8). Yet despite her bitterness, once she understands that Ithocles is suffering in the very way she describes, Penthea promises her brother some comfort, pledging, 'If sorrows / Have not too much dull'd my infected brain, / I'll cheer invention for an active strain' (3.2.115–17). Making a shift to help Ithocles, Penthea moves from her attitude of resentment to advocacy for her brother, whose 'saint' (3.2.93) is Princess Calantha, 'sole heir of Sparta' (3.2.101). Penthea's decision to 'cheer invention for an active strain' alerts us to the device she employs in her audience with Calantha.[63] In her formal speech Penthea uses a play metaphor to intensify her fatal intuition of her own end:

> On the stage
> Of my mortality, my youth hath acted
> Some scenes of vanity, drawn out at length
> By varied pleasures, sweeten'd in the mixture,
> But tragical in issue.
>
> (3.5.15–19)

Penthea's view of her life as 'tragical in issue' posits her death as the inevitable outcome of her narrative. For all her ability to play 'with harmless sport / Of mere imagination' (3.5.66–7), when we next see her Penthea will literally have become Macbeth's 'walking shadow', wasted by ten days' abstinence from food and sleep. Penthea's self-dramatization as an actress in her interview with Calantha highlights her entrapment in a situation not of her own making. In this respect her plight recalls the Duchess of Malfi's, who tells Bosola, 'I account this world a tedious Theatre, / For I doe play a part in 't'gainst my will.'[64] But Penthea's pessimistic rhetoric is more self-consciously strategic than the Duchess's language. When Calantha is moved to tears by Penthea's bleak forecast of her own death, Penthea responds in an aside, 'Her fair eyes / Melt into passion. Then I have assurance / Encouraging my boldness' (3.5.43–5). This spotting of her cue reveals the calculating artifice in Penthea's

subsequent bequeathing of Ithocles to Calantha as the dearest part of her 'will' (3.5.46). When in the next scene Calantha favours Ithocles by throwing him the ring requested by her suitor Nearchus, Prince of Argos, Ithocles exclaims, 'Penthea! / O, thou hast pleaded with a powerful language!' (4.1.57–8). His remark registers the heightened histrionism of Penthea's character: her efficacious acting distinguishes Ford's dynamic conception of female heroism from the stoic endurance of Webster's Duchess.

Penthea's description of her brain as 'infected' suggests a mind corroded by suffering. The juxtaposition of Penthea's 'infected brain' with her active assistance of Ithocles hints at the ambivalence surrounding her advancement of her brother's love. This ambivalence is captured in Penthea's expression of unity between herself and Ithocles before her pledge to find out an 'active strain' to help him:

> We are reconcil'd.
> Alas, sir, being children, but two branches
> Of one stock, 'tis not fit we should divide.
> Have comfort; you may find it.
>
> (3.2.111–14)

Several critics have interpreted the 'comfort' Penthea promises Ithocles not in terms of her willingness to help him, but as an expression of her desire for retribution.[65] But the inferential argument about Penthea's hostile motivation in approaching Calantha on Ithocles's behalf makes a matter of certainty what the text leaves opaque. This opacity is evoked in the song accompanied by 'soft music' which issues from Ithocles's chamber at the start of Act 3, before the discovery of Ithocles and Penthea seated on a chair. The lyric's opening lines, '*Can you paint a thought? Or number / Every fancy in a slumber?*' (3.2.1–2), gesture to the complexity of thought and motive witnessed in the encounter between brother and sister, a psychological complexity beyond representation. It is not until Penthea's mad scene that the motives compressed in her suing to Calantha receive their most resonant articulation.

At the start of this section, I proposed that Penthea's invocation of the sirens rings a uniquely Fordian change on the Elizabethan stage convention of feminine madness. The poetic combination of music and madness has a theatrical precedent in the stage direction of the First Quarto of *Hamlet*, in which Ophelia enters '*playing on a lute, and her hair down, singing*'.[66] In this text of Shakespeare's tragedy, Ophelia's singing and lute-playing soften the bizarre or 'antic' quality of her madness, which has

been evoked earlier by Horatio's description of her beating her heart, and 'her winks and nods and gestures' (4.5.11). What sets Ford's dramaturgy apart from previous playwrights' is the striking sobriety of Penthea's madness. Unlike the portraits of Ophelia and the Jailer's Daughter, Penthea's speech is not interrupted by snatches of song. Arguably it is *because* Penthea's madness is conveyed in sonorous blank verse that her discourse penetrates in its effects beyond the stylized set-piece of dis-tracted femininity, leaving the on- and offstage audiences irreparably affected. Ford's scripting of Penthea's mental disturbance skirts the boundary between madness as a choric music and madness as an aural and visual image of disorder.[67]

Nor is the music of Penthea's madness necessarily singular, or exclu-sively feminine. Dorothy Farr interprets Penthea's image of sirens singing 'one . . . another's knell' as an apt vision of the leading 'persons in the play', adducing that 'Penthea's fate is the first of a series of deaths, all interdependent'.[68] Farr sees Penthea as articulating a communal tragic vision. Her reading is supported by Ford's orchestration of Act 4, scene 2 as an ensemble scene, so concentrating the emotion aroused by Penthea's insanity. As if Penthea's diseased histrionism were genuinely contagious, her spectators respond by over(re)acting. Bassanes, who believes his frenzied jealousy has caused Penthea to lose his mind, calls down tortures upon himself, leading Orgilus to compare him to an 'antic rapture', or ham actor.[69] This theatrical imagery is carried through in Bassanes's acceptance of Orgilus's bitter reproaches as a 'talking motion [i.e., a puppet] / Provided for my torment'. Bassanes's subsequent vow to hold his breath and not 'speak a word' also has a histrionic quality, like the threat of a cantankerous child.

Penthea's madness resembles Ophelia's in the symbolic gesture and poetic language through which she communicates knowledge and feelings that add profound resonance to her tragedy. Her mad utterances are divided between her love for Orgilus, her father's death and his approval of the match, and what she calls 'the forfeit / Of noble shame' (4.2.149–50) stemming from her enforced marriage to Bassanes. But, unlike Ophelia, the sense of grievance harboured by Penthea sharpens her awareness of herself as a victim. While Ophelia's popular songs suggest her anxiety about her chastity, mingled with desire, for Penthea the loss of her chastity is an irrevocable certainty. Her 'aria of frustration'[70] describing the 'pretty prattling babes' to which she might have been mother, ends with the simple truth, ''tis not my fault' (4.2.94). Her gentle flirtation with Orgilus, accompanied by her wringing and kissing of his hand,

evokes the couple's lost happiness with a mimicry redolent of Hamlet's 'very ecstasy of love' (2.1.103). Penthea's evocation of her vanished opportunity for a union 'without jars' leads her to focus on Ithocles as the man who prevented the consummation of her wished-for marriage, and as the subject of a newly sprung love:

> But that is he;
> *Points at* ITHOCLES.
> And yet he paid for't home. Alas, his heart
> Is crept into the cabinet of the princess . . .
> That's he, and still 'tis he.
>
> (4.2.116–22)

In *Hamlet* Laertes's mere witnessing of Ophelia's madness spurs him to seek revenge on Hamlet for the death of Polonius; in *The Broken Heart* Penthea's incriminatory language, and her pointing finger, are read by Orgilus as an 'oracle' (4.2.133). Yet to see Penthea's speech and gesture here as strategic, that is, to view Penthea as intentionally planting the idea of revenge in Orgilus's mind, is to misrecognize the tragic irony of her acting.[71] Her mad speech encompasses a forceful rhetoric, the effects of which she is powerless to monitor.[72] Significantly, it is *after* Orgilus has exited that Penthea utters her most vehement denunciation of Ithocles and Bassanes:

> O, my wrack'd honour, ruin'd by those tyrants,
> A cruel brother, and a desperate dotage!
> There is no peace left for a ravish'd wife
> Widow'd by lawless marriage; to all memory
> Penthea's, poor Penthea's name is strumpeted.
>
> (4.3.144–8)

Penthea's self-reviling in this speech leads on from her description of herself as 'a spotted whore' in her interview with Ithocles (3.2.70). Yet joined to her sense of bodily corruption is her indictment of Ithocles and Bassanes as collaborators in her ruin. Her punitive resolve to drain her blood of the 'pollution' flowing from her marriage to Bassanes subtly evokes the self-willed bloodletting of the Roman Lucrece, the archetypal 'ravished wife'. What is distinct about Penthea's experience of violation is that it emanates from within the bonds of kin. Penthea's 'tyrants' are peculiarly her own – Ithocles and Bassanes, 'A cruel brother, and a desperate dotage'. Her injunction to 'Starve' (4.2.152) represents a repulsion of self, a self whose paradoxical 'fullness' can no longer be constrained by language. The collapse of her speech is followed by her

physical collapse, while the negation to which she is wedded expresses itself in her parting couplet: 'Griefs are sure friends; they leave, without control, / Nor cure nor comforts for a leprous soul' (4.2.168–9).

Penthea's declamation against Ithocles, Bassanes and herself comprises her most forceful utterance in the tragedy. Paradoxically, her most cogent outcry communicates her pathological disturbance, in her determination to starve her blood of 'taste of sustenance' (4.2.152). This self-destructive resolve embodies the paradox attendant on Penthea's role as an actor, a paradox which makes problematic the comparison between her 'strength of will and resourcefulness' and those of Shakespeare's heroines.[73] In her encounters with Orgilus, Ithocles and Calantha, Penthea employs an 'active strain'; but in all three scenes her rhetorical agency is accompanied by emotional repression. In this scene the enormity of that repression is displayed in Penthea's distraught demeanour, her unabashed courting of Orgilus, her accusatory pointing at Ithocles and her hysterical self-sentencing, climaxing in her faint. To the other characters Penthea is a 'wrong'd lady' (3.5.110), a 'griev'd beauty' (4.2.126); to the audience she is a victim made all the more disturbing by her vocal insistence.

* * *

The psychological complexity and transgressive power of Penthea's madness is complemented by Stuart tragedies depicting women who more spectacularly tread the border between reason and insanity. Like Ford's drama, these plays are theatrically reflexive, but their self-consciousness arises from women's dissembling of madness so as to advance or obstruct the tragic plot. This section compares the function of such feigning madwomen in Richards's *The Tragedy of Messallina* and Shirley's greatest tragedy, *The Cardinal* (1641).

'MADNESS BE MY MASQUE': DISTRACTION AND DISSEMBLING

In Richards's play Messallina's mother, Lepida, dissimulates madness after a bout of genuine insanity brought on by the myriad atrocities and filial disregard of her daughter. In its causes Lepida's madness is closer to King Lear's than to the madness of earlier mothers in tragedies by Kyd and Webster, whose distraction follows from their childrens' deaths.[74] Lepida is the most interesting, because conflicted, character in the play, loving her daughter but hating her 'desp'rate crimes' (986). Her sensitivity to evil is suggested by her appearance at the start of Act 2, '*in her night*

attire with a Booke and a lighted Taper' (676–7), having arisen to pray after a premonition that Messallina will perpetrate another crime. Almost immediately Lepida witnesses the brutal murders of three Roman dames who, refusing to join in the debauchery at the imperial court, flee to her house for succour with their pursuers hot on their heels. Confronting her daughter and her 'Chiefe of Counsel', Saufellus, Lepida hurls curses at them, telling Messallina that the dames' 'innocent blood like th'Atlantick sea / Lookes red with murder' (977–8). The faint echo of Macbeth's 'the multitudinous seas incarnadine' accentuates Lepida's compassion, while her daughter's obtuseness is marked by a misquotation from *Macbeth* in her retort: 'Beldame give o'er . . . ther's nothing done that's wisht undone by us' (982–3).[75]

Richards milks the pathos inspired by a 'mothers teares' in a tableau where Lepida, after her peremptory dismissal by Messallina, returns, and making '[her] foot [her] head' (1024), kneels and pleads with her daughter to desist from her evil path. Like Calantha moved by Penthea's pleading for Ithocles, Messallina 'begin[s] to melt' (1051), but Saufellus's curt rejection of Lepida's 'idle superstitious lecturing' (1055) stamps out the flicker of filial compunction. This scene seems to promise, but then withholds from the audience, a moving reconcilation between a mother and daughter such as occurs between Gratiana and Castiza in the subplot of Middleton's *The Revenger's Tragedy* (1606, pub. 1607).[76] Instead, left alone on stage, Lepida gradually realizes that Messallina is lost to her. The language in which Lepida express her bewilderment echoes Shakespearean fathers similarly surprised by their daughters' actions: 'It cannot be, nature against it selfe / Should so rebell' (1065–7).[77] Overcome by despair, Lepida attempts vainly to summon her own death, 'Crack, crack poore heart' (1075), clearly imitating Calantha's successful command. Her failure elicits an extraordinary pastiche of the tragic deliriums enacted by King Lear and Doctor Faustus:

> *Parcae* dispatch; when, when I say; no, no,
> *Falls distracted.*
> Then will I act Medea's murdr'ing part
> Upon my staine of blood; that gods and men
> May sit and laugh, and plaudite my revenge.
> (1079–83)

One wonders at the precocity of Thomas Jordan, the boy actor who played Lepida, in eliciting from Richards such a virtuoso display piece.[78] Jordan's mimetic authority grows more commanding in the last act as

Lepida spearheads a current of action against the slaughter pursued by Messallina. Observing Saufellus and his cohorts plotting in a corner after the bigamous wedding of Messallina to her favourite, Silius, Lepida, restored to sanity by divine intervention, counterfeits sleep so as to eavesdrop, declaring 'madnesse be my Maske' (1874). To her horror, she hears that Messallina has ordered Rome's vestal virgins to be impressed as actors in her wedding revels, as their rape and murder will 'prove an excellent closing to the Masque' (2144). Lepida's counterplot involves secreting the 'hundred vestall virgins' (1970)[79] in a 'spacious vault' (1979) in her house by means of a 'back secret way' (1981) connecting her residence to the vestals' temple. To the virgins' matron she describes her stratagem as 'a wretched shift / This wretched Age enforces' (2103–4). Richards uses the escape plan to orchestrate the kind of suspense which structures David Fincher's cinematic thriller *Panic Room* (2002), where a recently divorced mother and her daughter enclose themselves in an impenetrable room in their Manhattan townhouse, in retreat from three male intruders. In Richards's play, while the matron and Lepida salute their 'mother earth' in a gesture of thanks for the virgins' safety, '*a Noyse within of Follow, follow, follow*' (2132–3) signals an imminent break-in. After the women fly to the vault, Saufellus and two thugs, Hem and Stitch, appear on stage determined to hunt out 'the chaste puppets' (2142). To claps of thunder and lightning, the earth gapes to swallow up the three murderers 'by degrees', while for good measure Saufellus is shot with a thunderbolt. One can almost hear the audience cheering! The Salisbury Court spectators would have been applauding not just the pyrotechnics of the gods' judgement, but the ingenuity and courage of a mother whose sense of virtue and justice surmounts the bonds of nature.

Lepida's feigning of madness allows her to operate politically with impunity, as Hamlet intends his 'antic disposition' to conceal his deliberations over whether, when and how to avenge Old Hamlet's murder. Her description of her plot to save the virgins as a 'wretched shift' implies a critical view of her own intrigue, as if women should scheme and strategize only as a last resort. This moral ambiguity attached to women's shifts forms a focus of Shirley's *The Cardinal*, in which Duchess Rosaura similarly decides to 'pretend my brain with grief distracted' to plot revenge on the men responsible for the murder of her second husband, Count d'Alvarez.[80] Shirley's tragedy powerfully exposes the degree to which, under a patriarchal government, art and performance are constitutive of noble womanhood.

An opening exchange between two lords succinctly establishes Rosaura's predicament. Like Penthea, the Duchess lives in a state of self-division, arising from the King of Navarre's frustration of her choice of a second husband, after the death of the young Duke Mendoza 'left her a virgin and a widow' (1.1.6):

> 2 LORD: How does the Duchess bear herself?
> 1 LORD: She moves by the rapture of another wheel
> That must be obeyed; like some sad passenger,
> That looks upon the coast his wishes fly to,
> But is transported by an adverse wind,
> Sometimes a churlish pilot.
>
> (1.1.44–9)

The Second Lord's enquiry about the Duchess's demeanour constructs her identity as the effect of a courtly regime of observation and performance. This analysis of court society is confirmed by the interactions in Act 1, scene 2 between the Duchess and two ladies, Valeria and Celinda. Urged by the women to abandon her reflectiveness, Rosaura turns to predictably idle talk, asking Valeria, 'who has thy vote for the most handome man [at court]?', but murmuring in an aside, 'Thus must I counterfeit a peace, when all / Within me is at mutiny' (1.2.26–8). Rosaura's defence of the 'dark thoughts' (1.2.13) which remain with her creates a generalized echo of the second scene of *Hamlet*, in which Gertrude urges her son to 'cast [his] nightly colour off' (1.2.68). The echo is established only to be subverted, for Rosaura's melancholy derives not, as she declares, from memories of her former husband, but from the conflict between her love for Alvarez, to whom she was betrothed, and her imminent marriage to Columbo, the Cardinal's valiant nephew and the King's choice. Rather than concealing her feelings, as Rosaura intends, the speculation on the sexual attractiveness of male courtiers which she instigates works to reveal them, for her discontent at Celinda's praising of Columbo is noted aside by Valeria: 'she affects him not' (1.2.50).

Images of shifting effect a contrast between the trivial desire of Celinda for Columbo and Rosaura's beleaguered desire to uphold her vows to Alvarez. While the Duchess romantically wishes she could 'shift into / A meaner blood' (1.2.200–1) to evade the King's control over her marriage, Celinda's chat with Valeria as Columbo leaves the court on a military action signals her desire to switch clothes, and beds:

> CELINDA: Do such men
> Lie with their pages?
> VALERIA: Wouldst thou make a shift?

CELINDA: He is going to a bloody business;
'Tis pity he should die without some heir;
That lady were hard-hearted now that would
Not help posterity, for the mere good
O'th' king and the commonwealth.
<div align="right">(1.2.139–46)</div>

The moral fallibility signified through Celinda's smalltalk in this scene works implicitly to frame Rosaura's morally questionable performances. As Antonio, the Duchess's secretary, later figures Celinda as a book replete with 'errata' (5.2.26), so Rosaura's body is represented as inherently deceitful through the insincere tears she weeps on Columbo's departure to fight the Aragonians. The Cardinal marks the Duchess's demeanour, 'she appears sad / To part with him', interpreting her feigned sorrow as an encouraging sign of her love for his nephew (1.2.132). The audience is assured of Rosaura's intentions when, alone, she asks forgiveness from 'virtue' for her dissembling, swearing, 'I have not a thought / To tempt or betray [Columbo], but secure / The promise I first made to love and honour' (1.2.153–5). This concern of Rosaura to exonerate herself from the culpability and consequences of her feigning is reminiscent of the concern with her virtue displayed by Montagu's fiction-weaving Gemella in *The Shepherds' Paradise*. In both cases it is a king's improper use of his power which obliges the women to fabricate personae at odds with their natures.

As a body and identity constructed by a patriarchal court, Rosaura transmits misleading messages. Her awareness of herself as a text to be read is conveyed in her helplessness as Alvarez is admitted to her chamber, after Columbo's official departure:

How shall I
Behave my looks? The guilt of my neglect,
. . . will call up blood
To write upon my cheeks the shame and story
In some red letter.
<div align="right">(1.2.157–61)</div>

Rosaura's fear about her potential guilty blush reiterates the anxiety about women's involuntarily self-betraying bodies which I noted in earlier chapters in several Stuart plays scripted or performed by women. In *The Cardinal* Shirley amplifies the representation of women in Stuart tragedy, from texts to be read to authors of texts which signify in similarly ambivalent ways to women's bodies. It is the Duchess's 'hand' (2.1.97) in the literary sense which sets in motion the rising tragic action, in a letter she writes to Columbo asking that he resign his interest in her 'person',

'promise' and 'love'. Columbo feels his honour called into question by Rosaura's request, but on being reassured by Antonio of her serenity as she was writing, he interprets her letter as 'a device to hasten my return' (2.1.128), and composes what he thinks is a similarly ironic discharge of his pretentions to Rosaura's love.

In construing the Duchess's letter as a loving 'device', Columbo evinces as proof of her affection her demonstrative sorrow upon his departure: 'She expressed a trouble in her when I took / My leave, and chid me with a sullen eye' (2.1.126–7). When Columbo receives letters from the Cardinal informing him of Rosaura's subsequent marriage to Count d'Alvarez, he realizes that what he read as expressive of Rosaura's love was dissimulated. Thus Columbo presents Rosaura's letter to the King after his murder of Alvarez as evidence of Rosaura's 'juggling witchcraft' in seeking a written release from her betrothal. At issue is Columbo's honour, which Rosaura's letter made hinge upon his compliance with her wish, for only then might Columbo 'with safety of his fame, visit again the lost Rosaura' (3.2.154–5). Columbo defends his murder of Alvarez to the King as just requital for what he sees as Alvarez's and Rosaura's conspiracy 'to kill the soul of all my fame' (3.2.129). His defence is backed up by the Cardinal who describes Rosaura's letter as a 'cunning writ', an attempt 'to ruin [Columbo] with . . . scandal and contempt' (3.2.172, 176–7).

The Cardinal's description of Rosaura's literary art posits her letter as a textual parallel to the sirens' alluring, destructive song.[81] The boldness of Rosaura's shift is enhanced by the fact that she writes the letter independently of Alvarez's knowledge. Both the Duchess's letter, and Columbo's reply, are read aloud in court, but while Columbo's release of Rosaura from their engagement admits only one meaning, Rosaura's writing is ringed around with nuances of subtle 'arts and windings' (2.3.92) on a par with her counterfeiting of a lover's emotion.[82] Rosaura herself acknowledges that her letter is ambiguous in a soliloquy where she contemplates her destiny, hoping that Columbo 'will scorn to own what comes with murmur, *if he can / Interpret me so happily*' (2.2.23–5, emphasis mine).

Although the King of Navarre judges Rosaura to have been 'the cause of your own sorrows' (3.2.179), he distributes the guilt for Alvarez's death between the Duchess, himself and Columbo, averring that he 'did exceed the office of a king / To exercise dominion over hearts / That owe to the prerogative of heaven / Their choice, or separation' (3.2.185–8). The King's naming himself as 'a lateral agent' (3.2.190) in Alvarez's and Rosaura's demise is recalled in Rosaura's magnanimous gesture towards him as she dies: 'Your hand, great sir, and though you be a king, we may

exchange forgiveness' (5.3.289–90). The echo of Laertes's dying gesture towards Hamlet inflects Rosaura's last speech with a heroism and nobility which is sustained in her ardent call, 'I come, I come, Alvarez.'[83] While in such moments Shirley strives to capture the grandeur of an older dramatic tradition, it is in fact the very ordinariness of his characters and the plainness of his diction that gives his drama its subversive import. Both the King's admission of guilt in constraining Rosaura's choice, and Rosaura's final words discreetly drive home the fallibility of 'divine' monarchs.

If Shirley's tragedy contributes to the undermining of Stuart absolutism, the machinations of its protagonist further weaken the idea of the king as a political monolith. Shirley explicitly alludes to the political activities of the French Cardinal Richelieu in the prologue, thereby enhancing his play's topical appeal.[84] The most exciting scenes of the play are those which bring together the Duchess and the Cardinal, who seeks first to advance his own kindred by fostering the marriage of Columbo to the Duchess, and, after Columbo's death, to avenge himself on the Duchess through her rape and murder. One of the resemblances between the plots of *The Cardinal* and Kyd's *The Spanish Tragedy* is Shirley's provision of the Duchess with an accomplice to aid her in revenging the murder of her love, after the King fails to realize his promise to Rosaura to punish Columbo's crime.[85] It is Hernando, a colonel in the army, who kills Columbo in a duel, avenging at once the murder of a 'good man', Alvarez (4.2.164), and his humiliating dismissal by the general for counselling patience rather than outright attack in the conflict with the Aragonians. Yet it is the verbal 'controversy' (3.1.49) between Rosaura and the Cardinal, rather than the duel fought later by Hernando and Columbo, which rivets the audience's attention. This scene produces a fascinating symmetry between the Duchess's uncertain fame and the Cardinal's corrupt management of the church. The Cardinal's accusation of Rosaura's 'licence' in rejecting Columbo for a man of a 'softer cheek', 'wanton hair' and a concern for his appearance betrays an abhorrence of self-adornment which is a feature of contemporary antitheatrical discourse: Alvarez, the Cardinal alleges, will 'bring more effeminacy than man / Or honour to [Rosaura's] bed' (3.2.113–14).

Significantly, the Cardinal's querying of the Duchess's fame, and his sneer, 'you are no dissembling lady', do not elicit Rosaura's blanket denial; rather, her retort, 'would all your actions had no false lights', insinuates that the Cardinal's political misconduct is more damaging than her venial faults (2.3.133–5). The intellectual energy of all Shirley's witty

women is condensed in Rosaura's attack on the Cardinal's pride, avarice and 'abuse of the king's ear! / At which you hang a pendant, / Not to adorn, but ulcerate' (2.3.145–7). Her portrayal of a feminized, wounded church cowering for shelter 'within your reverend purples' (163) turns back on her antagonist his valorized language of martial glory, figuring his 'crimes' (2.3.141) in terms of rape and depredation. In parting, the Duchess exhorts the Cardinal to 'behold yourself / In a true glass, and see those injust acts / That so deform you . . . before the short-haired men / Do crowd and call for justice' (2.3.164–8). The Duchess's reference to the Puritan faction and her plea to the highest member of the clergy for his moral and political reform demonstrate Shirley's concern about the direction in which the Anglican church under Archbishop Laud was headed; the speech also powerfully dramatizes a woman exercising independent judgement and offering political counsel.[86]

The forceful 'spirit' and 'angry tongue' displayed by the Duchess in this scene are consistent with her representation as an efficacious actor, in both the theatrical and pragmatic senses of the word. Yet at the same time as Rosaura portrays herself 'busy to revenge [Alvarez's] ghost' (4.2.324), she tells Hernando that her hand is 'too weak . . . alone' to effect Columbo's murder (4.2.157). E. M. Yearling draws a persuasive parallel between Rosaura and the historical Lady Anne Halkett, as women 'caught between the tradition of female submissiveness and new ideas of independence and personal decision'.[87] This tension between Rosaura's bold initiative and her feminine dependence informs Shirley's working out of the mutual urges to vengeance of Rosaura and the Cardinal after Hernando's killing of Columbo in a duel. As the Cardinal sees Hernando as the Duchess's 'agent' in Columbo's death, so Rosaura believes the Cardinal complicit in Alvarez's murder and Columbo's pardon. While seeming appeased when the Cardinal protests his abhorrence, and innocence, of Columbo's cold-blooded killing of Alvarez, when alone, Rosaura scoffs at his claims, and reasserts her will to revenge as a 'wronged widow' (4.2.313).

The degree of the Cardinal's vicarious guilt is uncertain. Before Act 5 the Cardinal has appeared power-hungry, cunning and abrasive in his dealings with the Duchess and Hernando, but unlike Webster's Cardinal in *The Duchess of Malfi*, he is not portrayed as Machiavellian. After Rosaura's madness his character beomes positively ghoulish, as he con-templates rifling Rosaura's 'darling chastity' as a prelude to her murder, gloating that 'she's now within my talons' (5.1.91, 88). The Cardinal refers to the King's assigning him the role of Rosaura's guardian after the onset of her madness, a madness which the audience assumes is a strategic

pretence, having heard Rosaura's plan for avenging herself on the Cardinal in her soliloquy after his conciliatory visit. Act 5, however, shows the Duchess caught up in a picturesquely rambling grief, from which she emerges at intervals into a more lucid state. Antonio and the two lords note with ironic discontent the infantile quality of Rosaura's madness, commenting that a violent passion would prove a more effective façade for her vengeance on the Cardinal. In one sense Rosaura's distraction is a variation on Hamlet's 'antic disposition', in that it is a performative madness generated by an extreme emotion. But Rosaura's position as the dependent of the Cardinal, in contrast to Hamlet's status as a prince (albeit a prince whose liberty of action Claudius tries to circumscribe), limits the active scope of her madness. A more fruitful comparison is with Webster's imprisoned Duchess of Malfi, who, like Rosaura, has recourse to deceit in negotiating the patriarchal constraints on her life.[88]

The most significant difference between Webster's and Shirley's Duchesses is Shirley's contriving to keep Rosaura a 'virgin, wife and widow' (4.3.107) through the murder of Alvarez in the masque intended to celebrate the couple's marriage. By contrast, the Duchess of Malfi is a sexually active wife who in the course of the play produces three children by her second husband, Antonio. In the fourth act of Webster's play, the Duchess bravely withstands her protracted mental tormenting by Bosola at the behest of her brothers; she moves through anger and despair to meet her brutal death with a mixture of humility and resolve. In contrast, Rosaura's weakened mental state creates a sentimental image of female vulnerability and sensuality. When we first see her in Act 5, scene 3, having heard several reports of her madness, her mind flits between thoughts of Alvarez, fearfulness of the Cardinal and a pathetically loving attachment to Hernando, who after fleeing Navarre in the wake of his duel with Columbo has returned to execute the second part of the Duchess's revenge. In the ensuing action Shirley deploys Caroline pastoralism to construct a *mise en scène* of threatened virginity. Rosaura exits to sup with the Cardinal, leaving Hernando alone on stage. The sound of a lute introduces a pastoral dialogue of erotic flirtation between a man and a woman sung offstage; as Hernando remarks, this is 'not / Church music' (5.3.119–20) but one of the wanton airs which so offended William Prynne.

The lyric 'Come, my Daphne, come away', set by the court composer William Lawes, is described by Julia Wood as 'horribly ironic in effect, given the Cardinal's savage intentions'.[89] The song is part of the Cardinal's creation of a mellow ambience in the midst of which he intends to take the Duchess by surprise. It resonates with Rosaura's mood, for at the start

of the scene she reminisces to Hernando about the sweetness of Alvarez's singing voice. The song's eroticism, with its compliant Daphne, and a Strephon who sings of losing his way in the 'warm snow' (5.3.113) of Daphne's bosom, anticipates the Cardinal's situation; intending a rape, he finds that Rosaura 'is now the object of my amorous sense' (5.3.151). The kisses the Cardinal steals from Rosaura work on him like 'a strong enchantment' (5.3.152), and the scene of seduction turns to an attempted rape, averted by Hernando, who in a reprise of Bonario in *Volpone*, leaps out from behind the arras where he had hidden. In the catastrophe the Cardinal is stabbed by Hernando, who dies in the ensuing scuffle with the Cardinal's servants. Before he dies the Cardinal, now 'a Borgia, not a Richelieu', pretends to have poisoned the Duchess and offers her an antidote which is in fact a poison, of which he also drinks, wrongly believing his wounds to be mortal.[90]

The final act of *The Cardinal* has been accused of 'a weakening in conception', especially for the manner in which 'characters who have been gray throughout the drama suddenly part into black and white'.[91] The play's shift from ethical questions to Fletcherian melodrama accords with Shirley's Caroline aesthetic and his dramaturgical priorities. Chief among these was an appeal to women: Rosaura's sexual inexperience, her personalized name and her sense of agency are features of her characterization designed to endear the female audience, whose tastes for 'romance [and] direful tragedy' Shirley acknowledges in his prologue (line 14). The denouement attributes some of the responsibility for Hernando's revenge to the 'nimble Duchess' (5.3.255); the Cardinal chafes at being 'bandied out o'th' world by a woman's plot' (5.3.192), while Rosaura, finding her 'brain return', declares of her madness to the King, 'that shape I did usurp . . . to give / My art more freedom and defence' (5.3.248–9). These details belie the earlier evidence of the Duchess's 'straggled wits'; yet in spite of this confused handling of the play's final movement, Shirley deserves recognition for developing a woman's role in a revenge action beyond the elegiac, echoic presence of Webster's murdered Duchess.

'QUEEN OVER HER PASSION': SELF-SOVEREIGNTY AND THE ARTS OF DEATH

At the outset of this chapter, I invoked the image of Shakespeare's Cordelia as 'a queen over her passion' as an analogy for Ford's theatrical animation of Calantha's death. The First Gentleman's description of 'an

ample tear trill[ing] down / [Cordelia's] delicate cheek' is a rarefied image of the self-betraying female body, more commonly depicted in Renaissance drama in grotesque, morally dubious terms. When Othello strikes Desdemona her tears signify for him the epitome of feminine dissimulation: 'If that the earth could teem with woman's tears, / Each drop she falls would prove a crocodile' (4.1.245–6). I have argued that one of the distinctive features of Caroline tragedy is an intensified, and incipiently sympathetic, focus on women's sensuality. This proposition is contentious, particularly in light of recent readings of *The Broken Heart* which have highlighted the way that Ford's dramaturgy works to silence the body and the 'passional self'.[92] This final section examines the emotional forces and the aesthetic imperatives that shape the deaths of women in the plays I have been exploring.

Although his play is freighted with spectacular scenes of violence, torture and lust, Nathanael Richards keeps something in reserve for the 'dance of death' (2249) whereby Messallina and the men who have become her creatures meet their demise. The bigamous pair of Messallina and Silius celebrate their combined wedding and coronation by performing together in a masque. After an antimasque of '*eight Bachinalians*', to '*solemne Musicke playing:* Messallina *and* Silius *gloriously crown'd in an Arch-glitering Cloud aloft, Court each other*'. The pair serenade one another in verse that is ripe with the joys of sensual love:

> SILIUS: Amazing rarity, beauties treasure.
> EMPRESSE: Natures wonder, my delight, my pleasure.
> SILIUS: Let me suck Nectar, kisse, kisse, O kisse me.
> EMPRESSE: Soule to my lips, embrace, hug, hug me.
> SILIUS: Leap heart.
> EMPRESSE: Mount blood.
> SILIUS: Thus rellish all my blisse.
> EMPRESSE: Agen the pressure of that melting kisse.
>
> (2213–20)

The dialogue is a workmanlike version of the sublime duet between Nero and Poppea celebrating their equally illicit marriage in the last act of Monteverdi's opera, *L'Incoronazione di Poppea* (1637). The meretriciousness of the entertainment is underlined by the presence of '*three Curtezans in the habit of Queenes*' who after the couple's descent present them with '*Coronets of state*'. The dissolution of the marriage, and of Messallina's corrupt reign, is foreboded by an '*Alarum within*' heard at the conclusion of the wedding dance; while Messallina flies, Silius stays to meet his fate at the hands of the Emperor Claudius's soldiers. The redemptive force of

virtuous womanhood is asserted at Silius's death by his longsuffering wife, Syllana, who describes Silius to Claudius as 'this husband wrought by the *Circean* / Charmes of thy she divell' (2400–1). Syllana voluntarily expires over Silius's body, in another death seemingly influenced by Calantha's autonomous dying:

> Breake heart, swell griefe,
> And mount me to my love; I neede not I,
> The burning coales of *Portia*, *Lucrece* knife,
> One kisse wilt do't, thus ends Syllana's life.
> (2431–4)

If Syllana's death revises the tradition of classical heroism, the death of Messallina bears traces of the ends of Elizabethan villain heroes such as Shakespeare's Richard III and Marlowe's Barabas. Buoyed by the news that Lepida's friend, Vibidia, has gained her a day's hearing with Claudius, Messallina contemplates the 'rich *Revenge*' she will take on her husband after the reconciliation she aims to contrive, but her thoughts are arrested by two spirits who sing a song of despair, '*during which Lepida sits weeping*' (2520). When the ghosts of Messallina's murder victims surround her with torches, the vision elicits her acknowledgement, '''Tis true, I was your deaths chiefe Actor' (2550), but notwithstanding Lepida's pleas, her daughter will not repent. The entrance of a '*Headsman with Scaffold and a Guard*' heralds a shift of mood suggested by Messallina's admission that 'I . . . have liv'd too long' (2584), and her contemplation of where death will carry her. These details seem to lead naturally to Messallina mounting the block and declining her head, yet at the last minute Richards's protagonist '*suddainly rising up leaps downe, Snatcheth* Evodius *Sword and woundes her selfe*'. The Marlovian energy displayed in Messallina's last shift is more convincing than her filial recognition of Lepida, the triteness of which is superseded by a chilling endnote:

> Farewell, deare, deare Mother.
> Had I been rul'd by you, I had beene happy . . .
> A Caitiffe most accurst she is no other
> That scornes the vertuous counsells of a Mother;
> So farewell light of eyes, ne'r to intice,
> Horrour invades my blood, I am all Ice.
> (2605–11)

In the warmth of regretful filial feeling which Richards invokes, his tragedy contrasts interestingly with the alienated mother-daughter

relationship described by the messenger in Cary's *The Tragedy of Mariam*, who informs King Herod, and the reader, of Mariam's death on the scaffold. As Mariam processed through 'the curious gazing troop', her mother Alexandra 'did upon her daughter loudly rail', upbraiding her for her disobedience to Herod. Mariam demonstrates her stoicism by refraining to answer, yet she smiled 'a dutiful, though scornful smile'.[93] This Janus-like feat of expression is the nearest Cary's heroine approaches to doubleness.

In Ford's tragedies musical and theatrical elements lend an operatic colouring to the plays' handling of women's deaths. The death by starvation of Penthea in *The Broken Heart* exacerbates her paradoxical role as actor and victim. In Act 3, scene 5 Penthea presents her death to Calantha as an affirmative action: 'I must leave the world / To revel in Elysium' (95–6). The first indication of Penthea's death is the '*soft sad music [and] a song*' which issue from her lodgings at court:

> *Love is dead; let lovers' eyes,*
> *Lock'd in endless dreams . . .*
> *Ope no more, for now love dies . . .*
> > *implying*
> *Love's martyrs must be ever, ever dying.*
> > (4.3.148–53)

The solemnity conveyed by the offstage performance of this 'deathful air' recurs in Philema's and Chrystalla's account of Penthea's death:

> PHILEMA: She call'd for music,
> And begg'd some gentle voice to tune a farewell
> To life and griefs. Chrystalla touched the lute;
> I wept the funeral song.
> CHRYSTALLA: Which scarce was ended,
> But her last breath seal'd up these hollow sounds,
> 'O cruel Ithocles, and injur'd Orgilus!'
> So down she drew her veil.
> > (4.4.4–10)

Here, as earlier in the play, music is associated with Penthea's withdrawal from the world, its performance gesturing to her desire for a harmony located elsewhere.[94] The dissonant strain in this music is Penthea's final utterance, naming Ithocles as the perpetrator, and Orgilus as the victim of her tragedy. As heard in the play, Penthea's song has a ceremonial and a strategic function. Assimilated into Orgilus's plot of revenge, Philema's singing becomes a siren's lure, drawing Ithocles on to

his death. As Orgilus reveals to Ithocles after trapping him in a trick-chair, 'I foreknew / The last act of [Penthea's] life, and train'd thee hither / To sacrifice a tyrant to a turtle' (4.4.27–9).

Orgilus's reference to 'The last act of [Penthea's] life' presents her death as a heroic performance, albeit one which – unlike the deaths of Ithocles, Orgilus and Calantha – the audience does not witness. Like Emily Brontë, Penthea dies sitting upright, in a chair; an attitude both patient and fiercely determined. It is in this chair that the dead, veiled Penthea is carried on stage by Chrystalla and Philema at the start of Act 4, scene 4. The seating of Penthea's corpse between the captured Ithocles and Orgilus, her brother and her betrothed, encapsulates her tragically divided loyalties. By raising Penthea's veil Orgilus reopens 'the matter of Ithocles' tyranny', presenting Penthea's figure as an emblem of wasted beauty.[95] Richard Madelaine comments of Orgilus's discovery of Penthea, 'Since Hymen carries a veil as well as a torch, Orgilus's raising of Penthea's veil . . . has a bitterly-ironic hymeneal association connected with his vacating a chair at her side to act the part of her avenger.'[96] As both sister and bride-to-have-been, to which side does Penthea incline as a witness of Orgilus's action? Clifford Leech envisages Penthea after her death as 'a monument indeed, patiently waiting for revenge'.[97] In this reading Penthea becomes a vicarious participant in Orgilus's murder of Ithocles. But Orgilus's enlisting of Penthea as a witness of his revenge may equally well be seen as the apotheosis of her victimization, the moment in which, in the strongest sense, she is made a prey to someone else's meaning. This view is supported by Ithocles's lack of response upon Orgilus's demonstrative unveiling of Penthea's corpse. Instead, his statement, 'Thou mean'st to kill me basely' (4.4.27) shifts the focus of the scene on to the conflict between the two men, leaving Penthea a mere stage property. Her frozen figure is an image of a 'hollow woman', her role that of a pawn in a tragedy which, arguably, 'when sane' – and alive – she 'would have done anything to prevent'.[98]

Orgilus's device of the trick-chair demonstrates a difference to which I drew attention earlier, between a theatricality which trades in disguises and props and the intensified inward division of Ford's female characters. In the cases of Penthea and Euphrania, Ford represents their psychological self-division as originating in the repressive force of patriarchal tradition. Calantha, however, represents women as naturally divided in her request to the Spartan court for assistance to govern:

A woman has enough to govern wisely
Her own demeanours, passions, and divisions.
A nation, warlike and inur'd to practice
Of policy and labour, cannot brook
A feminate authority.

 (5.3.8–12)

This image of woman as the equivalent of a broken consort is contradicted by Calantha's reticence through the course of the play. As rhetoric her speech is strategic, for it allows her to open a dialogue with Prince Nearchus about conditions for a marriage between them. Yet the theme of female self-governance is a key concern of the play. Calantha's behaviour is at once exemplary of aristocratic manners, and in its extremism, an instance of the crushing, constraining effects of tradition and ritual.[99] Before she becomes Queen, Calantha acts as a social facilitator, a role reminiscent of the contemporary French fashion of *honnêteté*, in which 'women had a special responsibility for the smooth running of society'.[100] The deftness with which Calantha gains King Amyclas's approval of her betrothal to Ithocles demonstrates her skilful manipulation of language and appearances. Calantha has cause to doubt her father's approval of her socially unequal match, since Prince Nearchus is courting her with his encouragement. The surreptitious aspect of Calantha's suit to Amyclas is reflected by her two asides which frame the interview (4.3.76, 88). She addresses Amyclas in ambiguously formal language. Her request, 'Pray, sir, give me this young man, and no further / Account him yours than he deserves in all things / To be thought worthy mine' (4.3.78–80), conflates political and romantic service. While Amyclas believes he is handing his favourite to a future royal 'mistress' (4.3.86), Calantha's address to Ithocles, 'Th' art mine', followed by her aside, 'Have I now kept my word?' (4.3.88), indicates that Amyclas has unwittingly sanctioned the couple's marriage.[101]

The asides framing the exchange between Calantha, Amyclas and Ithocles show that the action bears a meaning only legible to interested observers, even while it is performed in full view of the court. In his hawk-like scrutiny of Ithocles's movements, Orgilus registers the true import of his election to Calantha's 'favour' (4.3.89), deducing that 'The son of Venus hath bequeath'd his quiver / To Ithocles his manage, by whose arrows / Calantha's breast is open'd' (4.3.110–13). Orgilus's flattering depiction of Ithocles as having Cupid's arrows in his 'manage' conflicts ironically with the dramatic situation in which Ithocles's ignoring of Calantha's endearment, 'Sweet, be not from my sight', leads to his

murder. Separated from Calantha's shrewdness, Ithocles's naivety renders him vulnerable to Orgilus's histrionic cunning.

The scene in which Calantha leads the wedding dance for the marriage of Prophilus and Euphrania condenses the arguments for and against the ordering power of ritual and ceremony. This scene elicits divided critical responses, from those who believe the tragedy celebrates Calantha's 'exhibition of perfection', and those who read the play as an 'indictment against a society that has lost its soul'.[102] Calantha's devotion to ceremony and her theatrical boldness unite in her disregard of the tragic news delivered to her by Armostes, Bassanes and Orgilus in the midst of the dance. While Penthea's 'active strain' took effect through language, Calantha's authority and art are expressed here through the movement of the dance:

> How dull this music sounds! Strike up more sprightly;
> Our footings are not active like our heart,
> Which treads the nimbler measure.
>
> (5.2.17–19)

As mistress of the revels Calantha is deputizing for the ailing King, whose parting command to his court was, 'None on his forehead / Wear a distemper'd look' (4.3.95–6). By accelerating the pace of the music, Calantha heightens the company's mirth, raising the colour in everyone's cheeks. It is an action which shows her charisma as a princess. In *Antony and Cleopatra* (1606, pub. 1623) Enobarbus recounts seeing the Egyptian queen 'hop forty paces through the public street, / And having lost her breath, she spoke and panted, / That she did make defect perfection, / And breathless, pour breath forth' (2.2.236–9). Calantha's 'motion' (5.2.20), more mannered than Cleopatra's hopping, embodies the energy Enobarbus merely describes, and its participants similarly need time to 'breathe awhile' once it is finished (5.2.20). Only when the music has ceased does Calantha acknowledge the messengers' encroachment on the dance, addressing Nearchus with a sovereign's voice:

> cousin, 'tis, methinks, a rare presumption
> In any, who prefers our lawful pleasures
> Before their own sour censure, to interrupt
> The custom of this ceremony bluntly.
>
> (5.2.23–7)

The juxtaposition of the court's 'lawful pleasures' with the 'sour censure' of those hostile to such ceremony represents the interruptions as an affront to royal privilege. In dramatizing a queen's determined pursuit of

the dance, Ford may have had at the back of his mind the 'sour censure' of Prynne, some of whose strictures focused emphatically on queens and dancing.[103] With unnerving aplomb, Calantha's performance realizes the rational ideal which Ithocles earlier rejected as untrue to human experience. To her spectators Calantha's 'toughness' and 'constancy' seem to place her beyond her sex. Only later, after the public witnessing by which she confirms her marriage to Ithocles, does Calantha reveal the emotional truth which underlay her gaiety, admitting to the court that she 'but deceiv'd your eyes with antic gesture'. By using the phrase 'antic gesture', Calantha hints at the histrionic dimension of her spirited dancing.[104] What underlay her exuberance was not emotional serenity, but division and discord. Repudiating the exhibitionism of 'mere women' (5.3.72), Calantha resolves to die a death which will testify to her truth of heart as a Spartan: 'They are the silent griefs which cut the heartstrings. / Let me die smiling' (5.3.75–6).

Calantha's commanding of her heart to crack is a supreme exertion of will, differing from Penthea's death in that it is performed before an audience. While in the course of the play Calantha moves from indirection to enactment, the action of her death is curiously inward, resting in the obedient cessation of her heart. As testimony of her emotional suffering, Calantha's death is paradoxically discreet and demonstrative: the epitome of a noble performance. In one sense the flesh and blood of Calantha's heart is 'registered by a cracking of heart-strings that is audible only to the dying Calantha'.[105] Yet in another sense Calantha's words, 'crack, crack', so potentially riveting in the theatre, ventriloquize the action of her innermost being.[106] Bassanes recognizes her death as a triumph of feminine bravery: 'O royal maid, would thou hadst miss'd this part; / Yet 'twas a brave one. I must weep to see / Her smile in death' (5.3.96–8). Bassanes's weeping testifies to the pathos of a death which confronts tragedy with poise. Like Patience on a monument, Calantha dies 'smiling at grief'.

In accounting for *The Broken Heart*'s celebration of 'style produced as an absolute value', Michael Neill instances the reverence for ceremony of Ford's patron, the Earl of Newcastle, to whom Ford dedicated his history play, *Perkin Warbeck*.[107] The analogy gains further credence from the plays of Newcastle's wife, Margaret Cavendish, which evince a preoccupation with women's staging of their own deaths, as if controlling the manner of one's dying was a mode of empowerment that early modern women might readily embrace, if only in 'fancy'. Calantha's orchestration of her death displays her artistry, specifically in the performance of 'the

song / I fitted for my end' (5.3.79–80). The singing of Calantha's funeral anthem by the choir waiting at the altar expands her dying into a 'high-tun'd poem' (5.2.132), an action both tragic and majestical. The words of the final chorus cement her death as an abdication and marriage: '*Love only reigns in death; though art / Can find no comfort for a broken heart*' (5.3.93–4).

Throughout this chapter I have been concerned to stress the forward-looking aspects of Shirley's, Ford's and Richards's representation of tragic women. Ford and Shirley especially forged a dramatic mode which lent itself to the expression of women's interests. Both playwrights are respon-sive to the possibilities of pastoral as a mode particularly attuned to women.[108] Not only was dramatic pastoral a mode in which early modern women wrote (Lady Mary Wroth's *Love's Victory* and the Cavendish sisters' *A Pastoral* demonstrate two different approaches to the form), it was also, as we have seen, the dominant mode of the plays and masques written for Stuart women to perform. It is no accident that Katherine Philips, who began writing poetry in the 1650s, adopts the pastoral as her favoured form. Several of Philips's pastoral dialogues were set to music by Henry Lawes, and they are likely to have been performed at the music meetings held at the composer's London home in the 1650s. While not advertised, such meetings (avatars of public concerts), were semi-public in that people paid to attend. It is possible that women performed in the dialogue songs which were a feature of the music meetings, some of which appeared in the popular collections of *Ayres and Dialogues* issued through-out the 1650s and 1660s by the music publisher John Playford.[109] This tradition of performance which arose during the Interregnum helps account for the revival of Shirley's *The Cardinal*, with its 'gaily amorous' pastoral dialogue, in the first decade of the Restoration theatre.[110] Shirley's tragedy was performed in 1662, 1667 and 1668 and was seen by Samuel Pepys on all three occasions. While he was unimpressed by the play at its first performance, finding no 'great matter in it', Pepys's apprecia-tion increased greatly after the introduction of an actress in the role of Rosaura: in 1668 he professed himself 'mightily pleased' with *The Cardinal*, 'but above all with Becke Marshall'.[111]

The Broken Heart is a tragedy strongly bounded by time and historical circumstance. It appears to have been unknown on the Restoration stage, and was not revived in England until 1898. Yet Calantha's mode of heroism still resonates powerfully in modern popular culture. In Baz Luhrmann's movie musical *Moulin Rouge* (2001) the 'great actress' and courtesan Satine confronts her image in a mirror before going on stage

and sings, 'Inside my heart is breaking, / My make-up may be flaking, / But my smile still stays on.' A more classical analogy for the high-tuned ceremony of Calantha's death is Dido's lament and the closing choruses of Henry Purcell's *Dido and Aeneas* (1684), the first fully operatic work written in English for female and male voices.[112] For Dido, as for Calantha, 'Death is now a welcome guest.' Ford's tragedies, and those of the other dramatists I have examined, were of course performed by male actors and singers. But the power of Ford's theatrical women positions his drama in a transitional space between the budding, and the flowering, of a female performing tradition in England. The next chapter shows how the playwright William Davenant advanced that tradition by presenting women singers in his operas staged under the Protectorate of Oliver Cromwell.

Interchapter: 'Enter Ianthe veiled'[1]

In 1642, following the outbreak of the first Civil War, the English parliament passed an order forbidding performances in commercial theatres, its justification being that 'Public Sports do not well agree with Public Calamities'.[2] Further ordinances against stage plays were issued in 1647 and 1648, with increased emphasis being placed upon the immorality of theatre. But the culture of female acting to which the Caroline reign gave rise did not cease with the parliamentary bans on public theatre. On the contrary, the rupture created by the English Civil Wars, and the discontinuance of an all-male stage, created new opportunities for women to perform and write drama. Women continued to read plays, to attend illegal performances and to participate in private house and academic theatricals.[3] In a raid on actors playing at the Red Bull in 1650, 'Ladies and Gentlewomen' were among those whose names were taken, while a report of another raid on the Red Bull mentions 'abundance of the Female Sex' in the audience, including 'women without Gowns' who, unable to pay the five shilling fine, had to forfeit a piece of their clothing.[4] Records of amateur theatricals both before and during the Interregnum confirm that female participation in drama was common and widespread. Women performed in household entertainments at Bretby (1639), Knowsley (1641), and Apthorpe, the home of Mildmay Fane, Earl of Westmorland (1640–5). The persistence of royalist enthusiasm for pastoral drama is testified by the borrowing in 1653 of an abridged manuscript copy of *The Shepherds' Paradise* belonging to Lady Frances Persall. The following year, at a country-house party in Kent, Dorothy Osborne played the heroine in Sir William Berkeley's tragicomedy *The Lost Lady*, a play which is indebted to Montagu's on several counts.[5] In the same year 'yong Ladyes' took part in a school performance of Thomas Jordan's masque, *Cupid's Coronation*, while 1654 also saw the publication of exiled royalist James Howell's translation of the French opera *The Nuptialls of Peleus and*

Thetis, which was performed in Paris that year with Henrietta Maria's daughter in the role of Erato.[6]

The publication of Howell's text formed part of the cultivation of 'a dramatic aesthetics of Stuart loyalism', of which both the Beaumont and Fletcher Folio (1647) and the Cartwright Folio (1651) were cornerstones.[7] Other publications such as Richard Flecknoe's play *Love's Dominion* (1654) came buttressed with 'a polemic for a moral and improved stage'. The flexibility of Cromwell's regime towards theatrical representation is shown by the performance of Shirley's masque, *Cupid and Death*, for the Portuguese ambassador on 26 March 1653.[8] The publication of dramatic texts and the occurrence of such 'reformed' theatrical events laid a foundation for Davenant's operatic enterprises in the mid- to late 1650s.

In 1639 Davenant had attempted without success to build a theatre capable of staging opera in London.[9] A servant of Henrietta Maria and a principal writer of her masques, Davenant identified himself as a 'ladies' man' in his prologue to a revival of Beaumont and Fletcher's *The Woman-Hater* (1606, revived *c.* 1638), in which he assured women that '[Fletcher's] Muse beleev'd not, what she then did write.'[10] In the ballad 'How Daphne pays his Debts', which satirizes his theatrical activities shortly before mounting *The First Day's Entertainment at Rutland House* (1656), he is depicted as restoring that culture which is French, fashionable and feminine:

> Already I have hir'd a house,
> Wherein to sing and dance;
> And now the Ladies shall have Masques
> Made a la mode *de France*.[11]

The entertainments which Davenant staged were not merely recapitulatory in nature, but innovative. He planned to make a profit by charging well-heeled patrons to see representations produced with the changeable scenery which had been a feature of masques and court drama. His innovations included presenting a female singer, Catherine Coleman, wife of the court composer Edward Coleman, on stage at Rutland House and subsequently at the Cockpit theatre.[12] Davenant's productions were mounted with the cooperation of two government officials, Secretary John Thurloe and Bulstrode Whitelocke, a member of Cromwell's Council of State and former Master of the Revels at the Middle Temple. To Thurloe, Davenant addressed a memorandum defending the staging of what he termed 'morall representations' as a means, in Susan Wiseman's words, of 'educat[ing] the people into supporting the interests of the

state'. The performances of *The Siege of Rhodes* (1656, 1659), *The Cruelty of the Spaniards in Peru* (1658) and *The History of Sir Francis Drake in Virginia* (1659) were preceded by *The First Day's Entertainment at Rutland House* (1656), which Wiseman calls '[a] drama about the possibility of staging drama'.[13] Catherine Coleman and 'a nother wooman' were among the singers in this entertainment, which consisted of declamations for and against 'public entertainment by moral representations' and the respective defects and attractions of London and Paris, interspersed with consort music and songs.[14]

One of the ways that Davenant made his next enterprise palatable to Protectorate officials was by representing *The Siege of Rhodes* as 'dramatic narrative in the form of musical theatre'. The title-page to the 1656 Quarto describes the work as 'Made a Representation by the Art of Perspective in Scenes, and the Story sung in Recitative Music'.[15] While no music survives, the second issue of the Quarto printed in 1656 attributes the music to Henry Lawes, Captain Henry Cooke, George Hudson, Matthew Locke and Edward Coleman, who sang the role of Alphonso, Ianthe's husband. While Davenant referred to the work as an 'opera' in a letter to Whitelocke, the entry in the Stationers' Register designated it as a 'masque'.[16] *The Siege of Rhodes* resembled the court masque in its division into entries rather than acts and scenes, in its librettist and musical personnel, and in the perspective scenery designed by John Webb (nephew and pupil of Inigo Jones and Surveyor of the Works to James I and Charles I). In addition, the musical role of Circe in *Tempe Restored* forms a precedent for the dramatic singing role of Ianthe. However, Davenant's musical drama differed from both the court masque and continental opera by having 'a unified romantic plot on a modern heroic subject', drawing on the 'early modern fascination with the Turks and the Ottoman empire'.[17] When Davenant expanded the play for performance in the Restoration theatre, he abandoned the sung dialogue and added the Turkish empress Roxalana, whose histrionic jealousy provides a foil for the virtuous Ianthe. The role of Ianthe in *1 Siege of Rhodes* deserves scrutiny as the first serious, heroic part scripted for a woman.

We have seen that in Davenant's masque *Salmacida Spolia* Henrietta Maria 'personat[ed] the chief heroine' dressed as a Caroline Amazon.[18] This image of the Queen resonated with a contemporary lexicon of female heroism expressed both in visual iconography and in literature valorizing the heroic deeds of illustrious women. This cultural movement flourished in France in the 1640s, partly in response to the participation in government and war of women such as Anne of Austria, Queen Regent of France from 1643 to 1652, and her niece Anne Marie d'Orléans, the 'Grande

Mademoiselle', who fought in the French civil wars known as the Fronde.[19] The ideal of the *femme forte*, or heroic woman, was disseminated in England via *The Gallery of Heroick Women* (1652), a translation of Pierre Le Moyne's *La Galerie des Femmes Fortes* (1647) by John Paulet, Marquess of Winchester. It was also embodied by Henrietta Maria, who with the onset of civil war in England embraced the chance to act out her role as a 'martial lady'. The Queen's loyalty to her husband took her to Holland, where she stayed for a year, pawning the crown jewels and buying arms and ammunition. Subsequently she landed in the north at Bridlington Bay, where she was beseiged by cannon-fire from parliamentary ships, after which she spent five months on the road at the head of an army before meeting Charles at Oxford. In a letter to Charles written at this time, she humorously dubs herself 'her she-majesty, generalissima'.[20] In characterizing Ianthe, Davenant drew on the image of the *femme forte* and on its recent incarnation in Henrietta Maria.[21]

Ianthe's portrayal aligns her heroism with feminine bashfulness and conjugal virtue. Davenant creates drama from the involuntary operation of feminine allure. From one angle, the Turkish siege of the Christian island of Rhodes by the emperor Solyman forms a backdrop to the emotional turbulence wrought by Ianthe's femininity. On her first appearance Ianthe is brought as a captive to Solyman, preceded by the striking stage direction, '*Enter MUSTAPHA, IANTHE veiled*'. Mustapha, bashaw to Solyman, describes how, during the capture of Ianthe's supply-ships, 'Her face still veiled, her valour did appear. / She urged their courage when they boldly fought; / And many shunned the dangers which she sought' (p. 207, 127–9). Ianthe's bringing of supplies purchased with her 'dower and jewels' to her husband Alphonso, who is fighting for the Rhodians, elicits Solyman's exclamation, 'O wonderous virtue of a Christian wife!' (p. 207, 137–8). As well as extolling Ianthe's love and courage to Solyman, Mustapha heightens the sense of her hidden beauty by describing her as 'the Sicilian flower, / Sweeter than buds unfolded in a shower' (p. 207, 132–3). Solyman's command for Ianthe to unveil, and her refusal, enhance her seductive power. (In subsequent scenes with Alphonso she appears unveiled.) Ianthe's assertion that 'this curtain only opens to [Alphonso's] eyes' affirms her virtue and positions the actress as the focal 'discovery' of Davenant's theatre (p. 208, 147).

Like Shakespeare's *Othello, Cymbeline* and *The Winter's Tale*, *1 Siege of Rhodes* creates pathos from the false supposition of a woman's sexual transgression. Ianthe's inspiration of a 'virtuous love' in Solyman (which moves him to grant her and Alphonso a safe passage back to Sicily)

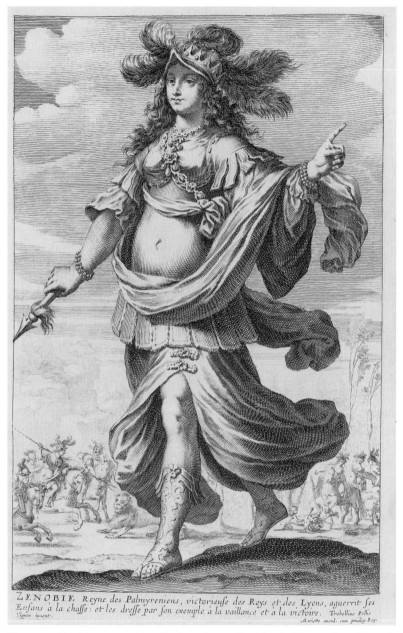

ZENOBIE Reyne des Palmyreniens, victorieuse des Roys et des Lyons, aguerrit ses
Enfans à la chasse: et les dresse par son exemple à la vaillance et à la victoire. *Trebellius Pollio*
Vignon inuent.
Mariette excud. cum priuileg. R.eg.

Figure 10. *Zenobia,* engraved by Abraham Bosse after Claude Vignon, from Pierre le
Moyne, *La Galerie des Femme Fortes,* 1665

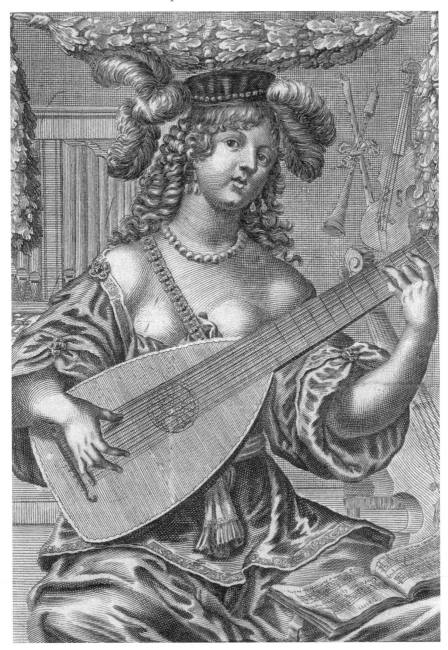

Figure 11. '*Musick*', frontispiece to *Select Ayrs and Dialogues for One, Two, and Three Voices*. This engraving forms part of the iconographic portrayal of 'Harmonia', embodied in the figure of Harmoney in *Tempe* Restored. The women's fashionable clothing and her animation suggest at the same time women's lively role in English musical culture of the 1640s and 1650s.

arouses jealousy in Alphonso (p. 208, 171). The fact that Ianthe's virtue 'seemed to civilize a barbarous foe' (p. 214, 155) unsettles Alphonso's assurance of her chastity: 'She is all harmony and fair as light; / But brings me discord and the clouds of night' (p. 215, 191–2). Rather than suffer her imputed infamy, Ianthe resolves to die, and throws herself into the conflict at the English military station, where she impresses her foes as a vision 'fairer than woman, and than man more fierce' (p. 224, 56). There is a hint of images of heroic women such as Le Moyne's Zenobia (Figure 10) in Solyman's lines on the 'vision' which 'had a dress much like the imagery / For heroes drawn, and may Ianthe be' (p. 224, 59, 61–2). Ianthe's wounding in battle, which brings her close to death, spurs Alphonso to recognize the injustice of his suspicions. The play ends in a scene of troubled reunion and forgiveness for which Ianthe appears '*in a nightgown*', supported in a chair (p. 228, 183.2), followed shortly by Alphonso, who enters wounded. His sober couplet, 'Draw all the curtains, and then lead her in; / Let me in darkness mourn away my sin', presents a husband chastened by his unjust accusation of his wife's virtue (p. 230, 273–4).

Ianthe's heroic persona has parallels in the contemporaneous closet drama of Thomas Killigrew and Margaret Cavendish, both of whose plays engage differently with the figure of the warrior woman.[22] By using a female singer to personate the play's 'chief heroine', Davenant was appealing to the royalist milieu concentrated around musicians such as Henry Lawes. Hero Chalmers draws attention to 'the respectful public exposure accorded to the artistic endeavours of women in Lawes's circle', which actively supported female composers, singers and poets.[23] Davenant draws on women's participation in amateur musical culture in the 'Chorus *of women*' at the end of the Second Entry in *1 Siege of Rhodes*, which depicts women enthusiastically forgoing their French adornments and musical pastimes to assist in preparations for war: 'Our gardens are bulwarks and bastions become. / Then hang up our lutes; we must sing to the drum' (pp. 209–10, 204). John Playford's 1659 collection of *Select Ayrs and Dialogues* carries a frontispiece of a fashionably dressed female lutenist representing 'Musick', which is reminiscent of the lute-playing women's chorus and suggests women's active involvement in Interregnum musical culture (Figure 11). Among those who attended Lawes's music meetings was Margaret Cavendish, who forms the focus of my next chapter. Like her younger contemporary, Katherine Philips, her writing was both fostered by, and participates in, the ongoing theatrical culture of the Interregnum.[24]

The fancy-stage of Margaret Cavendish, Duchess of Newcastle

> So full of shapes is fancy,
> That it alone is high fantastical.
>
> *Twelfth Night* (1.1.14–15)

The mind is a kind of theatre, where several perceptions successively make their appearance; pass, re-pass, glide away, and mingle in an infinite variety of postures and situations.[1]

In one of her *Sociable Letters* (1664) written during her exile from the English Protectorate with her husband, William Cavendish, then Marquess of Newcastle, Margaret Cavendish describes to a female correspondent some of the 'several Sights and Shews' to be purchased at 'Carneval Time' in the city of Antwerp. From a medley of human and animal performers she singles out a female freak, half woman, half animal:

amongst the rest there was a Woman brought to me, who was like a Shagg-dog, not in Shape, but Hair, as Grown all over her Body, which Sight stay'd in my Memory, not for the Pleasantness, but Strangeness, as she troubled my Mind a Long time, but at last my Mind kick'd her Figure out, bidding it to be gone, as a Doglike Creature.[2]

Repressing in this way the psychological disturbance caused by this figure, Cavendish recounts how she was further fixated by an Italian mountebank, who had with him a man who 'did Act the part of a Fool', together with 'two Handsom Women Actors'. The second of these women, in Cavendish's estimate, far outshone the other, both for her beauty and her skill in acting and dancing. 'Indeed', she writes,

she was the Best Female Actor that ever I saw; and for Acting a Man's Part, she did it so Naturally as if she had been of that Sex, and yet she was of a Neat, Slender Shape; but being in her Dublet and Breeches, and a Sword hanging by her side, one would have believed she had never worn a Petticoat, and had been more used to Handle a Sword than a Distaff; and when she Danced in a Masculine Habit, she would Caper Higher, and Oftener than any of the Men,

although they were great Masters in the Art of Dancing, and when she Danced after the Fashion of her own Sex, she Danced Justly, Evenly, Smoothly, and Gracefully. (pp. 406–7)

In the rest of the letter Cavendish explains how she took such delight in seeing 'this Woman, and the Fool her Husband' act, that she hired a room in the house next to the stage and went daily to watch them. However, in what seemed a short time, and 'to [her] great Grief', the itinerant troupe was commanded out of town by the local magistrate. To compensate for her loss Cavendish effected a characteristic gesture of interior withdrawal, in which

to please me, my Fancy set up a Stage in my Brain . . . and the Incorporeal Thoughts were the several Actors, and my Wit play'd the Jack Fool, which Pleased me so much, as to make me Laugh Loud at the Actions in my Mind . . . but after my Thoughts had Acted, Danced, and Played the Fool, some several times of Contemplating, my Philosophical and Physical Opinions, which are as the Doctors of, and in the Mind, went to the Judgement, Reason, Discretion, Consideration, and the like, as to the Magistrates, and told them, it was very Unprofitable to let such Idle Company be in the Mind . . . whereupon the Magistrates of the Mind Commanded the Fancy-Stage to be taken down, and the Thought-Actors to go out, and would not suffer them to Cheat, or Fool any longer. (p. 408)

Cavendish's writing is acutely conscious of 'Fancy's' power to substitute the scene of the mind for the theatre of the world. In this letter, however, it is a real theatre which is so transposed, and transposed twice-over, from open-air stage to private room, from private room to a closet theatre of mind.[3] While the first of these retreats is occasioned by the joint constraints of Cavendish's class and gender, she is compelled to the second only by the magistrate's order to the players to leave. In another of the *Sociable Letters*, in which she defends her 'Retired Life', Cavendish claims that she prefers her fantasy stage to worldly recreations: 'and though I do not go Personally to Masks, Balls, and Playes, yet my Thoughts entertain my Mind with such Pleasures, for some of my Thoughts make Playes, and others Act those Playes on the Stage of Imagination, where my Mind sits as a Spectator'.[4]

But Cavendish's rapt viewing of the woman actor undermines the integrity of this disavowal. So troubled was she 'for the Loss of that Pastime' that she rehearses the scene in her head until her own regulatory controls intervene, suppressing the 'Fancy-Stage' and its cheating, fooling 'Strangers'.[5] In a similar way her mind had earlier rid itself of the strange, 'Doglike Creature'. I suggest that the acts of suppression are linked and

that Cavendish, in a manner appropriate to fantasy, was simultaneously enthralled and disturbed by the actress's ambidextrous shifting between genders.[6]

One reason why the cross-dressing actress might be a disturbing as well as pleasurable figure is that her performance seals the argument which Cavendish's texts constantly broach as to whether gender difference is natural or constructed.[7] Not only does the actress play a man 'so Naturally as if she had been of that Sex', she surpasses her male colleagues in the frequency and height of her capers. For Margaret, Duchess of Newcastle, at once pampered and constrained, wanting 'the Agility, Art, Courage [and] Liberty' to slide on the ice,[8] the female actor embodies a potent fantasy – not just of freedom from a natural femininity – but of litheness, aptitude, art and aspiration.

CAVENDISH AS PLAYMAKER: SOME ENABLING CONTEXTS

In the dedication to the first of her two books of plays, published respectively in 1662 and 1668, Cavendish traces her pleasure in 'making' plays to the imagined performance which accompanies their conception. She dedicates her book chiefly

> to my own Delight, for I did take
> Much pleasure and delight these Playes to make;
> For all the time my Playes a making were,
> My brain the Stage, my thoughts were acting there.[9]

The last line is redolent of Cavendish's creative resource, the power of her imagination to usurp the real. It gestures at the same time to the absence of a material stage, for, as she goes on to indicate in one of her prefatory addresses, Cavendish wrote the plays which were published in her first volume during the Interregnum when public theatre performance was officially banned.[10] She was encouraged and assisted in her dramatic endeavours by William Cavendish, Duke of Newcastle, whom she married in Paris in 1645.[11] Like those of the Cavendish sisters, who became her stepdaughters by marriage, her plays make striking use of performance as a metaphor of possibility for women. Unlike Jane Cavendish and Elizabeth Brackley, Cavendish took the much bolder step of publishing her plays, which form only part of her prodigious literary output. In her address 'To the Readers' in her 1668 volume of plays Cavendish presents publication as a dangerous performance: 'Those that perform Publick Actions, expose themselves to Publick Censures; and so do Writers, live

they never so privately and retir'd, as soon as they commit their Works to the Press.'[12]

Cavendish's depiction of publication as a 'public action' shows her commitment to the educative function of the writer and poet. At the same time, her writing registers her awareness of the dangers for women in assuming public modes of speech and writing which challenge their relegation to a life of domestic virtue. This sensitivity informs the series of preliminary addresses in her first volume of plays, which constantly raise and displace the possibility of her plays being performed. They are, she tells her 'Lordship' in the dedicatory epistle,

> like dull dead statues, which is the reason I send them forth to be printed, rather than keep them concealed in hopes to have them first Acted; and this advantage I have, that is, I am out of the fear of having them hissed off from the Stage, for they are not like to come thereon; but were they such as might deserve applause, yet if Envy did make a faction against them, they would have had a publick Condemnation; and . . . it would have made me a little Melancholy to have my harmless and innocent Playes go weeping from the Stage, and whipt by malicious and hard-hearted censurers. (sigs. A3^{r-v})

In dialogue with her 'Noble Readers', however, the reason Cavendish gives for printing her plays

> before they are Acted, is, first, that I know not when they will be Acted, by reason they are in English, and England doth not permit . . . of Playes . . . but the printing of my Playes spoils them for ever to be Acted . . . so that my Playes would seem lame or tired in action, and dull to hearing on the Stage, for which reason I shall never desire they should be Acted. (sig. X1v)

Now Cavendish's 'reason' has come full circle, and the reason she puts her plays out in print is because they will not be acted because she puts them out in print. As if to confirm this failure to squash the genie of performance, Cavendish returns to acting in a further address. Here she refutes 'an erronious opinion . . . that it should be thought a crime or debasement for the nobler sort to Act Playes, especially on publick Theatres' (sig. X2r). In reply Cavendish articulates a scholastic argument for the edifying function of acting for 'the noblest youths': 'it learns them gracefull behaviours and demeanors, it puts Spirit and Life into them, it teaches them Wit, and makes their Speech both voluble and tunable, besides, it gives them Confidence, all which ought every man to have, that is of quality' (sig. X2r).[13]

Cavendish contrasts this kind of acting, that is 'for Honour, and becoming', with the 'mercenary Players' who act solely for financial profit.

Rather than viewing acting as an extension of the self, professional players engage in a form of *anti*-self-fashioning, or self-subversion; a deliberate fashioning of the self as other. We can see how Cavendish distrusts this protean theatricality and the social mobility it simulates by looking briefly at her play *The Apocriphal Ladies* (1662).

In this play the 'Unfortunate Dutchess' has been dispossessed of the right of her kingdom by her husband, the Duke Inconstancy. Living in exile, she is brought news by her woman of her husband's remarriage to the 'Apocriphal Dutchess' (641), who is also termed the 'Comical Dutchess' (640). The ensuing dialogue between the true Duchess and her woman elaborates the theatrical metaphor:

> WOMAN: She will be as a Dutchess in a Play, she will only act
> the part of greatness.
> UNFORTUNATE DUTCHESS: Indeed most Stage-Players are Curtizans.
> WOMAN: And most Curtizans are good Actors.
> UNFORTUNATE DUCHESS: I make no question but she will
> now have enough Spectators.
> WOMAN: But I hope they will hiss her off from the Stage.
>
> (641)

The passage uses the trope of female acting, or stage-playing, to signify social and sexual inauthenticity. Its obvious point of reference is Prynne's index entry, '*Women-Actors*, notorious whores'. This critique of social imposture conducted through the metaphor of female acting or make-believe is repeated several times in the text, through the Creating Princess who marries beneath her, so 'creat[ing] [her] Husband to Honour' (639), and the Imaginary Queen, who steps into a vacant throne but 'cannot act the part, for she appears like a good Country Huswife' (646). It is reinforced by a long oration delivered by the Lady True Honour, who asks resoundingly, 'shall Princes in Royal Courts, give place to Princes in Playes?' (647).

The antifeminist, antitheatrical discourse articulated in *The Apocriphal Ladies* raises the question of why Cavendish couches her prefatory defence of noble performance in exclusively male terms. The explanation may lie in the passage from her dedicatory address to Newcastle quoted above in which she fantasizes about not simply her plays' performance, but their 'publick Condemnation'. This passage personifies Cavendish's plays as feminine, portraying them as receiving the punitive treatment of a prostitute or public woman, an image echoed in the last line of the dialogue from *The Apocriphal Ladies*. The address aligns the public female dramatist with the actress, each notorious by reason of her self-promotion. This

dangerous proximity of the roles of female dramatist and actress accounts for the divorce between the discussion of male performance in Cavendish's prefaces and the feminine theatrical discourse of her plays.

In this chapter I show how Cavendish draws on the changing cultural and literary status of female performance to enable fantasies of female self-representation. It is not my intention to suggest that Cavendish's plays were written for women actors. Rather, I will show that because of her particular historical position, performance – simulated in the mind of her reader – is a bookish but catalysing fantasy in her plays.[14]

* * *

Through the circumstances of her adolescence and adult life Cavendish was an eye-witness to the developments in female performance occurring in England and on the continent in the mid-seventeenth century documented in my opening chapters. In her autobiography she describes her family's manner of spending half of each year in London where they engaged in town recreations, one of which was 'in winter time to go sometimes to plays'.[15] Her identification with Henrietta Maria is evinced by her volunteering to be a maid of honour to the Queen in Oxford in 1643, a gesture which demonstrates her royalism, her social ambition and her identification with the Queen's feminocentric culture.[16] At Oxford she would have witnesssed the plays and other entertainments which continued to be staged in modified form.[17] Her attraction to court forms is apparent from her early poem '*Phantasmes* [*sic*] Masque' which stages the episodes of her life up to and including her marriage to Newcastle against a backdrop of poverty and distress caused by the Civil Wars. Cavendish draws on the masque again in her prose fiction 'The Contract', in which two lovers are smitten during the dancing of the revels. The details of the occasion are vividly sketched, notably in the description of the tumult which meets the heroine and her uncle as they attempt to gain access: 'and when they came to enter through the Door to the Masquing Room, there was such a Croud, and such a Noyse, the Officers beating the People back, the Women squeaking, and the Men cursing, the Officers threatening and the Enterers praying, which Confusion made her afraid'.[18]

There is more evidence of Cavendish's colloquy with the culture surrounding the Queen. The exiling of Henrietta Maria's court to her native Paris supplied further contexts in which Cavendish could witness amateur and professional women actors, respectively, in the distinctive

French spectacle of the *ballet de cour* and in performances by local and visiting theatre companies.[19] Her play *The Presence* (1668) ends with 'a Ball after the *French fashion*', followed by 'an Anti-Mask',[20] and in another play, *The Female Academy* (1662), a woman delivers an oration on the theme of 'a Theatre' in which she criticizes the 'feign'd and constrain'd' acting of French and Italian players (671). It was in Paris, too, that Margaret met and married William Cavendish, Marquis of Newcastle, a man who brought with him a host of theatrical connections. His composition of plays, assisted by professional dramatists, brought her closer in touch with the practices of playwriting and performance.[21] Indeed, in the dedicatory epistle to the 1662 *Playes* Cavendish states that it was William's reading his plays to her which made her take up the form (sig. A3r). No doubt Newcastle encouraged her reading of Jonson, Shakespeare, and Beaumont and Fletcher, the dramatists she invokes favourably in 'A General Prologue to all my Playes'.[22]

Newcastle's plays *The Country Captain* and *The Varietie* had professional performances in England, at the beginning of the 1640s and while he was in Paris he wrote 'several things' for the company of English players maintained by Prince Charles. In 1658 the Newcastles gave a ball for Charles and his entourage in Antwerp at which there was four hours of dancing, speeches of welcome and farewell penned by Newcastle and delivered by the English actor Michael Mohun, and one of his songs, performed by the family's black page 'dressed all up in feathers'.[23] Finally, as we have seen, it was in Antwerp that Cavendish encountered women acting in street theatre, women for whom performance was a profession as opposed to a pastime. And once back in England, this was the dispensation of the Restoration theatre, in which women actors were a vital new force.

WOMEN'S SPEAKING JUSTIFIED IN 'PLAYES' (1662)

Cavendish's acute awareness of the prohibitions on female speech is manifested in the epilogue to a play in her first volume, *Natures Three Daughters, Beauty, Love, and Wit*. Within the play Mademoiselle Amour determines to 'break down Customs Walls' and follow 'honest Truth' by expressing her desire to Monsieur Nobilissimo (504). Her suit is successful, but, exceptionally, Cavendish assigns the epilogue to this character, renamed Lady True-Love, and makes her appeal directly to the audience for sanction:

O how my heart doth ake when think I do,
How I a modest Maid a man did woo!
To be so confident to woo him here,
Upon the publick Stage to every Ear.
Men sure will censure me for mad . . .

(527)

Pierre Danchin asserts that Cavendish's prologues and epilogues are based on the convention of the classical 'plaudite', bearing no witness of 'any actual experience of the stage'.[24] In this epilogue, however, actress and female character are compacted in seeking approval of their indiscreet 'action'. The slippage between the public theatre and the theatre of the world produces a stage of subjectivity in which acting functions to authenticate female identity. Cavendish highlights the propriety of Lady True-Love's acting within the play by contrasting her 'Modern Truth' with the 'antient custome' of women's dissembling (504). In so doing she challenges the truism we saw at work in Caroline comedy that 'women's hearts and tongues lie far asunder'. The epilogue develops this shift in sexual ideology; Lady True-Love's wooing of her man may appear a 'bold immodesty' but she analyses this response to her frankness as a masculine misapprehension. Proclaiming the success of her suit, Lady True-Love justifies her representation of the wooing part, pleading, 'If you approve my Act pray giv't a voice!'

The use of theatrical metaphor to enable the performance of female identity is developed in *Youths Glory, and Deaths Banquet*, whose protagonist, Lady Sanspareille appears a paragon of the self-fulfilling female intellectual. She is blessed with a father who provides her with a rigorously masculine education and is content for his daughter to remain unmarried in order to pursue her quest for fame. Early in the play Cavendish characterizes Lady Sanspareille's unusual expressiveness in terms of a theatrical trope. As her daughter wafts in '*repeating some verses of her own making*' (126SD), Lady Sanspareille's mother accuses her, 'I am sure you are transformed from what you should be, from a sober, young maid, to a Stage-player, as to act Parts, speak Speeches, rehearse Verses, sing Sonets, and the like.' Lady Sanspareille replies with a speech which reiterates Cavendish's defence of theatre as a means for 'the education of noble youth'. She rejects her mother's use of the term 'Stage-player', drawing the distinction we saw Cavendish make in her preface between noble amateurs and mercenary professionals: 'shall Kings, Princes or noble Persons, that dances, sings, or playes on Musick, or presents themselves in Masks, be thought, or called Dancers, or Fidlers, Morris-dancers, Stage-players,

or the like?' (127). Lady Sanspareille's omission of oratory from her list of performative modes can only be construed as a strategic display of daughterly tact. For later we learn that acting does indeed form part of her vocation, which involves the pervasive exercise of public speech. As a gentleman remarks:

This Lady *Sanspareile* hath a strange spreading wit, for she can plead causes at the Bar, decide causes in the Court of Judicature, make Orations on publick Theatres; act parts, and speak speeches on the Stage, argue in the Schooles, preach in the Pulpits, either in Theology, Philosophy, moral and natural, and also phisick and Metaphysick. (158)

Here Cavendish uses 'acting' as a metonym for women's public utterance. Specifically, she affirms as a feminine trait the boldness or confidence that a Lady Speaker in *The Female Academy* describes as belonging to 'Preachers, Pleaders, and Players, that can present themselves, speak, and act freely, in a publick Assembly' (674). As Lois Potter points out, Cavendish's fantasy had a topical basis, for academies offering public lectures had existed for some time on the continent and in 1649 a similar institution was opened in London by the royalist Sir Balthazar Gerbier. One of the lectures offered was especially for ladies, 'concerning the *Art of Well Speaking*'.[25]

Cavendish's depiction of Lady Sanspareille's verbal prowess exploits the overlap between rhetorical and theatrical notions of acting.[26] She speaks from a rostrum described as '*a place raised and railed with guilt rayles*' and of which a philosopher remarks to her father, 'Sir, you have adorned her Theater to inthrone her wit' (135–6). Apart from the attendance of Queen Attention at her oration on government, Lady Sanspareille's audience is wholly male. Moreover, the text emphatically marks the scopic nature of the event. For her first oration Lady Sanspareille appears '*drest all in black*'; upon her entrance the spectators are '*struck with amaze of her beauty*', one of them remarking to her father, 'Sir, we perceive now, you have invited us to feast our eyes, not our eares' (136). For her final oration, in which she justifies her vow never to marry, Lady Sanspareille enters '*all in white Satin, like as a Bride, and her Father and her audience, which are all Lovers; these stand gazing upon her*' (158SD). At the end her lovers exit silently in various states of transport, '*some lifting up their eyes, others their hands, some striking their hands on their breast*' (161SD). Susan Wiseman comments that 'in Cavendish's plays, the women represented as sexually exciting to men . . . are women displaying themselves both educationally and sexually within a masculine preserve'.[27]

The erotic spectacle of Lady Sanspareille's final address evokes women's role in the Platonic theatre of cruelty in Caroline drama. Her performance – dressed in white bridal satin before an audience of suitors, delivering an oration denouncing marriage as an impediment to the contemplative life – is the acme of sexual provocation and the Platonic woman's 'will to power'.[28] Cavendish registers an indecorum in Lady Sanspareille's public avowal of virginity when her heroine promises to 'dye every mans Maid'. Lady Sanspareille admits that the assembly 'hath occasioned a quarrel here; for bashfulnesse, and confidence hath fought a Duel in my Cheeks, and left the stains of blood there' (161). Subsequently, Lady Sanspareille is taken ill and dies. As Anna Battigelli remarks, this outcome suggests that for women, 'conflating the active life and the contemplative life simply will not work'.[29]

It is instructive to compare Cavendish's fantasy of public discoursing with her account of one of the few occasions in her life when she had the chance to make effective use of public speech. In her autobiography she describes her trip to England with her brother-in-law Sir Charles Cavendish in order to petition the parliamentary Committee for Compounding for a wife's share in Newcastle's sequestered estates. She received 'an absolute refusal' of her claim, being told that she had no entitlement to Newcastle's estate, since she had married him after his delinquency (his active support for the royalist cause), and moreover that she deserved nothing, her husband 'being the greatest traitor to the State'. Far from producing a show-stopping display of eloquence, Cavendish 'whisperingly spoke to my brother to conduct me out of that ungentlemanly place, so without speaking to them one word good or bad, I returned to my lodgings'.[30] In contrast to Dr Denton's commendation of the political usefulness of women's histrionic powers in a letter to Sir Ralph Verney, Cavendish patently failed, in his words, 'to act it with committees'.[31] In the self-defence which follows, she ascribes her failure partly to bashfulness, but she precedes this by criticizing the contemporary state of affairs in England where 'women become pleaders, attornies, petitioners, and the like', an activity she presents as a form of indecorous self-aggrandizement, 'nothing but jostl[ing] for the pre-eminence of words'.[32]

In considering this passage we should recall the type of bashfulness described by a Lady Speaker in *The Female Academy* as proceeding from the desire 'to out-act all others in Excellencies' (674). Cavendish's stressing of her shyness is undoubtedly a symptom of what Elaine Hobby calls her 'highly repressive image of her own femininity',[33] but her attack on women who spoke in public could equally well be motivated by the

bashfulness produced by 'aspiring Ambition' (674). Cavendish's fantasies of performance relate more often to the exceptional woman than to the female populace.[34] In *Bell in Campo* (1662), however, Cavendish combines a vision of women as actors in 'the Theatre of Warr' (669) with a reformation of middle-class women's domestic relations.

THE HEROIC WOMAN IN ACTION

In the play Lady Victoria persuades her husband the Lord General to allow her to accompany him to war, inspiring five or six thousand women to follow suit. When the men refuse to grant the women an active role in battle, Lady Victoria addresses her female followers and convinces them to form their own army, of which they elect her the 'Generalless'. Determined to prove themselves equal to men in constancy and valour, the female 'heroicks' 'surprize, seise and plunder' the garrison town (595), recruit its female population and entrench themselves to practise their military manoeuvres. The chance arises to rescue their flagging male counterparts: the '*Amazonian* Army' (595) moves in, vanquishes the enemy forces and performs further military feats. When the men capitulate by sending the women a 'complemental' letter, the female army delivers up its gains, happy with the honour of victory, and the women pass the rest of the time in heroic sports on the frontiers while their husbands get on with conquering the 'Kingdome of Faction' (625). At the end of the play, Lady Victoria is brought into the city in military triumph and is greeted by the King. Several acts are then read: one grants all women in the kingdom precedence in the home; another ensures that Lady Victoria will be memorialized in history.

Bell in Campo gives full rein to Cavendish's fantasy of entering the male world of heroic action and honour. In constructing this fantasy she drew on the contemporary phenomonen of the heroic woman, which, as Ian Maclean has demonstrated, was accompanied by an upsurge of feminist debate in France, a feminism he defines as 'a reassessment in women's favour of the relative capacities of the sexes'.[35] We have seen that in *1 Siege of Rhodes* Davenant modelled the figure of Ianthe after the heroic exploits of Henrietta Maria. Lady Victoria's participation in her husband's actions also draws impetus from Henrietta Maria's active support of her husband during the Civil War.[36] It was Newcastle himself, as commander of the loyalist forces in the north, who met the Queen on her landing from Holland, where she had gone to buy arms and ammunition, and conducted her to York, from where she journeyed to Oxford with part of his

army as escort. Cavendish was in Oxford with her family when the Queen made what was reported as 'a most triumphant and magnificent entry' into the city, and it was there that she conceived what she describes as 'a great desire to be one of her maids of honour'.[37] The inflationary gesture of Lady Victoria's triumph can be compared to the actual state entries in Europe of women such as Queen Christina of Sweden, of which Henrietta Maria's Oxford entry may have been a modified version.[38] For this episode the play moves into the descriptive register used in the printed texts of Stuart masques, detailing Lady Victoria's military costume and the order of the procession:

The Lady _Victoria_ was adorned after this manner; she had a Coat on all imbrodered with silver and gold, which Coat reach'd no further than the Calfs of her leggs, and on her leggs and feet she had Buskins and Sandals imbroidered suitable to her Coat; on her head she had a Wreath or Garland of Lawrel, and her hair curl'd and loosely flowing; in her hand a Crystall Bolt headed with gold at each end, and after the Chariot marched all her Female Officers with Lawrel Branches in their hands, and after them the inferiour she Soldiers, then going through the Stage, as through the City, and so entring again, where on the midst of the Stage as if it were the midst of the City, the Magistrates meet her. (631)

This passage represents a martial female athleticism, its picture of Lady Victoria corresponding with visual images such as the engraving of Zenobia in Le Moyne's _La Galerie des Femme Fortes_ (1647, 1665). Here the warrior Zenobia is represented striding forwards, her buskinned leg displayed to just above the knee (Figure 10). Rather than give an imperative stage direction, Cavendish combines evocative description with explanation in a manner peculiar to closet drama, coaxing the reader to imagine the stage standing for the city, where Lady Victoria's conquest is publicly lauded. In this manner the female triumph is represented simultaneously as a theatrical spectacle and a fictional event.[39]

Bell in Campo thus gives ample witness of Cavendish's imaginative investment in an ethic of female heroism, in the ostentation and bravura of a monarchist culture, and in the concept of individual sovereignty pertaining to it. While the play leaves us in no doubt of the apotheosis of its female hero, the gains won for women through her endeavours are more questionable. Earlier, Lady Victoria spurred the female army to action by arguing the tyranny of custom in denying them the education to be 'as good Souldiers and Privy Counsellers, Rulers and Commanders, Navigators and Architectors, and as learned Sholars [_sic_] both in Arts and Sciences, as men are' (588), urging the women to accustom themselves to 'do such actions . . . as men might change their opinions, insomuch as to

believe we are fit to be Copartners in their Governments, and to help to rule the World' (588–9). Her argument echoes feminist discourse found in texts such as *The Accomplished Woman* or *The Women's Sharpe Revenge*, and in drama such as Cartwright's *The Lady-Errant*. In the laws which are passed at the end of the play, the changes in women's status are limited to the domestic sphere, where women are to be 'Mistris in their own Houses and Families', to sit above their husbands at table, to keep the purse, to manage the servants, to have ownership and ordering of the household goods, and lastly, to 'be of their Husbands Counsel' (631).

These reforms invert the structure of the patriarchal family, the poignant last clause providing for partnership in marriage. Their narrowing of scope in relation to the preceding action is echoed in the second plot, where, in opposition to Lady Victoria's acting in the world and entering history, Madam Jantil, after the death of her husband, withdraws into his mausoleum and stages her own prolonged self-extinction, having first carefully arranged for the writing of her husband's *Life*. This division between the two plots, between Lady Victoria's triumph and the rewards offered women in general, are echoed by a division within the women's act itself. There are four further clauses unleashing all the feminine frivolity which conduct books and city comedies attempted to regulate:

Seventhly, They shall wear what fashioned Clothes they will.
Eightly, They shall go abroad when they will, without controul, or giving of any account thereof.
Ninthly, They shall eat when they will, and of what they will, and as much as they will, and as often as they will.
Tenthly, They shall go to Playes, Masks, Balls, Churchings, Christenings, Preachings, whensoever they will, and as fine and bravely attired as they will.
(631)

These clauses show a glimpse of a Land of Cockayne, a world in which feminine folly and freedom have reign. In contrast to the inflationary fantasy of the foregoing play, this vision of licence is disarmingly domestic. The freedom to eat, to roam, to indulge in the pleasures of self-display and sociable pastime form a nucleus of resistance to women's entrenchment in the family. In the context of the play, this fantasy is both deflationary and recuperative; in the context of the act it is a relic of female survival.[40]

Thus far I have been discussing Cavendish's use of theatrical language to enable a particular kind of female identity. Cavendish uses theatrical tropes in her first volume of plays to represent a self which is envisaged not merely as authentic, but as fantastically inflated and absolute. This use of

theatricality to supplement the self produces a subjectivity at once singular and sovereign because its boundaries are perceived as all-extensive. It would be useful to distinguish this fantasized subjectivity from the model of the female subject obtaining in Cavendish's nondramatic writing.

Catherine Gallagher reads Cavendish as installing herself as absolute monarch of a fantasy microcosm, producing a self which is private, interior and infinitely recessive. In Cavendish's plays, however, performance means crossing the boundary between inside and outside, animating the self in front of the gaze of others.[41] This fantasy depends on self-projection, not self-withdrawal, even though the self is part of the audience. In her closet theatre of the mind, Cavendish can marry the contrary impulses to solitude and sociability, bashfulness and exhibitionism, which inform the text of her life.

Plays, Never Before Printed (1668)

Cavendish's second volume of plays offers more evidence of her engagement with Caroline culture, particularly in her humorous use of Platonic ideas. The single preface 'To the Readers' is a defiant rejoinder to the criticism which she implies had been heaped on her first volume. Cavendish declares that she makes no pretence that her plays conform either to the 'ancient Rules' or 'the modern Humor', but simply 'having pleased my Fancy in writing many Dialogues upon several Subjects, and having afterwards order'd them into *Acts* and *Scenes*, I will venture, in spight of the Criticks, to call them *Plays*' (sig. A2ᵛ).[42]

Despite this claim, the plays in this volume adhere more closely to both dramatic and theatrical conventions: in the orthodox numbering of scenes within acts, in the restricted number of plots, in the use of dance and song, and in the more interactive nature of the writing.[43] The influence of Restoration drama is especially apparent in the first play in the volume, *The Sociable Companions; or, the Female Wits*, with its double-barrelled title and its use of personal first names such as 'Peg Valorosa' for the female protagonists. The influence is most marked in the play's heightened awareness of a theatrical culture. At one point Will Fullwit is reported to have gone to the playhouse, or 'the Acting-house' as one character calls it (15); when he returns he fools his friend into believing him first dead, then mad. Reverting to sanity, he explains that he has 'only acted an Intrigue', a humour he got 'with seeing a new Play' (18).

In keeping with this newly localized sense of theatre, the play is constructed around a series of female-inspired intrigues in which dissembling

and disguise are made concrete devices. Cavendish creates an unusually precise scenario showing a group of disbanded Cavalier soldiers who, resentful of the poor reward of their loyalty, are squandering all the money they have in taverns. Frustrated by their brothers' lethargy in seeking 'some good Offices and Employments' that would 'maintain us according to our births and breedings' (30), the sisters of the soldiers resolve to use their 'Wits and Honesty' to get rich husbands (48). One of the designs involves Peg Valorosa testifying in a counterfeit spiritual court that she has become platonically pregnant, the 'Idea of a Man' having created a child by conceit (65). Mistress Informer's account of how she was called to the birth is a comic tour de force, amply fulfilling her claim to 'out-act you all' (54). In a parallel intrigue Jane Fullwit dresses as 'Jack Clerk' (71) and enters the service of Lawyer Plead-all, whom she tricks into laying a charge against her brother. By counteraccusing Plead-all of keeping a gentle-woman in man's clothes, sister and brother cozen the lawyer into marriage.

The Sociable Companions represents a major alteration in the status of acting and theatricality in Cavendish's texts. Whereas in her previous volume acting or disguise is used metaphorically, or as part of Cavendish's reworking of the codes of romance, this play inscribes theatricality as a distinctive practice, legitimating the resourceful use – by indigent Cava-liers – of female counterfeit or intrigue. The women's use of 'Deed-Wit' (38) to procure themselves wealthy husbands is contrasted with the character Prudence, whose father Save-all abstained from fighting in the war and is therefore able to provide his daughter with a portion. In the manner of an identically named character in the earlier play *The Publick Wooing* (1662), Prudence, granted her own choice by her father, hears the suits of potential lovers herself. The last scene of *The Sociable Companions* takes the form of a public assembly where Prudence delivers a speech to her suitors, simultaneously justifying her choice of an 'ancient man' for a husband and her exercise of that choice: 'Concerning the Church and State, since they do allow of buying and selling young Maids to Men to be their Wives, they cannot condemn those Maids that make their bargain to their own advantage, and chuse rather to be bought then sold' (95).

The discourse of authenticity which accrues to Prudence, who is able, through her father's dishonour, to conduct her wooing in the open and to her own advantage, coexists with, rather than undermines, the other women's paradoxically 'honest' (because politically honourable) deployment of female deceit and disguise.

All of the four complete plays in Cavendish's 1668 volume make simi-larly concrete use of theatricality, in particular the device of cross-dressing

for both sexes. One might attribute the emphasis on female cross-dressing to the situation on the Restoration stage, where in contrast to the ornamental 'masculine' costuming adopted in female performances at the Caroline court, transvestite parts did involve the assumption of full masculine dress, including wearing breeches. As Wiseman argues, the pleasure afforded the female reader by Cavendish's use of disguise and potential discovery depends on the safety and privacy of the closet drama form.[44] This is particularly true of *The Convent of Pleasure* (1668) in which disguise functions simultaneously as a form of male sexual expediency and as part of a fantasy feminine world. For this play Cavendish drew on an established romantic-comic plot in which a man enters a convent in female disguise.[45] What is appealing, and innovative, about her use of this plot is the way in which the male voyeurism made possible through the cross-dressing device is subordinated to the romantic perspective of Lady Happy, who fully believes she has fallen in love with a woman.

In the play the heiress Lady Happy decides to 'incloister [her]self from the World' (6), both to avoid the company of men, 'who make the Female Sex their slaves' (7), and to enjoy the pleasures she can afford with her father's fortune. She defines her action in chaste and pragmatic opposition to orthodox sexual choice, for, as she remarks, 'Marriage to those that are virtuous is a greater restraint then a Monastery' and 'should I quit Reputation and turn Courtizan, there would be more lost in my Health, then gained by my Lovers' (3). Accordingly, Lady Happy sets up cloister with a number of noble women, of greater birth than fortune, all of whom have vowed virginity, and together they embark on a life in which each sense is supplied, and as Madam Mediator remarks, 'every Lady . . . enjoyeth as much Pleasure as any absolute Monarch can do, without the Troubles and Cares, that wait on Royalty' (17). In a lavish inventory, reminiscent of poetic invitations to the pastoral realm, Lady Happy describes to the women 'how I have order'd this our *Convent of Pleasure*' (13). The vision she creates is one of a domesticated golden world in which changes of season will merely bring increased sensuous delights and in which luxury will extend down to the smallest detail. Significantly, men are wholly excluded from this world: in contrast to the voyeuristic access granted to men in the earlier Female Academy, Lady Happy's convent 'will admit none of the Masculine Sex, not so much as to a Grate' (11).

In one scene, however, Cavendish portrays the comic eagerness of a group of gallants to invade and disrupt this community of women. Their designs include 'smoak[ing] them out, as they do a Swarm of Bees' (18) and entering the convent 'in Womens apparel' (20). This last idea is

discounted by one of the gallants, who argues that they would discover themselves by their masculine voices and carriage, 'for we are as untoward to make Courtsies in Petticoats, as Women are to make Legs in Breeches' (20). This assertion of sexual determinism is in keeping with the men's facile desire to create sexual havoc in the convent. Having raised this possibility, the play shifts into a romantic register which accommodates sexual ambiguity within a make-believe, theatrical world.

Shortly after the convent is established, Lady Happy admits as a novice to her female community 'a great Foreign Princess', described as 'a Princely brave Woman . . . of a Masculine presence' (16), who, hearing of the convent's fame, has decided to 'quit a Court of troubles for a *Convent of Pleasure*' (22). The Princess tells Lady Happy that 'the greatest pleasure I could receive, were, To have your Friendship', and desiring that Lady Happy 'would be my Mistress, and I your Servant', she makes one particular request: 'I observing in your several Recreations, some of your Ladies do accoustre [*sic*] Themselves in Masculine-Habits, and act Lovers-parts; I desire you will give me leave to be sometimes so accoustred and act the part of your loving Servant' (22).

Lady Happy is delighted with the innocence of this request and sits down with the Princess to watch a play performed by the other women.[46] Rather than a decorous pastoral, the play is a grim sequence of episodes depicting the miseries of marriage and the female condition, from the negligence and promiscuity of husbands, perpetual pregnancy, infant mortality, wife abuse, the pains of childbirth, the irresponsibility of children, and death in childbirth to the sexual predatoriness of lords. The epilogue hammers home the socially inclusive message of this feminist drama: '*Marriage is a Curse we find, / Especially to Women kind: / From the Cobler's Wife we see, / To Ladies, they unhappie be*' (30). This theatrical elaboration of the hardship of the female condition in the workaday world functions as antimasque to the recreative theatrical wooing of the Princess and Lady Happy. Just before their scene together, Lady Happy enters '*drest as a Shepherdess*' and debates with herself: 'My Name is *Happy*, and so was my Condition, before I saw this Princess; but now I am like to be the most unhappy Maid alive: But why may not I love a Woman with the same affection I could a Man?' (32).

Lady Happy dissuades herself of this possibility by averring the un-changing laws of Nature, after which the Princess enters '*in Masculine Shepherd's Clothes*'. She reponds to Lady Happy's doubts by asserting the virtuous nature of their love in a discourse which draws on the tenets of Platonic friendship: 'Let us please our selves, as harmless Lovers use to do

... as, to discourse, imbrace and kiss, so mingle souls together' (32–3). In answer to Lady Happy's objection, 'But innocent Lovers do not use to kiss', the Princess replies, 'Not any act more frequent amongst us Women-kind; nay, it were a sin in friendship, should not we kiss', after which the women *'imbrace and kiss, and hold each other in their* Arms' (33SD). This action is followed by the Princess's transgressive and salacious couplet: 'These my Imbraces though of Femal kind, / May be as fervent as a Masculine mind' (33).

Her couplet is followed by the extraordinary stage description:

The Scene is open'd, the Princess *and Lady* Happy *go in.*
A Pastoral within the Scene.
The Scene is changed into a Green, or Plain, where Sheep
are feeding, and a May-Pole in the middle.
Lady Happy *as a Shepherdess, and the* Princess *as a Shepherd are sitting there.*
(33)

In this transformation Cavendish shows us the moment of entry into the fictive theatrical world. In the ensuing scene the Princess and Lady Happy praise one another's wit and poetic genius, distinguishing their wooing from the 'amorous . . . Verse' of 'other Pastoral Lovers' (37). The 'amorous' dimension of their courtship conveyed by Lady Happy's profession, 'I can neither deny you my Love nor Person' (37), is channelled into the '*Rural Sports*' which follow, such as '*Country Dances about the Map*-[i.e., May] *Pole*', at the end of which the Princess and Lady Happy are crowned King and Queen of the Shepherds (38SD). In a subsequent marine masque the Princess and Lady Happy appear as Neptune and a Sea-Goddess, surrounded by '*the rest of the Ladies . . . drest like Water-Nymphs*' (41SD).

At these points Cavendish's play takes on the infinitely recessive quality which Gallagher notes as peculiar to her writing.[47] In her closet theatre of the mind she imagines a female convent in which there is a theatre within which women act out fantasy selves. Their acting, moreover, is freed from necessity, for within their self-enclosed female environment they mimic heterosexual conventions for pleasure. Although the Princess defines their love as harmless, Lady Happy has graver misgivings and bursts out shortly after the rural scene:

O Nature, O you gods above,
Suffer me not to fall in Love;
O strike me dead here in this place
Rather then fall into disgrace.
(40)

Because Lady Happy has already queried the legitimacy of her love for a woman, this last line must be read as referring to the disgrace, not simply of falling in love, but of falling in love with a woman. Cavendish seems to have married the cross-dressing convention of a female pastoral theatre with the chastity of Platonic friendship, derived from Henrietta Maria's feminine culture, to allow a fleeting fantasy of what we would call lesbian love.[48] It is fleeting because the hints of the Princess's self-division which have already been laid are borne out immediately after the pastoral in a soliloquy: 'What have I on a Petticoat, *Oh Mars!* thou God of War, pardon my sloth . . . But what is a Kingdom in comparison of a Beautiful Mistress?' (39).

Yet with wonderful tenacity Cavendish will not abandon her view of the Princess's sex, for the stage description above the soliloquy reads, '*Enter the* Princess *Sola, and walks a turn or two in a Musing posture, then views* her *Self and speaks*' (39SD, emphasis mine). Contrary to her earlier practice in *Loves Adventures* (1662), where the disguised Affectionata's soliloquies and asides revealing her true identity use feminine pronouns, Cavendish introduces a discrepancy between the prose description and the dramatic situation, in which the 'Princess' reveals himself as a man in disguise. The Princess is subsequently described as again '*in a Man's Apparel*' (45SD), producing the effect of an endlessly inhabitable series of sexual selves. This absolute uncertainty of the Princess's gender is sustained at the moment of catastrophe in which Madam Mediator interrupts the Princess and Lady Happy dancing. At this point the text moves into an extended passage of description:

And after they have Danced a little while, in comes Madam Mediator *wringing her hands, and spreading her arms; and full of Passion cries out.*

O Ladies, Ladies! you're all betrayed, undone, undone; for there is a man disguised in the *Convent*, search and you'l find it.

They all skip from each other, as afraid of each other; only the Princess *and the Lady* Happy *stand still together.* (45–6)

Madam Mediator's use of the indefinite pronoun, 'search and you'l find it', registers at the climax of the play a moment of aporia, in which it is impossible to know whether the Princess is, as we are directed to believe, 'a Princely brave Woman, *truly* of a Masculine presence', or, as Cavendish's comma has it, 'a Princely brave *Woman truly*, of a Masculine presence' (16, emphasis mine). In the denouement the entrance of an '*Embassador to the* Prince' (46SD) simultaneously forces the dissolution of

the convent's fantasy feminine world and marks the decisive entry of a masculinist discourse into the play, as the 'Prince' declares that if his counsellors of state refuse him leave to marry Lady Happy, he will 'have her by force of Arms' (47).

Clearly *The Convent of Pleasure* offers different kinds of textual pleasure to different readers. The reader engaged in one way by Lady Happy's feminine world may share her credulity as to the Princess's gender and enjoy the suggestion of an erotic relationship between women. For other readers the story of a Prince who infiltrates a convent disguised as a woman who then acts as a man offers fantasies of voyeuristic access to a woman-centred world and of the suspension of an essential masculine identity. We could see the play itself as caught in a conflict between these different, sexually determined modes of reading. For there is some doubt as to whether Cavendish's disposal of her female freak at the end of the play is a gesture motivated solely by her own reason. As well as the infiltration of a man into the convent, there is evidence of a man having penetrated Cavendish's text. In some copies of the 1668 *Plays*[49] the final two scenes after the revelation of the Princess as a man are headed with a pasted-in slip reading 'Written by my Lord Duke' (47), but with no indication, as with similar instances elsewhere in Cavendish's texts, of where 'my Lord Duke' ends. One might surmise that Cavendish lost interest after the disclosure of the Princess as a man and left the writing of the rest of her play to her husband; or she did write the final two scenes, which poke fun at Puritan prurience and older women's sexual desires, but thought they would be judged unseemly coming from a woman.[50] Whoever wrote the final two scenes, it is Cavendish who has the last word on the Princess's gender, for in one of her breaks with tradition in this volume she prints the *Dramatis Personae*, or 'the Actors Names', at the end rather than at the beginning of the play, and if we look at the final page of text of *The Convent of Pleasure* we see that, contrary to Mimick's assertion that 'the *Prince* has imitated a Woman' (51), in Cavendish's mind 'the Princess' (sig. O2ᵛ) was not an actor but an actress. One might speculate on Cavendish's placing of 'the Actors Names' at the end of three of the plays in this volume, as a means of deliberately enhancing the suspense enjoyed by the reader with respect to the gender of the characters. Certainly *The Convent of Pleasure* takes her experimentation with the closet drama form to the most sophisticated degree of the page becoming stage, producing the ultimate textual fantasy of female performance.

A PRINCELY BRAVE WOMAN

Cavendish herself, in her rhetoric of dress and behaviour, seems to have aimed at a blurring of the boundaries between genders similar to that produced by *The Convent of Pleasure*. Charles Lyttelton wrote of his meeting with the Newcastles on the way to York in 1665 that Margaret was 'dressed in a vest, and, instead of courtsies, made legs and bows to the ground with her hand and head'.[51] His description of her masculine dress and gestures echoes Bulstrode Whitelocke's account of the clothing and behaviour of Queen Christina of Sweden on his first reception at her court as Cromwell's ambassador. According to Whitelocke, Christina appeared soberly dressed in grey, with 'a jackett such as men weare' over her habit and 'a black velvet cappe . . . which she used to put off and on as men doe their hattes'.[52] Whitelocke goes on to describe Christina's attitude while he was delivering his speech in a way which suggests a social fantasy of her behaviour as sexually provocative and intimidating:

The queen was very attentive whilst he spake, and comming up close to him, by her looks and gestures (as was supposed) would have daunted him; butt those who have bin conversant in the late great affayres in England, are not so soon as others appaled, with the presence of a young lady and her servants.[53]

Whitelocke both evokes, and distances himself from, a form of seductiveness able to be manipulated by women in positions of power; an example of which is the overt sexual display characteristic of aristocratic female performance. Whitelocke saw Christina act 'a moorish lady' and 'a citizen's wife' in a masque.[54] He also witnessed her abdication, after which she set off on an extravagant tour of Europe where her flamboyant conduct, particularly her masculine dress and behaviour, caused much amazed comment.[55] This contextualizes Samuel Pepys's remark that there was as much expectation of Cavendish's coming to court in London in 1667, 'that so [many] people may come to see her, as if it were the Queen of Sweden'.[56] Many details in Pepys's diary concur with Whitelocke's image of Queen Christina, which suggests that Cavendish may also have been trying to create an image of herself as 'a Princely brave Woman'. Pepys refers to Cavendish's 'velvet-cap', her 'many black patches', her décolletage and her 'black juste-au-corps', or 'justico', a garment similar to a masculine riding coat, made popular as a fashion for women by Queen Catherine of Braganza. He also refers twice to her 'antic' dress and appearance.[57] Mary Evelyn's account of Cavendish as a spectacle viewed at close quarters confirms the hint that her sartorial self-fashioning should be

seen as forming a continuum with her creation of fantasy selves in her writing:

I was surprised to find so much extravagancy and vanity in any person not confined within four walls. Her habit particular, fantastical . . . Her mien surpasses the imagination of poets, or the descriptions of a romance heroine's greatness: her gracious bows, seasonable nods, courteous stretching out of her hands, twinkling of her eyes, and various gestures of approbation, show what may be expected from her discourse, which is as airy, empty, whimsical and rambling as her books.[58]

This image of excess, of Cavendish bursting out of confinement, chimes with Colley Cibber's description of the actress Susannah Mountfort's performance as Melantha in Dryden's *Marriage à la Mode* (1671) as seeming 'to contain the most compleat System of Female Foppery that could possibly be crowded into the tortur'd form of a fine Lady'.[59] The comparison is enhanced by the fact that, with her gentry origins, Cavendish was herself an apocryphal lady.[60] Evelyn indicates that 'the theatre of Margaret' was the ultimate monologic performance: 'My part was not yet to speak, but to admire.'[61] Only at one point in her London visit did Cavendish engage in a performative act which bore a semblance of the dialogic, during her visit with the Duke of Newcastle to the Lincoln's Inn Theatre for a performance of Newcastle's play *The Humorous Lovers,* written in collaboration with Thomas Shadwell. Pepys assumed that the play was by Cavendish and recorded how 'she at the end made her respect to the players from the box and did give them thanks'.[62] A contemporary letter alluding to this event decribes the Duchess as 'all the pageant now discoursed on: Her brests all laid out to view in a play house with scarlett trimmed nipples.'[63] Cavendish's acting out the fantasy of having her plays performed was itself a piece of theatre. It seems appropriate that Cavendish's acknowledgement of the art of female performance should have taken the form of such an outrageous upstaging.

Styles of female greatness: Katherine Philips's translations of Corneille

In Etherege's Restoration comedy *The Man of Mode* (1676), the hero Dorimant, disguised as Mr Courtage, endears himself to his prospective mother-in-law Lady Woodvill by extolling 'forms and ceremonies, [as] the only things that uphold quality and greatness'. Lady Woodvill concurs wholeheartedly with Courtage's disparaging of modern manners: 'Well! this is not the women's age, let 'em think what they will, lewdness is the business now, love was the business in my time.'[1]

Lady Woodvill's attachment to the 'forms and civility of the last age' (1.1.135) implicitly juxtaposes the licentious court of Charles II, epitomized in Dorimant's serial amours, with the social ascendancy of women at the court of Charles I. This is a form of harking back, the point of which is not to insinuate that Lady Woodvill is in her dotage; rather, the ideals upheld by 'the famous Lady Woodvill' (1.1.129–30) posit criteria by which 1670s Restoration society may be found wanting, notwithstanding the self-assurance of Etherege's new generation. By 'greatness' we must understand not just noble rank, but ideals of magnanimity, valour and loyalty which Etherege signals as defunct. Dorimant's opening reciting of lines from Waller's poem 'Of a War with Spain' appropriates the heroic register merely as a spur to sexual conquest.

Lady Woodvill's judgement that 'this is not the women's age' (4.1.19) evokes the feminocentric culture of the Caroline court, but from the vantage-point of 1676 it also looks back to the previous decade of the 1660s. Partly owing to the new presence of women actors, the early years of the Restoration theatre were characterized by a pronounced concern for the 'characters' of women in drama newly written for the stage.[2] It was these years which saw the enthusiastic reception in Dublin and London of Katherine Philips's translations of Pierre Corneille's neoclassical tragedies.

An elegy on Philips's death in 1664 extols her as having taught 'Honour, Love, and Friendship to this Age' and as adorning the stage with 'Tragique

buskins'.[3] Her *Pompey* was the first heroic play written in rhymed couplets produced on the British stage. Philips undertook her complete translation of Corneille's *La Mort de Pompée* (1644) on the encouragement of Roger Boyle, Earl of Orrery, whom she encountered among the aristocratic society of Restoration Dublin. Under Orrery's sponsorship, Philips's play was performed at the new pupose-built Smock Alley Theatre in February 1663, accompanied by the music and spectacle characteristic of theatrical productions at the Caroline court. Her unfinished translation of Corneille's *Horace* (1640) was performed after her death at the court of Charles II in 1667, in a version completed by Sir John Denham.

Gerald Blakemore Evans describes Philips as 'one of the few connecting links between Cartwright's world and the world of Charles II and Dryden'.[4] Like Margaret Cavendish's, Philips's writing was fuelled by an engagement with the culture of *préciosité*, in both its French and English manifestations.[5] Similarly, like Cavendish, her writing exhibits a charged relationship to theatricality and the idea of performance. However, unlike the Duchess of Newcastle, Philips was hailed by her contemporaries as an exemplary female author and actor, who had established new standards of writing and behaviour. In his prologue to *Pompey*, Wentworth Dillon, Earl of Roscommon, invites the 'bright Nymphs' in the audience to

> hear a Muse, who has that *Hero* [Caesar] taught
> To speak as gen'rously, as e're he fought.
> Whose eloquence from such a Theme deters
> All Tongues but English, and all pens but Hers.[6]

It is unlikely that any women were among the players who acted *Pompey* at its Dublin performance; actresses were a later addition to the troupe maintained by John Ogilby, the Irish Master of the Revels, and it seems probable that on this occasion the roles of Cleopatra, Cornelia and Charmion were played by men.[7] Female performance *was* part of the coterie ambience within which *Pompey* was produced, though, as illustrated by Philips's poem 'To my Lady Elizabeth Boyle, Singing – Since affairs of the State &co', the first of five songs Philips added to the play.[8] Moreover, Philips's writing was seen as a model of decorum, as Sir Edward Dering observed when he wrote in the epilogue to *Pompey*:

> no Bolder thought can tax
> These scenes of Blemish to the blushing Sex . . .
> As Chast the words, as harmless is the Sence,
> As the first smiles of Infant Innocence.
> (3–8)

Philips's translations of Corneille thus form a crucial bridge between the elite culture of the Caroline court, which created new opportunities for female acting and authorship, and the *milieux* of Restoration England and Ireland, where both these activities were transformed within the new public theatres. In this chapter I discuss the particular social and cultural climate which fostered Philips's career as a poet and translator. I then analyse the registers of female heroism in *Pompey* and *Horace*, suggesting ways in which these plays appropriate and transform elements of early Stuart drama.

CAROLINE LITERARY AND THEATRICAL MODELS

Philips's poetic persona of 'Orinda' highlights the instrumentality of theatrical self-invention to her writing. Her appropriation of pastoral solitude as a *mise en scène* for her authorship is highlighted in a letter printed in the preface to the posthumous edition of her works published in 1667. Philips wrote the letter to her mentor, Sir Charles Cotterell, in January 1664, shortly after the appearance of an unauthorized edition of her poems with her initials on the title-page. The apologia was constructed with care, and accompanied another letter to Cotterell in which Philips asks him to publicize her repudiation of the edition.

In the letter Philips deprecates her poems as 'Ballads' and her urge to write as a 'humour', declaring that '*[I] never writ any line in my life with an intention to have it printed.*'[9] Her resentment intensifies in her complaint about the public exposure entailed by the printing of her poems:

But is there no retreat from the malice of this World? I thought a Rock and a Mountain might have hidden me, and that it had been free for all to spend their solitude in what Resveries *[sic] they please, and that our Rivers (though they are babbling) would not have betray'd the follies of impertinent thoughts upon their Banks; but 'tis only I who am that unfortunate person that cannot so much as think in private, that must have my imaginations rifled and exposed to play the Mountebanks, and dance upon the Ropes to entertain all the rabble.*[10]

The mythology of female authorship which Philips cultivated under the pseudonym of 'Orinda' is clear from this passage. The myth is that of a lonely Welsh shepherdess, confiding her thoughts to the rocks and rivers with no expectation of their repetition beyond the echo provided by nature. Against this image of pastoral retirement, Philips represents the publication of her poems as a degraded performance. Her language

combines the idea of rape – '*imaginations rifled*' – with the image of the poet forced to perform tumbling tricks for an unsavoury, illiterate '*rabble*'.[11] In publishing *Poems by the Incomparable, Mrs K. P.*, Philips asserts, the printer had transported her writing from its proper pastoral context into the literary marketplace.[12]

As Elaine Hobby points out, 'Orinda' had already acquired a considerable reputation among 'the coterie of court and leading poets' before the publication of the 1664 *Poems*.[13] In 1651 she contributed a commendatory poem to the posthumous edition of Cartwright's *Comedies* and in the same year a poem praising her as 'a wittie faire one' appeared in a collection of Henry Vaughan's poetry.[14] Another commendatory poem by Philips appeared at the start of Henry Lawes's *Second Book of Ayrs* published in 1655, a collection containing Lawes's setting of her poem 'Friendships Mysterys'.[15] Philips and her friend Anne Owen, or 'Lucasia', were co-dedicatees of Francis Finch's treatise, *Friendship* (privately printed, 1654) and in 1657 Bishop Jeremy Taylor published *A Discourse of the Nature and Offices of Friendship. In a Letter to the Most Ingenious and Excellent Mrs K. P.*

Philips's empathy with the theatrical sensibility fostered by Henrietta Maria is especially evident in her choice of 'Orinda' as her 'disguised Name', the phrase used by Cotterell for the sobriquets bestowed by Philips on 'her particular friends'.[16] When her poems and translations were published posthumously in 1667, the common name 'Mrs. Katherine Philips' was dwarfed on the title-page by letters spelling the legend 'The matchless ORINDA' (Figure 12). In the 1660s that superlative would have resonated with the heroines of Cavalier drama, who are frequently represented as 'matchless'.[17]

Philips's cultivation of female friendship likewise has its roots in the Caroline drama and poetry inspired by the French movements of *préciosité* and *honnêteté*.[18] In her discussion of court drama such as Cartwright's, Erica Veevers observes that 'women's sense of virtue sought to extend the ideal of friendship and honour . . . to friendship and honour between women'.[19] Philips's admiration for Cartwright is evident both from her poem addressing him as 'prince of Fancy' and in the borrowing of names from his drama as pseudonyms for members of her so-called 'Society'.[20] In one of her letters to Cotterell, or 'Poliarchus', Philips echoes lines from *The Lady-Errant*, and her reference to their mutual friend Anne Owen as 'Calanthe' in the same letter demonstrates an acquaintance with Cartwright's play in a manuscript state, for in the text of the play published in 1651 this character name was changed to 'Lucasia'.[21] As we saw in Chapter 4, *The Lady-Errant* shows the currency in England of

POEMS

By the moſt deſervedly Admired

M͞ʳˢ *KATHERINE PHILIPS*

Edward The matchleſs *Smyth*

ORINDA.

To which is added

MONSIEUR CORNEILLE'S

POMPEY
& ⎱TRAGEDIES.
HORACE,⎰

With ſeveral other Tranſlations out of
FRENCH.

LONDON,

Printed by *J. M.* for *H. Herringman,* at the Sign of
the *Blew Anchor* in the Lower Walk of the
New Exchange. 1 6 6 7.

Figure 12. Title-page of *Poems by the Most Deservedly Admired Mrs Katherine Philips,* 1667.

feminist ideas drawn from Neoplatonic philosophy, and vividly drama-
tizes women's acting, eloquence and literacy. Philips's particular know-
ledge of this tragicomedy is highly suggestive, given her own literary and
linguistic gifts and her imbrication in England's complex political
struggles.

The belief in women's reason and dignity encouraged by *honnête*
writers such as Du Bosc encompassed a view of their capacity to partici-
pate in government. The most striking manifestation of this new estimate
of women's potential is the figure of the *femme forte*, or heroic woman, in
French and English literature. Well before the restoration of the Stuart
monarchy, Philips was writing poetry which 'translated the meanings of
the queen's [or aristocratic woman's] virtue to the larger community'.[22] In
her verses 'To the Right honourable: Alice, Countess of Carberry, on her
enriching Wales with her presence', Philips depicts the Countess as
renewing 'the vertuous grandeur' which the world has lost.[23] The geneal-
ogy of English heroic womanhood derives added depth from the fact that
the recently married Countess of Carberry was the former Alice Egerton,
who as a young woman acted in Milton's masque about chastity and
truth. As Ian Maclean has demonstrated, the depiction of the *femme forte*
in French feminist writing of the mid-century overlaps to a considerable
extent with the representation of women in French heroic drama.[24]
Corneille's elevated portrayal of women is one obvious source of his plays'
attraction for Philips, whose character was shaped by the idealized
feminism fostered by Henrietta Maria at the Caroline court.

FEMALE HEROISM IN EARLY STUART DRAMA

In 1637 Joseph Rutter had produced the first English translation of
Corneille's *Le Cid*. The high-minded debates between love and honour
engaged in by Corneille's characters found a receptive audience at the
Caroline court which had already been entertained with this sort of drama
by Davenant, Suckling and Cartwright.[25] After the English Civil Wars,
the beheading of the King and the unsettled period of republican
government, Corneille's play glorifying Pompey's death and dramatizing
the political cunning of Ptolomy, Caesar and Cleopatra was bound to
appeal to a young woman who was an enthusiastic convert to Royalism,
and whose marriage to Colonel James Philips, an MP in Cromwell's
parliament for Cardigan in Wales, brought her closely in touch with the
realities of political strife and rebellion.

Moreover, Corneille's play provided Philips with the opportunity to explore the virtues of friendship, clemency and reconciliation; virtues which had political overtones during the Interregnum, and acquired more active connotations at the Restoration, when James Philips was first suspended, and then expelled from his seat in parliament, jeopardizing his and Katherine's material and emotional security.

Crucial to the play's political meanings are its two powerful female characters: Cleopatra, sister of the Egyptian King, Ptolomy, and Pompey's widow, Cornelia. Recent criticism of *Pompey* has concentrated almost exclusively on the figure of Cornelia.[26] This focus ignores the play's engagement with the idea of female sovereignty, in particular the 'metonymic overlap between female chastity and royal authority' which works to legitimize Cleopatra's bid for queenship.[27]

Like Mary Sidney in her sixteenth-century translation of Robert Garnier's *Antonie* (1590), Philips inherited from Corneille a Cleopatra interestingly altered from classical sources. In his *examen* of *Pompée*, Corneille accounts for his portrayal of Cleopatra as follows:

Le caractère de Cléopatre garde une ressemblance ennoblie par ce qu'on y peut imaginer de plus illustre. Je ne la fais amoureuse que par ambition, et en sorte qu'elle semble n'avoir point d'amour qu'en tant qu'il peut servir à sa grandeur.

[The character of Cleopatra has an elevated quality because one may imagine her as being more noble. I made her amorous only through ambition, so that she seems to have just enough love to set off her greatness.][28]

Corneille's image of Cleopatra as driven primarily by political ambition involves a reappraisal of the power-seeking woman whom Renaissance authors found deeply unsettling. The ambivalent attitude aroused by Cleopatra is apparent in Thomas May's Caroline translation of Lucan's *Pharsalia* (1635), a history with which Philips may have been familiar.[29] In May's depiction Cleopatra's single-minded ambition produces an equivocal levelling between her and Caesar, whom May addresses thus:

> Let not the guiltie greatness with thy mind
> Be by vain men extolled; since here we find
> A womans breast the same impressions moves
> Ambitious pride, and Soveraignties dire love
> A like in thee and *Cleopatra* plac'd
> Made thee disloyal prove, and her unchast.[30]

Corneille revises the classical historians' image of Cleopatra as '*meretrix regina*'[31] by making her sexual liaison with Caesar into a courtship that is conducted with rigorous observance of form and ceremony. This

ritualizing of the relationship between Cleopatra and Caesar liberates Philips from the scandalous associations of history's 'harlot queen', allowing her to explore more fully Cleopatra's political ambition and agency.

The models of female greatness and bravery presented in *Pompey* and *Horace* were not peculiar to Corneille; this kind of heroine formed part of the English tradition of Senecan closet drama in Daniel's *Cleopatra* (1593), Kyd's *Cornelia* (1594) and Cary's *The Tragedy of Mariam*. These portrayals in turn fed into tragedy written for the public stage, such as Marston's *Sophonisba*, written in the same year as Shakespeare's *Antony and Cleopatra* (1606), with its dynamic, contradictory heroine. Particularly relevant to Philips's translation of *Pompey* is Fletcher and Massinger's tragicomedy *The False One*, (1620), which dramatizes the meeting between Cleopatra and Julius Caesar in Egypt after Pompey's defeat.[32]

By juxtaposing *Pompey* with *The False One* we may see Philips drawing upon aspects of female characterization from earlier English dramatic and theatrical tradition.[33] A comparison of these plays will highlight the aesthetic and formal innovations of French neoclassical drama, and suggest the aspects of this drama which appealed especially to Philips as a woman writing for the Restoration stage.[34]

'BY HER GLORY MOV'D': FEMALE STASIS AND GRANDEUR IN 'POMPEY'

In his *examen* on *Pompée* Corneille expresses his consciousness of an indecorum concerning his use of theatrical space. He notes that the second and fifth acts of the play begin with scenes in which, respectively, Cleopatra and Cornelia enter into the 'grand vestibule' or the hall on to which all the rooms in the royal palace open. Corneille comments, 'Elles sembleraient toutes deux avoir plus de raison de parler dans leur appartement; mais l'impatience de la curiosité feminine les en peut faire sortir' [Both of them would seem to have more reason to talk in their private chamber, but the impatience of feminine curiosity might compel them to come out].[35] Corneille here registers a transgression of his theatre's gendered demarcation of public and private spheres, a transgression he justifies with reference to 'feminine curiosity'. He explains further that Cleopatra's eagerness to learn of Pompey's fate, and Cornelia's desire to discover the latest news of Ptolomy's rebellion against Caesar, propel them into the public hall of the palace.

Such explicit concern for feminine propriety is absent from Fletcher and Massinger's *The False One*, which stresses both Cleopatra's heroic aspiration and the theatrical allure of her sexuality. The playwrights utilize the association of women with enclosed space to accentuate Cleopatra's desirability, and the witty initiative with which she jettisons herself into the action.

At the start of *The False One*, Cleopatra has been confined by her brother Ptolomy to prevent her claiming her rightful title of queen and a share in the government. Her entrance is heralded by a song praising her '*shut-up-beauty*' which '*like fire, / . . . breakes out clearer still and higher*'.[36] The paradoxes of freedom within imprisonment, enlargement through confinement, shift in status from metaphors to a theatrical imperative as the song asserts that

> *the beauty of your mind,*
> *Neither checke, nor chaine hath found.*
> *Looke out nobly then, and dare,*
> *Even the Fetters that you weare.*
>
> (1.2.41–4)

The instruction for Cleopatra to '*Looke out*', echoing the song's opening line, '*Look out bright eyes*', suggests that she appears above on the balcony during the singing, before proceeding to a dialogue with Apollodorus in which he brings news of Pompey's defeat and Caesar's arrival in Egypt. This news encourages Cleopatra literally to '*dare*' her fetters and 'find out' a way of coming to Caesar.

Fletcher and Massinger maximize the theatrical possibilities presented by Cleopatra's conveying herself to Caesar in 'a mattress or flock bed', an episode which in Shakespeare's play forms part of the legend of the Egyptian Queen's amorous conquests.[37] In Act 2, scene 3 a '*Noise within*' is followed by the stage direction, '*Enter* Sceva, *with a packet,* Cleopatra *in it*' (2.3.50, 61.1). Cleopatra's emergence from the '*packet*', or roll of bedding, works a stunning effect. Caesar's response, 'What heavenly vision?' (2.3.78), creates doubt as to whether she is human or divine, an uncertainty which tips in the direction of burlesque with Sceva's impression of her as 'a tempting Devill' (2.3.82). Sceva's line – 'Now she begins to move too' – indicates a masque-like sequence in which an initially immobile Cleopatra comes to life (2.3.81). Caesar's image of Cleopatra as 'some celestiall sweetnesse, / The treasure of soft love' (2.3.104–5) evokes an attitude of feminine beauty and vulnerability borne out by Cleopatra's gesture of kneeling before Caesar and begging him to 'raise me like a Queene from my sad ruines' (2.3.144).

Here the playwrights consciously exploit the idea we saw propounded in the Jacobean masque that 'women work the best motions'. In *The False One* this brilliantly orchestrated motion secures Cleopatra Caesar's patronage and love. By contrast, in *Pompey* the first encounter between Caesar and Cleopatra is continually deferred. In fact, for the space of three and a half acts the audience is denied the opportunity to witness the interaction of the play's two primary characters. By the end of Act 2, the report of Pompey's betrayal and murder by the Roman Septimius (Fletcher's and Massinger's 'false one'), has cleared the way for the previously undecided Cleopatra to receive Caesar's addresses. At the beginning of Act 3 we learn that the Queen has repaired to her 'Appartment', where 'unmov'd [she] expects [Caesar's] Complement' (3.1.3–4) Two scenes later, Caesar reveals that Antony has acted as the mediator of his suit. Not until Act 4, scene 3 do Cleopatra and Caesar speak directly to each other, each accompanied by their retinues.

The suspension of a meeting between the play's romantic leads frees Philips to explore the complexity of motive in Cleopatra's wish to be restored to the Egyptian throne, her claim to which has been obstructed by Ptolomy. Cleopatra's coveting of her 'share of Power' (2.3.14) is accompanied in Corneille's play by a loyalty to Pompey which derives from his having assisted Caesar to help her father quash an Egyptian rebellion. Hence, at the outset, Cleopatra's love for Caesar is qualified by her knowledge of the danger posed to the defeated Pompey by her brother and his state advisers. To Charmion, her maid of honour, she confides:

> I Love him, but a Flame so much refin'd,
> How bright soever, dazles not my mind:
> For Virtue makes my inclination know,
> What *Caesars* Mistress does to *Pompey* owe:
> And none dares own a passion so sublime,
> But she that scorn's the shaddow of a crime.
>
> (2.1.1–6)

Philips's Cleopatra professes a Platonic love for Caesar, the correctness of which informs her political conduct. The punctilio she observes here is as much ethical as moral, the potential 'loss of Fame' (2.1.82) about which she is concerned stems from her ancestral, political obligation to Pompey. When Charmion presses to know whether Cleopatra is assured of Caesar's love, Cleopatra expounds the etiquette by which she is governed:

> Know that a Princess by her glory mov'd,
> No Love confesses till she be belov'd.
> Nor the most noble passion ever shows,
> When it shall her to a Contempt expose.
> (2.1.31–4)

This speech recalls the definition of female civility in Montagu's *The Shepherds' Paradise* where women reciprocate male affection, rather than initiating expressions of love.[38] In both plays this feminine aloofness is represented as empowering. In Montagu's pastoral Queen Bellessa's rule is restricted to the society who live in the retreat. In contrast, Philips's Cleopatra exhibits an urge for omnipotence resembling a Marlovian overreacher:

> Were it but one day, 'twere enough for me,
> One day, the Mistress of the World to be.
> I have Ambition, and bee't good or ill,
> It is the only Soveraign of my Will.
> And 'tis this Noble Passion sure, or none,
> A Princess may without a Blemish own.
> (2.1.75–80)

Ian Maclean comments in relation to Cleopatra's speech in Corneille's play: 'ambition is an un-Christian attribute which [French] writers at this time do not attempt to justify, but simply accept as the result of *générosité*', or the nobleness that derives from high birth.[39] In the song added by Philips at the end of Act 5, Cleopatra is praised as one '*who ambition could withstand*' (5.5.62), alluding to her eventual offer to sacrifice her love for Caesar to ensure his political survival. While the song presents Cleopatra's actions as magnanimous, one could equally read her offer as a ruse calculated to strengthen Caesar's favour towards her.

Philips's song seems designed to stabilize the 'shadow of uncertainty [which] hovers around Cleopatr[a]',[40] an uncertainty which stems from her mingling of Platonic affection and political will. Philips's translation consistently sharpens Cleopatra's agency and charisma through words such as 'will', 'wit' and 'art'.[41] When Charmion questions the security of Cleopatra's liaison with Caesar, instancing his marriage to Calphurnia, Cleopatra asserts:

> Perhaps I better shall secure his love,
> Perhaps my passion may find out an Art
> Better to manage that Illustrious Heart.
> (2.1.70–2)

In Shakespeare's tragedy, and Fletcher's and Massinger's portrayal of 'Young Cleopatra', the Queen's myriad 'becomings (*Anthony and Cleopatra*, 1.3.97) and 'behaviours' (*The False One*, 3.2.34) compel both wonder and suspicion. There is always the possibility, in Fletcher and Massinger's play, that Cleopatra is 'the false one' of the title. In *Pompey* the monumentalizing of Cleopatra achieves above all an effect of *admiratio*, or surprise, for her greatness is animated by the motions of a 'truly noble' spirit.[42] Her exemplary honour and humanity are best seen in her ascension to the throne at the end of the play. Her assumption of the title of queen is overshadowed by the death of Ptolomy, who drowns trying to avoid capture after instigating a plot against Caesar. Cleopatra's demurring address to Caesar crystallizes her combination of honourable action and political astuteness:

> Excuse me, if the Crown conferr'd by You
> As it obliges, Does afflict me too.
> And if to see a Brother justly kill'd
> To Nature I as well as Reason yield.
> No sooner on my Grandeur I reflect,
> But my Ambition by my Blood is checkt.
> I meet my Fortune with a secret Groan,
> Nor dare without Regret ascend the Throne.
>
> (5.5.35–42)

'O WORTHY WIDOW OF A MAN SO BRAVE!' (3.4.48)

Cleopatra's recognition of the competing claims of nature and reason makes her an exemplary Cornelian heroine. The level manner in which she accommodates these conflicting demands contrasts with the strife experienced by Pompey's widow, Cornelia, whom Corneille transforms from his sources into a Roman heroine, breathing defiance against Caesar.

Cornelia's encounters with Caesar illuminate the paradoxical function of patriotism in bolstering *and* subjecting women's wills. Her resolve not to be reconciled with her husband's victor is presented by both Corneille and Philips as the hallmark of her Roman identity. Philips transforms the Duchess of Malfi's stoicism into Cornelia's active braving of Caesar:

> For never think my Hatred can grow less,
> Since I the Roman Constancy profess;
> And though thy Captive, yet a Heart like mine,
> Can never stoop to hope for ought from Thine:
> Command, but think not to subject my Will,
> Remember this, I am *Cornelia* still.[43]
>
> (3.4.42–7)

While Cornelia's Roman identity spurs her resentment against Caesar, it also moves her to recognize the magnanimity of his actions. In the following couplet Philips's Englishing of 'comme vraiment Romaine'[44] makes 'Romanness' a quality which unites Cornelia and Caesar across genders: 'But as a Roman, though my Hate be such, / I must confess, I thee esteem as much' (5.4.62–3). When Pompey's freedman, Philip, renders Cornelia her husband's ashes on Caesar's instructions, Cornelia identifies with his heroic generosity:

> So many Int'rests with my Husband's met,
> Might to his [Caesar's] Virtue take away my debt.
> But as Great Hearts judge by themselves alone,
> I choose to guess his honour by my own.
>
> (5.1.99–102)

Earlier, Caesar himself expresses his appreciation of Cornelia's 'truly Roman Heart' (4.4.9) when she brings him news of Ptolomy's plot against his life. Caesar interprets Cornelia's warning as a sign of her good will, claiming that Pompey 'does still subsist, and act in you' (4.4.16). However, Cornelia explains that she has saved Caesar from an infamous death to have the pleasure of exciting 'some brave Arm' (4.4.35) to revenge Pompey's murder nobly in the field. In preserving Caesar's life, Cornelia has Rome's interest at heart, for should Caesar fall to Egypt, Rome's liberty would be lost to a foreign power.

Timothy Reiss suggests that Corneille introduced Cornelia to represent 'a reasoned middle path between Rome and its destruction, between Caesar and her debt to and love for Pompey, and all the time under the tension of the desire for vengeance'.[45] However, the zeal of Cornelia's hatred, which she says 'shall be my *Pompey* now' (5.4.60), prevents her from being interpreted as representing a rational mean.[46] Her anguished interruptions make her reminiscent of the widowed Queen Margaret in Shakespeare's *Richard III*; like Margaret's cursing, Cornelia's harangues are described by Caesar as the threats of a powerless woman: 'Could she perform more, she would wish it less' (5.5.10).

Philips adds pathos to Corneille's tortured widow in the interlude at the end of Act 3 where Pompey's ghost appears 'to *Cornelia* asleep on a Couch' (3.4.93.1) In a 'Recitative Air' Pompey predicts Caesar's '*fall by Treason*' (3.4.114) and sings of his and Cornelia's future happiness in Elysium. The vision heightens the exorbitancy of Cornelia's role, emphasizing that the restoration she looks forward to is personal, not political:

> Thy stormie Life regret no more,
> For Fate shall waft thee soon a shoar,
> *And to thy* Pompey *thee restore.*
>
> (3.4.118–20)

While Cornelia's role as an actor is limited, her vision and her prophetic language 'foretell[s] a conflict that will last through three generations'.[47]

'A LITTLE LESS TO ONE MAN'S LOVE RESIGNED': TRAGIC SELF-DIVISION IN 'HORACE'[48]

For all its ambivalence, 'Romanness' provides a point of affiliation and self-definition for Cornelia. By contrast, in *Horace* the female characters struggle with, and ultimately reject the demands of patriotism. The play deconstructs with astonishing clarity the ideals of constancy and fortitude associated with the masculine heroic ethos.

The action of *Horace* makes starkly apparent the Roman state's subordination of private feeling to public duty.[49] However, the characterization of the women disrupts and questions the obligation for the displayed self to be seamlessly aligned with political interests. The play opens with a discussion between Sabina and Julia about the emotional trauma presented by the civil war between Rome and Alba in which Sabina's husband Horace and her brothers, the Curatii, are opponents. Even while resolving 'to stop my tears', Sabina avers that in 'such a storm . . . it may become the strongest heart to shake' (1.1.13, 3–4). Sabina's insistence on the validity of her distress serves repeatedly to question the ideal of constancy upheld by the men, in particular the Roman patriarch, Old Horace. When Old Horace brings news that the fight between Horace and the Curatian brothers is going ahead, Sabina rejects the solace of 'Reason' when faced with 'such a Tide of Sorrow' (3.5.8–9). She claims that to express grief in such a crisis is the ingenuous response, and asserts that the masculine stiff upper lip is destructive and deceitful:

> Perhaps, we our despair might seem to scorn;
> And with false Constancy our selves adorn;
> But when without a blush, we may admit,
> Of Grief; 'twere weakness to dissemble it.
> We to your Sex can such a cunning spare;
> And will pretend only to what we are.
>
> (3.5.12–17)

This speech subverts the conventional view of women's grief as a strategic performance, a view expressed in Old Horace's depiction of the women's

sorrow as 'cunning tenderness' (2.7.5). As well as inverting gender stereo-
types, Sabina's language persistently fractures the ideals of heroic action.
When Old Horace urges his son and son-in-law to the battlefield, she
assures him that they are 'too worthy' their father not to uphold his standard
of 'severer vertue' (2.7.8, 12); however, Sabina's addressing those same sons
as 'Tigers' (2.7.16) highlights the rapacious nature of their warlust.

Sabina's dilemma is absolute; like Shakespeare's Octavia she is
caught between the performative expectations of her familial roles, and
finds 'no midway / 'Twixt the[se] extremes' (*Anthony and Cleopatra*,
3.4.19–20). The impossibility of Sabina 'well express[ing] the Sister, and
the Wife' (2.6.44) leads her to pursue an alternative role as a martyr. In
Act 2, scene 6 she offers herself as a sacrificial spur to Curiace and
Horace, proposing that her death earn them 'right to each others hate'
(2.6.21). Sabina's challenging of the men to kill her threatens to melt
their resolution: momentarily they are subdued and respond simply with
the cries, 'O! wife! – / O! Sister! –' (2.6.55). When Sabina upbraids their
want of valour, however, Horace asks what 'quarrell' has precipitated her
'sharp revenge', reducing her valiant gesture to the level of a domestic
dispute (2.6.59–60).

As Hero Chalmers crucially observes, Philips's translation makes more
explicit than Corneille's original the division between masculine military
prowess and feminine compassion, thereby seeming to promote 'a peculi-
arly feminine drive towards unity and peace'.[50] It is not just the female
characters who provoke debate on the place of the emotions in the
political sphere. While Horace exults in the stringency of Fortune which
obliges him to expend 'a destructive fury' (2.3.23) on his kin, Corneille's
Curiace questions Horace's notion of heroic performance, finding his idea
of exceptional virtue 'somwhat [*sic*] barbarous' (2.3.34). Like Shakespeare's
Macduff, he balks at the courage which requires him 'to quit the Laws
ev'n of Humanitie' (2.6.60): 'I hope to doe what you or dare, or can; /
My heart's as great; but I am still a Man' (2.3.45–6).

The oppositional voice tentatively expressed by Curiace, and boldly
asserted by Sabina, is climactically embodied in Camilla's braving of
Horace after his mortal combat with her betrothed, Curiace. Earlier,
Camilla expresses her sense of powerlessness: ' "Heav'n governs us without
our own consents; / And we are passive in these great Events" '(3.3.31–2).[51]
However, the deaths of her two younger brothers, and Horace's slaying of
Curiace, spur her to defy her father's prohibition on displaying her
feelings. Old Horace's command to Camilla to meet her 'Triumphant

Brother . . . with . . . a cheerfull look' (4.3.20–1) precipitates Camilla's
rebellion and her disavowal of her filial bond:

> from this Father I'le degenerate;
> And will deserve this Gallant Brother's hate.
> For Humane frailty sure, Illustrious grows,
> When Brutishness for Vertue they impose.
>
> (4.4.43–6)

Women's battling with their emotions has formed a large part of the
onstage drama of *Horace*. Camilla's declaration, 'Appear my Griefs'
(4.4.47) marks the moment when her tears become weapons, intensified
by her audacious naming to Horace of 'My *Curiace!* ah! too brave! too
dear!' (4.5.17).

Camilla's words challenge the meanings Horace imposes upon experi-
ence; rather than celebrate his victory, she terms him 'Barbarian' (4.5.27),
'savage Conquerour' (4.4.49). Indeed, Camilla challenges the heart of
Horace's being, wishing that he 'by some wretched action, soon defame
/ Thy so ador'd, and yet so brutish name' (4.5.42–3): 'Horace' enacts
horrors. Her calling down ruin upon Rome, their shared birthplace, goads
Horace into stabbing Camilla, and she expires with the words 'Ah!
Traytour!' (4.5.70), defining his act as at once a political crime and a
betrayal of blood. Philips's translation stops at this climax; the remaining
scenes, which debate the arguments for and against Horace's rigour, were
translated by Sir John Denham.

Philips's *Horace* comprises a complex engagement with what Maclean
calls 'the dramatic, dialectical nature of the *femme forte*'.[52] At the outset,
female bravery consists in overcoming emotional weakness, but as the play
develops, the women pit verbal defiance against the heroic deeds of the
Horatian race, Camilla provokes her own death and, in Denham's con-
tinuation, Sabina is moved to renounce 'Roman Vertue'.[53] In her two
translations from Corneille, Philips modifies the image of female heroism
current in Stuart culture, an image which, as we have seen, embraces
women's martial feats. Barash points out that the author who identified
herself simply as 'Philo-Philippa' sees Philips opposing love as 'a bold and
active counter to political violence'.[54] This redefinition of the *femme forte*
extends to Philips's drama.

It is less in their deeds than in their commanding speech that Philips's
women achieve truly heroic stature. Her Cleopatra may be decorously
'cold in blood', but her political passion burns in her warning to Photinus
and Achillas on Caesar's approach:

Tremble bad Men, at your approaching Doom,
My Breath is now your Destiny become.
Caesar's come, I'm a Queen, *Pompey's* reveng'd,
Tyranny ruin'd, and the times are chang'd.
 (*Pompey*, 2.2.123–6)

It is interesting to speculate on how the times *were* changing in Dublin in 1663, where 'the notion of a court and its decorum was still being invented'.[55] A woman had written a play and had it produced in the professional British theatre where it was 'Acted with great Applause'. It may indeed be the case, as Karen Raber argues, that the choice of Philips's *Pompey* as the first newly written play to be staged in viceregal Dublin was influenced by the political need of the returning aristocrats to 'generate a more inclusive form of theater'.[56] In post-Restoration culture, the ideal of civility could work to produce greater social and sexual equality, as Philips suggests when she comments to Charles Cotterell (Master of Ceremonies to Charles II) on the favour accorded her by the group of nobles gathered around the Duke of Ormonde, Lord Lieutenant of Ireland, 'never any body found more Civility, Kindness and Respect from all manner of Persons, especially of the highest Quality, than I do in this Country'.[57] If the choice of Philips as translator served royalists' political interests, it is also evident that Philips was aiming at upward mobility through her literary endeavours. Several months before her death from smallpox, she wrote to Cotterell from Wales, fretting at the difficulty of convincing her husband that for his own advancement they should journey to London. Philips hoped 'the general Opinion of his Friends in Town' could persuade 'Antenor'

that 'tis likely an Attendance at the Fountain-Head may . . . procure something for him . . . and . . . that 'twill be more prudent to resolve on that course, before the present hopes that are given me of an Interest and of being well receiv'd at Court, wither by Time, and are lost for want of laying hold on the Opportunity that now offers.[58]

Perhaps she was hoping for a place at court such as maid of honour, the position through which Margaret Cavendish achieved the marriage which enabled her literary career.

CONCLUSION

Katherine Philips's poetic accomplishment and success were stimulated by an elite culture which created new openings for women's literary involvement and instilled a new respect for women's social and intellectual

abilities. Her proficiency in French stems from the popularity of the language during the Caroline reign, and the ideas or conventions that captured her interest, such as pastoral, idealized friendship and female heroism, were all part of the literary sensibility fostered by Henrietta Maria. One dimension of Corneille's *Pompée* by which Philips was particularly inspired is the play's ennobling portrayal of feminine passion and ambition. Corneille's Cleopatra differs most sharply from Shakespeare's in her careful self-scrutiny and concern for decorum. The code of honour by which Corneille's characters are governed allowed Philips to represent female greatness and bravery without transgressing the boundaries of feminine propriety.

In a similar way, Philips's persona of 'Orinda' allowed her to exercise her literary gifts with impunity. Her formidable talent and determination bring to mind Cavendish's Lady Sanspareille, from the aptly named play *Youths Glory, and Deaths Banquet*. Philips's early death from smallpox in 1664 had the effect of turning her into a cult figure. The folio volume of her *Poems . . . and . . . Tragedies* published in 1667 bears a frontispiece depicting a bust of 'Orinda' as a poet in the literary pantheon.[59] It is a fittingly august image for a woman who was inspired by, and aspired to, an idea of female greatness.

Coda

The year 1659 saw the publication of two very different plays in England: Walter Montagu's *The Shepheard's Paradise*, appearing in print some twenty-five years after its first performance, and the anonymous *Lady Alimony*, which combines satire on the Civil Marriage Act of 1653 with an attack on William Davenant as the purveyor of innovative theatre featuring female performers.[1] These two texts represent opposite ends of the spectrum in their constructions of theatrical women. Prefixed to Montagu's play was a poem invoking the memory of the 'beauteous Actors', namely Queen Henrietta Maria and her ladies. Addressing 'his Friend the Stationer', the printer, Thomas Dring, forecasts a readership made up of 'Young Amorists' from the Inns of Court, whom he imagines 'smitten with *Bellesa's* look / Caught by the Gills, and fastned to your Book'.[2] The prologue to *Lady Alimony* praises those virtuous women who, unlike the play's subjects, 'scorn to mix Platonicks with their own': 'Platonicks' stands here as a byword for cosmetic artifice, sexual promiscuity and intellectual pretentions, for the alimony ladies are portrayed as 'confident pretender[s] to Language'.[3] Elsewhere the women are described by their husbands as 'over-acting Prostitutes' (sig. H4ʳ), an epithet recalling Prynne's equation of women actors with 'notorious whores'. The liberty and civility which in *The Shepherds' Paradise* form adjuncts to the female characters' histrionic agency are perceived in *Lady Alimony* as the distorted accretions of an elitist, feminocentric culture.

The historian Linda Pollack has remarked that 'it is the ordering of the various elements of a concept in any given era or culture which render it distinctive'.[4] As opposed to the sporadic appearances of women in sixteenth-century civic shows or guild drama, the theatrical culture centred upon women inaugurated by Anna of Denmark and extended by Henrietta Maria was extravagant and elitist. For this very reason the cultural innovations of these queens consort shifted the boundaries of licit female action and expression in mid-seventeenth-century England.

The appearance of the actress on the restored stage in 1660 is the outcome of a vigorous debate conducted in the drama and theatrical entertainments of the early Stuart period. Established theatrical history fails to register the fact that in the Caroline period the concept of the woman actor, in the senses both of a female player on the stage and an active woman, gained a partial acceptance in drama and elite society, albeit with a concomitant tendency to be mocked and satirized. Although the word 'actress' does not appear in dramatic literature before the Restoration, Caroline drama yields a sheaf of terms representing women as theatrical: epithets such as 'brave', 'fantastic', 'mimic' and 'antic'; nouns such as 'gesture', 'posture', 'motion' and 'action'. I have argued that this poetics of female performance originates in the masque texts of Jonson, Daniel and others where women's stage presence generates meaning. The sexual rhetoric attached to the female masquer and actor in pastoral drama is accompanied by an intensive focus on women as the subjects of sexual desire. In their drama for the professional stage, Caroline dramatists image theatricality not just as a tool in women's romantic armoury but as a powerful means of self-determination, registering a new awareness of women as active subjects.

The acceptance of actresses in the Restoration theatre has been explained in terms of a new relish for 'female assertiveness' and the 'histrionic seductiveness represented by the actress'.[5] Yet in pre-Restoration drama such as Jonson's *The New Inn* and Cartwright's *The Lady-Errant*, female cunning and rhetorical adroitness compels fascination and is held up to the view of the audience for its enjoyment. The portrayal of female theatricality in Stuart drama is intensified by the cultural initiatives of Henrietta Maria and by the controversy and debate that her initiatives triggered. Thus the advent of the professional actress is characterized not just by continuities of attitude, but crucially, by continuities of literary representation.

The doubleness of the discourse interpolating women as actors which I have traced in a wide range of material is reproduced in Thomas Jordan's 'Prologue to introduce the first Woman that came to Act on the Stage in the Tragedy, call'd *The Moor of Venice*'.[6] The prologue, spoken by a male actor, presents the actress as a measure 'to civilize the Stage', echoing both the prologue to *The Lady-Errant* and the arguments of the patents in which women were licensed to act in the Restoration theatres.[7] The case for the actress is strengthened by contrasting the aesthetic deficiencies of adult male actors in female roles with the emotional persuasiveness of a woman actor. While purporting to legitimize the acting of a woman in

public, the prologue in fact presents a two-fold image of the actress as virtuous *and* sexually transgressive. Appealing to the gentlemen in the audience to 'censure' fairly, the speaker declares:

> 'Tis possible a vertuous woman may
> Abhor all sorts of looseness, and yet play;
> Play on the Stage, where all eyes are upon her,
> Shall we count that a crime *France* calls an honour?
>
> (9–12)

These lines confront the ambivalence attached to a woman who becomes the object of the public gaze. That ambivalence is heightened by the fact that the actress is freed from being defined solely in relation to her husband:

> In other Kingdoms Husbands safely trust 'um,
> The difference lies onely in the custom . . .
> I'm sure this Custom's better then th' Excise,
> And may procure us custom; hearts of flint
> Will melt in passion when a woman's in't.
>
> (13–18)

The prologue's suggestion of women's inherent power to move spectators goes hand in hand with the depiction of the actress's femininity as enhancing the company's profits. The 'custom' the actress herself may attract is suggested by the speaker's dissuasion of the gentlemen in the pit from visiting her once the play is over (19–26). While insisting on the possibility of the female player remaining virtuous, the prologue presents a conflicting image of the actress as sexually alluring and as exercising a significant sexual and personal freedom.

The epilogue attempts to neutralize the implications of 'dishonour' raised by the actress's 'freedom' by appealing to the ladies in the audience for their approval (7–12). The opening lines dwell on the actress's transgression of the border between public and private spheres, insisting that visibility need not compromise feminine virtue. In evoking *and* contesting the actress's vulnerability to being defined as a whore, the prologue and epilogue establish a template for the divided characterization of women in Restoration drama.[8]

The advent of the professional actress at the Restoration set in motion a cultural and discursive event different from that which had gone before. The courteous appeal to the ladies in the epilogue to the performance of *Othello*, reminiscent of the addressing of the ladies in the Caroline audience, was succeeded by a discourse that was far more sardonic in

tone. As opposed to the prologue's promise to 'purge every thing that is unclean' (35), the drama produced for actresses such as Nell Gwyn and Elizabeth Barry moved rapidly towards a greater sexual realism. This development gave rise to plays that were cynical and challenging, sentimental and sensational, and which further expanded the range of female behaviour and emotion represented on stage.

To what extent is the new awareness of women as active subjects which I have identified in Stuart drama accompanied by a greater sympathy towards women's social and political agency? A greater responsiveness towards women's involvement in politics can be gauged by comparing the 'busie, factious Ladies' who briefly assume the reins of government in Cartwright's *The Lady-Errant* with the more sympathetic portrayals of politically ambitious women in the drama of Cavendish and Philips. There is a similar contrast between the hostility of Sir Henry Cary towards his wife's 'abilities in agency of affairs' in 1626 and the advice given by Dr Denton to the exiled Sir Ralph Verney some twenty years later: 'instruct your wife, and leave her to act it with committees, theire sexe entitles them to many privileges and we find the comfort of them more now than ever'.[9]

Writing of Nell Gwyn's scintillating impact on Restoration comedy, Peter Holland notes that 'what was new was not simply having women on stage but a woman who could credibly rival male wit'.[10] Theatrical performance offered women the chance to develop their mimetic and artistic capacities, and to impress these capacities upon an audience. As Sarah Burton observes, the Restoration stage 'was a place where women were privileged to speak, to engage and hold attention, to lecture people or make them laugh'.[11] During the early Stuart period, the 'liveliness of mind' that formed a part of histrionic performance became an admissable part of aristocratic female accomplishment.[12] But as the example of Gwyn makes clear, it was not just aristocratic women who could impress through their wit and intelligence. In 1667 Samuel Pepys recorded in his diary a conversation with the theatre manager Thomas Killigrew about the actress Mary Knep. Killigrew told Pepys 'That Knipp is like to make the best actor that ever came upon the stage, *she understanding so well*.'[13] The second part of Killigrew's remark, 'That they are going to give her 30*l* a year more', shows that actresses' intellectual abilities were valued, and influenced their earning capacity. While the Restoration actress was certainly no 'self-regulating artist', this anecdote bears out Burton's conclusion that her advent 'gave proof of the potential equality of the sexes'.[14]

Katharine Maus asserts with reference to the Restoration theatre that 'the employment of actresses does not . . . coincide with a more general broadening of female participation in public life',[15] but her argument overlooks the important development of the professional female playwright. I have argued that the debate about female performance in the literature and culture of the mid-seventeenth century functioned as a spur for women's production of their own dramatic writing. The equation between femininity and theatricality that is precariously productive for Margaret Cavendish and Katherine Philips is embraced more strategically by the professional dramatist Aphra Behn in whose writing, as Hero Chalmers has shown, the 'heroic eroticism' associated with the actress functions both as an enabling means of self-representation and as 'an extension of the politically motivated celebration of a morally freer theatre'.[16]

As a professional writer Behn was engaged in pillaging, but also transforming, earlier cultural materials. Her novella *Oroonoko* (1688) shows the generative power of the Neoplatonic poetics associated with a feminine performative culture, while in her comedy *The Lucky Chance* (1686) Behn adapts a plotline from Shirley's *The Lady of Pleasure* (1635) to explore the predicament of a woman trapped in an unhappy marriage from a female viewpoint.[17] Thus the metamorphosis of the female actor and wit into the female playwright brought an enlarging of dramatic perspectives. This two-fold expansion of literary possibilities emerged out of the female-oriented culture of the early Stuart period, in which women began playing the woman's part for themselves.

Notes

INTRODUCTION

1 Annie Lennox with Aretha Franklin, 'Sisters Are Doin' It For Themselves', Eurythmics, *Be Yourself Tonight*, 1985.

2 Clifford Davidson, 'Women and the Medieval Stage', *Women's Studies* 11 (1984), 99–113; James Stokes, 'Women and Mimesis in Medieval and Renaissance Somerset (and Beyond)', *Comparative Drama* 27 (1993), 176–96; Stephen Orgel, *Impersonations: The Performance of Gender in Shakespeare's England* (Cambridge University Press, 1996), pp. 1–11. See also the earlier essay by Thornton Shirley Graves, 'Women on the Pre-Restoration Stage', *Studies in Philology* 22 (1925), 184–97.

3 Welcome exceptions are Alison Findlay and Stephanie Hodgson-Wright with Gweno Williams, *Women and Dramatic Production 1550–1700* (Harlow: Longman Pearson, 2000) and Clare McManus, *Women on the Renaissance Stage: Anna of Denmark and Female Masquing in the Stuart Court 1590–1619* (Manchester University Press, 2002).

4 John Harold Wilson, *All the King's Ladies: Actresses of the Restoration* (Chicago University Press, 1958), p. 6; John Loftis *et al.* (eds.), *The Revels History of Drama in English, V 1660–1750* (London: Methuen, 1976), p. 121.

5 Elizabeth Howe, *The First English Actresses: Women and Drama 1660–1700* (Cambridge University Press, 1992), p. 23. See also Susan Wiseman, *Drama and Politics in the English Civil War* (Cambridge University Press, 1998), p. 92.

6 Katharine Eisaman Maus, '"Playhouse Flesh and Blood": Sexual Ideology and the Restoration Actress', *ELH* 46 (1979), 595–617.

7 Leeds Barroll, *Anna of Denmark, Queen of England: A Cultural Biography* (Philadelphia: University of Pennsylvania Press, 2001), p. 4.

8 Cited in Carole Levin, '"We Princes, I tell you, are set on stages": Elizabeth I and Dramatic Self-Representation' in S. P. Cerasano and Marion Wynne-Davies (eds.), *Readings in Renaissance Women's Drama: Criticism, History, and Performance 1594–1998* (London and New York: Routledge, 1998), pp. 113–24, (p. 114).

9 Historical Manuscripts Commission, *Calendar of Hatfield Manuscripts*, XVI, 388, '[The Council] to the King [1604 Dec.]'. I am indebted to David Norbrook for this reference.

10 Ben Jonson, 'The Queen's Masques, The first, of BLACKNESS' in *Ben Jonson: The Complete Masques*, ed. Stephen Orgel (New Haven and London: Yale University Press, 1969), pp. 47–60, line 18. Hereafter references are given by line in parentheses in the text.

11 Leeds Barroll, 'The Court of the First Stuart Queen' in Linda Levy Peck (ed.), *The Mental World of the Jacobean Court* (Cambridge University Press, 1991), pp. 191–208 (p. 191).

12 Heather Weidemann, 'Theatricality and Female Identity in Mary Wroth's *Urania*' in Naomi J. Miller and Gary Waller (eds.), *Reading Mary Wroth: Representing Alternatives in Early Modern England* (Knoxville: University of Tennessee Press, 1991), pp. 191–209 (p. 192).

13 Margaret J. M. Ezell, *The Patriarch's Wife: Literary Evidence and the History of the Family* (Chapel Hill and London: University of North Carolina Press, 1987), ch. 3, and *Writing Women's Literary History* (Baltimore and London: Johns Hopkins University Press, 1993); Karen Raber, *Dramatic Difference: Gender, Class, and Genre in the Early Modern Closet Drama* (Newark and London: University of Delaware Press and Associated University Presses, 2001), p. 23. The term 'prehistory' is used by Jennifer Summit in her introduction to *Lost Property: The Woman Writer and English Literary History, 1380–1589* (University of Chicago Press, 2000), p. 3.

14 See the General Introduction to Hero Chalmers, Julie Sanders and Sophie Tomlinson (eds.), *Three Seventeenth-Century Plays on Women and Perform-ance: Fletcher's The Wild-Goose Chase, Shirley's The Bird in a Cage and Margaret Cavendish's The Convent of Pleasure*, Revels Companion Library (Manchester University Press, 2005), p 2.

15 Barroll, *Anna of Denmark*, pp. 99–100 (p. 100).

16 Cited in Walter Montagu, *The Shepherds' Paradise by Walter Montagu*, ed. Sarah Poynting (Malone Society Reprint, vol. 159; Oxford University Press, 1998), p. xiii, n. 40.

17 William Prynne, *Histrio-Mastix: The Player's Scourge or, Actor's Tragedy*, 2 vols. (1633; repr. New York and London: Johnson Reprint, 1972), sig. 6R (4)r; William Hawkins, *Apollo Shroving* (1627), p. 8; James Shirley, *The Ball* in Shirley, *The Dramatic Works and Poems*, ed. William Gifford and Alexander Dyce, 6 vols. (London: John Murray, 1833), III, p. 79; David Scott Kastan, 'Performances and Playbooks: The Closing of the Theatres and the Politics of Drama' in Kevin Sharpe and Steven N. Zwicker (eds.), *Reading, Society and Politics in Early Modern England* (Cambridge University Press, 2003), pp. 167–84 (p. 169).

18 *JCS*, IV, p. 549.

19 Michael Shapiro, *Gender in Play on the Shakespearean Stage: Boy Heroines and Female Pages* (Ann Arbor: University of Michigan Press, 1994), p. 33; see also Shapiro's essay 'The Introduction of Actresses in England: Delay or Defensiveness?' in Viviana Comensoli and Anne Russell (eds.), *Enacting Gender on the Renaissance Stage* (Urbana and Chicago: University of Illinois Press, 1998), pp. 177–200. For the praising of continental actresses by English

gentlemen travellers, see Thomas Coryate, *Coryats Crudities* (1611), p. 247; David Mann, *The Elizabethan Player: Contemporary Stage Representations* (London and New York: Routledge, 1991), p. 246, n.16.

20 Adapting Stephen Greenblatt, *Renaissance Self-Fashioning: From More to Shakespeare* (University of Chicago Press, 1980), pp. 2, 1.

21 See Catherine Belsey, *The Subject of Tragedy: Identity and Difference in Renaissance Drama* (London and New York: Methuen, 1985); Valerie Traub, M. Lindsay Kaplan and Dympna Callaghan (eds.), *Feminist Readings of Early Modern Culture: Emerging Subjects* (Cambridge University Press, 1996); Mihoko Suzuki, *Subordinate Subjects: Gender, the Political Nation, and Literary Form in England, 1588–1688* (Aldershot: Ashgate, 2003).

22 Richard Braithwait, *The English Gentlewoman* (1631), p. 48.

23 Francis Osborne, *Historical Memoires on the Reigns of Queen Elizabeth and King James* (1658), pp. 60–1.

24 T. E., *The Lawes Resolutions of Womens Rights: or, The Lawes Provision for Woemen* (1632), p. 6, emphasis mine. On the authorship of *The Lawes Resolutions*, see W. R. Prest, 'Law and Women's Rights in Early Modern England', *The Seventeenth Century* 6 (1991), 169–87 (pp. 172–5).

25 Thomas Middleton and Thomas Dekker, *The Roaring Girl, or Moll Cutpurse*, ed. Paul Mulholland, The Revels Plays (Manchester University Press, 1987), 3.1.105, 100.

26 Margaret Cavendish, *CCXI Sociable Letters* (1664), XVI, p. 27, emphasis mine. In all references to this work, the roman numeral indicates the letter number.

27 Kim Walker, *Women Writers of the English Renaissance* (New York: Twayne, 1996), p. 138.

28 John Fletcher, *The Woman's Prize, or The Tamer Tamed*, ed. Fredson Bowers, in *The Dramatic Works in the Beaumont and Fletcher Canon*, gen. ed. Bowers (Cambridge University Press, 1979), IV, 1.2.133–8, epilogue, lines 6–8; for the court performance of *The Woman's Prize* on the night after Shakespeare's *The Taming of the Shrew*, see N. W. Bawcutt (ed.), *The Control and Censorship of Caroline Drama: The Records of Sir Henry Herbert, Master of the Revels 1623–73* (Oxford: Clarendon Press, 1996), p. 185. E. H. C. Oliphant suggested that the prologue and epilogue were written for the revival of the play at the Blackfriars theatre in October 1633; see Oliphant, *The Plays of Beaumont and Fletcher* (1927; repr. New York: AMS Press, 1970), p. 155.

29 Roy Strong, *Van Dyck: Charles I On Horseback* (London: Allen Lane, Penguin, 1972), p. 70.

30 Ben Jonson, *Love's Triumph Through Callipolis* in Jonson, *Complete Masques*, ed. Orgel, pp. 454–61, lines 10, 123–4. Hereafter references are given by line in parentheses in the text.

31 Anna Battigelli, *Margaret Cavendish and the Exiles of the Mind* (Lexington: University Press of Kentucky, 1998), p. 11.

32 Alison Shell, *Catholicism, Controversy and the English Literary Imagination, 1558–1660* (Cambridge University Press, 1999), pp. 146, 155–6.

33 Lady Jane Cavendish and Lady Elizabeth Brackley, *The Concealed Fancies* in
 S. P. Cerasano and Marion Wynne-Davies (eds.), *Renaissance Drama by
 Women: Texts and Documents* (London and New York: Routledge, 1996), pp.
 127–54. For critical discussion, see my essay 'Too Theatrical?: Female
 Subjectivity in Caroline and Interregnum Drama', *Women's Writing* 6 (1999),
 65–79 (pp. 73–6); Alison Findlay, 'Playing the "Scene Self": Jane Cavendish
 and Elizabeth Brackley's *The Concealed Fancies*' in Comensoli and Russell
 (eds.), *Enacting Gender*, pp. 154–76; Lisa Hopkins, *The Female Hero in English
 Renaissance Tragedy* (Basingstoke: Palgrave Macmillan, 2002), pp. 184–93.

34 On Anna of Denmark's Danish cultural inheritance, see Mara R. Wade, 'The
 Queen's Courts: Anna of Denmark and her Royal Sisters – Cultural Agency
 at Four Northern European Courts in the Sixteenth and Seventeenth
 Centuries' in Clare McManus (ed.), *Women and Culture at the Courts of the
 Stuart Queens* (Basingstoke: Palgrave Macmillan, 2003), pp. 49–80; on her
 patronage of English writers and artists, see Barroll, *Anna of Denmark*, ch. 3;
 James Knowles, ' "To Enlight the Darksome Night, Pale Cinthia Doth
 Arise": Anna of Denmark, Elizabeth I and the Images of Royalty' in
 McManus (ed.), *Women and Culture*, pp. 21–48. For Henrietta Maria's
 French background and its cultural impact in England, see Jean Jacquot, 'La
 Reine Henriette-Marie et L'Influence Française dans les Spectacles à la Court
 de Charles I', *Cahiers de l'Association Internationale des Etudes Françaises* 9
 (1957), 128–60; John Peacock, 'The French Element in Inigo Jones's Masques
 Designs' in David Lindley (ed.), *The Court Masque* (Manchester University
 Press, 1984), pp. 149–68; Erica Veevers, *Images of Love and Religion: Queen
 Henrietta Maria and Court Entertainments* (Cambridge University Press,
 1989); Karen Britland, '*Florimène*: The Author and the Occasion', *Review of
 English Studies* 53 (2002), 475–83.

35 Wade, 'The Queen's Courts', p. 78, n.62; Graham Parry, *The Golden Age
 Restor'd: The Culture of the Stuart Court, 1603–42* (Manchester University
 Press, 1981), pp. 146–9; Michael Leapman, *Inigo: The Troubled Life of Inigo
 Jones, Architect of the English Renaissance* (London: Review, 2003); Sarah
 Poynting, 'A Critical Edition of Walter Montagu's *The Shepherds' Paradise*,
 Acts 1–3', 2 vols. (DPhil thesis, University of Oxford, 1999), I, pp. 19–20.

36 This paragraph draws on Barroll, *Anna of Denmark*, ch. 3.

37 Barroll, *Anna of Denmark*, p. 8. For comment on Van Somer's portrait, see
 Knowles, 'Anna of Denmark, Elizabeth I and the Images of Royalty', p. 25.

38 Letter of Sir John Chamberlain to Sir Dudley Carleton, 10 February 1614,
 cited in McManus (ed.), 'Introduction: The Queen's Court', *Women and
 Culture*, pp. 1–17 (p. 1). Barbara Lewalski cites a letter of Dudley Carleton
 dated January 1605 in which he refers to 'the Queen's Court'; see Lewalski,
 Writing Women in Jacobean England (Cambridge, Mass., and London:
 Harvard University Press, 1993), p. 26.

39 Samuel Daniel, *Hymen's Triumph by Samuel Daniel*, ed. John Pitcher
 (Malone Society Reprint, Oxford University Press, 1994), pp. v–x. In the
 absence of records of the performers, Barroll conjectures that *Hymen's*

Triumph was acted by 'young unmarried ladies not of the queen's close circles' (*Anna of Denmark*, pp. 70, 130–1, 141).

40 Knowles, 'Anna of Denmark, Elizabeth I and the Images of Royalty', pp. 44–5, n. 37; for a discussion of *Cupid's Banishment*, see ch. 3.

41 McManus, *Women on the Renaissance Stage*, pp. 208–13 (p. 209).

42 R. Malcolm Smuts, *Court Culture and the Origins of a Royalist Tradition in Early Stuart England* (Philadelphia: University of Pennsylvania Press, 1987), pp. 183–5.

43 *JCS*, IV, p. 549; Barbara Ravelhofer, 'Bureaucrats and Courtly Cross-dressers in the *Shrovetide Masque* and *The Shepherd's Paradise*', *ELR* 29 (1999), 75–96.

44 Alison Plowden, *Henrietta Maria: Charles I's Indomitable Queen* (Stroud: Sutton, 2001), p. 122. On Van Dyck's portrait, see Arthur Wheelock, 'The Queen, the Dwarf and the Court: Van Dyck and the Ideals of English Monarchy' in Hans Vlieghe (ed.), *Van Dyck 1599–1999: Conjectures and Refutations* (Turnhout: Brepols, 2001), pp. 151–66, and Erin Griffey, 'Multum in Parvo: Portraits of Jeffrey Hudson, Court Dwarf to Henrietta Maria', *British Art Journal* 4 (2003), 39–53 (pp. 45–6).

45 Smuts, *Court Culture*, pp. 194–5; Battigelli, *Exiles of the Mind*, p. 17.

46 Lewalski, *Writing Women*, p. 26

47 *JCS*, I, pp. 39, 48, n.5, 232–3; V, pp. 1285–8. Bentley deduces that these performances 'were almost certainly special night performances for the court, not the regular afternoon performances', *JCS*, VI, pp. 34–6 (p. 35). For Anna's patronage of professional drama, see Lewalski, *Writing Women*, p. 24.

48 James Shirley, *The Humorous Courtier*, ed. Marvin Morillo (New York and London: Garland, 1979), 1.1.32, 2.2.262–6.

49 Sandra Burner, *James Shirley: A Study of Literary Coteries and Patronage in Seventeenth-Century England* (Lanham: University Press of America, 1988), p. 102.

50 Martin Butler, *Theatre and Crisis 1632–1642* (Cambridge University Press, 1984); Kevin Sharpe, *Criticism and Compliment: The Politics of Literature in the England of Charles I* (Cambridge University Press, 1987).

51 Julie Sanders (ed.), *The Bird in A Cage* in Chalmers, Sanders and Tomlinson (eds.), *Three Seventeenth-Century Plays on Women and Performance*, Dedication, lines 12–16.

52 See the introduction to *The Bird in a Cage* in Chalmers, Sanders and Tomlinson (eds.), *Three Seventeenth-Century Plays on Women and Performance*, pp 21–32, especially p. 25.

53 Howe, *The First English Actresses*, p. 37.

54 Jacques Du Bosc, *L'Honnête Femme* (1632), cited by Nicholas Hammond, *Creative Tensions: An Introduction to Seventeenth-Century French Literature* (London: Duckworth, 1997), p. 122; Walter Montagu, *The Accomplished Woman* (1656), p. 56. For *honnêteté*, see Hammond, *Creative Tensions*, pp. 78–80, and Veevers, *Images of Love and Religion*, pp. 26–8. For the conjectural

date of 1632 for Montagu's translation of *L'Honnête Femme*, see Veevers, *Images of Love and Religion*, p. 28.

55 See Mary Beth Rose, *The Expense of Spirit: Love and Sexuality in English Renaissance Drama* (Ithaca, N.Y., and London: Cornell University Press, 1988), ch. 4, 'Transforming Sexuality: Jacobean Tragicomedy and the Reconfiguration of Private Life'.

56 Dympna Callaghan, *Woman and Gender in Renaissance Tragedy* (New York: Harvester Wheatsheaf, 1989), p. 67.

57 Elizabeth Cary, *The Tragedy of Mariam, The Fair Queen of Jewry* in Cerasano and Wynne-Davies (eds.), *Renaissance Drama by Women*, pp. 46–75, Act 1, line 1; Margaret Cavendish, *Natures Three Daughters, Beauty, Love, and Wit* in Cavendish, *Plays Written by the Thrice Noble, Illustrious and Excellent Princess, the Lady Marchioness of Newcastle* (1662), p. 527.

58 Richard Brome, *The Dramatic Works of Richard Brome*, ed. R. H. Shepherd, 3 vols. (London, 1873; repr. New York: AMS Press, 1966), I, p. 271; Raber, *Dramatic Difference*.

59 This distinction was forcefully proposed by Virginia Woolf in *A Room of One's Own* (1929; repr. London: Granada, 1977); Woolf's account of women's literary history is challenged by Ezell in *Writing Women's Literary History*, ch. 2, *passim*. See also Hero Chalmers, *Royalist Women Writers 1650–1689* (Oxford: Clarendon Press, 2004).

60 William Cartwright, *The Plays and Poems of William Cartwright*, ed. G. Blakemore Evans (Madison, Wis.: University of Wisconsin Press, 1951), p. 51; Katherine Philips, 'A Friend' in *CWKP* I, pp. 165–8, lines 19–22.

61 Raber, *Dramatic Difference*, pp. 17, 243–4;, *CWKP* II, p. 54.

62 Margaret Cavendish, *Natures Pictures drawn by Fancies Pencil to the Life* (1656), sig. A13ʳ.

1 'MAGIC IN MAJESTY': THE POETICS OF FEMALE PERFORMANCE IN THE JACOBEAN MASQUE

1 Arthur Wilson, *The History of Great Britain* (1653), pp. 53–4.

2 Barroll, 'The Court of the First Stuart Queen', p. 208.

3 Robert Ashton (ed.), *James I By His Contemporaries* (London: Hutchinson, 1969), p. 95.

4 Letter to Gilbert Talbot, Earl of Shrewsbury, 8 December 1603, in *The Letters of Lady Arbella Stuart*, ed. Sara Jayne Steen (New York and Oxford: Oxford University Press, 1994), p. 193. The 'enterlude' may have been identical with a masque privately presented to Prince Henry on his arrival at Winchester in October by the Queen and her ladies, described by the French amabassador as 'less a "ballet" than a "masquerade champêtre"'; see E. K. Chambers, *The Elizabethan Stage*, 4 vols. (Oxford: Clarendon Press, 1923), I, p. 171. Barroll links the Winchester masque with a masque of Queen Anna reported in the diary of Lady Anne Clifford as having given rise to scandal; see *Anna of Denmark*, p. 77. Both these female commentators were

occasional participants in masques: Stuart danced in Jonson's *Masque of Beauty* (1608) and Samuel Daniel's *Tethys' Festival* (1610), while Clifford appeared in Jonson's *Masque of Queens* (1609) and Thomas Campion's *Caversham Entertainment* (1613).

5 Barroll, *Anna of Denmark*, p. 98; McManus, *Women on the Renaissance Stage*, p. 203.

6 In addition to Barroll and McManus, various critics make claims for a subversive or oppositional dimension of the Jacobean queen's masques: Lewalski, *Writing Women*, ch. 1, 'Enacting Opposition: Queen Anne and the Subversions of Masquing'; Marion Wynne-Davies, 'The Queen's Masque: Renaissance Women and the Seventeenth-Century Court Masque' in S. P. Cerasano and Marion Wynne-Davies (eds.), *Gloriana's Face: Women, Public and Private, in the English Renaissance* (New York and London: Harvester Wheatsheaf, 1992), pp. 79–104; Kathryn Schwarz, *Tough Love: Amazon Encounters in the English Renaissance* (Durham and London: Duke University Press, 2000), ch. 3, 'Stranger in the Mirror: Amazon Reflections in the Jacobean Queen's Masque'. For a contrary view see Suzanne Gossett, '"Man-Maid, Begone!": Women in Masques', *ELR* 18 (1988), 96–113.

7 Anon., *The Coleorton Masque* (1618) in David Lindley (ed.), *Court Masques: Jacobean and Caroline Entertainments 1605–1640* (Oxford University Press, 1995), pp. 126–35, line 257. Hereafter references are given by line in the text.

8 Lewalski, *Writing Women*, p. 30.

9 Ben Jonson, *Hymenaei, or the Solemnities of Masque and Barrier at a Marriage*, in Jonson, *Complete Masques*, ed. Orgel, pp. 75–106, lines 16–17. Unless otherwise noted, all references to Jonson's masques derive from this edition and hereafter are given by line in parentheses in the text.

10 Samuel Daniel, *The Vision of the Twelve Goddesses*, ed. Joan Rees, in T. J. B Spencer and Stanley Wells (eds.), *A Book of Masques in Honour of Allardyce Nicoll* (Cambridge University Press, 1967), line 265. Hereafter references are given by line in parentheses in the text.

11 On the Neoplatonists' idea of woman, see Ian Maclean, *The Renaissance Notion of Woman: A Study in the Fortunes of Scholasticism and Medical Science in European Intellectual Life* (Cambridge University Press, 1980), pp. 24–5. John C. Meagher discusses the Classical and Renaissance vision of dance as an image of cosmic order in his *Method and Meaning in Jonson's Masques* (Notre Dame, Ind.: University of Notre Dame Press, 1966), pp. 81–106.

12 Parry, *The Golden Age Restored*, p. 42.

13 Linda Phyllis Austern, '"Sing Againe Syren": The Female Musician and Sexual Enchantment in Elizabethan Life and Literature', *Renaissance Quarterly* 52 (1989), 420–48 (p. 420).

14 Robert White, *Cupid's Banishment: A Maske Presented to Her Majesty By the Young Gentlewomen of the Ladies Hall in Deptford at Greenwich* in Cevasano and Wynne-Davies (eds.), *Renaissance Drama by Women*, pp. 76–89, line

327. For the virtuous influence of the female audience, see the epilogue to Shirley's *The Coronation* (1635), *Dramatic Works*, III, p. 540.

15 The title-page to the 1608 Quarto edition of both masques is headed, 'The Characters of Two Royall Masques. The one of BLACKNESSE, the other of BEAUTIE', *Jonson*, VII, p. 167.

16 *Jonson*, X, p. 449.

17 Joseph Loewenstein, *Responsive Readings: Versions of Echo in Pastoral, Epic, and the Jonsonian Masque* (New Haven and London: Yale University Press, 1984), p. 101.

18 On the use of Elizabethan imagery to represent Anna in portraits and texts, see Knowles, 'Anna of Denmark, Elizabeth I and the Images of Royalty'.

19 Meagher, *Method and Meaning in Jonson's Masques*, p. 110.

20 Stephen Orgel, *The Jonsonian Masque* (Cambridge, Mass.: Harvard University Press, 1965), p. 120.

21 D. J. Gordon elucidates the symbolism of the hieroglyphics in detail; see Gordon, 'The Imagery of Ben Jonson's *Masques of Blacknesse and Beautie*' in Stephen Orgel (ed.), *The Renaissance Imagination: Essays and Lectures by D. J. Gordon* (Berkeley, Los Angeles, and London: University of California Press, 1975), pp. 134–56 (pp. 138–41).

22 McManus, *Women on the Renaissance Stage*, p. 10.

23 *Ibid.* p. 15.

24 My discussion of the Echo song is indebted to Hardin Aasand, '"To Blanch an Ethiop, and Revive a Corse": Queen Anne and *The Masque of Blackness*', *Studies in English Literature, 1500–1900* 32 (1992), 271–85 (p. 282). See also Loewenstein, *Responsive Readings*, pp. 99–100.

25 George Chapman, *Ovid's Banquet of Sense* in *George Chapman, Plays and Poems*, ed. Jonathan Hudston (London: Penguin, 1998), lines 108–111.

26 Frank Kermode sees Corynna's song as that of 'a cultivated courtesan'; see 'The Banquet of Sense' in Kermode, *Shakespeare, Spenser, Donne: Renaissance Essays* (London: Routledge and Kegan Paul, 1971), pp. 84–115 (p. 106). His view is elaborated by Darryl J. Gless, 'Chapman's Ironic Ovid', *ELR* 9 (1979), 21–41 (pp. 35–7). For a different view of Corynna's sexuality as 'innocent', see Austern, '"Sing Againe Syren"', pp. 438–40.

27 Loewenstein, *Responsive Readings*, p. 99.

28 *Ibid.*, p. 101.

29 McManus, *Women on the Renaissance Stage*, p. 11.

30 Orgel, *Jonsonian Masque*, pp. 127–8; David Riggs suggests that the viscosity of the masquers' blackface disguise makes their metamorphosis unrepresentable; see Riggs, *Ben Jonson: A Life* (Cambridge, Mass.: Harvard University Press, 1989), p. 119.

31 Kim F. Hall, *Things of Darkness: Economies of Race and Gender in Early Modern England* (Ithaca, N.Y., and London: Cornell University Press, 1995), pp. 128–41 (p. 129); Aasand, 'To Blanch an Ethiop'; Orgel, 'Marginal Jonson' in David Bevington and Peter Holbrook (eds.), *The Politics of the Stuart Court Masque* (Cambridge University Press, 1998), pp. 144–75. Dympna

Callaghan, *Shakespeare Without Women: Representing Gender and Race on the Renaissance Stage* (London and New York: Routledge, 2000), pp. 81–2.

32 The French actor Gérard Philipe (1922–59) said of the Palladian theatre at Vicenza in Italy, 'il joue par lui-même'. This analogy between the surprising effects of masque costume and Renaissance theatre architecture was proposed by Barbara Ravelhofer in a lecture given at the University of Cambridge in 1999 entitled 'Cross-Dressers and Court Caterpillars: Staging Royalty in the Stuart Masque'.

33 Austern, '"Sing Againe Syren"', p. 436.

34 On the sexual resonances of black skin in the Renaisssance, see Janet Adelman, 'Cleopatra's Blackness' in Adelman, *The Common Liar: An Essay on Antony and Cleopatra* (New Haven and London: Yale University Press, 1973), pp. 184–8; Hall, *Things of Darkness*, p. 130; Callaghan, *Shakespeare Without Women*, p. 81. Lewalski suggests that the masquers' black skin may have evoked an association with the Amazons; see Lewalski, *Writing Women*, p. 32.

35 See Jonson's reference to 'Lady, or Pusil [prostitute], that wears maske, or fan' in his poem on Fletcher's *The Faithful Shepherdess*, 'To the worthy Author M. *John Fletcher*', *Jonson*, VIII, p. 370, line 4. In Webster's *The Duchess of Malfi* (1614) Ferdinand plans to shame his sister by sending her 'masques of common Curtizans'; see Webster, *The Works of John Webster*, ed. David Gunby, David Carnegie and Anthony Hammond (Cambridge University Press, 1995), I, 4.1.121.

36 *Jonson*, X, p. 449.

37 Orgel, 'Marginal Jonson', pp. 149–50.

38 For the title and subject of the painting, see Oliver Millar, *Van Dyck in England* (London: National Portrait Gallery, 1982), fig. 42, p. 85.

39 Cited in Peter Stallybrass, 'Patriarchal Territories: The Body Enclosed' in Margaret W. Ferguson, Maureen Quilligan and Nancy J. Vickers (eds.), *Rewriting the Renaissance: The Discourses of Sexual Difference in Early Modern Europe* (Chicago and London: University of Chicago Press, 1986), pp. 123–42 (p. 127), and McManus, *Women on the Renaissance Stage*, pp. 5–6.

40 Baldassare Castiglione, *The Courtyer of Count Baldessar Castilio*, 1561, trans. Sir Thomas Hoby, sig. C1v. Riggs interprets *Blackness* as a demonstration of *sprezzatura*; see Riggs, *Ben Jonson*, p. 121.

41 Callaghan, *Shakespeare Without Women*, p. 82.

42 See Andrew Gurr, *The Shakespearean Stage, 1574–1642*, 3rd edn. (Cambridge University Press, 1992), pp. 99–100. The pirated quarto edition of Daniel's *The Vision of the Twelve Goddesses* offered itself as *The True Description of a Royall Masque . . . Personated by the Queenes Most Excellent Majestie* (1604). Significantly, the theatrical word 'personated' is absent from Daniel's own edition of the masque, entitled *The Vision of the Twelve Goddesses Presented in a Masque . . . by the Queen's Most Excellent Majesty, and her Ladies* (1604).

43 *Jonson*, X, p. 466. The Privy Council's letter cited in my introduction refers to Queen Anna as an 'actor'; see above, p. 2.

44 For this distinction, see Andrew Gurr, 'Elizabethan Action', *Studies in Philology* 63 (1966), 144–56.

45 Orgel, *Jonsonian Masque*, p. 117.

46 Boreas's tale animates the obstructive figure of Night, who is depicted on a curtain which is later drawn back to reveal the masquers on the scenic stage.

47 Christina Larner, 'James VI and I and Witchcraft' in Alan G. R. Smith (ed.), *The Reign of James VI and I* (London: Macmillan, 1973), pp. 74–90 (p. 80).

48 McManus, *Women on the Renaissance Stage*, p. 90.

49 *Jonson*, X, p. 457. On the designation of the Queen as the 'authoress', see Wynne-Davies, 'The Queen's Masque', pp. 79–80 and Barroll, *Anna of Denmark*, p. 203, n.74.

50 Orgel, 'Marginal Jonson', p. 164.

51 William Shakespeare, *The Winter's Tale*, 5.3.39.

52 Weidemann, 'Theatricality and Female Identity', p. 197.

53 *OED*: brave A. *adj.* 2: 'To go more gayer and more brave, Than doth a lord' (1568). Simon Forman wrote of the Jacobean poet Aemelia Lanyer, 'She was maintained in great pomp . . . she was very brave in youth'; A. L. Rowse, *The Poems of Shakespeare's Dark Lady* (London: Cape, 1978), p. 11. Stephen Orgel notes that after the performance of *Prince Henry's Barriers* (with speeches by Jonson) in 1610, King James 'vetoed a similar project for the next year', apparently disturbed by 'the martial side of the prince's nature'; see Orgel, *The Illusion of Power* (Berkeley, Los Angeles and London: University of California Press, 1975), p. 67.

54 *JCS*, V, pp. 1288–90 (p. 1289).

55 Simon Shepherd, *Amazons and Warrior Women: Varieties of Feminism in Seventeenth-Century Drama* (Brighton: Harvester Press, 1981), pp. 14–15. The ambivalence attached to the female masquer as Amazon is illuminated by Shakespeare and Middleton's tragedy *Timon of Athens* (1606?) in which an Amazon masque is presented to Timon at his banquet by unnamed ladies (1.2.111–53). The presentation of the masque, and the commentary upon it, suggest that it should be read as animating the philosophical emblem of the Banquet of Sense which operated in Renaissance literature as the moral obverse of the Banquet of Heavenly Love derived from Plato's *Symposium*. Apemantus's scathing judgement of the masquers, 'the worst is filthy, and would not hold taking' (1.2.149–50), associates the masque with the meretricious virtue of Timon's flatterers, here represented as a female body that will not 'hold taking' or penetrating, owing to its syphilitic corruption. Co-authorship studies show that Middleton wrote the entire banquet scene; see Shakespeare and Middleton, *Timon of Athens*, ed. John Jowett, The Oxford Shakespeare (Oxford University Press, 2004), pp. 2, 136–44. Jowett observes that 'the representation of the lady masquers as Amazons seems to reflect a complex and partly misogynistic reaction to female courtiers on stage in court masques' (p. 43). The masque is discussed by Schwarz, 'Stranger in the Mirror', pp. 128–33.

56 C. E. McGee, '"The Visit of the Nine Goddesses": A Masque at Sir John Crofts's House', *ELR* 21 (1991), 371–84 (line 42). McGee states that 'to date the masque "early 1620s" is the best we can do at this time' (p. 374). He suggests Thomas Carew as the most likely author (pp. 375–6).

57 Suzanne Gossett, 'Women in Masques', p. 100. Although there is no extant record of the performers, I assume with Margaret Maurer that the witches were 'danced by the male dancers of the King's Men'; see Maurer, 'Reading Ben Jonson's *Queens*' in Sheila Fisher and Janet E. Halley (eds.), *Seeking the Woman in Late Medieval and Renaissance Writings: Essays in Feminist Contextual Criticism* (Knoxville: University of Tennessee Press, 1989), pp. 233–63 (p. 255).

58 McManus interprets the witches' dancing as a violation of 'courtly grace'; see McManus, *Women on the Renaissance Stage*, pp. 24–5 (p. 25).

59 Andrew Parker and Eve Kosofsky Sedgwick (eds.), *Performativity and Performance* (New York and London: Routledge, 1995), p. 1.

60 Ruth Marion Little, 'Rogues and Ravens: Ben Jonson and the Staging of Courtiership' (PhD thesis, University of Cambridge, 1993), p. 124.

61 For a discussion of the function of music in *Queens*, see Peter Walls, *Music in the English Courtly Masque, 1604–1640* (Oxford: Clarendon Press, 1996), pp. 78–9, 305–6.

62 I am indebted for this point to Maurer, 'Reading Ben Jonson's *Queens*', p. 24. Cf. Schwarz, 'Stranger in the Mirror', pp. 122–3.

63 Lewalski makes a similar point but in a nontheatrical context, suggesting that the queens 'appropriate rather than destroy the power of the witches', for 'they themselves are figures of fierce violence'; see Lewalski, *Writing Women*, p. 37.

64 Orgel, *Jonsonian Masque*, pp. 145–6.

65 Noting Jonson's prescriptions for 'loud music' and 'full triumphant music', Walls remarks that 'no attempt seems to have been made to give a more specific realization of the idea that Fame sounded her trumpet'; see Walls, *Music in the English Courtly Masque*, p. 306.

66 On the costume's Amazonian properties, see Orgel, *Illusion of Power*, p. 61; McManus, *Women on the Renaissance Stage*, pp. 122–35.

67 Barroll, *Anna of Denmark*, p. 113.

68 Jonson, *Complete Masques*, ed. Orgel, pp. 122, 547.

69 Wilson, *The History of Great Britain*, p. 54.

70 Orgel, 'Jonson and the Amazons' in E. D. Harvey and K. Eisaman Maus (eds.), *Soliciting Interpretation: Literary Theory and Seventeenth-Century Poetry* (Chicago and London: University of Chicago Press, 1990), pp. 119–39 (p. 130). For the view of *Queens* as rendering the female masquers passive and subordinate, see Gossett, 'Women in Masques', pp. 100–1; Lorraine Helms, 'Roaring Girls and Silent Women: The Politics of Androgyny on the Jacobean Stage', *Themes in Drama* 11 (1989), 59–73.

71 McManus, *Women on the Renaissance Stage*, p. 133.

72 Lewalski, *Writing Women*, p. 38; see also Schwarz, 'Stranger in the Mirror', and Diane Purkiss, *The Witch in History: Early Modern and Twentieth-Century Representations* (London and New York: Routledge, 1996), p. 206.

73 Orgel comments of *Queens*, 'Empowering women was not a Jonsonian ideal, and the Queen was not the patron he sought'; see Orgel, 'Marginal Jonson', p. 174. One might respond that in the case of *Queens*, empowering the King's consort was, perforce, a Jonsonian ideal.

74 Jonson narrates that the Bohemian queen, Valasca, 'to redeem herself and her sex from the tyranny of men which they lived in under Primislaus . . . led on the women to the slaughter of their barbarous husbands and lords . . . [and] lived many years after with the liberty and fortitude of Amazons' (*Complete Masques*, p. 546). In 1989 Margaret Maurer grounded her provocative reading of *Queens* on the inseparability of fame, infamy and oblivion, pointing to the critical irony that 'most of the ladies named [as performers] have been ill-served by Fame'; see Maurer, 'Reading Ben Jonson's *Queens*', p. 244. Yet, as the studies of Barroll, McManus and others testify, a new generation of critics is intent upon making Queen Anna's actions spoken about again.

75 Lewalski, *Writing Women*, p. 18.

76 Jonathan Goldberg, 'Fatherly Authority: The Politics of Stuart Family Images' in Ferguson, Quilligan and Vickers (eds.), *Rewriting the Renaissance*, pp. 3–32 (pp. 18, 9).

77 Ezell, *The Patriarch's Wife*, ch. 1.

78 Barroll, *Anna of Denmark*, pp. 31, 34.

79 Samuel Daniel, *Tethys' Festival* in Lindley (ed.), *Court Masques*, pp. 54–65, line 169. Hereafter references are given by line in parentheses in the text.

80 Lewalski, *Writing Women*, p. 30; Knowles, 'Anna of Denmark, Elizabeth I and the Images of Royalty', p. 28; for representations of Elizabeth I as Pallas, see Helen Hackett, *Virgin Mother, Maiden Queen: Elizabeth I and the Cult of the Virgin Mary* (Basingstoke: Macmillan, 1995), pp. 88, 104, 119–20. McManus treats Daniel's *Vision* in terms of 'a dialogue between Anna and her predecessor, Elizabeth I'; see McManus, *Women on the Renaissance Stage*, pp. 106–11 (p. 106).

81 Knowles, 'Anna of Denmark, Elizabeth I and the Images of Royalty', p. 42.

82 McManus, *Women on the Renaissance Stage*, p. 141. 'Moeliades' is an anagram of 'Miles a Deo' ('Soldier from God'); Daniel gives the name as 'Meliades' (144).

83 Jones's costume design for Tethys is reproduced in Stephen Orgel and Roy Strong (eds.), *Inigo Jones: The Theatre of the Stuart Court*, 2 vols. (London, Berkeley and Los Angeles: Sotheby Parke Benet and University of California Press, 1973), I, p. 90, fig. 54.

84 I follow John Pitcher's reading of the masque's 'counsel against imperialism'; see Pitcher, '"In those figures which they seeme": Samuel Daniel's *Tethys' Festival*' in Lindley (ed.), *The Court Masque*, pp. 33–46 (pp. 37–8).

85 Rees, introduction to *The Vision of the Twelve Goddesses* in Spencer and Wells (eds.), *A Book of Masques*, p. 23.

86 See lines 219, 227 ('in a moment'), 364, 369, 406.

87 Barroll, *Anna of Denmark*, p. 35.

88 White, 'To the Honourable and Right Worthy Lady Lucy Countess of Bedford', *Cupid's Banishment*, p. 83. Hereafter references are given by line in parentheses in the text. In her reading of *Cupid's Banishment* McManus focuses on the probable space of its performance in the Queen's palace at Greenwich and on the assignment of the speaking part of Fortune to 'Mistress Ann Watkins'; see McManus, *Women on the Renaissance Stage*, pp. 179–201. See also her essay 'Memorialising Anna of Denmark's Court: *Cupid's Banishment* at Greenwich Palace' in McManus (ed.), *Women and Culture at the Courts of the Stuart Queens*, pp. 81–99.

89 *JCS*, V, p. 1258. C. E. McGee's research into the identities of the masque's twenty-four named female performers suggests that Ladies Hall 'was a school attended by the daughters of learned officers of the court'; see McGee, '*Cupid's Banishment, A Masque Presented to Her Majesty by Young Gentlewomen of the Ladies Hall, Deptford, May 4, 1617*', ed. C. E. McGee, *Renaissance Drama*, n.s. 19 (1988), 227–64 (p. 259, note to line 1).

90 *Ibid.*, p. 231.

91 *Ibid.*, p. 233.

92 The bracketed words in line 17 derive from McGee's edition of the masque ('*Cupid's Banishment*', 94), for Cerasano and Wynne-Davies's rendition of this line as 'which the circle of the sacred sphere' does not make sense.

93 On Actaeon, see Philippa Berry, *Of Chastity and Power: Elizabethan Literature and the Unmarried Queen* (Cambridge University Press, 1989), pp. 4–5, 42–3, 45, 141; for Philomel, see below, notes 99 and 100.

94 Enid Welsford, *The Court Masque: A Study in the Relationship between Poetry and the Revels* (Cambridge University Press, 1927), p. 197.

95 The casting of *Cupid's Banishment* is unusually mixed: in addition to White, the masque involved six male actors (named in the text), two of whom, Charles Coleman and George Lippett, were members of the King's Music. McGee suggests that the character dances of the 'Ante-masque' showing 'the several humours of drunkards' may have been performed by dancers of the Inns of Court ('*Cupid's Banishment*', p. 228). The references to 'two boys, Bacchanalians' and 'Bacchus' children' (155, 247) indicate the additional involvement of juvenile dancers.

96 Chambers, *Elizabethan Stage*, I, p. 157. McGee links the ritual baiting of Cupid in White's masque with the dance in which Falstaff is baited by the Windsor fairies at the climax of Shakespeare's *The Merry Wives of Windsor*; see McGee, '*Cupid's Banishment*', p. 262, note to line 391.

97 Diana's nymphs are later described as wearing 'their breasts naked' (284.5). For a different view of this imitation of 'the court's erotic bodily ideal', see McManus, *Women on the Renaissance Stage*, p. 187.

98 Berry, *Of Chastity and Power*, p. 37

99 *The Rape of Lucrece* had gone through six editions by 1616 and remained very popular up to the Civil War. The musical terms 'descant' and 'diapason' occur in close proximity in Shakespeare's poem: Lucrece tells Philomel, 'I at each sad strain will strain a tear, / And with deep groans the diapason bear; / For burden-wise I'll hum on Tarquin still, / While thou on Tereus descants better skill' (*The Rape of Lucrece*, lines 1131–4). Maurice Evans defines 'diapason' as 'a tune in the bass in concord with the line of the air in the treble'; see William Shakespeare, *The Narrative Poems* (Harmondsworth: Penguin, 1989), p. 229, note to lines 1124–41. Cerasano and Wynne-Davies speculate that White may have drawn on Jonson's 1616 *Works* for his knowledge of masque conventions (*Cupid's Banishment*, p. 78); White seems also to have been familiar with Shakespeare, Daniel's *Queen's Arcadia* and possibly the plays of John Lyly (see below, notes 104 and 107).

100 George Sandys, *Ovid's Metamorphoses Englished*, 2nd edn. (1632; repr. New York and London: Garland, 1976), Book 6, pp. 210–15. Sandys's complete translation of Ovid first appeared in 1626 and was republished in 1632 with extensive commentary. In his tragedy *Titus Andronicus*, contemporaneous with his Roman poem, Shakespeare uses Philomel's story to arouse extreme pathos at the spectacle presented by the raped Lavinia, who has lost both of her hands as well as her tongue. In *Pericles* Philomel is invoked as 'the night bird' who is silenced by Marina's singing (scene 15, 25–7). She is also invoked in the fairies' song in *A Midsummer Night's Dream*, 2.2.13–14.

101 Sandys comments on Philomel and her sister Procne, who was turned into a swallow, 'The Nightingale and Swallow are alluded to [*sic*] Poetry and Oratory: called sisters, because there is in both a similitude of Harmony; see Sandys, *Ovid's Metamorphoses*, p. 228.

102 McManus, *Women on the Renaissance Stage*, p. 185. McManus meditates extensively on Fortune's speech in 'Memorialising Anna of Denmark's Court', pp. 90–6. The daughters of Lady Russell, Anne and Elizabeth, spoke as shepherdesses in the *Entertainment at Bisham* performed for Elizabeth I in 1592; see Jean Wilson, *Entertainments for Elizabeth I* (Woodbridge: D. S. Brewer, 1980), pp. 43–7. For a provincial Jacobean entertainment in which women spoke, see below, note 112.

103 John Lyly, *Galatea*, ed. George K. Hunter, *Midas*, ed. David Bevington, The Revels Plays (Manchester University Press, 2000). Hereafter references are given by line in parentheses in the text. Although written in 1584–5, *Galatea* was not published until 1592.

104 Compare Diana's assertion to Cupid in White's masque, 'Thy darts and chains are of no power with us; / Nor are we in the compass of thy bow' (75–6).

105 Introduction to Lyly, *Galatea*, ed. Hunter, p. 12.

106 Joel Altman, *The Tudor Play of Mind: Rhetorical Inquiry and the Development of Elizabethan Drama* (Berkeley: University of California Press, 1978), pp. 212, 213.

107 This line echoes the address of Palaemon to Queen Anna as 'Bright Pallas, sov'raigne of all Nimphes, / The royall Mistresse of our Pastoral Muse' in Daniel's *The Queenes Arcadia* (1605); see Daniel, *The Queenes Arcadia*, ed. Elizabeth Story Donno, in Donno (ed.), *Three Renaissance Pastorals: Tasso, Guarini, Daniel* (Binghamton, N.Y.: Centre for Medieval and Renaissance Studies, 1993), 5.4.86–7. White derived several lines of Occasion's parting address to the Queen from Palaemon's speech, and from the speech of Silvia preceding it.

108 Anon., *The Coleorton Masque* (1618) in Lindley (ed.), *Court Masques*, pp. 126–35. Hereafter references are given by line in the text. Proposed authors of the masque include Arthur Wilson of my opening quotation; the Reverend Thomas Pestell, rector and 'family laureate' of Coleorton; and the playwright John Fletcher. See David Norbrook, 'The Reformation of the Masque' in Lindley (ed.), *The Court Masque*, pp. 94–110 (pp. 102–3, n. 29), and *Poetry and Politics in the English Renaissance*, rev. edn. (Oxford University Press, 2002), p. 239; Philip J. Finkelpearl, 'The Authorship of the Anonymous "Coleorton" Masque of 1618', *Notes and Queries*, n.s. 40 (1993), 224–6 (p. 225), and 'The Fairies' Farewell: *The Masque at Coleorton* (1618)', *Review of English Studies*, n.s. 46 (1995), 333–51; Gordon McMullan, *The Politics of Unease in the Plays of John Fletcher* (Amherst: University of Massachusetts Press, 1994), pp. 29–33.

109 Devereux was fourteen, his bride thirteen, on their marriage in 1606. There is a further connection between the two masques in Lord Willoughby, who danced in both *Hymenaei* and the masque at Coleorton.

110 This phrase is used by Ann Rosalind Jones and Peter Stallybrass, writing about the constitutive role of clothing in shaping the Renaissance subject; see Jones and Stallybrass, *Renaissance Clothing and the Materials of Memory* (Cambridge University Press, 2000), p. 2.

111 In earlier mixed masques such as *Hymenaei* and Campion's *The Lords' Masque* the male masquers appeared first. In *The Politics of Unease*, McMullan situates the Coleorton masque within Fletcher's 'patronage milieu', which centred upon Henry and Elizabeth Hastings, the fifth Earl and Countess of Huntingdon (p. 156). The antimasque names 'honest Harry of Ashby' (68–9) as among the few remaining upholders of country hospitality. Finkelpearl ('The Fairies' Farewell') relates the feminism of the Coleorton masque to the cult of praise focused on the Countess Elizabeth.

112 Letter of John Chamberlain, 25 January 1620, cited by Linda Woodbridge in *Women and the English Renaissance: Literature and the Nature of Womankind, 1540–1620* (Brighton: Harvester Press, 1984), p. 143; Valerie Traub, *The Renaissance of Lesbianism in Early Modern England* (New York: Cambridge University Press, 2002), p. 67; see also Finkelpearl, 'The Fairies' Farewell', pp. 341–5.

113 John Marston, 'The Entertainment of the Dowager Countess of Derby' in *The Poems of John Marston*, ed. Arnold Davenport (Liverpool University Press, 1961), pp. 189–207, lines 431, 425–6. The 'Entertainment' was

presented to Lady Alice by her daughter and son-in-law, Elizabeth and Henry Hastings (see note 111, above). The eclogue pays a studied compliment to Elizabeth on her love for her mother at the latter's departure; it concludes with the shepherd pronouncing his victory over the nymph's hate, for that was predicated on the impossibility of filial love arising from simple piety, and Elizabeth is living proof to the contrary. The 'Entertainment' is of further interest because of a manuscript sealed into the back of the Dowager Countess's presentation copy held in the Huntington Library, California. The manuscript contains verses assigned to fourteen named women, designed to accompany a gift-giving celebrating a betrothal. The verses have been attributed to Shakespeare by Peter Levi (*A Private Commission: New Verses by Shakespeare*, (London: Macmillan, 1988)), but James Knowles has argued in favour of assigning them to the Leicestershire poet Sir William Skipworth ('WS MS', *TLS*, 29 April 1988, pp. 472, 485). The verses, written to be spoken by women, provide further evidence of flexible codes of performance at entertainments away from court. Alice Stanley was the dedicatee of poems by Spenser and was the later recipient of Milton's pastoral entertainment, *Arcades* (1633).

114 McMullan, *Politics of Unease*, p. 156.

2 'NAKED HEARTS': FEMINIZING THE STUART PASTORAL STAGE

1 John Vanbrugh, *The Provoked Wife*, ed. Antony Coleman, The Revels Plays (Manchester University Press, 1982), 3.1.360–2.

2 Jeremy Collier, *A Short View of the Immorality and Profaneness of the English Stage* (1698).

3 See Daniel's version of the Chorus to Act 1 of the *Aminta*, published as 'A Pastoral' in his *Works* of 1601, in Daniel, *Aminta* in Donno (ed.), *Three Renaissance Pastorals: Tasso, Guarini, Daniel*, Appendix 2, lines 17–18.

4 Daniel's pastorals are discussed briefly by Lewalski, *Writing Women*, pp. 35–6, 41–2. See also J. Procter, '*The Queenes Arcadia* (1606) and *Hymen's Triumph* (1615): Samuel Daniel's Court Pastoral Plays' in J. Salmons and W. Moretti (eds.), *The Renaissance in Ferrara and its European Horizons* (Cardiff and Ravenna: University of Wales Press and M. Lapucci, 1984), pp. 83–109.

5 Daniel, *The Queenes Arcadia* in Donno (ed.), *Three Renaissance Pastorals*, 5.2.65. *The Queenes Arcadia* addresses itself explicitly to Queen Anna as 'the royall Mistresse of our Pastorall Muse' (5.4.87).

6 On Daniel as a 'Poet of Imaginative Sympathy', see Geoffrey G. Hiller and Peter L. Groves (eds.), *Samuel Daniel: Selected Poetry and A Defense of Rhyme* (Asheville, N.C.: Pegasus Press, 1998), pp. 8–12. In *The Queenes Arcadia* Daniel's sympathetic focus on the coy, witty maiden overcome by love is accompanied by a satirical exposure of female hypocrisy in the figure of Techne, 'a subtle wench of Corinth'.

7 Milton, *Arcades* (1630–3?, pub. 1645) in *Milton: Complete Shorter Poems*, ed. John Carey (London: Longman, 1971), lines 61–73; Prynne, *Histrio-Mastix*, I, 420.

8 John G. Demeray, *Milton and the Masque Tradition: The Early Poems, Arcades and Comus* (Cambridge, Mass., Harvard University Press, 1968), p. 95. In *Women and Dramatic Production* (coauthored with Findlay and Williams), Stephanie Hodgson-Wright discusses manuscript entertainments written by the youthful Lady Rachel Fane (1631–80) of Apthorpe, and 'probably performed during the 1630s', pp. 52–4 (p. 52).

9 Stephen Gosson, *The Schoole of Abuse* (London, 1579), sig. A2ᵛ. See Orgel, 'Marginal Jonson', p. 144.

10 In rendering Circe a victim of love, *Tempe Restored* differs from an earlier Jacobean treatment of the Circe myth, William Browne's *Inner Temple Masque* (1615), which depicts Circe successfully pursuing the love of Ulysses; see Walls, *Music in the English Courtly Masque*, pp. 264–5. In this masque Circe was performed by a male singer.

11 See Frances A. Yates, *The French Academies of the Sixteenth Century* (London and Norwich: The Warburg Institute and Empire Press, 1947), pp. 199–235, 252, 258–9.

12 See Eleanor Gwynne Relle, 'Studies in the Presentation of Chastity, chiefly in post-Reformation English Literature, with particular reference to its ecclesiastical and political connotations and to Milton's treatment of the theme in *Comus*', PhD thesis, University of Cambridge, 1969, chs. 4, 7–9.

13 Characters respectively from Shakespeare's *The Winter's Tale*, Fletcher's *The Faithful Shepherdess* and *The Prophetess* and Marston's *The Wonder of Women or, The Tragedy of Sophonisba*.

14 On the relationship between the *Balet Comique* and *Tempe Restored*, see Meagher, *Method and Meaning in Jonson's Masques*, pp. 22–30, and Veevers, *Images of Love and Religion*, pp. 191–5.

15 Roy Booth, 'The First Female Professional Singers: Madam Coniack', *Notes and Queries* 44 (1997), 533. It seems that Madame Coniack was well advanced in years, for Randolph's poem compares her to a worn-out lute which yet produces a ravishing sound.

16 Aurelian Townshend, *Tempe Restored* in Lindley (ed.), *Court Masques*, pp. 155–65, line 145. Hereafter references are given by line in parentheses in the text. In her essay '"Not as Myself": The Queen's Voice in *Tempe Restored*', *Modern Philology* 101 (2003), 48–67, Melinda J. Gough interprets the interactions between Circe, Harmony and Divine Beauty in Townshend's masque with reference to several French court ballets in which Henrietta Maria and her mother, Marie de Medici, had performed. Challenging critical views of *Tempe Restored*'s thematic incoherence, Gough argues that Harmony's ventriloquization of Divine Beauty's power exemplifies the masque's 'overarching theme', namely, 'a defense of beauty instantiated in art but also in artful performing women' (p. 52).

17 No music survives for *Tempe Restored*, but the song's likely composer was Nicholas Lanier, who is described as having 'represented' the Highest Sphere in the main masque (line 205). Lanier and Henry Lawes were the first English

composers to develop masque song along the declamatory lines advocated by the Florentine Camerata, whose members were pioneering the development of opera in Italy at the end of the sixteenth century.

18 Jones's 'Allegory' draws heavily on the last of four expositions of the allegorical meaning of the *Balet Comique de la Reine*, published with the original text (see the citations in Yates, *The French Academies*, p. 249). This allegory was written by 'Sieur Gordon Escoçois', the Scottish Protestant John Gordon, who served in France as Gentleman in Ordinary to Charles IX, Henri III and Henri IV, and was summoned to England in 1603 by James I. Veevers speculates that Jones's derivation of his allegory from that of Gordon 'may have vouched for "Protestant" approval of a French (Catholic) source'; see Veevers, *Images of Love and Religion*, pp. 193–4 (p. 194).

19 Lucy Green, *Music, Gender, Education* (Cambridge University Press, 1997), p. 35.

20 Orgel and Strong (eds.), *Inigo Jones*, I, p. 61.

21 In a reading which complements my own, David Lindley proposes that 'the insinuating song of Circe . . . enacts a subversive gesture that the work as a whole fails quite to subdue'; see Lindley, 'The Politics of Music in the Masque', in Bevington and Holbrook (eds.), *The Politics of the Stuart Court Masque*, pp. 273–95 (p. 288).

22 Orgel and Strong suggest that the lute accompaniment to Circe's song was provided by the Chorus of Musicians, some of whom are pictured in Jones's sketches with lutes; see Orgel and Strong (eds.), *Inigo Jones*, II, pp. 488–9. These sketches may depict the Chorus of Musicians who accompanied Harmony, whom Jones depicts holding a viol and bow, an image modelled upon that of Harmonia in Ripa's *Iconologia* (II, 496). Even if Circe was accompanied by a larger lute chorus, this does not preclude the possibility that Madame Coniack played a lute of her own.

23 Coryate, *Coryats Crudities*, p. 267. Compare the examples given in Linda Phyllis Austern, '"Sing Againe Syren"', pp. 442–7, and the same author's '"Alluring the Auditorie to Effeminacie": Music and the Idea of the Feminine in Early Modern England', *Music and Letters* 74 (1993), 342–52.

24 Jonathan Goldberg, *James I and the Politics of Literature: Jonson, Shakespeare, Donne, and their Contemporaries* (Baltimore and London: Johns Hopkins University Press, 1983), p. 67.

25 My reading of this incident has benefited from Suzanne Gossett's interpretation, though our emphases are quite different; see Gossett, 'Women in Masques', pp. 108–10.

26 I am grateful to Barbara Ravelhofer for this suggestion. The musicologist Thurston Dart notes that the countertenor voice 'seems to have been an especially English one – Purcell and Henry Lawes were both counter-tenors'; see Dart, *The Interpretation of Music* (1954; repr. London: Hutchinson, 1967), p. 49. Henry Lawes composed and performed in Caroline masques, most notably Milton's *Comus*.

27 Sigmund Freud, 'Medusa's Head' (1922), in Freud, *Collected Papers*, ed. James Strachey, 5 vols. (London: The Hogarth Press and The Institute of Psycho-Analysis, 1950), V, pp. 105–6 (p. 105).

28 Gough, 'The Queen's Voice in *Tempe Restored*', p. 67.

29 I am indebted to Barbara Ravelhofer for the suggestion of Circe as a diplomat.

30 In the *Balet Comique* the part of Minerva was played by a female courtier, so a conflict between differently gendered performers does not arise.

31 The name 'Bellessa' derives from the Tixall Manuscript of the play, edited by Poynting as *The Shepherds' Paradise by Walter Montagu*. Unless otherwise specified, all quotations are taken from this edition, with references given by line in parentheses in the text. Cross-references are given by page to the 1659 edition of *The Shepheard's Paradise*, or by line number to Poynting's Malone Society edition. The way *The Shepherds' Paradise* reflects the concerns of the Queen's coterie, and its encrypting of the story of Charles and Henrietta Maria's courtship, is the focus of much recent criticism. See Orgel and Strong (eds.), *Inigo Jones*, I, p. 63; John Peacock, 'The French Element in Inigo Jones's Masque Designs' in Lindley (ed.), *The Court Masque*, pp. 149–68 (pp. 156–7); Veevers, *Images of Love and Religion*, pp. 39–47; Lois Potter, *Secret Rites and Secret Writing: Royalist Literature 1641–1660* (Cambridge University Press, 1989), pp. 79–80; Sharpe, *Criticism and Compliment*, pp. 39–44. The fullest account of the play hitherto is given by Poynting in the introduction to her DPhil thesis, 'A Critical Edition of Walter Montagu's *The Shepherds' Paradise*, Acts 1–3' (1999). Poynting argues that the play's 'topical references' are 'allusive and discontinuous', and far from espousing Neoplatonism, she sees Montagu arguing for 'an empirical and material view of the world' (I, pp. 111, 155).

32 Poynting, 'Critical Edition', I, p. 119.

33 Cited in *Revels History IV 1613–1660*, p. 13. Owing to delays, the play was not performed until 9 January 1633, with a probable repeat performance on 2 February; see Poynting, *The Shepherds' Paradise*, p. xii.

34 Cited by John Orrell, *The Theatres of Inigo Jones and John Webb* (Cambridge University Press, 1985), p. 119. For further contemporary comment, see *JCS*, IV, pp. 917–19.

35 See, for instance, in Shakespeare's *Much Ado About Nothing*, the Friar's 'noting' of Hero's shifting complexion, after she has been misaccused of sexual betrayal by Claudio at the altar:

> I have marked
> A thousand blushing apparitions
> To start into her face, a thousand innocent shames
> In angel whiteness beat away those blushes,
> And in her eye there hath appeared a fire
> To burn the errors that these princes hold
> Against her maiden truth.
>
> (4.1.160–6)

Danielle Clarke examines the incidence of the language of blushing in religious texts associated with Henrietta Maria in 'The Iconography of the Blush: Marian Literature of the 1630s' in Kate Chedgzoy, Melanie Hansen and Suzanne Trill (eds.), *Voicing Women: Gender and Sexuality in Early Modern Writing* (Edinburgh University Press, 1998), pp. 111–28.

36 Anne Barton, 'A Blush may Spell Disaster' in Patrick Lyons (ed.), *Congreve's Comedies: A Selection of Critical Essays* (London: Macmillan Press, 1982), pp. 209–12.

37 There are two holograph manuscripts of *Love's Victory*, one of which, held in the Huntington Library, is incomplete. On the Huntington text of the play, and the likely auspices of its performance, see Josephine A. Roberts, 'The Huntington Manuscript of Lady Mary Wroth's Play, *Loves Victorie*', *Huntington Library Quarterly* 46 (1983), 156–74, and Margaret Anne McLaren, 'An Unknown Continent: Lady Mary Wroth's Forgotten Pastoral Drama, *Loves Victorie*' in Cerasano and Wynne-Davies (eds.), *Readings in Renaissance Women's Drama*, pp. 219–33. The longer Penshurst Manuscript is the basis of an edition by Michael Brennan for the Roxburgh Club, published in 1988. As this volume is not widely accessible, I have used the modernized edition of *Love's Victory* in Cerasano and Wynne-Davies's anthology, *Renaissance Drama by Women*. Criticism of the play written with knowledge of the longer text includes Carolyn Ruth Swift, 'Feminine Self-Definition in Lady Mary Wroth's *Love's Victorie* (c. 1621)', *ELR* 19 (1989), 171–88; Lewalski, *Writing Women*, pp. 296–307; Danielle Clarke, *The Politics of Early Modern Women's Writing* (London: Longman, 2000), pp. 106–18; Alexandra Bennett, 'Playing By and With the Rules: Genre, Politics, and Perception in Mary Wroth's *Love's Victorie*' in McManus (ed.), *Women and Culture at the Courts of the Stuart Queens*, pp. 122–39. Bennett's essay, which dovetails with this chapter's concerns, proposes that *Love's Victory* 'explores the creation of Renaissance femininity as an overt performance within the parameters of contemporary court culture' (p. 124).

38 Quotations are from the text of *Love's Victory* published in Cerasano and Wynne-Davies (eds.), *Renaissance Drama by Women*, pp. 91–126, 4.1.125–8. Hereafter references are given by act, scene and line in parentheses in the text.

39 Gary Waller, '"Like One in a Gay Masque': The Sidney Cousins in the Theaters of Court and Country"' in Cerasano and Wynne-Davies (eds.), *Readings in Renaissance Women's Drama*, pp. 234–45 (p. 240).

40 *Ibid.*, p. 240.

41 See Elizabeth Howe's discussion of 'couch scenes', of which this scene is an antecedent, *The First English Actresses*, pp. 39–43. Poynting detects a pun on premature ejaculation in the 1659 quarto, in Moramante's statement, while approaching Bellessa, that '[his] spirit is shot out upon [her]' (1659: 113), 'Critical Edition', I, pp. 132–3. This variant, unique to the published edition of the play, both heightens the scene's piquancy and jeopardizes its decorum.

42 Giambattista Guarini, *Il Pastor Fido*, trans. Tailboys Dymoke, in Donno, *Three Renaissance Pastorals,* 2.1. The audience may also have detected a resemblance between this scene and the second song in Philip Sidney's sonnet sequence *Astrophil and Stella,* 'Have I caught my heavenly jewel/ Teaching sleep most fair to be?' in which Astrophil approaches the sleeping Stella and steals a kiss.

43 1659: 134–9. See fig. 250 of Orgel and Strong (eds.), *Inigo Jones,* II, pp. 514–15, which depicts a pagoda-like structure within a wood. Browne's *Inner Temple Masque* suggests how this scene might have been staged. Scene 2 of the masque takes place in 'an artificial wood'; the scene features an Echo song, sung by 'the Nymphs in the Wood', for which the 'Echoes [were] placed in several parts of the boscage'; see Spencer and Wells (eds.), *A Book of Masques,* pp. 179–206, lines 346–47. An Echo scene features in Act 4, scene 8 of Guarini's *Il Pastor Fido* and was imitated by John Webster in *The Duchess of Malfi,* discussed below.

44 Cf. Ben Jonson, *The New Inn* (1629), ed. Michael Hattaway, The Revels Plays (Manchester University Press, 1984), 1.6, note to line 64. On Charles's 'cabinet council', see Barry Coward, *The Stuart Age: England, 1603–1714,* 3rd edn. (Harlow: Longman Pearson, 2003), p. 93.

45 Sandys, *Ovid's Metamorphoses,* Book 3, p. 89. In his commentary Sandys proposes a sexual relationship between Echo and Jupiter, asserting that Juno deprived Echo of speech 'for being formerly *Jupiters* property' (p. 103).

46 *Ibid.*, p. 89, emphasis mine.

47 William Shullenberger, 'Tragedy in Translation: The Lady's Echo Song', *ELR* 33 (2003), 403–23 (p. 405).

48 Michael Neill discusses 'the uncomfortably porous boundary between affective and servile relationships' in his essay '"He that thou knowest thine": Friendship and Service in *Hamlet*' in Richard Dutton and Jean E. Howard (eds.), *A Companion to Shakespeare's Works,* 4 vols., *Volume I: The Tragedies* (Malden, M.A.: Blackwell, 2003), pp. 319–38 (p. 327).

49 See Poynting, 'Critical Edition', I, pp. 129–34.

50 Montagu, *The Shepheard's Paradise,* 1659, p. 90

51 *Ibid.*, p. 90 (Malone Soc. Repr.: 2703–8).

52 Poynting, 'Critical Edition', I, p. 130

53 Webster, *The Duchess of Malfi,* 1.1.192–3. Hereafter references are given by act, scene and line in parentheses in the text.

54 In an iconographic interpretation of Webster's Echo scene, Michael Neill reads the Echo, and the 'mysteriously illuminated tomb' of the Duchess, as signifying her 'monumental triumph over time'; see Neill, 'Monuments and Ruins as Symbols in *The Duchess of Malfi*', *Themes in Drama* 4 (1982), 71–87 (pp. 76, 75).

55 Elizabeth D. Harvey, *Ventriloquized Voices: Feminist Theory and English Renaissance Texts* (London and New York: Routledge, 1992), p. 2, referring to *The Duchess of Malfi.*

56 *Ibid.*, pp. 2–5 (p. 4).

57 *Ibid.*, p. 3.
58 Webster, *The Duchess of Malfi*, 1.2.439–41. See Michael Neill's discussion of the wooing scene in his essay '"What Strange Riddle's This?": Deciphering *'Tis Pity She's a Whore*' in Neill (ed.), *John Ford: Critical Re-Visions* (Cambridge University Press, 1988), pp. 153–79. Neill remarks of the lines I quote, 'it is surely an implicit stage direction, inviting [Antonio] to feel her living warmth' (p. 170).
59 Catherine Belsey, 'Emblem and Antithesis in *The Duchess of Malfi*' in Harold Bloom (ed.), *The Duchess of Malfi*, Modern Critical Interpretations (New York: Chelsea House, 1987), pp. 97–113 (p. 97).
60 *Ibid.*, pp. 111–12 (p. 112).
61 Testimony of the seriousness with which gentlewomen took such points of etiquette is provided by Margaret Lucas, who during her courtship with William Cavendish, then Marquess of Newcastle, wrote, 'my lord, it is a custom I observe that I never speak to any man before they address themselves to me, nor to look so much in their face as to invite their discourse', adding, in response to a report from William that an acquaintance had found Margaret 'rude and unapproachable', 'I hope I never was uncivil to any person of what degree so ever'; cited in Katie Whitaker, *Mad Madge: The Extraordinary Life of Margaret Cavendish, Duchess of Newcastle, the First Woman to Live by her Pen* (New York: Basic Books, 2002), p. 76. Margaret later created a character named 'Madam Civility' in her play *The Presence* (pub. 1668).
62 In her examination of imagery in *The Shepherds' Paradise*, Poynting explores the set of tropes which 'draws on Montagu's interest in art and architecture'. She discusses a striking example in Bellessa's soliloquy preceding her dialogue with Echo, where Moramante's "love and honour" are objectified as being bent by his humility into "a lovely arch" which [Bellessa] may allow her thoughts to cross as a safe way of thinking about his physical attractiveness'; see Poynting, 'Critical Edition', I, pp. 120–1.
63 *Ibid.*, I, 122.
64 Harvey, *Ventriloquized Voices*, p. 3.
65 See my essay 'Theatrical Vibrancy on the Caroline Court Stage: *Tempe Restored* and *The Shepherds' Paradise*' in McManus (ed.), *Women and Culture at the Courts of the Stuart Queens*, pp. 186–203 (pp. 194–9).
66 Poynting, *The Shepherds' Paradise*, boxed stage direction following line 3712. The version of the revelation scene in the 1659 quarto specifies a veil, rather than a scarf (p. 167).
67 In this final scene Fidamira is revealed to be Princess Miranda, sister to Bellessa/Princess Saphira; the sisters are the two lost daughters of the King of Navarre.
68 William Riley Parker, *Milton: A Biography*, 2 vols. (Oxford: Clarendon Press, 1968), I, p. 132. In a recent provocative essay Stephen Orgel argues that *Comus* is 'definitively' a family affair; see Orgel, 'The Case for *Comus*', *Representations* 81 (2003), 31–45 (p. 33).

69 For the argument that *Comus* is a 'reformation of the masque', see John Creaser, '"The Present Aid of this Occasion": The Setting of *Comus*' in Lindley (ed.), *The Court Masque*, pp. 110–34; Norbrook, 'The Reformation of the Masque' in Lindley (ed.), *The Court Masque*, and *Poetry and Politics*, pp. 233–6; Lewalski, 'Milton's *Comus* and the Politics of Masquing' in Bevington and Holbrook (eds.), *Politics of the Stuart Court Masque*, pp. 296–320.

70 Prynne, *Histrio-Mastix*, I, p. 546.

71 Barbara K. Lewalski, *The Life of John Milton* (Oxford: Blackwell, 2000), pp. 53–68. For the idea that at the time of writing *Comus* Milton embraced 'the idea of chastity as an active principle, not a negation', see E. M. W. Tillyard, 'Milton and the Doctrine of Chastity' in Tillyard, *Milton,* rev. edn. (London: Chatto and Windus, 1966), Appendix C (p. 326).

72 See Katharine Eisaman Maus, 'A Womb of his Own: Male Renaissance Poets in the Female Body' in James Grantham Turner (ed.), *Sexuality and Gender in Early Modern Europe* (Cambridge University Press, 1993), pp. 266–88 (pp. 277–9). While Maus interprets the Lady's role as 'deeply self-expressive' for Milton (p. 278), I see him as identifying with both the Lady's and Comus's positions.

73 Quotations are taken from 'A Masque presented at Ludlow Castle, 1634' in Carey (ed.), *Milton: Complete Shorter Poems*, lines 785–6. Hereafter references are given by line in parentheses in the text.

74 Norbrook, 'The Reformation of the Masque', p. 105.

75 Milton, *Arcades*, line 73.

76 John Milton, *A Maske: The Earlier Versions*, ed. S. E. Sprott (Toronto and Buffalo: University of Toronto Press, 1973), pp. 64–5. Sprott prints in parallel the autograph manuscripts held in the Wren Library, Cambridge, and the Bridgewater Library, and the printed edition of 1637. He comments that the Bridgewater manuscript, in which stage directions are amplified, was 'probably used as a basis for the performance' (p. 16).

77 *Ibid.,* p. 66.

78 Only when dressed as the page Cesario, and imaginatively inhabiting her master's mind, does Shakespeare's Viola envisage 'halloo[ing Olivia's] name to the reverberate hills' (*Twelfth Night*, 1.5.261).

79 For the view of the Lady's choice of song as 'self-limiting', see Mary Laughlin Fawcett, '"Such Noise as I can Make": Chastity and Speech in *Othello* and *Comus*', *Renaissance Drama*, n.s. 16 (1985), 159–80 (p. 170).

80 Walls, *Music in the English Courtly Masque*, pp. 295, 299 (p. 295).

81 Carey suggests that Milton uses 'love-lorn' to mean 'lost or ruined through love'; see Carey (ed.), *Milton: Complete Shorter Poems*, note to line 233.

82 Shullenberger, 'Tragedy in Translation', p. 407.

83 *Ibid.,* p. 407. In his reading of the Lady's song Shullenberger explores the 'strangeness and implicit risk' (p. 417) aroused by the Lady's invocations of Echo and Philomel, two women who 'lose the power to speak for [themselves]' (p. 407).

84 *Ibid.,* p. 407.

85 Cedric Brown, *John Milton's Aristocratic Entertainments* (Cambridge University Press, 1985), pp. 84–5. Loewenstein interprets the lack of an echo song proper in *Comus* as an 'evasion of resonance' on Milton's part; see Loewenstein, *Responsive Readings*, pp. 133–46 (p. 134); cf. Orgel, 'The Case for *Comus*', pp. 39–41.

86 Milton later replayed this scene when Satan beholds Eve's beauty in *Paradise Lost*. See John Milton, *Paradise Lost*, ed. Alistair Fowler (London: Longman, 1971), IX, 455–66.

87 Walls, *Music in the English Courtly Masque*, pp. 300, 299.

88 Milton, *Paradise Lost*, IX, 549.

89 Ben Jonson, *Cynthias Revels, or The Fountayne of selfe-Love* (1600), *Jonson*, IV, 1.2.11. Jonson's comical satire contains a treatment of the Echo myth with which Milton may have been familiar.

90 Maus, 'A Womb of his Own', p. 283.

91 That passage of the Lady's oration extolling the 'sun-clad power of chastity' was added by Milton to the 1637 edition of *Comus* (lines 778–805 of the Longman text). Milton may have felt it appropriate to reserve the political connotations of the 'sun-clad power' as an image of the true Protestant church for a reading text; consequently, the acted version of the Lady's speech foregrounds her reasoning skills in revealing Comus's argument as an endorsement of 'swinish gluttony' (775).

92 Norbrook, *Poetry and Politics*, pp. 255–9.

93 The Lady's spiritual self-confidence contrasts with the mindset of the raped Lucrece in Shakespeare's poem, who while claiming that her mind is 'immaculate and spotless' (1656), kills herself to clear her husband's name of the 'infamy' accruing from a wife's rape (1173). Orgel observes that the Lady's claim of mental freedom is untrue to the extent that her marital future rests in her father's power ('The Case for *Comus*', p. 42); however illusory, the assertion of female freedom remains significant.

94 It is not known who sang Sabrina. Parker suggests Lawes's wife (*Milton: A Biography*, II, p. 791, n.36), while Demaray suggests Alice's older sister, Penelope Egerton, who had danced in Jonson's *Chloridia* (*Milton and the Masque Tradition*, pp. 77–8). If Penelope performed in the masque, one would expect her to be among the list of those who 'presented' found in the Bridgewater manuscript but only Alice, John and Thomas Egerton are named.

95 I incline to Lewalski's view that 'Sabrina's tainted origin points to original sin as the source of the Lady's plight'; see Lewalski, 'Politics of Masquing', p. 314. For further discussion of lines 915–17, see Maus, 'A Womb of his Own', p. 283; Edward Le Comte, *Milton and Sex* (London and Basingstoke: Macmillan, 1978), pp. 1–2; Leah S. Marcus, 'John Milton's *Comus*' in Thomas N. Corns (ed.), *A Companion to Milton* (Oxford: Blackwell, 2001), pp. 232–45 (pp. 236–7).

96 Norbrook, *Poetry and Politics*, p. 254.

97 Gossett, 'Women in Masques', p. 113.

98 On the emergence and development of the concept of 'civility' in this period, see Anna Bryson, *From Courtesy to Civility: Changing Codes of Conduct in Early Modern England* (Oxford: Clarendon Press, 1998).

99 Lewalski, 'Politics of Masquing', p. 310.

3 'SIGNIFICANT LIBERTY': THE ACTRESS IN CAROLINE COMEDY

1 Howe, *The First English Actresses*, pp. 174, 17.

2 Ira Clark, *Professional Playwrights: Massinger, Ford, Shirley and Brome* (Lexington: University Press of Kentucky, 1992), p. 24.

3 Montagu, *The Shepheard's Paradise*, p. 90. This exchange was omitted from the Tixall manuscript of *The Shepherds' Paradise*, occurring between lines 2702 and 2703 of Poynting, *The Shepherds' Paradise by Walter Montagu*.

4 *Ibid.*, p. 90.

5 In the line under discussion, the word 'equal' does not mesh precisely with modern usage; it means 'evenly proportioned or distributed' (*OED* 4a), more than 'having the same rights or privileges' (*OED* 2a), though the latter sense is also implied by Camena's line. Cf. William Cartwright's ascription of 'equall Temperance' to Lucy Hay in 'A Panegyric to the most Noble LUCY Countesse of Carlisle' (line 42) in Cartwright, *Plays and Poems of William Cartwright*, ed. Blakemore Evans, p. 442, where Cartwright appears to be punning on the tuning system of 'equal temperament' in music.

6 For a discussion of the lives and court careers of the women who acted with Henrietta Maria in *The Shepherds' Paradise*, see Sarah Poynting, '"In the Name of all the Sisters": Henrietta Maria's Notorious Whores' in McManus (ed.), *Women and Culture at the Courts of the Stuart Queens*, pp. 163–85.

7 Fletcher, *The Wild-Goose Chase*, ed. Tomlinson, in *Three Seventeenth-Century Plays on Women and Performance*, 4.1.77–9.

8 Keith Wrightson makes the point: 'a 40s. freehold entitled a man to vote in the parliamentary elections of his county; it conferred political rights'; see Wrightson, *English Society 1580–1680* (London: Hutchinson, 1982), p. 31. See also Christopher Hill, 'Pottage for Freeborn Englishmen: Attitudes to Wage-Labour' in Hill, *Change and Continuity in Seventeenth-Century England* (1974, rev. edn., New Haven and London: Yale University Press, 1991). My thanks to Constance Jordan for referring me to Hill's essay.

9 Kathleen McLuskie, *Renaissance Dramatists*, Feminist Readings (Hemel Hempstead: Harvester Wheatsheaf, 1989), p. 198.

10 *Ibid.*, p. 222.

11 On the theatrical self-consciousness of *The New Inn*, see Harriett Hawkins, 'The Idea of a Theater in Jonson's *The New Inn*', *Renaissance Drama* 9 (1966), 205–26; Anne Barton, *Ben Jonson, Dramatist* (Cambridge University Press, 1984), ch. 12, *passim*. In a series of articles, Julie Sanders explores the political implications of Jonson's engagement with female performance and

the Caroline cult of Neoplatonism in *The New Inn*: '"The Day's Sports Devised in the Inn": Jonson's *The New Inn* and Theatrical Politics', *Modern Language Review* 91 (1996), 545–60; '"'Twill Fit the Players Yet": Women and Theatre in Jonson's Late Plays' in Richard Cave, Elizabeth Schafer and Brian Woolland (eds.), *Ben Jonson and Theatre: Performance, Practice, Theory*, (London and New York: Routledge, 1999); 'Caroline Salon Culture and Female Agency: The Countess of Carlisle, Henrietta Maria and Public Theatre', *Theatre Journal* 52 (2000), 449–64. See also Martin Butler, 'Late Jonson' in Gordon McMullan and Jonathan Hope (eds.), *The Politics of Tragicomedy: Shakespeare and After* (London and New York: Routledge, 1992), pp. 166–88.

12 Jonson, *The New Inn*, ed. Hattaway, 'The Argument', lines 5–6. Hereafter references are given by act, scene and line in parentheses in the text.

13 The play's failure to please its original Blackfriars audience is conveyed on the title-page to the 1631 octavo edition, which describes *The New Inn* as 'never acted, but most negligently play'd, by some, the Kings Servants. And more squeamishly beheld, and censured by others, the Kings Subjects.' For discussion of why the play might have failed, see Barton, *Ben Jonson, Dramatist*, ch. 12, *passim*, and Jonson, *The New Inn*, ed. Hattaway, pp. 6–10. The past few decades have seen a concerted attempt to rescue *The New Inn* from critical misconstruction, including a production by the Royal Shakespeare Company in 1986. For a summary of the play's critical history, see the introduction to *The Selected Plays of Ben Jonson*, ed. Martin Butler, 2 vols. (Cambridge University Press, 1989), II, pp. xix–xx.

14 See Coppélia Kahn, 'The Absent Mother in *King Lear*' in Ferguson *et al.* (eds.), *Rewriting the Renaissance*, pp. 33–49. For a different perspective on Jonson's treatment of the elder Lady Frampul, see Helen Ostovich, 'Mistress and Maid: Women's Friendship in *The New Inn*', *Ben Jonson Journal* 4 (1997), 1–26 (p. 3).

15 Veevers, *Images of Love and Religion*, p. 38.

16 See Morris Palmer Tilley, *A Dictionary of the Proverbs in England in the Sixteenth and Seventeenth Centuries* (Ann Arbor: University of Michigan Press, 1950), W672. The quotation derives from Robert Greene's prose romance, *Never Too Late*, 1590. This idea recurs in Shirley's *Hyde Park*, discussed below, and in Chapman's *Bussy D'Ambois*, cited in McLuskie, *Renaissance Dramatists*, p. 154.

17 Barton, *Ben Jonson, Dramatist*, p. 270.

18 Marianne Novy, *Love's Argument: Gender Relations in Shakespeare* (Chapel Hill and London: University of North Carolina Press, 1984), p. 83.

19 My interpretation of the 'Shakespearean' dimension of *The New Inn* is influenced by Lorna Hutson's argument in 'Why do Shakespeare's women have characters?', ch. 6 of Hutson, *The Usurer's Daughter: Male Friendship and Fictions of Women in Sixteenth-Century England* (London and New York: Routledge, 1994). Hutson argues that Shakespeare 'resolved the problem of representing women within the doubtful, gossipy mode of

the Terentian plot [of New Comedy] by . . . identifying the representation
of *women*, rather than men, with the dramatic productivity of "error" '
(p. 189).

20 In *The Wild-Goose Chase* Mirabell tells the studious Lillia-Bianca, 'Sure thy
husband / Must have a strong philosophers' stone, he will ne'er please thee
else' (1.3.194–5). For more examples, see Gordon Williams, *A Dictionary of
Sexual Language and Imagery in Shakespeare and Stuart Literature*. 3 vols.
(London: Athlone Press, 1994), III, p. 1322.

21 See Frank Kermode, 'The Banquet of Sense' in Kermode, *Renaissance Essays*,
and Donald K. Anderson, 'The Banquet of Love in English Drama (1595–
1642)', *Journal of English and German Philology* 63 (1964), 422–32.

22 *OED* gives one meaning of 'shift' as 'a body-garment of linen, cotton . . .
subsequently, a woman's "smock"; or chemise'; shift, *n.* IV, 10a. For
illustrations of early modern women's shifts or smocks, see Elizabeth Ewing,
Dress and Undress: A History of Women's Underwear (London: Batsford,
1978), p. 36, figs. 26 and 27, p. 53, fig. 47.

23 Michael Billington in Ronnie Mulryne and Margaret Shewring, *This Golden
Round: The Royal Shakespeare Company at the Swan* (Stratford-on-Avon:
Mulryne and Shewring, 1989), p. 55.

24 Jonson, *The New Inn*, ed. Hattaway, p. 24.

25 The stress on Pinnacia's size makes it probable that she was played by a
mature actor, rather than a boy. This is implicit in Hattaway's comment,
'On stage the main effect would be a couple of splendid grotesques:
Pinnnacia is enormous, a gross dame . . . and Stuff . . . is a "toy", "a slight
mannet"' (*The New Inn*, p. 24)

26 The colour yellow was both fashionable and notorious in Stuart England,
being associated with the seamstress Mrs Anne Turner, an agent in the
murder of Sir Thomas Overbury, who was credited with introducing the
fashion of yellow ruffs and cuffs at court. See David Lindley, *The Trials of
Frances Howard: Fact and Fiction at the Court of King James* (London:
Routledge, 1993), p. 184, and Orgel, *Impersonations*, pp. 83–4. Mary Chan
notes that yellow was 'a colour worn in revels', and that it was especially
popular with Henrietta Maria; see Chan, *Music in the Theatre of Ben Jonson*
(Oxford: Clarendon Press, 1980), p. 346, n.26.

27 Barton, *Ben Jonson, Dramatist*, p. 273.

28 In a note to Jonson's 'Argument', Hattaway asserts that Prudence is 'not
simply . . . a servant but a gentlewoman – like Maria in Shakespeare's
Twelfth Night (*The New Inn*, p. 52, note to line 34), while Ostovich
comments that '*chambermaid* is not adequate as a job description' ('Mistress
and Maid', p. 10). Although, as Ostovich eloquently demonstrates, Pru is
both friend and confidante to Frances Frampul, the Host's quip about
'reach[ing] her ladyship – The chamber-pot' reminds us of the menial
nature of her tasks (2.6.5).

29 Louis Adrian Montrose, 'The Purpose of Playing: Reflections on a
Shakespearean Anthropology', *Helios*, n.s. (1980), 51–74 (pp. 53, 66).

30 Hutson, *The Usurer's Daughter*, pp. 164–6 (p. 165).

31 Weidemann, 'Theatricality and Female Identity' (p. 192), referring to Wroth's *Urania*.

32 Barton, *Ben Jonson, Dramatist*, p. 278.

33 Cf. Hutson, 'Whereas in [Shakespeare's] Italian and Roman sources, the significance of the "woman's part" to the resolution of the dilemma depends upon her having had sex, in Shakespeare this significance is translated into an implicit, or uncertain argument involving her *disposition* to have sex, or her "sexuality"; see Hutson, 'Rhetoric and the Body in *Twelfth Night*', in Stephen Orgel and Sean Keilen (eds.), *Shakespeare and Gender* (New York: Garland, 1999), pp. 148–82 (p. 164).

34 Butler, *Selected Plays of Ben Jonson*, II, p. 300.

35 Shapiro, *Gender in Play on the Shakespearean Stage*, pp. 140–2 (p. 141).

36 *Ibid.*, p. 140.

37 Barton, *Ben Jonson, Dramatist*, p. 275.

38 Hutson, *The Usurer's Daughter*, p. 162.

39 At 5.4.24–6 Pru directs a remark to Laetitia about her stolen marriage, but receives no reply, Beaufort answering for her. Laetitia's last words are uttered under the speech prefix 'Frank', just before her exit with Beaufort (4.4.223–4).

40 Barton, *Ben Jonson, Dramatist*, p. 259.

41 For a perceptive account of the song's structural and symbolic function, see Chan, *Music in the Theatre of Ben Jonson*, pp. 348–52.

42 In an epilogue intended for a court performance which never eventuated, Jonson presents *The New Inn* as aimed at an audience who 'will not hiss/ Because the chambermaid was naméd Cis' ('Another Epilogue', *The New Inn*, p. 204, lines 7–8). He explains of the character, 'she only meant was for a girl of wit / To whom her lady did a province fit' (13–14). Noting that 'both "Cis" and "Pru" were type names in the period for a female domestic', Barton comments that 'the point about Pru's name is that it fails glaringly to define her' (p. 276). An alternative context for the significance of the name 'Prudence' is furnished in courtly conduct books such as N. N.'s *The Compleat Woman* (1639) and Montagu's *The Accomplish'd Woman* (1656), in which 'prudence and discretion' feature as desirable female traits; see also Butler, 'Late Jonson', pp. 172–3.

43 Cited in Christopher Hill, *Liberty Against the Law: Some Seventeenth-Century Controversies* (Harmondsworth: Allen Lane, Penguin Press, 1996), p. 246. Cf. Jonson's proposal, in *Timber, or Discoveries* that, by the senses 'the *Soule workes*' (*Jonson*, VIII, p. 588).

44 Owen Feltham, 'An Answer to the Ode of Come Leave the Loathed Stage' in Jonson, *The New Inn*, ed. Hattaway, pp. 216–18, lines 27–30. On this aspect of the play, see Barton, *Ben Jonson, Dramatist*, p. 283. In her introduction to *The New Inn* for the forthcoming Cambridge edition of Jonson's *Complete Works*, Julie Sanders comments that Pru's becoming a lady 'is Jonson's most socially inclusive, and therefore most romantic,

gesture of all'. I am grateful to Professor Sanders for sharing her work with me before its publication.

45 Kathleen M. Lynch, *The Social Mode of Restoration Comedy* (1929; repr. New York: Biblo and Tannen, 1965), pp. 34–42; Norman Rabkin and Russell A. Fraser (eds.), *Drama of the English Renaissance, II The Stuart Period* (New York: Macmillan, 1976), p. 743. For a caution against viewing Shirley solely as a progenitor of later drama, see Ben Lucow, *James Shirley* (Boston: Twayne, 1981), p. 144.

46 James Shirley, *The Lady of Pleasure*, ed. Ronald Huebert, The Revels Plays (Manchester University Press, 1986), p. 1.

47 Arthur C. Kirsch, 'A Caroline Commentary on the Drama', *Modern Philology* 66 (1968–9), 256–61 (p. 258).

48 I cite the actress Fiona Shaw who played Carol in the Royal Shakespeare Company's production of *Hyde Park* at the Swan playhouse in 1987; see Mulryne and Shewring, *This Golden Round*, p. 132. See also Lynch, *The Social Mode of Restoration Comedy*, p. 40; Rabkin in Rabkin and Fraser (eds.), *Drama of the English Renaissance*, p. 743; Lucow, *James Shirley*, p. 69.

49 *OED* quotes the fourteenth-century romance, *Arthur and Merlin*: 'Miri time it is in may . . . Damisels carols ledeth'; for other citations see 'carol', *n.* 1 and 2. The only other dramatic work featuring a character named 'Carol' in the period 1500–1660 is Jonson's *Christmas, His Masque* (1616), in which Carol is one of the ten children of Christmas; in this case a boy who appears in 'a long tawny coat, with a red cap, and a flute at his girdle, his torch-bearer carrying a song-book open'; see Lindley (ed.), *Court Masques*, pp. 109–16, lines 33–4.

50 See Jonson's *The Devil is an Ass* (1616), 1.6.214–17, in *Jonson*, VI. The Julietta/Bonvile plot in *Hyde Park* foreshadows a feature of Restoration drama which Anne Barton describes as 'the purposeful movement of characters between the town-house interior and the public, erotically dangerous but exciting world of the park'; see 'Comic London' in Barton, *Essays, Mainly Shakespearean* (Cambridge University Press, 1994), pp. 329–51 (p. 349).

51 In his critical edition of the 1637 quarto of *Hyde Park*, Theodore K. Miles corrects the assumption generally made by historians that Hyde Park 'was opened to the public early in the reign of Charles [I]'. Miles provides copious evidence to suggest that before 1625 the park was enjoyed only by 'members of the Court group', and that thereafter it was open to a limited 'public' made up of the leisured classes, but primarily 'the Court and its fashionable hangers-on'; see Miles, 'James Shirley's *Hyde Park* edited from the Quarto of 1637 with Introduction and Notes', PhD thesis, University of Chicago, 1940, pp. xiv, xvii.

52 See the Dedication, '*To the Right Hono[u]rable* HENRY EARL OF HOLLAND . . . The comedy, in the title, is a part of your lordship's command, which heretofore graced and made happy by your smile, when it was presented . . . upon first opening of the Park, is come abroad to kiss your lordship's hand', in Fraser and Rabkinin (eds.), *Drama of the English*

Renaissance, p. 744, lines 1–4. Hereafter references are given by act, scene and line in parentheses in the text.

53 Richard Levin discusses the interrelationship of the play's three plots and their emotional levels in *The Multiple Plot in English Renaissance Drama* (Chicago and London: University of Chicago Press, 1971), pp. 96–9.

54 Butler, *Theatre and Crisis*, p. 178.

55 Albert Wertheim proposes the eponymous heroine of Fletcher's *The Scornful Lady* (1613–16) as Shirley's model for Carol; see Wertheim, 'Games and Courtship in James Shirley's *Hyde Park*', *Anglia* 90 (1972), 71–91 (pp. 85–6).

56 Butler, *Theatre and Crisis*, pp. 178–9.

57 Montagu, *The Shepheard's Paradise*, pp. 51–2 (51 misnumbered 15), emphasis mine. The use of the terms 'propriety' and 'prerogative' in this discussion echoes the legal discourse of *The Lawes Resolutions of Womens Rights*: 'the prerogative of the Husband is best discerned in his dominion over all externe things in which the wife by combination devesteth herself of proprietie in some sort, and casteth it upon her governour' (p. 129). Hereafter references to *The Lawes Resolutions* are given by page in parentheses in the text. I alternate this shortened title with the treatise's running title, 'The Womans Lawier'.

58 *The Lawes Resolutions*, p. 232, emphasis mine; cited in Amy Erickson, *Women and Property in Early Modern England* (London and New York: Routledge, 1993), p. 153. In a discussion of the likely readership of *The Lawes Resolutions*, W. R. Prest proposes that the book's 'major audience must have come from the exclusively male membership of the inns of court', adding, 'the possibility that some few women did . . . obtain and read copies of "The Womans Lawyer" cannot be altogether discounted' ('Law and Women's Rights in Early Modern England', p. 181).

59 'The Girl with No Interest in Marriage' in *Collected Works of Erasmus*, XXXIX, *Colloquies*, trans. Craig R. Thompson (Toronto, Buffalo and London: University of Toronto Press, 1997), pp. 279–301 (pp. 291–2). As master of the grammar school at St Albans between 1620 and 1624, Shirley would undoubtedly have been familiar with the Latin edition of Erasmus's *Colloquies* (1533) which began 'as a modest manual to help boys improve their colloquial Latin' (p. xxvii).

60 Erasmus, *Colloquies*, p. 288.

61 For a discussion of *Hyde Park* that complements my own, see Julie Sanders, *Caroline Drama: The Plays of Massinger, Ford, Shirley and Brome* (Plymouth: Northcote House, 1999), pp. 45–50.

62 In Act 2, scene 1 Bonavent swears to Lacy, 'as I am a gentleman, / I know not how to foot your chamber jigs' (lines 12–13), while in Act 4, scene 3 he refers to himself as a soldier (lines 315–16). His seven-year absence from Caroline England (since the accession of Charles I) may explain his unfamiliarity with the 'chamber' or social dances being danced in the Bonavent home to celebrate Lacy's and Mistress Bonavent's wedding. In early modern England desertion of a spouse for seven years or more

constituted grounds for a legal separation; see Lawrence Stone, *Road to Divorce: England 1530–1987* (Oxford University Press, 1990), pp. 7, 192–3.

63 For a different reading of the meaning of this exchange, see Clark, *Professional Playwrights*, pp. 146–7.

64 Veevers, *Images of Love and Religion*, pp. 27–8, 36.

65 *The Lawes Resolutions*, p. 6.

66 Clark reads the moral awakening of Bonvile through his attempted seduction of Julietta as a 'reversion to the prerogatives of privilege' which he sees as upheld in all three courtship plots (*Professional Playwrights*, p. 145). His interpretation privileges the import of the action for Bonvile rather than recognizing Julietta's new self-assertiveness, or the open-endedness of this relationship at the play's conclusion. To assert that Julietta 'hono[u]rs and obeys her husband "in Noble waies"' (p. 149) is to ignore her pointed reference to herself as a virgin in her last words to Bonvile (5.2.127–8).

67 See Jean E. Gagen, *The New Woman: Her Emergence in English Drama 1600–1730* (New York: Twayne, 1954), pp. 137–8. The text of *Hyde Park* justifies a reading of Carol as a type of 'new woman' in her lines: 'I would all women were/But of my mind, we would have a new world / Quickly' (1.2.31–3) and in Fairfield: 'this is a new doctrine from women' (1.2.85–6). The Royal Shakespeare Company production of *Hyde Park* in 1987 capitalized on these hints of Carol as a 'new woman'.

68 Butler, *Theatre and Crisis*, p. 178; Wertheim, 'Games and Courtship', pp. 85–8.

69 Butler, *Theatre and Crisis*, p. 178.

70 A note in the programme to the Royal Shakespeare Company's season of *Hyde Park* at The Pit, in the Barbican Centre, London, records the *donnée* which may have prompted director Barry Kyle to relocate Shirley's Caroline play to a pre-war, 1908 London: 'at the age of eight Virginia Woolf edited her first publication, a newspaper for family and friends . . . called "Hyde Park Gate News"'. In an interview Shaw expressed ambivalence about Kyle's transfer of the play to the Bloomsbury period, while commenting that 'any aid to help [the play] become accessible seemed a very good idea. I think the *next* production should be set in 1632. That should be fascinating' (Mulryne and Shewring, *This Golden Round*, p. 132).

71 Fairfield has behind him writers on etiquette such as Richard Braithwait who extols the 'pretty pleasing kinde of wooing drawne from a conceived but concealed *Fancy*' (*The English Gentlewoman* (1631), p. 131).

72 For an alternative reading of this scene, see Clark, *Professional Playwrights*, pp. 144–5, 151–3.

73 Tim Stretton, 'Women, Property and Law' in Anita Pacheco (ed.), *A Companion to Early Modern Women's Writing* (Oxford: Blackwell, 2002), pp. 40–57 (p. 44). Stretton comments that the terms Carol stipulates for a loan to Trier suggest 'an astute financial dealer' (personal correspondence).

74 I am grateful to Tim Stretton for this point, and for sharing with me his knowledge of women's relationship to the law in early modern England.

Stretton summarizes the changing state of female litigation in the period, including examples of married women pursuing suits in the ecclesiastical and equity courts, in his chapter cited above, 'Women, Property and Law'. See also Stretton's monograph, *Women Waging Law in Elizabethan England* (Cambridge University Press, 1998), ch. 3 of which includes a survey of satiric representations of women litigants in Elizabethan and Jacobean drama. For exceptions to the common law against wives issuing a writ in their own name, see *The Lawes Resolutions*, p. 204.

75 The 'non-suit[ing]' of a pleader at law means 'the stoppage of a suit by the judge, when, in his opinion, the plaintiff fails to make out a legal cause of action or to bring sufficient evidence' (Miles, 'James Shirley's *Hyde Park*', p. 95, note to lines 18–23). Williams cites a Restoration text of 1661 which puns similarly on 'non-suit' and 'case'; see Williams, *A Dictionary of Sexual Language and Imagery*, I, 212.

76 For forensic puns on a woman's 'case' or vagina, see Williams, *A Dictionary of Sexual Language and Imagery*, I, pp. 211–13.

77 In his note to Fairfield's line, 'I should new ravish thee', Miles suggests that 'the reading of the Huntington copy [of the 1637 quarto], "I should ne're ravish thee"[,] clarifies the allusion to the ancient story of Philomela' ('James Shirley's *Hyde Park*', p. 126, note to line 2). However, the allusion is equally clear in the reading of Miles's copy-text: 'new'. The difference between the two readings involves a choice between a sexually menacing outburst ('new ravish') and a sexually insulting one ('ne're ravish').

78 William Congreve, *The Way of the World* in *The Complete Plays of William Congreve*, ed. Herbert Davis (Chicago and London: University of Chicago Press, 1967), 3.1.308–19.

79 Congreve's indebtedness to Jonson in *The Way of the World* is supported by Mirabell's explicit reference to *Volpone* (2.1.292–5), and more generally by Congreve's fashioning of himself as a comic playwright after Jonson and Terence. See his essay 'Concerning Humour in Comedy' (1695) in John C. Hodges (ed.), *William Congreve: Letters and Documents* (London: Macmillan, 1964), pp. 176–86.

80 Congreve, *The Way of the World*, 4.1.315–16.

81 *Ibid.*, 4.1.185–7.

82 Several critics trace the famous 'proviso' scene in *The Way of the World* to Act 2, scene 4 of *Hyde Park*, where Carol stipulates to Fairfield the freedoms she will not relinquish before committing herself to his pact; see Wertheim, 'Games and Courtship', p. 88; Alexander Leggatt, *English Drama: Shakespeare to the Restoration 1590–1660* (London and New York: Longman, 1988), p. 253.

83 Butler, *Theatre and Crisis*, pp. 44–9 (p. 47).

84 *JCS*, III, pp. 136–9.

85 Cartwright, 'A Panegyric to the most Noble LUCY Countesse of *Carlisle*', lines 51, 99–100, ed. Blakemore Evans, *Plays and Poems of William*

Cartwright. Hereafter references to Cartwright's works are taken from this edition and are given by line in parentheses in the text.

86 See Mary Beth Rose's discussion of Jacobean tragicomedy in *The Expense of Spirit*, pp. 178–235 (p. 182).

87 Cartwright, *Plays and Poems of William Cartwright*, ed. Blakemore Evans, pp. 83–4. A date for the play in the early to mid-1630s is supported by the occurrence of the term 'lady errant' in several plays from the period. Another mock Lady Errant, or 'Hercules come from the distaff' appears in Thomas Randolph's academic drama of 1632, *The Jealous Lovers.*

88 I am grateful to Professor Vivienne Gray of the University of Auckland for clarifying the Greek and Latin derivations of Cartwright's character names. The name 'Machessa', with its diminutive suffix, may point to one of Cartwright's sources for his feminist theme, Erasmus's colloquy, 'Senatulus', or 'The Council of Women', where the Latin 'Senatulus' translates as 'little' or 'miniature' senate. For a discussion of sources for *The Lady-Errant*, see Cartwright, *Plays and Poems of William Cartwright*, ed. Blakemore Evans, pp. 87–8.

89 Karen Newman, *Fashioning Femininity and English Renaissance Drama* (Chicago and London: University of Chicago Press, 1991), p. 134.

90 Patricia Crawford, 'Women's Published Writings 1600–1700' in Mary Prior (ed.), *Women in English Society, 1500–1800* (London and New York: Methuen, 1985); Lois G. Schwoerer, 'Women's Public Political Voice in England: 1640–1740' in Hilda L. Smith (ed.), *Women Writers and the Early Modern Political Tradition* (Cambridge University Press, 1998), pp. 56–74.

91 Patricia Crawford, 'The Challenges to Patriarchalism: How Did the Revolution Affect Women?' in John Morrill (ed.), *Revolution and Restoration: England in the 1650s* (London: Collins and Brown, 1992), pp. 112–28 (p. 124); Katherine Philips, 'To Antenor, on a paper of mine wch J. Jones threatens to publish to his prejudice', *CWKP*, I, pp. 116–17; Mary Tattle-Well, *The Women's Sharp Revenge* in Katherine Usher Henderson and Barbara F. McManus, (eds.), *Half Humankind: Contexts and Texts of the Controversy about Women in England, 1540–1640* (Urbana: University of Illinois Press, 1985), pp. 305–25 (p. 306); Sara Mendelson and Patricia Crawford, *Women in Early Modern England* (Oxford: Clarendon Press, 1998), pp. 399–401 (p. 399). For the decisive increase in women's published writings during the Interregnum, see Crawford, 'Women's Published Writings', p. 213.

92 Cited in Patricia Higgins, 'The Reactions of Women, With Special Reference to Women Petitioners' in Brian Manning (ed.), *Politics, Religion and the English Civil War* (London: Edward Arnold, 1973), pp. 179–222 (p. 205). In *The Church History of Britain* (1655) Thomas Fuller uses the term 'Lady Errant' to describe the religious writer and activist Mary Ward (p. 364).

93 Anon., *Arden of Faversham*, ed. Martin White, New Mermaids (London and New York: Ernest Benn, 1982), scene 1, 436–8.

94 On women as 'leaky vessels', see Gail Kern Paster, *The Body Embarrassed: Drama and the Disciplines of Shames in Early Modern England* (Ithaca, N.Y.: Cornell University Press, 1993), ch. 1. In an address by Lord Keeper Finch to the Long Parliament in 1640, the image of Henrietta Maria as Charles's mirror was given a positive political inflection; see Sharpe, *Criticism and Compliment*, pp. 298–9.

95 For a discussion of the sources of this aesthetic in the philosophy of Aristotle, see Sharpe, *Criticism and Compliment*, pp. 277–80, 282–7.

96 Alfred Harbage, *Cavalier Drama* (New York and London: Modern Language Association of America and Oxford University Press, 1936), p. 144.

97 Similar sentiments are expressed in Katherine Philips's poem, 'Friendship's Mysterys, to my dearest Lucasia', *CWKP*, I, pp. 90–1. Blakemore Evans notes that 'such a democracy in love was one of the tenets of Platonic love' (Cartwright, *Plays and Poems of William Cartwright*, p. 581, note to lines 1101–2).

98 Veevers, *Images of Love and Religion*, pp. 65–74 (p. 72).

99 Henrietta Maria's dwarf Jeffrey Hudson performed in Jonson's *Chloridia* (1631) and Davenant's *Salmacida Spolia* (1640). In Thomas Campion's *The Lords' Masque* (1613), the female masquers appear as statues who are brought to life by Jove.

100 Natalie Zemon Davis, 'Women on Top: Symbolic Sexual Inversion and Political Disorder in Early Modern Europe' in Barbara Babcock (ed.), *The Reversible World: Symbolic Inversion in Art and Society* (Ithaca, N.Y.: Cornell University Press, 1978), pp. 148–83.

101 This is the tactic employed in the flurry of *Parliament of Ladies* pamphlets issued in the 1640s and 1650s by the republican Henry Neville. However, Mihoko Suzuki argues for the complexity of these texts' political import; see Suzuki, *Subordinate Subjects*, pp. 154–8.

102 See Mendelson and Crawford, *Women in Early Modern England*, p. 413; Schwoerer, 'Women's Public Political Voice'.

103 Christopher Hill, *Liberty against the Law*. I am grateful to Constance Jordan for discussions on this subject.

104 William Penn, 'Preface to the Frame of Government', 1682, in Philip B. Kurland and Ralph Lerner (eds.), *The Founders' Constitution* University of Chicago Press, I, p. 614, *http://press-pubs.uchicago.edu/founders/documents/v1ch17s4.html*, viewed 15 January 2005.

105 Julietta's modulated concept of liberty contrasts with the full-blown claims to sexual equality of Hic Mulier in the pamphlet *Haec Vir, or The Womanish Man* (1620): 'We are as freeborn as Men, have as free election and as free spirits; we are compounded of like parts and may with like liberty make benefit of our Creations' (Henderson and McManus, *Half Humankind*, p. 284). The contrast suggests to me that the latter text is primarily satirical in aim.

106 William Wycherley, *The Country Wife*, ed. Thomas H. Fujimura, Regents Restoration Drama (London: Edward Arnold, 1965), 2.1.42, 50–2.

107 Rose, *Expense of Spirit*, pp. 178–235 (p. 182). Walter Cohen discusses the political resonances of Stuart tragicomedy in 'Prerevolutionary Drama' in Gordon McMullan and Jonathan Hope (eds.), *The Politics of Tragicomedy: Shakespeare and After* (London and New York: Routledge, 1992), pp. 122–50.

108 Butler, *Theatre and Crisis*, p. 48.

109 See the study by Carol Barash, *English Women's Poetry, 1649–1714: Politics, Community, and Linguistic Authority* (Oxford: Clarendon Press, 1996), and Chalmers, *Royalist Women Writers*, ch. 1.

110 Karen Britland notes that the women's costume was 'modelled on the fashion of the day' and that 'it imported the trappings of war on to the stage'; see Britland, 'An Under-Stated Mother-in-Law: Marie de Médicis and the Last Caroline Masque' in McManus (ed.), *Women and Culture at the Courts of the Stuart Queens*, pp. 204–23 (p. 216).

111 Rose, *Expense of Spirit*, p. 182.

112 *Ibid.*, p. 199.

113 *Ibid.*, p. 235.

4 SIRENS OF DOOM AND DEFIANCE IN CAROLINE TRAGEDY

1 Smuts, *Court Culture*, p. 196.

2 Martin Butler, *Love's Sacrifice*: Ford's Metatheatrical Tragedy' in Neill (ed.), *John Ford: Critical Re-Visions*, pp. 201–31 (p. 208).

3 Ford's tragedies *Love's Sacrifice*, *'Tis Pity She's A Whore* and *The Broken Heart* were published in 1633; the dates of performance for these plays are unknown. In an essay exploring Ford's relationship with the Phoenix and Blackfriars theatres, Andrew Gurr proposed the following sequence of composition: *The Broken Heart* (Blackfriars, 1629), *'Tis Pity She's a Whore* (Phoenix, 1630), *Love's Sacrifice* (Phoenix, 1631); see Gurr, 'Singing Through the Chatter: Ford and Contemporary Theatrical Fashion' in Neill (ed.), *Critical Re-Visions*, pp. 81–96 (p. 93). In his edition of *Love's Sacrifice*, A. T. Moore proposes 1626–31 as the likely period of composition; see John Ford, *Love's Sacrifice*, ed. A. T. Moore, The Revels Plays (Manchester University Press, 2002), pp. 2–9.

4 Ford, *Love's Sacrifice*, ed. Moore, James Shirley, 'To my Friend Mr John Ford', lines 5–8; 'The Epistle Dedicatory', line 22. Hereafter references are given by act, scene and line in parentheses in the text.

5 Veevers, *Images of Love and Religion*, p. 89. See also Sanders, *Caroline Drama*, p. 33.

6 Veevers, *Images of Love and Religion* p. 89.

7 Michael Neill, '"Anticke Pageantrie": The Mannerist Art of *Perkin Warbeck*', *Renaissance Drama*, n.s. 7 (1976), 117–50; Ronald Huebert, *John Ford: English Baroque Dramatist* (Montreal and London: McGill-Queen's University Press, 1977); Harriett Hawkins, 'Mortality, Morality, and Modernity in *The Broken Heart*: Some Dramatic and Critical Counter-Arguments', in Neill (ed.), *Critical Re-Visions*, pp. 129–52; Lisa Hopkins,

John Ford's Political Theatre (Manchester University Press, 1994); Burner, *James Shirley.*

8 For *Arcades*, see ch. 2, n.7; Nathanael Richards, *The Tragedy of Messallina, The Roman Empresse*, ed. A. R. Skemp, Materialien zur Kunde des älteren Englischen Dramas (1910; repr. Vaduz: Kraus Reprint, 1963), lines 463–4. Hereafter references are given by line in parentheses in the text.

9 Walter Pater, 'The School of Giorgione' (1877) in Adam Philips (ed.), *The Renaissance: Studies in Art and Poetry* (Oxford University Press, 1986), p. 86.

10 Moore rejects Bentley's conjecture that Fernando's description of the 'antic' performance of court ladies in Brussells alludes to Henrietta Maria's involvement in staging Montagu's *The Shepherds' Paradise* (*JCS*, III, pp. 451–3), observing that her performances had begun as early as 1626. He accepts the suggestion made by F. G. Fleay that Ford's recollection of the French actresses who played to a noisy reception at the Blackfriars and other London playhouses in 1629 may have contributed to his representation of 'outlandish feminine antics' (*Love's Sacrifice*, pp. 5–8).

11 For example, Bel-Imperia, in the play-within-the-play in Kyd's *The Spanish Tragedy* (1587), and Isabella and Livia in the pastoral masque in Act 5, scene 2 of Middleton's *Women Beware Women* (1621). See Inga-Stina Ewbank, ' "These Pretty Devices": A Study of Masques in Plays' in Spencer and Wells (eds.), *A Book of Masques*, pp. 405–48 (pp. 437–48).

12 John Ford, *The Broken Heart* in *The Selected Plays of John Ford*, ed. Colin Gibson (Cambridge University Press, 1986), 2.2.8–10. Hereafter references are given by act, scene and line in parentheses in the text.

13 On *The Broken Heart*'s divided catastrophe, see Anne Barton, 'Oxymoron and the Structure of Ford's *The Broken Heart*', *Essays and Studies* 33 (1980), pp. 70–94 (pp. 88–9).

14 Prynne, *Histrio-Mastix*, I, p. 420.

15 *Ibid.*, I, pp. 268–9.

16 James Shirley, *James Shirley's Love's Cruelty: A Critical Edition*, ed. John Frederick Nims (New York and London: Garland, 1980), p. 42, lines 1–2. Hereafter references are given by page and line number in parentheses in the text.

17 Butler believes that in Bellamente's spontaneous death Shirley was writing with the example of *The Broken Heart* in mind; see Butler, 'Ford's Metatheatrical Tragedy', p. 208. I discuss below further examples of deaths influenced by Calantha's.

18 As well as his one play, Richards wrote religious and satirical poetry, the latter with an anti-Jesuit bias. He provided commendatory verses to Thomas Rawlins's tragedy *The Rebellion* (pub. 1639) and to Middleton's *Women Beware Women* (pub. 1657). On Richards's Puritan connections, see Margot Heinemann, *Puritanism and Theatre: Thomas Middleton and Opposition Drama under the Early Stuarts* (Cambridge University Press, 1980), pp. 171, 174, 234. In *Theatre and Crisis* Butler includes Richards as one of 'a group of dramatists who, though writing for the elite theatres, remained closely in

touch with [older Elizabethan dramatic forms] and voiced social and political sentiments much more traditional, popular and radical than obtain in the work of other elite-theatre writers' (p. 185).

19 Thomas Rawlins, 'To his worthy Friend M^r^. *Nathanael Richards*, upon his Tragedy of *Messallina*', line 163, *The Tragedy of Messallina, The Roman Empresse*. To avoid confusion, I use the form of Messallina's name as it appears in Richards's text.

20 Butler, *Theatre and Crisis*, p. 193.

21 *Ibid.*, p. 193.

22 Maria Wyke, *The Roman Mistress: Ancient and Modern Representations* (Oxford University Press, 2002), pp. 328, 389.

23 See Wyke, 'Monstrous Messalina Reconsidered', *The Roman Mistress*, pp. 330–34 (p. 334).

24 Wyke, *The Roman Mistress*, p. 325.

25 In his discussion of Richards's use of his classical sources, Skemp documents the play's exaggeration of Messallina's wickedness, and Richards's refashioning of Messallina's mother, Lepida, and Silius's wife, Silana, as contrasting figures of virtue (*Tragedy of Messallina*, pp. 32–51).

26 Huebert, *John Ford: English Baroque Dramatist*, p. 183.

27 John Ford, *'Tis Pity She's a Whore* in *Selected Plays of John Ford*, ed. Gibson, 5.5.0.1–2. Cf. *Love's Cruelty*, 'Enter Hippolito and Clariana upon a bed', 4.1.0.1.

28 McLuskie, *Renaissance Dramatists*, p. 154.

29 For the latter interpretation see Ford, *Love's Sacrifice*, ed. Moore, p. 81.

30 Several critics interpret the chaste love vowed by Fernando and Bianca in relation to the Caroline cult of Platonic love; see Peter Ure, 'Cult and Initiates in Ford's *Love's Sacrifice*' in J. C. Maxwell (ed.), *Elizabethan and Jacobean Drama* (Liverpool University Press, 1974), pp. 93–103, and Mark Stavig, *John Ford and the Traditional Moral Order* (Madison, Milwaukee and London: University of Wisconsin Press, 1968), pp. 122–43. I agree with Butler, who observes that '[*Love's Sacrifice*] contains little specifically platonic language, nor are the lovers notably more interested in souls than bodies' ('Ford's Metatheatrical Tragedy', p. 207); see also Ford, *Love's Sacrifice*, ed. Moore, pp. 81–2.

31 Butler, 'Ford's Metatheatrical Tragedy', p. 211. Ford, *Love's Sacrifice*, ed. Moore, pp. 77–85, surveys critical responses to the play.

32 John Ford, *John Ford: Five Plays*, ed. Havelock Ellis (1888; repr. New York: Hill and Wang, 1957), p. xiii.

33 In his essay 'The Perverse: An Aspect of Ford's Art', Robert B. Heilman writes of Bianca as an example of what he calls 'the perverse in erotic emotion'; see Donald K. Anderson, Jr. (ed.), *Concord in Discord: The Plays of John Ford 1586–1986* (New York and London: AMS Press, 1986), pp. 27–48 (p. 31).

34 Heilman, 'The Perverse', p. 33.

35 Fernando's response is 'probably lacking a line or more' (Ford, *Love's Sacrifice*, ed. Moore, 5.1, note to lines 16–18).

36 *Ibid.*, pp. 25–8, 42, 44–5, 55–6, 59–61.

37 *Ibid.*, p. 44.

38 See Rose, *Expense of Spirit*, ch. 3, 'The Heroics of Marriage in English Renaissance Tragedy'.

39 Ford, *Love's Sacrifice*, ed. Moore, pp. 43–4, 84.

40 Butler, '*Love's Sacrifice*: Ford's Metatheatrical Tragedy', p. 216.

41 Cf. McLuskie on Fletcher's 'complex theatricality', which 'brings ideas *into play* in the sense both of "into operation" and "into playfulness"' (*Renaissance Dramatists*, p. 194); see also McLuskie's essay, '"Language and Matter with a Fit of Mirth": Dramatic Construction in the Plays of John Ford' in Neill (ed.), *Critical Re-Visions*, pp. 97–127; Ford, *Love's Sacrifice*, ed. Moore, p. 83. Earlier critics have viewed the play's final scenes as evidence of Ford's having 'deliberately abnegat[ed] artistic responsibility'; see Robert Ornstein, *The Moral Vision of Jacobean Tragedy* (Madison and Milwaukee: University of Wisconsin Press, 1965), p. 217; cf. Ford, *John Ford*, ed. Ellis, p. xiii.

42 See Edward Pechter, 'Why Should We Call Her Whore?: Bianca in *Othello*' in Jonathan Bate, Jill L. Levenson and Dieter Mehl (eds.), *Shakespeare and the Twentieth Century* (Newark and London: Associated University Presses, 1998), pp. 364–77.

43 Ford, *'Tis Pity She's a Whore*, 4.3.57–63. There is a precedent for Annabella's shift into Italian in John Marston's tragicomedy *Antonio and Mellida* (1602), where the two lovers of the title, upon recognizing one another, speak an 'antiphonal duet' in Italian; see Marston, *The Selected Plays of John Marston*, ed. Macdonald Jackson and Michael Neill (Cambridge University Press, 1986), 4.1, note to lines 181–98. I am grateful to Mac Jackson for this reference.

44 Michael Neill comments that 'on one level, the coarse directness with which [Bianca] violates social taboo becomes a kind of outrageous verbal substitute for her frustrated adultery'; see Neill, 'Neo-Stoicism and Mannerism in the Drama of John Ford', PhD thesis, University of Cambridge, 1974, pp. 32–3. See also Ornstein, *Moral Vision of Jacobean Tragedy*, p. 220.

45 McLuskie, *Renaissance Dramatists*, p. 154.

46 See Stone, *Road to Divorce*. In 1653 the Puritan-led parliament introduced a Civil Marriage Act which 'provided that marriages be celebrated by justices of the peace and removed all litigation concerning marriages from the ecclesiastical courts to the civil magistrates'; see Susan Staves, *Players' Scepters: Fictions of Authority in the Restoration* (Lincoln: University of Nebraska Press, 1979), p. 14.

47 Heilman, 'The Perverse', p. 34; Huebert, *John Ford: English Baroque Dramatist*, p. 41.

48 *The Works of John Webster*, I, 1.1.439.

49 Brian Opie, '"Being All One": Ford's Analysis of Love and Friendship in *Love's Sacrifice* and *The Ladies Triall*' in Neill (ed.), *Critical Re-Visions*, pp. 233–60 (p. 241). Opie interprets Bianca as radically appropriating 'the otherwise male discourse of unity to justify her love for Fernando' (p. 242).

50 John Dryden, Prologue to *Marriage à la Mode* (1672), cited in Maus, '"Playhouse Flesh and Blood"', p. 602. Homais is the smouldering heroine of Manley's tragedy *The Royal Mischief* (1696); Semele is the literally smouldering eponymous heroine of Congreve's opera, for which John Eccles composed the original, unperformed score in 1706. Published with Congreve's *Works* in 1710, the libretto was later set by Handel and performed at the Theatre Royal, Covent Garden in 1744.

51 Carol Thomas Neely, '"Documents in Madness": Reading Madness and Gender in Shakespeare's Tragedies and Early Modern Culture' in Shirley Nelson Garner and Madelon Sprengnether (eds.), *Shakespearean Tragedy and Gender* (Bloomington: Indiana University Press, 1996), pp. 75–104 (pp. 75–6).

52 Neely, 'Reading Madness and Gender', p. 78; Neill (ed.), *Critical Re-Visions*, p. 1.

53 Douglas Bruster analyses the Jailer's Daughter as part of a broader shift in dramatic representation of which Fletcher's drama was indicative, a shift away from mingling social spheres and towards strong female roles; see Bruster, *Quoting Shakespeare: Form and Culture in Early Modern Drama* (Lincoln: University of Nebraska Press, 2000), ch. 5, 'Quotation and Madwomen's Language', pp. 143–70. Bruster's observation that the Jailer's Daughter 'acts more as a choric figure than an agent in [the] plot' pinpoints the character's liberating possibilities and her limitations (p. 146). For a different reading of the 'distinctively modern' conceptualization of the Jailer's Daughter, see Rose, *Expense of Spirit*, pp. 224–8 (p. 226).

54 Thomas Middleton and William Rowley, *The Changeling*, ed. Patricia Thomson, New Mermaids (London: Ernest Benn, 1964), 4.3.131.

55 *Ibid.*, 4.3.50. Cf. the French *fabliau* 'The Knight of the Long Ass' ('Berengier au lonc cul'), in which the wife disguises herself as a knight to confirm her husband's cowardice and vindicate her taking a lover; see *http://www.llp. armstrong.edu/5800/longass.html*, viewed 17 January 2005. I am grateful to Susan Carter for making the connection to medieval *fabliaux,* and to Tracy Adams for the example.

56 See, for example, the multi-sectional mad songs, 'I burn' and 'From Rosie Bowr's', from Thomas D'Urfey's three *Don Quixote* plays (1694–95), set respectively by the composers John Eccles and Henry Purcell. These songs were made famous by the performances of the actress-singer Anne Bracegirdle.

57 Ford, *The Broken Heart* in *Selected Plays of John Ford*, ed. Gibson, 4.2.57.1–2. The iconic tradition of feminine madness begins with Thomas Kyd's Isabella in *The Spanish Tragedy* (1587), and includes Shakespeare's Ophelia in *Hamlet*, Webster's Cornelia in *The White Devil*, and Fletcher and Shakespeare's Jailer's Daughter in *The Two Noble Kinsmen*; see McLuskie, *Renaissance Dramatists*, pp. 131–3.

58 Noted by Donald K. Anderson, Jr., in his edition of *The Broken Heart*, Regents Renaissance Drama (London: Edward Arnold, 1968), p. xviii.

59 The phrase originates in Anderson's introduction to his edition of *The Broken Heart*, p. xvi; it is developed by R. J. Kaufmann in 'Ford's "Waste Land"': *The Broken Heart*', *Renaissance Drama*, n.s. 3 (1970), 167–87, and further amplified by Michael Neill in 'Ford's Unbroken Art: The Moral Design of *The Broken Heart*', *Modern Language Review* 75 (1980), 249–68. In his chapter entitled 'Ford's Tragedy of Ritual Suffering', Ira Clark uses the theory of sociologist Emile Durkheim to illuminate *The Broken Heart's* focus on role-playing and ceremonies 'that define and sustain identities and communities' (*Professional Playwrights*, p. 95). In contrast to Anderson, Kaufmann and Neill, Clark presents role-playing as 'personality-forming rather than personality-thwarting' (*Professional Playwrights*, p. 209, n. 49 see also n. 58).

60 Kaufmann, 'Ford's "Waste Land"', p. 185.

61 In his Cambridge edition Colin Gibson accepts J. C. Maxwell's conjectural emendation of the quarto's 'words' to 'madness', 4.2.44; however, I am more persuaded by Anne Barton's reading of the phrase 'left a prey to words' as meaning that Penthea becomes both the speaker and victim of words 'which her rational and waking mind would never have permitted her to utter'; see Barton, 'Oxymoron and the Structure of Ford's *The Broken Heart*', p. 81.

62 Compare Penthea's vow to Orgilus, "I have not given admittance to one thought / Of female change, since cruelty enforc'd / Divorce betwixt my body and my heart', 2.3.55–7.

63 For a detailed analysis of this scene, see Neill, 'Ford's Unbroken Art', pp. 263–4.

64 *The Works of John Webster*, I, 4.1.82–3.

65 Clifford Leech, *John Ford*, Writers and their Work (London: Longmans, Green and Co., 1964), pp. 25–6; Kaufmann, 'Ford's "Waste Land"', p. 174. For contrasting views, see Dorothy Farr, *John Ford and the Caroline Theatre* (London: Macmillan, 1979), p. 90, and T. J. B. Spencer's introduction to *The Broken Heart*, The Revels Plays (Manchester University Press, 1980), pp. 42–3. Emma Fielding, in the Royal Shakespeare Company production of *The Broken Heart* in 1994, opted quite clearly for the 'vengeful' reading of Penthea's actions, placing meaningful emphasis on the phrases 'if you please to kill him' and 'scorched by your disdain' in Penthea's interview with Calantha in Act 3, scene 5.

66 William Shakespeare, *Hamlet*, ed. G. R. Hibbard, The Oxford Shakespeare (Oxford University Press, 1987), 4.5.20.1–2.

67 In the list of 'Speakers Names, fitted to their Qualities' printed with the quarto edition of *The Broken Heart* (reproduced in Spencer's edition, p. 216), Penthea's name is rendered as 'Complaint'; she thus embodies the notion of tragedy as a plaintive song.

68 Farr, *John Ford and the Caroline Theatre*, p. 92.

69 See Gibson's note to Act 4, scene 2, line 103, in *Selected Plays of John Ford*.

70 Kaufmann, 'Ford's "Waste Land"', p. 174.

71 See Leech, *John Ford*, pp. 26–7.

72 Cf. Ford, *The Broken Heart*, ed. Spencer, pp. 43–4.

73 See William D. Dyer, 'Holding/Withholding Environments: A Psycho-analytic Approach to Ford's *The Broken Heart*', *ELR* 21 (1991), 401–24 (p. 401).

74 In Kyd's *The Spanish Tragedy* Isabella, the mother of the murdered Horatio, goes mad with grief and kills herself; in Webster's *The White Devil* the murder of Marcello by his brother Flamineo leads to the distraction of their mother, Cornelia.

75 On Lepida's echoing of Macbeth's lines, see Skemp in his edition of *The Tragedy of Messallina*, p. 118, note to lines 977f. With Messallina's reply, compare Lady Macbeth's, 'what's done, cannot be undone (5.1.65).

76 Middleton's mother-daughter relationship reverses the moral assignments of Messallina and Lepida, for the mother, Gratiana, has been tempted to prostitute her daughter for money, but is converted when her daughter pretends to embrace the offered viciousness. Richards and Middleton prove the exception to the rule of the 'absent mother' in Renaissance drama, each of them focusing on mother-daughter relationships.

77 Cf. Brabantio in *Othello*, 1.3.99–101.

78 Interestingly, Jordan wrote the later prologue 'to introduce the first Woman that came to act on the stage in the tragedy called the Moor of Venice', for a performance of *Othello* by the King's Company on 8 December 1660; see the Coda below. Jordan also wrote a masque, *Cupid's Coronation*, performed by schoolchildren in 1654.

79 An instance of Richards's literary amplification: not only is there no historical foundation for the attempted abduction of the virgins, the number of vestal virgins in Rome never rose above seven (Richards, *Tragedy of Messallina*, ed. Skemp, p. 142, note to line 1970).

80 James Shirley, *The Cardinal*, ed. E. M. Yearling, The Revels Plays (Manchester University Press, 1986), 4.2.316. Hereafter references are given by act, scene and line in parentheses in the text.

81 Cf. Thomas Kyd's *The Spanish Tragedy* where the letter of Bel-Imperia to Hieronimo telling him of the identity of his son's murderers is wrongly interpreted by Hieronimo as a 'train' to lure him to his death. The letter, which Hieronimo calls a 'bloody writ', is composed in Bel-Imperia's own blood; in this case the identification of the text with the woman's body hints at the letter's truthfulness; see Kyd, *The Spanish Tragedy*, ed. Philip Edwards, The Revels Plays (Manchester University Press, 1959), 3.2.38, 26.

82 Cf. Rosaura's references to 'art' at 1.2.226 and 2.3.45–6.

83 Cf. *Antony and Cleopatra* (5.2.282) and Shirley's own *The Traitor*.

84 However, the prologue disclaims any precise analogy between the play's protagonist and Richelieu: ''Cause we express no scene, / We do believe most of you gentlemen / Are at this hour in France . . . But keep your fancy active till you know, / By th'progress of our play, 'tis nothing so' (1–6). On the play's topical elements, see Shirley, *The Cardinal*, ed. Yearling, pp. 5–6.

85 Fredson Bowers, *Elizabethan Revenge Tragedy 1587–1642* (Princeton University Press, 1966), p. 228; Shirley, *The Cardinal*, ed. Yearling, p. 5.

86 Frederick S. Boas, *An Introduction to Stuart Drama* (Oxford University Press, 1946), pp. 375–6.

87 Shirley, *The Cardinal*, ed. Yearling, p. 23.

88 Performed in 1614, *The Duchess of Malfi* was published in quarto in 1623 and reissued in 1640, one year before *The Cardinal* was licensed for performance. Yearling (*The Cardinal*, pp. 4–5) believes that Shirley's plot is closer to *The Spanish Tragedy* than *The Duchess of Malfi*. In terms of language and imagery, however, Webster's revenge tragedy inhabits Shirley's late example of the genre as a potent cultural memory.

89 Julia K. Wood, 'William Lawes's Music for Plays' in Andrew Ashbee (ed.), *William Lawes: Essays on his Life, Time and Work* (Aldershot: Ashgate, 1998), pp. 11–67 (p. 37).

90 Boas, *Introduction to Stuart Drama*, p. 377.

91 Bowers, *Elizabethan Revenge Tragedy*, p. 234. Bowers focuses on the change in the Cardinal, and condemns Shirley for 'Fletcherian theatricality' (p. 234). In contrast, Yearling notes *The Cardinal*'s comparative avoidance of spectacle and flamboyant death scenes (*The Cardinal*, p. 27).

92 Michael Neill, *Issues of Death: Mortality and Identity in English Renaissance Tragedy* (Oxford: Clarendon Press, 1997), p. 367; Kristin Crouch, '"The Silent Griefs Which Cut the Heart Strings"': John Ford's *The Broken Heart* in Performance' in Edward J. Esche (ed.), *Shakespeare and his Contemporaries in Performance* (Aldershot: Ashgate, 2000), pp. 261–74; Lisa Hopkins, *The Female Hero* in Hopkins, *English Renaissance Tragedy* (Basingstoke: Palgrave Macmillan, 2002), pp. 168–84.

93 Elizabeth Cary, *The Tragedy of Mariam, The Fair Queen of Jewry*, in Cerasano and Wynne-Davies (eds.). *Renaissance Drama by Women*, Act 5, lines 21, 36 and 52.

94 See Penthea's lines to Bassanes, 2.1.91–2.

95 Richard Madelaine, '"Sensationalism" and "Melodrama" in Ford's Plays', in Neill (ed.), *Critical Re-Visions*, pp. 29–53, (p. 36).

96 *Ibid.*, p. 36.

97 Leech, *John Ford*, p. 27.

98 Barton, 'Oxymoron and the Structure of Ford's *The Broken Heart*', p. 82.

99 Sanders, *Caroline Drama*, p. 25.

100 Veevers, *Images of Love and Religion*, p. 27.

101 I am indebted to Anne Barton's reading of this scene in 'Oxymoron and the Structure of Ford's *The Broken Heart*', p. 89. Ira Clark asserts that 'Calantha chooses her own husband only after her father grants the privilege' (*Professional Playwrights*, p. 93), but if Amyclas has knowingly authorized a marriage between Calantha and Ithocles, rather than Nearchus, it is inexplicable that he retires to his bedchamber without broaching plans for a royal wedding.

102 Crouch, '"The Silent Griefs"', p. 270; Hopkins argues suggestively that *The Broken Heart* is a play which manifests the ineffectiveness of Protestant

rituals, and might therefore be read as constituting 'an appeal for a return to Catholic rites'; see Hopkins, *John Ford's Political Theatre*, pp. 162–72 (p. 171). The staging of the dance in the Royal Shakespeare Company's 1994 production of Ford's play effected a split between the 'quick stepping steps of the dancers' feet' and the slow, sombre mood of Craig Armstrong's musical score, which was 'heavily evocative of doom' (Crouch, '"The Silent Griefs"', p. 268).

103 'Dancing . . . (*yea even in Queenes themselves, and the very greatest persons, who are commonly most devoted to it*) hath beene alwaies scandalous and of ill report' (Prynne, *Histrio-Mastix*, I, p. 236).

104 Hopkins speculates that the dance performed in Act 5, scene 2 is 'very probably . . . a brawl, or bransle, a circular dance in which partners are alternated so that each woman dances with each man'. This would make the dance 'another of those apparent images of peace and stability in the play which are in fact so savagely undercut: for the fact that Calantha . . . dances with each man in turn may make her look very like the figure of Death in the medieval Dance of Death'; see Hopkins, *John Ford's Political Theatre*, pp. 167–8 (p. 167). The grotesque connotations of 'antic gesture' accord with this suggestion.

105 Neill, *Issues of Death*, p. 374.

106 Reviewing the Royal Shakespeare Company's 1994 production of *The Broken Heart*, Peter Holland wrote, '[Olivia Williams's] awesome shout of those two words is one of the most extraordinary and appalling sounds I have ever heard in the theatre'; see Holland, 'Modality Ford's Strange Journeys', *TLS* 28 October 1994, p. 21.

107 Neill, *Issues of Death*, pp. 369–70 (p. 369).

108 Hopkins, *The Female Hero*, pp. 178–9, 189.

109 Patrick Thomas, *Katherine Philips ('Orinda')*, Writers of Wales (Cardiff: University of Wales Press, 1988), pp. 9–10; Ian Spink, *Henry Lawes: Cavalier Songwriter* (Oxford University Press, 2000), pp. 94–6; Mary Chan, 'A Mid-Seventeenth-Century Music Meeting and Playford's Publishing' in John Caldwell, Edward Olleson and Susan Wollenberg (eds.), *The Well Enchanting Skill: Music, Poetry, and Drama in the Culture of the Renaissance* (Oxford: Clarendon Press, 1990), pp. 231–44. The possibility of women singers performing at music meetings was suggested to me in personal correspondence from Mary Chan.

110 C. R. Forker, cited in Wood, 'William Lawes's Music for Plays', p. 37. Lawes's dialogue was published in all three song collections brought out by Playford during the 1650s (p. 42)

111 Cited in Shirley, *The Cardinal*, ed. Yearling, p. 28. Before the closure of the theatres, Rosaura was played by Charles Hart, who gained his reputation in the role (p. 27).

112 For the suggestion that the performance of *Dido and Aeneas* in 1689 by female pupils of Josias Priest's Chelsea boarding school is likely to have been a revival, see Bruce Wood and Andrew Pinnock, '"Unscarr'd by

Turning Times"'?: The Dating of *Dido and Aeneas*', *Early Music* 20 (1992), 373–90.

INTERCHAPTER: 'ENTER IANTHE VEILED'

1 This chapter title duplicates Rosamond Gilder, *Enter the Actress: The First Women in Theater* (New York: Theater Arts Books, 1931), p. 132. William Davenant, *The Siege of Rhodes* in Janet Clare (ed.), *Drama of the English Republic 1649–60* (Manchester University Press, 2002), p. 207, 108.1. Hereafter references are given by page and line in parentheses in the text.

2 'Order for Stage-plays to cease', 2 September 1642, cited in *Revels History IV 1613–1660*, pp. 61–2.

3 On the reading of drama, see Louis B. Wright, 'The Reading of Plays during the Puritan Revolution', *Huntington Library Bulletin* 6 (1934), 73–108. Humphrey Moseley's address to the reader in the Folio edition of Beaumont and Fletcher's *Comedies and Tragedies* (1647) justifies the omission of certain plays on the grounds that 'it would have rendred the Booke so Voluminous, that *Ladies* and *Gentlewomen* would have found it scarce manageable, who in Workes of this nature must first be remembred' ('The Stationer to the Reader', sig. a6r).

4 Leslie Hotson, *The Commonwealth and Restoration Stage* (Cambridge, Mass.: Harvard University Press, 1928), pp. 46, 56–7.

5 Clifford Leech, 'Private Performances and Amateur Theatricals (excluding the academic stage) from 1560–1660', PhD thesis, University of Cambridge, 1967, pp. 195–8, 232–3, Appendix A: The Apthorpe Plays; Poynting, *The Shepherds' Paradise*, pp. xv–xvi; G. C. Moore Smith, *The Letters of Dorothy Osborne to William Temple* (Oxford: Clarendon Press, 1928), pp. 172–3; D. F. Rowan *et al.* (eds.), *The Lost Lady by Sir William Berkeley* (Oxford: printed for the Malone Society by David Stanford at the University Printing House, 1987). Like Montagu's Fidamira, Berkeley's heroine, Acanthe, disguises herself as a moor and a ghost. On dramatic pastoral in the Interregnum, see Dale B. J. Randall, *Winter Fruit: English Drama 1642–1660* (Lexington: University Press of Kentucky, 1995), pp. 184–207.

6 Thomas Jordan, 'Cupid his Coronation, In a Mask, As it was presented with Good Approbation at the Spittle Diverse Tymes by Masters and Yong Ladyes that were theyre Scholers in the yeare 1654', Bodleian Library, Rawlinson MS, B.165; Wiseman, *Drama and Politics*, pp. 127–30.

7 Chalmers, Sanders and Tomlinson (eds.), General Introduction, *Three Seventeenth-Century Plays on Women and Performance*, p. 10.

8 On the Interregnum masques and operas of Shirley, Howell and Flecknoe, see Wiseman, *Drama and Politics*, pp. 114–36 (p. 135). *Cupid and Death* was not written for the 'court' occasion on which it was performed, but probably belongs to the 1640s; see Wiseman, *Drama and Politics*, p. 122.

9 Mary Edmond, *Rare Sir William Davenant* (Manchester University Press, 1987), pp. 75–6.

10 Beaumont and Fletcher, 'The Prologue to the *Woman-hater*, or the *Hungry Courtier*', line 21, *DWBFC*, I, pp. 236–7. Davenant's prologue was printed in his *Madagascar, with Other Poems* (1638) with the title, 'Prologue to a reviv'd play of Mr Fletcher's, call'd *The Woman-hater*', and in a quarto edition of *The Woman-Hater* published in 1649. For the notion of the authorial 'ladies' man', see Juliet Fleming, 'The Ladies' Man and the Age of Elizabeth' in Turner (ed.), *Sexuality and Gender in Early Modern Europe*, pp. 158–81.

11 Cited in Hotson, *Commonwealth and Restoration Stage*, p. 142.

12 The 1656 edition of *The Siege of Rhodes* describes the performance as given 'At the back part of Rutland House', Davenant's residence, where he had erected a small stage in a narrow hall; the title-page to the second edition of 1659 notes that the work had been performed at the Cockpit in Drury Lane.

13 Wiseman, *Drama and Politics*, pp. 142, 143.

14 Hotson, *Commonwealth and Restoration Stage*, p. 150; Edmond, *Rare Sir William Davenant*, pp. 123–6 (p. 125).

15 Clare, *Drama of the English Republic*, pp. 181, 193.

16 *Ibid.*, pp. 34–5.

17 Edmond, *Rare Sir William Davenant*, p. 126; Clare (ed.), *Drama of the English Republic*, p. 186.

18 William Davenant, *Salmacida Spolia*, line 16 in Lindley (ed.), *Court Masques*, pp. 200–13.

19 Ian Maclean, *Woman Triumphant: Feminism in French Literature 1610–1652* (Oxford University Press, 1977).

20 Quentin Bone, *Henrietta Maria: Queen of the Cavaliers* (London: Peter Owen, 1973), ch. 6, *passim*; M. A. E. Green (ed.), *Letters of Henrietta Maria* (London, 1857), p. 214.

21 William Davenant, *1 and 2 Siege of Rhodes*, ed. Ann-Mari Hedbäck (Studia Anglistica Upsaliensia, 14, Uppsala, 1973), pp. li–lvi; Clare (ed.), *Drama of the English Republic*, pp. 183–4.

22 Raber, *Dramatic Difference*, ch. 5; Chalmers, *Royalist Women Writers*, ch. 1, discusses the heroic woman as an enabling authorial image for Cavendish. See below, Chapters 5 and 6.

23 Chalmers, *Royalist Women Writers*, p. 19. One such woman was Lawes's pupil Mary Knight, whom John Evelyn refers to in his diary entry for 5 May 1659 as 'the famous Singer'; see Philip H. Highfill, Jr., *A Biographical Dictionary of Actors, Actresses . . . in London, 1660–1800*, 16 vols. (Carbondale: Southern Illinois University Press 1984), IX, p. 60.

24 Margaret Cavendish describes attending music meetings at Lawes's house 'three or four times' during her return trip to England from the continent between 1651 and 1653; see Cavendish, *The Life of William Cavendish, Duke of Newcastle, To Which Is Added The True Relation Of My Birth, Breeding And Life*, ed. C. H. Firth, 2nd edn. (London: Routledge, 1906), p. 169.

5 THE FANCY-STAGE OF MARGARET CAVENDISH, DUCHESS OF NEWCASTLE

1 David Hume, *A Treatise of Human Nature* (1738), ed. L. A. Selby-Bigge (1888; repr. Oxford: Clarendon Press, 1958), Book I, 'Of the Understanding', Part IV, vi, 'Of personal identity', p. 253. I am grateful to Jocelyn Harris for this reference.

2 Cavendish, *CCXI Sociable Letters* (1664), CXCV, p. 405. The reference to 'Carneval Time' is from the preceding letter (CXCIV, p. 402). Hereafter references to letter CXCV are given in parentheses in the text. The woman Cavendish saw may be identical with the 'dutch-wench all hairy and rough upon her body' seen by Thomas Crosfield in Oxford in 1635 (Bawcutt, *Control and Censorship*, p. 77). This was probably the German woman Barbara van Beck, who was exhibited in London as 'the bearded lady' and seen by John Evelyn and the Pepyses in 1657 and 1668. In his diary entry for 15 September 1657, Evelyn wrote that he saw 'the hairy maid, or Woman whom twenty yeares before I had also seene when a child . . . she had . . . a most prolix beard, and mustachios, with long lockes of haire growing on the very middle of her nose, exactly like an Island [i.e., Iceland] Dog'. Whereas Cavendish represents the woman in Antwerp through a discourse of monstrosity, Evelyn records his conversation with Van Beck, revealing that she was married with a child, and adds that she 'plaied well on the Harpsichord'; see Evelyn, *The Diary of John Evelyn*, ed. Guy de la Bédoyère (Woodbridge: Boydell Press, 1995), pp. 104–5. For a biography and contemporary engraving of Van Beck (b. 1629) see Highfill, *Biographical Dictionary*, XV, pp. 103–4. Susan Wiseman discusses Cavendish's letter as part of an opposition in Interregnum discourse between an image of female performance as monstrous spectacle and a positive vision of the dissimulating actress; see Wiseman, 'Margaret Cavendish Among the Prophets: Performance Ideologies and Gender in and after the English Civil War', *Women's Writing* 6 (1999), 95–111.

3 On the Renaissance rhetorical tradition in which the mind is viewed as a theatre, see Frances A. Yates, *The Art of Memory* (Harmondsworth: Penguin, 1966).

4 Cavendish, *Sociable Letters*, XXIX, p. 57.

5 In an illuminating essay, Diana Barnes interprets the mountebank letter as a 'rescripting of public political discourse' in which the contemplative woman's 'exemplarity lies in her capacity to turn away from pleasure and discipline herself'. For Barnes the letter is significant because it 'depicts a woman's mind in which "Fancy" is not given free rein'; see Barnes, 'The Politics of Female Performance in Margaret Cavendish's *Sociable Letters* (1664)', paper presented at a seminar on 'Women and Performance in Early Modern Europe', Shakespeare Association of America Conference, New Orleans, 8–10 April 2004. See also Diana Barnes, 'The Restoration of Royalist Form in Margaret Cavendish's *Sociable Letters*' in Jo Wallwork and Paul Salzman (eds.), *Women Writing 1550–1750*, a special issue of *Meridian* 18 (2001), 201–14.

6 I use the word 'fantasy' here in the modern sense of the imaginary fulfilment of conscious or unconscious wishes (*OED*, 3b). In seventeenth-century usage the words 'fantasy' and 'fancy' were used interchangeably to signify the imaginative faculty or process. However, the *OED* also gives as a possible meaning of 'fantasy' from the fourteenth century onwards 'the fact or habit of deluding oneself by imaginary perceptions or reminiscences' (3a), which indicates an earlier form of the modern usage. Cavendish's letter, and the rest of her writing, testify to the fluidity between her concept of 'fancy' and 'fantasy' in its modern form.

7 A pertinent example is the series of 'Femal Orations' in Margaret Cavendish, *Orations of Divers Sorts, Accommodated to Divers Places* (1662), pp. 225–32, especially p. 229.

8 Cavendish, *Sociable Letters*, CXCII, p. 400.

9 Margaret Cavendish, *Playes* (1662), sig. A2r. Hereafter references to this volume are given by page in parentheses in the text.

10 In *Sociable Letters* Cavendish mentions that the ship carrying her 'Twenty Playes' into England to be printed has sunk, a fact which accounts for their delayed publication (CXLIII, pp. 295–6).

11 Although Newcastle was not made a duke until 1665, I will use this title for the sake of simplicity. The collaborative dimension of Cavendish's drama is addressed by Jeffrey Masten, *Collaboration, Authorship and Sexuality in Renaissance Drama* (Cambridge University Press, 1997), pp. 156–64 and Raber, *Dramatic Difference*, pp. 218–36.

12 'To the Readers', *Plays, Never Before Printed* (1668), sig. A2r. On Cavendish's use of the word 'Action' as a term for publication, see Marta Straznicky, 'Reading the Stage: Margaret Cavendish and Commonwealth Closet Drama', *Criticism* 37 (1995), 355–90 (pp. 371–2).

13 On the role of oratory in English grammar school education in the Renaissance, see T. W. Baldwin, *William Shakespere's Small Latine and Less Greeke*, 2 vols. (Urbana: University of Illinois Press, 1944), II, ch. 40, *passim*. The educative function of acting was conceded in a number of early Puritan attacks on the stage; see Jonas A. Barish, *The Anti-Theatrical Prejudice* (Berkeley: University of California Press, 1981), pp. 82–3, 90–1, 206.

14 On the fantasy elements of Cavendish's plays, see Elaine Hobby, *Virtue of Necessity: English Women's Writing 1649–88* (London: Virago Press, 1988), pp. 110–11; Lois Potter in *Revels History IV 1613–1660*, pp. 277–9; Linda R. Payne, 'Dramatic Dreamscape: Women's Dreams and Utopian Vision in the Works of Margaret Cavendish, Duchess of Newcastle' in Mary Anne Schofield and Cecilia Macheski (eds.), *Curtain Calls: British and American Women and the Theater, 1660–1820* (Athens: Ohio University Press, 1991), pp. 18–33. Two recent collections of essays on Cavendish contain valuable contributions on her drama: Stephen Clucas (ed.), *A Princely Brave Woman: Essays on Margaret Cavendish, Duchess of Newcastle* (Aldershot: Ashgate, 2003), and Line Cottegnies and Nancy Weitz (eds.), *Authorial Conquests: Essays on Genre in the Writings of Margaret Cavendish* (Madison, Teaneck, and London:

Fairleigh Dickinson University Press and Associated University Presses, 2003); see also the special issue of *In-between* 9 (2000).

15 Cavendish, *The Life of William Cavendish*, p. 160.

16 *Ibid.*, pp. 161–2. For an account of the riots in Colchester which forced the Lucas family to retreat to Oxford, see Sara Heller Mendelson, *The Mental World of Stuart Women: Three Case Studies* (Brighton: Harvester Press, 1987), p. 16. On Cavendish's life in England before her departure for France, see Kathleen Jones, *A Glorious Fame: The Life of Margaret Cavendish, Duchess of Newcastle, 1623–1673* (London: Bloomsbury, 1988), chs. 1 and 2, and Whitaker, *Mad Madge*, chs. 1–4. Anna Battigelli argues for the crucial influence of Henrietta Maria's Platonic love doctrines on the formation of Cavendish's intellect and literary sensibility in her *Exiles of the Mind*, ch. 2.

17 Carola Oman, *Henrietta Maria* (London: Hodder and Stoughton, 1936), p. 151; Hotson, *The Commonwealth and Restoration Stage*, pp. 8–9.

18 Margaret Cavendish, *Poems and Fancies* (1653), pp. 155–60; *Natures Pictures drawn by Fancies Pencil to the Life* (1656), pp. 183–214 (p. 190). See Tanya Caroline Wood, 'The Fall and Rise of Absolutism: Margaret Cavendish's Manipulation of Masque Conventions in "The Claspe: *Fantasmes* Masque" and *The Blazing World*', *In-between* 9 (2000), 286–99.

19 On the entertainments of royalists in Paris and Holland, see Hotson, *The Commonwealth and Restoration Stage*, pp. 21–3, and Harbage, *Cavalier Drama*, pp. 206–8.

20 Cavendish, *Plays, Never Before Printed* (1668), *The Presence*, p. 92. The plays in this volume are paginated individually.

21 On Newcastle's literary activity, see Douglas Grant, *Margaret the First: A Biography of Margaret Cavendish, Duchess of Newcastle* (London: Hart-Davis, 1957), pp. 15, 57–9, 75–81, 93–5, 113–14, 147–50, 160, 223–7. On his literary patronage, see Geoffrey Trease, *Portrait of a Cavalier, William Cavendish, First Duke of Newcastle* (London: Macmillan, 1979), pp. 41, 46, 66–8, 70, 72, 83–4, 189–91. Nick Rowe discusses Newcastle's patronage of and influence on Jonson's drama in ' "My best patron": William Cavendish and Jonson's Caroline Dramas', *The Seventeenth Century* 9 (1994), 197–212.

22 *Playes* (1662), sigs. A7r–A8r (sig. A7v). One of Cavendish's *Sociable Letters* takes the form of an essay on Shakespeare (CXXIII, pp. 244–8). Julie Sanders demonstrates the importance of Jonson and Shirley as influences on Cavendish's drama in her ' "A Woman Write a Play!": Jonsonian Strategies and the Dramatic Writings of Margaret Cavendish; or, Did the Duchess Feel the Anxiety of Influence?' in Cerasano and Wynne-Davies (eds.), *Readings in Renaissance Women's Drama*, pp. 293–305.

23 *Revels History IV 1613–1660*, pp. 24, 278; Hotson, *The Commonwealth and Restoration Stage*, pp. 20–2; Grant, *Margaret the First*, pp. 173–4; Whitaker, *Mad Madge*, pp. 221, 380–1, n.9.

24 Pierre Danchin, *The Prologues and Epilogues of the Restoration 1660–1700, Part One: 1660–1676*, 4 vols. (Nancy: Publications Université Nancy II, 1981); I, p. 98.

25 *Revels History IV 1613–1660*, p. 278; Hotson, *The Commonwealth and Restoration Stage*, p. 136. These academies offer a context for Cavendish's play *The Female Academy* (1662) in which women practice rhetorical skills in their own educational institution. Sara Mendelson discusses Cavendish's epistolary relationship with Oxford and Cambridge universities, to whom she gave copies of her books; see Mendelson, *Mental World*, pp. 44–5.

26 See Chapter 1, n. 43.

27 Susan Wiseman, 'Gender and status in dramatic discourse: Margaret Cavendish, Duchess of Newcastle' in Isobel Grundy and Susan Wiseman (eds.), *Women, Writing, History 1640–1740* (London: Batsford, 1992), pp. 159–177 (p. 165).

28 Mendelson observes that in Cavendish's fiction 'the focus is not on love *per se* but on a woman's "will to power", expressed as the chronicle of her extraordinary ambitions, or as her psychological conquest of a male protagonist'; see Mendelson, *Mental World*, p. 22. Mendelson identifies suicide as an 'aggressive instrument of retaliation' adopted by Cavendish's heroines (p. 23), a point illustrated in the second plot of *Youths Glory, and Deaths Banquet,* in which Lady Innocent, wrongfully accused of theft by her future husband's mistress, vengefully stages her own suicide in a banquet of theatrical self-assertion.

29 Battigelli, *Exiles of the Mind*, p. 34. Raber remarks of Lady Sanspareille's death that 'a woman who speaks publicly cannot produce a comic outcome' (*Dramatic Difference*, p. 222). While this is an accurate analysis of *Youths Glory*, it is contradicted by the epilogue to *Natures Three Daughters*, spoken by Lady True-Love.

30 Cavendish, *Life of William Cavendish*, pp. 166–7 (p. 167).

31 Quoted in Alice Clark, *Working Life of Women in the Seventeenth Century* (1919; repr. London: Routledge and Kegan Paul, 1982), p. 20. Noting the coincidence of Cavendish's petitioning experience with the publication of her first volume, *Poems and Fancies*, in 1653, Chalmers proposes that Cavendish may have 'use[d] the notion that she was a spokesperson for her exiled husband as a means of finding a voice in print' (Chalmers, *Royalist Women Writers*, p. 22).

32 Cavendish, *Life of William Cavendish*, pp. 167–86 (p. 168).

33 Hobby, *Virtue of Necessity*, p. 83. On Cavendish's bashfulness, see also Jacqueline Pearson, *The Prostituted Muse: Images of Women and Women Dramatists 1642–1737* (Hemel Hempstead: Harvester Wheatsheaf, 1988), pp. 128–9, and Mendelson, *Mental World*, pp. 17–18.

34 On the tensions informing Cavendish's feminist pronouncements, see Mendelson, *Mental World*, pp. 54–6; Catherine Gallagher, 'Embracing the Absolute: The Politics of the Female Subject in Seventeenth-Century England', *Genders* 1 (1988), 24–39 (pp. 25–33); Rachel Trubowitz, 'The Reenchantment of Utopia and the Female Monarchical Self: Margaret Cavendish's *Blazing World*', *Tulsa Studies in Women's Literature* 11 (1992), 229–45; Wiseman, *Drama and Politics*, pp. 104–13.

35 Maclean, *Woman Triumphant*, p. viii. See also Jones, *A Glorious Fame*, pp. 56–7.

36 Raber notes that the fiction of *Bell in Campo* 'resonates with the material lives of civil war women' and she reads Cavendish, in the figure of the Lord General, as mounting a defence of her husband's military actions; see Raber, *Dramatic Difference*, pp. 214–18, 230–2 (p. 216). Alexandra G. Bennett presents both *Bell in Campo* and *The Sociable Companions* in the context of war and its particular impact upon women in her edition of Margaret Cavendish, *Bell in Campo and The Sociable Companions* (Ontario: Broadview Press, 2002); see also Bennett's essay 'Margaret Cavendish and the Theatre of War', *In-between* 9 (2000), 263–73.

37 Jones, *A Glorious Fame*, pp. 22–3 (p. 22); Cavendish, *Life of William Cavendish*, pp. 18–19, 23, 161 (p. 161).

38 After her abdication in 1654 and her conversion to Catholicism, Christina embarked on a triumphal tour of Europe, beginning with the Italian papal states; see Georgina Masson, *Queen Christina* (London: Secker and Warburg, 1968), chs. 7 and 8, *passim*.

39 On Cavendish's unusually discursive stage directions, see Straznicky, 'Reading the Stage', pp. 378–80.

40 There is a precedent for the act in *Bell in Campo* in Fletcher's comedy *The Woman's Prize* where Maria and her female supporters require her husband Petruchio to agree to a series of 'articles' before she will return to his bed. While Cavendish's act sympathetically enhances women's existence, Fletcher's satirical focus is firmly on women's conspicuous consumption, summed up in Petruchio's comment on the articles, 'as I expected: Liberty and clothes' (*DWBFC*, IV, 2.4.136).

41 Gallagher, 'Embracing the Absolute', p. 32. Cf. Straznicky, 'Reading the Stage', pp. 377–8, 389, n.97.

42 Cavendish, *Plays, Never Before Printed* (1668), sig. A2v. Hereafter references to plays in this volume are given by page in parentheses in the text. In *The Blazing World* the Duchess comments of her plays that 'the wits of these present times condemned them as incapable of being represented or acted, because they were not made up according to the rules of art'; see Margaret Cavendish, *The Blazing World and Other Writings*, ed. Kate Lilley (London: Penguin, 1994), p. 220.

43 Cf. Hobby, *Virtue of Necessity*, pp. 106–7. This volume further differs from *Playes* (1662) in its conformation to the English neoclassical tradition of play printing which originated with Jonson, particularly in the use of centred speech prefixes at the start of a scene. Cavendish may have been influenced in this regard by William Killigrew's *Plays* (1666), which adopts neoclassical printing conventions.

44 Wiseman, 'Gender and Status', p. 169.

45 Cavendish could have found this plot in Fletcher's play *Monsieur Thomas* (1615, pub. 1639) or in Fletcher's source, the French pastoral romance *L'Astrée* by Honoré d'Urfé (1607–27, trans. 1620). A Shakespearean analogue is discussed by Irene G. Dash in her 'Single-Sex Retreats in Two Early Modern

Dramas: *Love's Labor's Lost* and *The Convent of Pleasure*, *SQ* 47 (1996), 387–95. Chalmers explores the intertextual relationship between *The Convent of Pleasure*, Shirley's *The Bird in a Cage* and Montagu's *The Shepherds' Paradise* in *Royalist Women Writers*, pp. 132–48. See also the introduction to *The Convent of Pleasure* in Chalmers, Sanders and Tomlinson, *Three Seventeenth-Century Plays on Women and Performance*.

46 This play within a play evokes a Renaissance tradition of convent theatre and drama; see Elissa Weaver, 'Spiritual Fun: A Study of Sixteenth-Century Tuscan Convent Theatre' in Mary Beth Rose (ed.), *Women in the Middle Ages and the Renaissance: Literary and Historical Perspectives* (Syracuse, N.Y.: Syracuse University Press, 1986), pp. 173–205. See also Rebecca D'Monté, 'Mirroring Female Power: Separatist Spaces in the Plays of Margaret Cavendish, Duchess of Newcastle' in Rebecca D'Monté and Nicole Pohl (eds.), *Female Communities 1600–1800: Literary Visions and Cultural Realities* (Basingstoke: Macmillan Press, 2000), pp. 93–110.

47 Gallagher, 'Embracing the Absolute', pp. 130–3.

48 A context for the idea of love between women modelled on female friendship is the poetry of Katherine Philips. In ch. 4 of *The Renaissance of Lesbianism* Traub includes *The Convent of Pleasure* in her discussion of lesbian desire in early modern drama.

49 Chalmers collates nineteen copies of the 1668 *Plays* in her edition of *The Convent of Pleasure* in Chalmers, Sanders and Tomlinson (eds.), *Three Seventeenth-Century Plays on Female Performance*.

50 In her edition of *The Convent of Pleasure*, Anne Shaver deduces that Newcastle wrote the final two scenes and the epilogue; see Margaret Cavendish, *The Convent of Pleasure and Other Plays*, ed. Anne Shaver (Baltimore and London: Johns Hopkins University Press, 1999), p. 238n. Tanya Wood argues that 'Cavendish's resignation of her own authorship into the hands of her husband has direct parallels with the main action of the play', that is, the silencing of Lady Happy after her marriage to the Prince; see Wood, 'Margaret Cavendish, Duchess of Newcastle, *The Convent of Pleasure* (1668), Ending Revised By Her Husband, the Duke of Newcastle' in Helen Ostovich and Elizabeth Sauer (eds.), *Reading Early Modern Women: An Anthology of Texts in Manuscript and Print, 1550–1700* (New York and London: Routledge, 2004), pp. 435–7.

51 Cited in Grant, *Margaret the First*, p. 184.

52 Bulstrode Whitelocke, *Journal of the Swedish Embassy in the Years 1653 and 1654*, 2 vols. (London, 1772), I, p. 234. I am grateful to Susan Wiseman for alerting me to this text.

53 *Ibid.*, I, pp. 235–6.

54 *Ibid.*, II, pp. 52–3.

55 See the accounts by Madame de Motteville and Anne Marie d'Orléans of Christina at the French court in 1656, quoted in Masson, *Queen Christina*, pp. 274–7.

56 Robert Latham and William Matthews (eds.), *The Diary of Samuel Pepys*, 11 vols. (London: Bell and Hyman, 1970–83), VIII, pp. 163–4. According to Kathleen Jones, the Newcastles met Queen Christina briefly on her visit to Antwerp in 1654; see Jones, *A Glorious Fame*, p. 102.

57 *Diary of Samuel Pepys*, VIII, pp. 186–7, 163, 243.

58 Cited in Myra Reynolds, *The Learned Lady in England from 1650 to 1760* (1920; repr. Gloucester, Mass.: Peter Smith, 1964), p. 51. Cf. Pepys's remark that 'The whole story of this Lady is a romance, and all she doth is romantic' (*Diary of Samuel Pepys*, VIII, p. 163). The connection between Cavendish's dress and her writing is explored by James Fitzmaurice in 'Fancy and the Family: Self-Characterizations of Margaret Cavendish', *Huntington Library Quarterly* 53 (1990), 198–209.

59 Colley Cibber, *An Apology for the Life of Colley Cibber, with An Historical View of the Stage During his Own Times*, ed. B. R. S. Fone (Ann Arbor: University of Michigan Press, 1968), p. 96.

60 Mendelson, *Mental World*, pp. 12, 22.

61 Cited in *Ibid.*, p. 53.

62 *Diary of Samuel Pepys*, VIII, p. 163; Cotton, pp. 48–9.

63 Letter from Charles North to his father, 13 April 1667, Bodleian Library, North MS, c. 4, fol. 146. On the 'courtly practice of breast-exposure' which Cavendish appears to have been imitating, see McManus, *Women on the Renaissance Stage*, pp. 127–31.

6 STYLES OF FEMALE GREATNESS: KATHERINE PHILIPS'S TRANSLATIONS OF CORNEILLE

1 George Etherege, *The Man of Mode or, Sir Fopling Flutter* in *The Plays of George Etherege*, ed. Michael Cordner (Cambridge University Press, 1982), 4.1.16–17, 19–21. Hereafter references are given by act, scene and line in parentheses in the text.

2 See, for instance, the 'great respect' professed for the ladies by William Killigrew in the prologue to *The Siege of Urbin* (1666), which 'does make him raise / A Figure rarely practis'd in our dayes? / To set a Lustre on your sex, that may / Your reserv'd Virtues to the World display!', in Danchin (ed.), *Prologues and Epilogues of the Restoration*, I, p. 200, lines 5–8.

3 J[ohn] C[rouch], 'AN ELEGIE, Upon the Death of the most Incomparable, Mrs. KATHERINE PHILIPS, the Glory of her SEX', *CWKP*, III, pp. 207–9, lines 15–16.

4 Cartwright, *Plays and Poems of William Cartwright*, ed. Blakemore Evans, p. 53. Maureen E. Mulvihill shows the importance of kinship networks and support from men of letters for Philips's literary career in Mulvihill, 'A Feminist Link in the Old Boys' Network: The Cosseting of Katherine Philips', in Schofield and Macheski (eds.), *Curtain Calls*, pp. 71–104.

5 Carol Barash, *English Women's Poetry*, pp. 32–40.

6 *Pompey, A Tragedy*, *CWKP*, III, p. 4. Hereafter references to *Pompey* are given by act, scene and line in parentheses in the text. Chalmers discusses the role

Pompey played 'in augurating the discourse of English translation as an act of cultural supremacy which bolsters the Restoration political settlement' in *Royalist Women Writers*, pp. 97–104 (p. 97).

7 A Shakespeare prompt-book surviving from the Smock Alley Theatre and dating from the early 1670s names eighteen actors and only three actresses. See William Smith Clark, *The Early Irish Stage: The Beginnings to 1720* (Oxford: Clarendon Press, 1955), p. 74. Christopher Morash gives no evidence for his statement that 'the presence of women on the stage in Smock Alley during that first 1662/3 season was one of the most visible signs that the theatre was entering into a new era', nor for his assertion that 'one tradition has it that [Katherine Philips] acted in the performance [of *Pompey*]'; see Morash, *A History of the Irish Theatre 1601–2000* (Cambridge University Press, 2002), pp. 25, 24.

8 *CWKP*, I, pp. 177–8.

9 *CWKP*, II, p. 128.

10 *CWKP*, II, pp. 128–9.

11 The reference to '*danc[ing] upon the Ropes*' would have been linked by Restoration readers to 'a famous Rope-daunser call'd the Turk' who amazed London crowds in the late 1650s. John Evelyn recorded the astonishing agility of this acrobat who performed feats such as 'dauncing blindfold on the high-roope . . . with a boy of 12 yeares old, tyed to one of his feete about 20 foote beneath him dangling as he daunced, and yet moved as nimbly, as it had ben but a feather'; *Diary of John Evelyn*, 15 September 1657, p. 104.

12 Germaine Greer points out that Philips's protesting letter was written *after* Cotterell and her friend John Jeffreys had taken steps to have the edition suppressed. She suggests that the financial plight of Philips's husband in 1664 might have provided her with a motive for the publication; see Greer, *Slip-Shod Sibyls: Recognition, Rejection and the Woman Poet* (Harmondsworth: Penguin, 1995), pp. 154–64. Peter Beal, *In Praise of Scribes: Manuscripts and their Makers in Seventeenth-Century England* (Oxford: Clarendon Press, 1998), pp. 162–5, puts persuasive arguments against Greer's thesis.

13 Hobby, *Virtue of Necessity*, p. 129.

14 'In Memory of Mr Cartwright', *CWKP*, I, p. 143; Henry Vaughan, 'To the most Excellently accomplish'd Mrs K. Philips', cited in Thomas, *Katherine Philips, 'Orinda'*, p. 27.

15 To the Truly Noble Mr Henry Lawes', *CWKP*, I, pp. 87–8; 'Friendship's Mysterys, to my dearest Lucasia. (set by Mr. H. Lawes.)', *CWKP*, I, pp. 90–1.

16 [Charles Cotterell], 'The Preface' to Katherine Philips, *Poems by the Most Deservedly Admired Mrs Katherine Philips, the Matchless Orinda*, 1667, sig. A1ʳ.

17 Cf. the 'matchles ffidamira' in *The Shepherds' Paradise by Walter Montagu*, line 209 [1659: 6]. Patrick Thomas estimates that the name 'Orinda' was established by October 1653, when Francis Finch's completed treatise was addressed to 'D. noble Lucasia-Orinda' (*CWKP*, I, p. 8).

18 For an example of a Cavalier poet who celebrates female friendship in terms similar to Philips, see Edmund Waller's 'Upon the death of my Lady Rich' in Waller, *Poems* (1645), pp. 60–1.

19 Veevers, *Images of Love and Religion*, p. 67.

20 For the use of this term to describe Philips's literary coterie in which the concept of friendship was central, see a letter from Sir Edward Dering to Anne Owen, written after Philips's death (7 February 1664), cited in *CWKP*, I, p. 11. On politicized friendship in Philips's royalist circle, see Chalmers, *Royalist Women Writers*, pp. 59–72.

21 *CWKP*, II, pp. 44–5; Cartwright, *Plays and Poems of William Cartwright*, ed. Blakemore Evans, pp. 52–3, n.10.

22 Barash, *English Women's Poetry*, p. 34.

23 *CWKP*, I, pp. 84–5, line 28. The poem dates from 1652 and was written on the occasion of the Countess's first visit to the Welsh estate of her husband, Richard Vaughan.

24 Maclean, *Woman Triumphant*, pp. 87, 178–94.

25 Kenneth Richards suggests that Henrietta Maria may have encouraged Rutter to translate Corneille's play; see Richards, 'Queen Henrietta Maria as a Patron of the Drama', *Studia Neophilologica* 42 (1970), 9–24 (p. 22). However, Dorothea Frances Canfield states that Rutter's translation was undertaken 'at the command of the Earl of Dorset, Lord Chamberlain to the Queen'; see Canfield, *Corneille and Racine in England* (1904; repr. AMS Press, 1966), pp. 1–5 (p. 3).

26 Timothy J. Reiss, 'Corneille and Cornelia: Reason, Violence, and the Cultural Status of the Feminine: Or, How a Dominant Discourse Recuperated and Subverted the Advance of Women', *Renaissance Drama*, n.s. 18 (1987), 3–41; Andrew Shifflett, *Stoicism, Politics, and Literature in the Age of Milton* (Cambridge University Press, 1998), pp. 75–106. Chalmers, *Royalist Women Writers*, pp. 86–95, offers a finely nuanced interpretation of the 'political sympathies' of Philips's *Pompey* (p. 87).

27 Barash, *English Women's Poetry*, p. 50.

28 Pierre Corneille, *Writings on the Theatre*, ed. H. T. Barnwell (Oxford: Blackwell, 1965), p. 123, translation mine.

29 In a letter to Charles Cotterell commenting on the contemporaneous translation of *Pompey the Great* by 'Persons of Honour', Philips criticizes Edmund Waller's 'calling Pompey a Consull, when that was not in the Original, or the History' (*CWKP*, II, p. 112). Shifflett comments of this letter, 'Philips appears to be thinking of the *Pharsalia*'; see Shifflett, '"How Many Virtues Must I Hate"; Katherine Philips and the Politics of Clemency', *Studies in Philology* 94 (1997), 103–35 (p. 110).

30 Thomas May, *Lucans Pharsalia* (1627), 3rd edn., 1635, p. 25.

31 Barnwell points out that this phrase is not found in Lucan, to whom Corneille attributes it, but in works by Propertius and Pliny the Elder; see *Writings on the Theatre*, p. 255, n.17.

32 In *Ideas of Greatness: Heroic Drama in England* (London: Routledge and Kegan Paul, 1971), Eugene M. Waith draws attention to the common ethos shared by Corneille's drama and the plays of Beaumont and Fletcher. He points out the similar subject matter of *La Mort de Pompée* and *The False One,* noting that Fletcher and Massinger altered history in similar ways to Corneille, specifically in their treatment of Cleopatra (p. 177).

33 In her letters Philips mentions having seen Fletcher's plays *Wit Without Money* and *The Maid's Tragedy,* the first in Dublin and the second, with Cotterell, in London (*CWKP,* II, pp. 54, 63).

34 The Dublin quarto edition of *Pompey* (1663) was followed by an edition printed in London in the same year. William van Lennep suggests that *Pompey* may have been staged in London in the late spring of 1663; see Van Lennep, *The London Stage 1660–1800, Part One: 1660–1700* (Carbondale: Southern Illinois University Press, 1965), p. 64. He bases his conjecture on the performance in the late summer of 1663 of Davenant's *A Playhouse to be Let,* Act 5 of which, he maintains, comprises a farce based on *Pompey.* Thomas discounts the suggestion of a London performance of *Pompey,* seeing Davenant's parody as equally likely to be based on Corneille's original *Pompée* as on any English version (*CWKP,* II, p. 70, n.9).

35 Barnwell, *Writings on the Theatre,* p. 122, translation mine.

36 *DWBFC,* VIII, 1.2.37–8. Hereafter references are given by act, scene and line in parentheses in the text.

37 William Shakespeare, *Anthony and Cleopatra,* ed. Michael Neill (Oxford University Press, 1994), 2.6.68–71, note to line 69.

38 By contrast, in *The False One,* Cleopatra admits her willingness to trade her sexuality with Caesar in return for power: 'Though I purchase / His grace, with losse of my virginity, / It skills not, if it bring home Majesty' (1.2.104–6). One of Philips's objections to the rival poets' translation of *Pompey the Great* was 'making Cleopatra say she *courts Caesar*' (*CWKP,* II, p. 113).

39 Maclean, *Woman Triumphant,* p. 191.

40 Claire L. Carlin, *Pierre Corneille Revisited* (New York: Twayne, 1998), p. 84.

41 See 2.1.78; 1.3.116; 1.3.87; 2.1.71.

42 'True nobility' was a concern of Orinda's society. See 'To the truly noble Mr Henry Lawes', *CWKP,* I, pp. 87–8. On *admiratio* as an aesthetic effect of the *femme forte,* see Maclean, *Woman Triumphant,* pp. 86–7, 179–94.

43 Cf. *The Duchess of Malfi,* 4.2.131, and the 'masculine constancy' exhibited by Fletcher and Massinger's Cleopatra during the rebellion against Caesar provoked by Ptolomy and Photinus: 'then we forsake / The strong fort of our selves, when we once yield, / Or shrink at [Fortune's] assaults; I am still my selfe' (5.4.18, 20–2). Cornelia's echo of Webster's Duchess is commented on by Shifflet, *Stoicism,* p. 86, and Raber, *Dramatic Difference,* p. 251.

44 Pierre Corneille, *Théâtre Complet* ed. Pierre Lièvre and Roger Caillois, 2 vols. (Paris: Gallimard, 1950), I, p. 1051.

45 Reiss, 'Corneille and Cornelia', p. 22.

46 Shifflett argues that Cornelia is locked into a 'psychological problematic' of hatred and admiration for Caesar (*Stoicism*, p. 93). This description weakens his argument that through Cornelia, Philips criticizes Charles II's policy of royal clemency. Chalmers suggests more persuasively that Cornelia gives Philips the chance 'to anatomize the true cost of subduing personal pain in the interests of a political reconciliation demanded by patriotic duty'; see Chalmers, *Royalist Women Writers*, p. 91.

47 Reiss, 'Corneille and Cornelia', p. 23. See also Shifflett's discussion of the *entr'acte* as 'prophetic and providentialist', *Stoicism*, pp. 89– 91 (p. 90).

48 *Horace, A Tragedy*, CWKP, III, 1.1.89. Hereafter references are given by act, scene and line in parentheses in the text.

49 Chalmers points out that the terms 'Private' and 'Publick' occur only in the version of *Horace* from the Rosania Manuscript which Greer and Little take as the copy-text for their edition (*Royalist Women Writers*, p. 95, n.153). The words do not appear in the revised version of *Horace* published in Philips's *Poems* (1667), which the editors state 'has clearly been revised by a hand other than Orinda's' (*CWKP*, III, p. 119). Philips translates Corneille's 'Ne préfère-t-il point L'État à sa famille?' (*Théâtre Complet*, I, p. 792) as 'Does not the Publick Private thoughts ôrecome?' (1.3.21).

50 Chalmers, *Royalist Women Writers*, pp. 95–6 (p. 96); see especially notes 153, 155 and 156.

51 As the editors note (p. 159, n.2), the rendition of 3.3.27–32 as ordering sententiae is Philips's own. These lines lack quotation marks in Corneille, and in the version of *Horace* printed in the 1667 edition of Philips's works.

52 Maclean, *Woman Triumphant*, p. 194.

53 *The Missing Scenes of* Horace *Translated by Sir John Denham*, CWKP, III, Appendix 4, pp. 247–59 (p. 249).

54 Barash, *English Women's Poetry*, p. 58.

55 Morash, *History of the Irish Theatre*, pp. 25–6.

56 Raber, *Dramatic Difference*, p. 246.

57 *CWKP*, II, p. 71.

58 *CWKP*, II, pp. 123–4.

59 The frontispiece published in the 1667 *Poems* is reproduced and discussed by Beal, *In Praise of Scribes*, pl. 95, pp. 175–7.

CODA

1 Staves, *Players' Scepters*, pp. 14, 118–20; Arthur H. Nethercot, *Sir William D'Avenant: Poet Laureate and Playwright-Manager* (Chicago, 1938; repr. New York: Russell and Russell, 1966), pp. 338–40. Despite being described on the title-page of the quarto edition as 'Duly Authorized', *Lady Alimony* was not entered in the Stationers' Register. Dale Randall, *Winter Fruit*, pp. 307–10, offers evidence for it having been composed close to 1659 and terms it a 'pastiche'. See also Deborah Payne, 'Patronage and the Dramatic Marketplace under Charles I and II', *The Year's Work in English Studies* 21 (1991), 137–52;

Nigel Smith, *Literature and Revolution in England 1640–1660* (New Haven: Yale University Press, 1994), p. 90.

2 Walter Montagu, *The Shepheard's Paradise* (1659), sig. A4r.

3 Anon., *Lady Alimony or, The Alimony Lady* (1659), sig. B3v.

4 Linda A. Pollack, 'The Child in Time', review of Nicholas Orme, *Medieval Children, TLS* 15 March 2002, 10.

5 Maus, 'Playhouse Flesh and Blood', pp. 600, 614.

6 Danchin, *Prologues and Epilogues of the Restoration, Part One,* I, pp. 55–6. Performed 8 December 1660 at the King's Theatre. The part of Desdemona was said to have been played by Margaret Norris. Hereafter references to the prologue and epilogue are given by line in parentheses in the text.

7 See Maus, 'Playhouse Flesh and Blood', pp. 597–8. The patent granted to Thomas Killigrew and William Davenant in 1662, which specifies the introduction of actresses, is reproduced in David Thomas (ed.), *Theatre in Europe: A Documentary History, Restoration and Georgian England 1660–1788* (Cambridge University Press, 1989), pp. 16–18.

8 Howe, *The First English Actresses,* pp. 147–70.

9 Cited in Clark, *Working Life of Women,* p. 20. Cary wrote to Lord Conway, 'I conceive women to be no fit solicitors of state affairs.'

10 Peter Holland, *The Ornament of Action: Text and Performance in Restoration Comedy* (Cambridge University Press, 1979), p. 86.

11 Sarah Burton, 'The Public Woman: An Investigation into the Actress-Whore Connexion' (PhD thesis, University of London, 1998), p. 339.

12 See Balthasar de Beaujoyeulx's description of the performance of Mademoiselle de Victry, a lady-in-waiting to Queen Louise, in his *Balet Comique de la Royne,* performed at the French court in 1581:

> Mlle de Victry . . . rose and began to recite to the King the following verses, so clearly and with such modest assurance, that the connaisseurs [*sic*] present, who had not known about her up till this moment, came to the conclusion immediately that her liveliness of mind made her capable and worthy of higher and more difficult things in the sciences and disciplines.
>
> *Le Balet Comique de la Royne,* trans. Carol and Lander MacClintock, Musicological Studies and Documents 25 (American Institute of Musicology, 1971), p. 68.

13 *The Diary of Samuel Pepys,* VIII, p. 55, emphasis mine.

14 On the myth of the Restoration actress as a 'self-regulating artist' see Germaine Greer's foreword to *Women's Writing* 6 (1999), p. 4; Burton, 'The Public Woman', p. 392.

15 Maus, 'Playhouse Flesh and Blood', p. 600.

16 Chalmers, *Royalist Women Writers,* p. 150.

17 *Oroonoko or, The Royal Slave* in Aphra Behn, *Oroonoko and other Writings,* ed. Paul Salzman (Oxford University Press, 1994), especially the episode of Imoinda's dancing, pp. 23–4; for Behn's debt to Shirley in *The Lucky Chance,* see Gerard Langbaine, *An Account of the English Dramatick Poets,* 1691, p. 20.

Bibliography

PRIMARY SOURCES

MANUSCRIPTS

Bodleian Library, North MS, c. 4

Bodleian Library, Rawlinson MS, B.165: 'Cupid his Coronation, In a Mask, As it was presented with Good Approbation at the Spittle Diverse Tymes by Masters and Yong Ladyes that were theyre Scholers in the yeare 1654'.

Historical Manuscripts Commission, *Calendar of Hatfield Manuscripts*, XVI.

PRINTED BOOKS

The place of publication for works printed before 1700 is London unless otherwise stated.

Anon., *Arden of Faversham*, ed. Martin White, New Mermaids, London and New York: Ernest Benn, 1982.

 The Coleorton Masque in David Lindley (ed.), *Court Masques*, Oxford University Press, 1995, pp. 126–35.

 'The Knight of the Long Ass' ('Berengier au lonc cul'), *http://www.llp. armstrong.edu/5800/longass.html.*

 Lady Alimony; or, The Alimony Lady, 1659.

Ashton, Robert (ed.), *James I By His Contemporaries*, London: Hutchinson, 1969.

Beaumont, Francis and John Fletcher, *Comedies and Tragedies Written by Francis Beaumont and John Fletcher, Gentlemen*, 1647.

 The Dramatic Works in the Beaumont and Fletcher Canon, gen. ed. Fredson Bowers, 10 vols., Cambridge University Press, 1966–96.

Beaujoyeulx, Balthasar de, *Le Balet Comique de la Royne*, trans. Carol and Lander MacClintock, Musicological Studies and Documents 25, American Institute of Musicology, 1971.

Behn, Aphra, *Oroonoko and Other Writings*, ed. Paul Salzman, Oxford University Press, 1994.

Braithwait, Richard, *The English Gentlewoman*, 1631.

Brome, Richard, *The Dramatic Works of Richard Brome*, ed. R. H. Shepherd, 3 vols., London, 1873; repr. New York: AMS Press, 1966.

Cartwright, William, *The Plays and Poems of William Cartwright*, ed. G. Blakemore Evans, Madison, Wis.: University of Wisconsin Press, 1951.

Cary, Elizabeth, *The Tragedy of Mariam, The Fair Queen of Jewry* in S. P. Cerasano and Marion Wynne-Davies (eds.), *Renaissance Drama by Women: Texts and Documents*, London: Routledge, 1996, pp. 43–75.

Castiglione, Baldassare, *The Courtyer of Count Baldessar Castilio*, trans. Sir Thomas Hoby, 1561.

Cavendish, Lady Jane and Lady Elizabeth Brackley, *The Concealed Fancies* in S. P. Cerasano and Marion Wynne-Davies (eds.), *Renaissance Drama by Women: Texts and Documents*, London and New York: Routledge, 1996, pp. 127–54.

Cavendish, Margaret, *Poems and Fancies*, 1653.

Natures Pictures drawn by Fancies Pencil to the Life, 1656.

Orations of Divers Sorts, Accommodated to Divers Places, 1662.

Playes Written by the Thrice Noble, Illustrious and Excellent Princess, the Lady Marchioness of Newcastle, 1662.

CCXI Sociable Letters, 1664.

Plays, Never Before Printed, 1668.

The Life of William Cavendish, Duke of Newcastle, To Which Is Added The True Relation Of My Birth, Breeding And Life, ed. C. H. Firth, 2nd edn., London: Routledge, 1906.

The Blazing World and Other Writings, ed. Kate Lilley, London: Penguin, 1994.

The Convent of Pleasure and Other Plays, ed. Anne Shaver, Baltimore and London: Johns Hopkins University Press, 1999.

Bell in Campo and The Sociable Companions, ed. Alexandra G. Bennett, Ontario: Broadview Press, 2002.

Chalmers, Hero, Julie Sanders and Sophie Tomlinson (eds.), *Three Seventeenth-Century Plays on Women and Performance: Fletcher's The Wild-Goose Chase, Shirley's The Bird in a Cage and Margaret Cavendish's The Convent of Pleasure*, Revels Companion Library, Manchester University Press, 2005.

Chapman, George, *George Chapman, Plays and Poems*, ed. Jonathan Hudston, London: Penguin, 1998.

Cibber, Colley, *An Apology for the Life of Colley Cibber, with An Historical View of the Stage During his Own Times*, ed. B. R. S. Fone, Ann Arbor: University of Michigan Press, 1968.

Clare, Janet (ed.), *Drama of the English Republic 1649–60*, The Revels Plays, Manchester University Press, 2002.

Collier, Jeremy, *A Short View of the Immorality and Profaneness of the English Stage*, 1698.

Congreve, William, *The Way of the World* in *The Complete Plays of William Congreve*, ed. Herbert Davis, Chicago and London: University of Chicago Press, 1967.

'Concerning Humour in Comedy' (1695) in John C. Hodges (ed.), *William Congreve: Letters and Documents*, London: Macmillan, 1964, pp. 176–86.

Corneille, Pierre, *Writings on the Theatre*, ed. H. T. Barnwell, Oxford: Blackwell, 1965.

 Théâtre Complet, ed. Pierre Lièvre and Roger Caillois, 2 vols., Paris: Gallimard, 1950.

Coryate, Thomas, *Coryats Crudities*, 1611.

Cotton, Nancy, *Women Playrights in England c. 1363–1750*, Associated University Presses, 1980.

Danchin, Pierre, *The Prologues and Epilogues of the Restoration 1660–1700, Part One: 1660–1676*, I, 4 vols., Nancy: Publications Université Nancy II, 1981.

Daniel, Samuel, *The Vision of the Twelve Goddesses Presented in a Masque . . . by the Queen's Most Excellent Majesty, and her Ladies*, 1604.

 The Vision of the Twelve Goddesses, ed. Joan Rees in T. J. B. Spencer and Stanley Wells (eds.), *A Book of Masques in Honour of Allardyce Nicoll*, Cambridge University Press, 1967, pp. 17–42.

 The Queenes Arcadia in Elizabeth Story Donno (ed.), *Three Renaissance Pastorals: Tasso, Guarini, Daniel*, Binghamton, N.Y.: Centre for Medieval and Renaissance Studies, 1993, pp. 183–250.

 Hymen's Triumph by Samuel Daniel, ed. John Pitcher, Malone Society Reprint, Oxford University Press, 1994.

 Tethys' Festival in David Lindley (ed.), *Court Masques*, Oxford University Press, 1995, pp. 54–65.

 Selected Poetry and A Defense of Rhyme, ed. Geoffrey G. Hiller and Peter L. Groves, Asheville, N.C.: Pegasus Press, 1998.

Davenant, William, *1 and 2 Siege of Rhodes*, ed. Ann-Mari Hedbäck, Studia Anglistica Upsaliensia 14, Uppsala, 1973.

Du Bosc, Jacques, *The Compleat Woman*, trans. N. N., 1639.

E.[dgar], T.[homas], *The Lawes Resolutions of Womens Rights: or, The Lawes Provision for Woemen*, 1632.

Etherege, George, *The Man of Mode; or, Sir Fopling Flutter* in *The Plays of George Etherege*, ed. Michael Cordner, Cambridge University Press, 1982, pp. 211–333.

Evelyn, John, *The Diary of John Evelyn*, ed. Guy de la Bédoyère, Woodbridge: Boydell Press, 1995.

Fletcher, John, *The Wild-Goose Chase*, ed. Sophie Tomlinson, in Hero Chalmers, Julie Sanders and Sophie Tomlinson (eds.), *Three Seventeenth-Century Plays on Women and Performance*, Revels Companion Library, Manchester University Press, 2005.

Ford, John, *John Ford: Five Plays*, ed. Havelock Ellis, London; 1888, repr. New York: Hill and Wang, 1957.

 The Broken Heart, ed. Donald K. Anderson, Jr., Regents Renaissance Drama, London: Edward Arnold, 1968.

 The Broken Heart, ed. T. J. B. Spencer, The Revels Plays, Manchester University Press, 1980.

The Selected Plays of John Ford, ed. Colin Gibson, Cambridge University Press, 1986.

Love's Sacrifice, ed. A. T. Moore, The Revels Plays, Manchester University Press, 2002.

Fuller, Thomas, *The Church History of Britain*, 1655.

Gosson, Stephen, *The Schoole of Abuse*, 1579.

Green, M. A. E (ed.), *Letters of Henrietta Maria*, London, 1857.

Guarini, Giambattista, *Il Pastor Fido*, trans. Tailboys Dymoke, in Elizabeth Story Donno (ed.), *Three Renaissance Pastorals: Tasso, Guarini, Daniel*, Binghamton, N.Y.: Centre for Medieval and Renaissance Studies, 1993, pp. 54–182.

Harbage, Alfred, *Annals of English Drama 975–1700*, 3rd edn., rev. Sylvia Stoler Wagonheim, London: Routledge, 1989.

Hawkins, William, *Apollo Shroving*, 1627.

Henderson, Katherine Usher and Barbara F. McManus (eds.), *Half Humankind: Contexts and Texts of the Controversy about Women in England, 1540–1640*, Urbana: University of Illinois Press, 1985.

Highfill, Philip H., Jr., *et al.* (eds.), *A Biographical Dictionary of Actors, Actresses, Musicians, Dancers, Managers, and Other Stage Personnel in London, 1660–1800*, 16 vols., Carbondale: Southern Illinois University Press, 1973–93.

Hume, David, *A Treatise of Human Nature* (1738), ed. L. A. Selby-Bigge, 1888, repr. Oxford: Clarendon Press, 1958.

Jonson, Ben, *Ben Jonson*, ed. C. H. Herford and Percy and Evelyn Simpson, 11 vols., Oxford: Clarendon Press, 1925–52.

Ben Jonson: The Complete Masques, ed. Stephen Orgel, New Haven and London: Yale University Press, 1969.

The New Inn, ed. Michael Hattaway, The Revels Plays, Manchester University Press, 1984.

The Selected Plays of Ben Jonson, ed. Martin Butler, 2 vols., Cambridge University Press, 1989.

Kyd, Thomas, *The Spanish Tragedy*, ed. Philip Edwards, The Revels Plays, Manchester University Press, 1959.

Langbaine, Gerard, *An Account of the English Dramatick Poets*, 1691.

Lindley, David (ed.), *Court Masques: Jacobean and Caroline Entertainments 1605–1640*, Oxford University Press, 1995.

Lyly, John, *Galatea*, ed. George K. Hunter, *Midas*, ed. David Bevington, The Revels Plays, Manchester University Press, 2000.

Marston, John, 'The Entertainment of the Dowager Countess of Derby' in Arnold Davenport (ed.), *The Poems of John Marston*, Liverpool University Press, 1961, pp. 189–207.

The Selected Plays of John Marston, ed. Macdonald Jackson and Michael Neill, Cambridge University Press, 1986.

May, Thomas, *Lucans Pharsalia*, 1627, 3rd edn., 1635.

McGee, C. E., '"The Visit of the Nine Goddesses": A Masque at Sir John Crofts's House', *ELR* 21 (1991), 371–84.

Middleton, Thomas and William Rowley, *The Changeling*, ed. Patricia Thomson, New Mermaids, London: Ernest Benn, 1964.

and Thomas Dekker, *The Roaring Girl, or Moll Cutpurse*, ed. Paul Mulholland, The Revels Plays, Manchester University Press, 1987.

Miles, Theodore K., 'James Shirley's *Hyde Park* edited from the Quarto of 1637 with Introduction and Notes', PhD thesis, University of Chicago, 1940.

Milton, John, 'A Masque presented at Ludlow Castle, 1634 [Comus]' in John Carey (ed.), *Milton: Complete Shorter Poems*, London, Longman, 1971, pp. 168–229.

Paradise Lost, ed. Alistair Fowler, London: Longman, 1971.

A Maske: The Earlier Versions, ed. S. E. Sprott, Toronto and Buffalo: University of Toronto Press, 1973.

Montagu, Walter, *The Accomplished Woman*, 1656.

The Shepheard's Paradise: A Comedy, 1629 [*recte* 1659].

The Shepherds' Paradise by Walter Montagu, ed. Sarah Poynting, Malone Society Reprint, vol. 159. Oxford University Press, 1998.

'A Critical Edition of Walter Montagu's *The Shepherds' Paradise*, Acts 1–3', 2 vols., Sarah Poynting, DPhil thesis, University of Oxford, 1999.

Orgel, Stephen and Roy Strong (eds.), *Inigo Jones: The Theatre of the Stuart Court*, 2 vols., London, Berkeley, and Los Angeles: Sotheby Parke Benet and University of California Press, 1973.

Osborne, Francis, *Historical Memoires on the Reigns of Queen Elizabeth and King James*, 1658.

Penn, William, 'Preface to the Frame of Government', 1682, in Philip B. Kurland and Ralph Lerner (eds.), *The Founders' Constitution*, vol. 1, p. 614, University of Chicago Press, *http://press-pubs.uchicago.edu/founders/documents/v1ch17s4.html*.

Pepys, Samuel, *The Diary of Samuel Pepys*, ed. Robert Latham and William Matthews, 11 vols., London: Bell and Hyman, 1970–83.

Philips, Katherine, *Poems by the Most Deservedly Admired Mrs Katherine Philips, the Matchless Orinda, to which is added Monsieur Corneille's Pompey and Horace, Tragedies*, 1667.

The Collected Works of Katherine Philips the Matchless Orinda, I The Poems, ed. Patrick Thomas, Stump Cross: Stump Cross Books, 1990.

The Collected Works of Katherine Philips, II The Letters, ed. Patrick Thomas, Stump Cross: Stump Cross Books, 1992.

The Collected Works of Katherine Philips, III The Translations, ed. Germaine Greer and Ruth Little, Stump Cross: Stump Cross Books, 1993.

Prynne, William, *Histrio-Mastix: The Player's Scourge or, Actor's Tragedy*, 2 vols., 1633; New York and London: Johnson Reprint, 1972.

Richards, Nathanael, *The Tragedy of Messallina, The Roman Empresse*, ed. A. R. Skemp, Materialien zur Kunde des älteren Englischen Dramas, 1910, Vaduz: Kraus Reprint, 1963.

Rowan, D. F., *et al.* (eds.), *The Lost Lady by Sir William Berkeley*, Oxford: Printed for the Malone Society by David Stanford at the University Printing House, 1987.

Rowse, A. L., *The Poems of Shakespeare's Dark Lady: Salve Deus Rex Judeorum by Emilia Lanier*, London: Cape, 1978.

Sandys, George, *Ovids Metamorphoses Englished*, 2nd edn. 1632, repr. New York and London: Garland, 1976.

Shakespeare, William, *Hamlet*, ed. G. R. Hibbard, The Oxford Shakespeare Oxford University Press, 1987.

The Narrative Poems, ed. Maurice Evans, The New Penguin Shakespeare, Harmondsworth: Penguin, 1989.

The Complete Works, gen. eds. Stanley Wells and Gary Taylor, compact edn., Oxford: Clarendon Press, 1994.

Anthony and Cleopatra, ed. Michael Neill, The Oxford Shakespeare, Oxford University Press, 1994.

and Thomas Middleton, *Timon of Athens*, ed. John Jowett, The Oxford Shakespeare, Oxford University Press, 2004.

Shirley, James, *The Dramatic Works and Poems*, ed. William Gifford and Alexander Dyce, 6 vols., London, 1833.

Hyde Park in Russell A. Fraser and Norman Rabkin (eds.), *Drama of the English Renaissance, II The Stuart Period*, New York: Macmillan, 1976, pp. 743–70.

The Humorous Courtier, ed. Marvin Morillo, New York and London: Garland, 1979.

James Shirley's Love's Cruelty: A Critical Edition, ed. John Frederick Nims, New York and London: Garland, 1980.

The Cardinal, ed. E. M. Yearling, The Revels Plays, Manchester University Press, 1986.

Hyde Park, performed by the Royal Shakespeare Company, The Pit, Barbican Centre, August 1988, programme.

The Bird in a Cage, ed. Julie Sanders, in Hero Chalmers, Julie Sanders and Sophie Tomlinson (eds.), *Three Seventeenth-Century Plays on Women and Performance*, Revels Companion Library, Manchester University Press, 2005.

Smith, G. C. Moore, *The Letters of Dorothy Osborne to William Temple*, Oxford: Clarendon Press, 1928.

Spencer, T. J. B. and Stanley Wells, *A Book of Masques in Honour of Allardyce Nicoll*, Cambridge University Press, 1967.

Steen, Sara Jayne (ed.), *The Letters of Lady Arbella Stuart*, New York and Oxford: Oxford University Press, 1994.

Thompson, Craig R. (trans.), *Collected Works of Erasmus*, vol. XXXIX, *Colloquies*, Toronto, Buffalo and London: University of Toronto Press, 1997.

Townshend, Aurelian, *Tempe Restored* in David Lindley (ed.), *Court Masques*, Oxford University Press, 1995, pp. 155–65.

The True Description of a Royall Masque . . . Personated by the Queenes Most Excellent Majestie, 1604.

Vanbrugh, John, *The Provoked Wife*, ed. Antony Coleman, The Revels Plays, Manchester University Press, 1982.

Van Lennep, William (ed.), *The London Stage 1660–1800, Part One: 1660–1700*, Carbondale: Southern Illinois University Press, 1965.

Waller, Edmund, *Poems*, 1645.

Webster, John, *The Works of John Webster*, 2 vols., I, ed. David Gunby, David Carnegie and Anthony Hammond; II ed. Gunby, Carnegie and Macdonald P. Jackson, Cambridge University Press, 1995, 2003

White, Robert, '*Cupid's Banishment: A Masque Presented to Her Majesty by Young Gentlewomen of the Ladies Hall, Deptford, May 4, 1617*', ed. C. E. McGee, *Renaissance Drama*, n.s. 19 (1988), 226–64.

Cupid's Banishment: A Maske Presented to Her Majesty By the Young Gentlewomen of the Ladies Hall in Deptford at Greenwich in S. P. Cerasano and Marion Wynne-Davies (eds.), *Renaissance Drama by Women: Texts and Documents*, London: Routledge, 1996, pp. 76–89.

Whitelocke, Bulstrode, *Journal of the Swedish Embassy in the Years 1653 and 1654*, 2 vols., London, 1772.

Wilson, Arthur, *The History of Great Britain, Being the Life and Reign of King James the First, relating to what passed from his first Accese to the Crowne, till his Death*, 1653.

Wilson, Jean, *Entertainments for Elizabeth I*, Woodbridge: D. S. Brewer, 1980.

Woolf, Virginia, *A Room of One's Own*, 1929; repr. London: Granada, 1977.

Wroth, Mary, *Love's Victory* in S. P. Cerasano and Marion Wynne-Davies (eds.), *Renaissance Drama by Women: Texts and Documents*, London: Routledge, 1996, pp. 91–126.

Wycherley, William, *The Country Wife* ed. Thomas H. Fujimura, Regents Restoration Drama, London: Edmund Arnold, 1965.

SECONDARY SOURCES

Aasand, Hardin, '"To Blanch an Ethiop, and Revive a Corse": Queen Anne and *The Masque of Blackness*', *Studies in English Literature, 1500–1900* 32 (1992), 271–85.

Adelman, Janet, *The Common Liar: An Essay on Antony and Cleopatra*, New Haven and London: Yale University Press, 1973.

Altman, Joel, *The Tudor Play of Mind: Rhetorical Inquiry and the Development of Elizabethan Drama*, Berkeley: University of California Press, 1978.

Anderson, Donald K., 'The Banquet of Love in English Drama (1595–1642)', *Journal of English and German Philology* 63 (1964), 422–32.

Austern, Linda Phyllis, '"Sing Againe Syren": The Female Musician and Sexual Enchantment in Elizabethan Life and Literature', *Renaissance Quarterly* 52 (1989), 420–48.

'"Alluring the Auditorie to Effeminacie": Music and the Idea of the Feminine in Early Modern England', *Music and Letters* 74 (1993), 342–52.

Baldwin, T. W., *William Shakespere's Small Latine and Less Greeke*, 2 vols., Urbana: University of Illinois Press, 1944.

Barash, Carol, *English Women's Poetry, 1649–1714: Politics, Community, and Linguistic Authority*, Oxford: Clarendon Press, 1996.

Barish, Jonas A., *The Antitheatrical Prejudice*, Berkeley: University of California Press, 1981.

Barnes, Diana, 'The Restoration of Royalist Form in Margaret Cavendish's *Sociable Letters*' in Jo Wallwork and Paul Salzman (eds.), *Women Writing 1550–1750*, a special book issue of *Meridian* 18 (2001), pp. 201–14.

'The Politics of Female Performance in Margaret Cavendish's *Sociable Letters* (1664)', paper presented at a seminar on 'Women and Performance in Early Modern Europe', Shakespeare Association of America Conference, New Orleans, 8–10 April 2004.

Barroll, Leeds, 'The Court of the First Stuart Queen' in Linda Levy Peck (ed.), *The Mental World of the Jacobean Court*, Cambridge University Press, 1991, pp. 191–208.

Anna of Denmark, Queen of England: A Cultural Biography, Philadelphia: University of Pennsylvania Press, 2001.

Barton, Anne, 'Oxymoron and the Structure of Ford's *The Broken Heart*', *Essays and Studies* 33 (1980), 70–94.

'A Blush May Spell Disaster' in Patrick Lyons (ed.), *Congreve's Comedies: A Selection of Critical Essays*, London: Macmillan Press, 1982, pp. 209–12.

Ben Jonson, Dramatist, Cambridge University Press, 1984.

Essays, Mainly Shakespearean, Cambridge University Press, 1994.

Battigelli, Anna, *Margaret Cavendish and the Exiles of the Mind*, Lexington: University Press of Kentucky, 1998.

Bawcutt, N. W. (ed.), *The Control and Censorship of Caroline Drama: The Records of Sir Henry Herbert, Master of the Revels 1623–73*, Oxford: Clarendon Press, 1996.

Beal, Peter, *In Praise of Scribes: Manuscripts and their Makers in Seventeenth-Century England*, Oxford: Clarendon Press, 1998.

Belsey, Catherine, *The Subject of Tragedy: Identity and Difference in Renaissance Drama*, London and New York: Methuen, 1985.

'Emblem and Antithesis in *The Duchess of Malfi*' in Harold Bloom (ed.), *The Duchess of Malfi*, Modern Critical Interpretations, New York: Chelsea House, 1987, pp. 97–113.

Bennett, Alexandra, 'Margaret Cavendish and the Theatre of War', *In-between* 9 (2000), 263–73.

'Playing By and With the Rules: Genre, Politics, and Perception in Mary Wroth's *Love's Victorie*' in Clare McManus (ed.), *Women and Culture at the Courts of the Stuart Queens*, Basingstoke: Palgrave Macmillan, 2003, pp. 122–39.

Bentley, G. E., *The Jacobean and Caroline Stage*, 7 vols., Oxford: Clarendon Press, 1941–68.

Berry, Philippa, *Of Chastity and Power: Elizabethan Literature and the Unmarried Queen*, Cambridge University Press, 1989.

Boas, Frederick S., *An Introduction to Stuart Drama*, Oxford University Press, 1946.

Bone, Quentin, *Henrietta Maria: Queen of the Cavaliers*, London: Peter Owen, 1973.

Booth, Roy, 'The First Female Professional Singers: Madam Coniack', *Notes and Queries* 44 (1997), 533.

Bowers, Fredson, *Elizabethan Revenge Tragedy 1587–1642*, Princeton University Press, 1966.

Britland, Karen, '*Florimène*: The Author and the Occasion', *Review of English Studies* 53 (2002), 475–83.

'An Under-Stated Mother-in-Law: Marie de Médicis and the Last Caroline Masque' in Clare McManus (ed.), *Women and Culture at the Courts of the Stuart Queens*, Basingstoke: Palgrave Macmillan, 2003, pp. 204–23.

Brown, Cedric, *John Milton's Aristocratic Entertainments*, Cambridge University Press, 1985.

Bruster, Douglas, *Quoting Shakespeare: Form and Culture in Early Modern Drama*, Lincoln: University of Nebraska Press, 2000.

Bryson, Anna, *From Courtesy to Civility: Changing Codes of Conduct in Early Modern England*, Oxford: Clarendon Press, 1998.

Burner, Sandra, *James Shirley: A Study of Literary Coteries and Patronage in Seventeenth-Century England*, Lanham: University Press of America, 1988.

Burton, Sarah, 'The Public Woman: An Investigation into the Actress-Whore Connexion', PhD thesis, University of London, 1998.

Butler, Martin, *Theatre and Crisis 1632–1642*, Cambridge University Press, 1984.

'*Love's Sacrifice*: Ford's Metatheatrical Tragedy' in Michael Neill (ed.), *John Ford: Critical Re-Visions*, Cambridge University Press, 1988, pp. 201–31.

'Late Jonson' in Gordon McMullan and Jonathan Hope (eds.), *The Politics of Tragicomedy: Shakespeare and After*, London and New York: Routledge, 1992, pp. 166–88.

Callaghan, Dympna, *Woman and Gender in Renaissance Tragedy*, New York: Harvester Wheatsheaf, 1989.

Shakespeare Without Women: Representing Gender and Race on the Renaissance Stage, London and New York: Routledge, 2000.

Canfield, Dorothea Frances, *Corneille and Racine in England*, New York: AMS Press, 1966.

Carlin, Claire L., *Pierre Corneille Revisited*, New York: Twayne, 1998.

Chalmers, Hero, *Royalist Women Writers 1650–1689*, Oxford: Clarendon Press, 2004.

Chambers, E. K., *The Elizabethan Stage*, 4 vols, Oxford: Clarendon Press, 1923.

Chan, Mary, *Music in the Theatre of Ben Jonson*, Oxford: Clarendon Press, 1980.

'A Mid-Seventeenth-Century Music Meeting and Playford's Publishing' in John Caldwell, Edward Olleson and Susan Wollenberg (eds.), *The Well Enchanting Skill: Music, Poetry, and Drama in the Culture of the Renaissance*, Oxford: Clarendon Press, 1990, pp. 231–44.

Clark, Alice, *Working Life of Women in the Seventeenth Century*, 1919; repr. London: Routledge and Kegan Paul, 1982.

Clark, Ira, *Professional Playwrights: Massinger, Ford, Shirley and Brome*, Lexington: University Press of Kentucky, 1992.

Clark, William Smith, *The Early Irish Stage: The Beginnings to 1720*, Oxford: Clarendon Press, 1955.

Clarke, Danielle, 'The Iconography of the Blush: Marian Literature of the 1630s' in Kate Chedgzoy, Melarie Hansen and Suzanne Trill (eds.), *Voicing Women: Gender and Sexuality in Early Modern Writing*, Edinburgh University Press, 1998, pp. 111–28.

The Politics of Early Modern Women's Writing, London: Longman, 2000.

Clucas, Stephen (ed.), *A Princely Brave Woman: Essays on Margaret Cavendish, Duchess of Newcastle*, Aldershot: Ashgate, 2003.

Cohen, Walter, 'Prerevolutionary Drama' in Gordon McMullan and Jonathan Hope (eds.), *The Politics of Tragicomedy: Shakespeare and After*, London and New York: Routledge, 1992, pp. 122–50.

Comensoli, Viviana and Anne Russell (eds.), *Enacting Gender on the Renaissance Stage*, Urbana and Chicago: University of Illions Press, 1998.

Cottegnies, Line and Nancy Weitz, *Authorial Conquests: Essays on Genre in the Writings of Margaret Cavendish*, Madison, Teaneck and London: Fairleigh Dickinson University Press and Associated University Presses, 2003.

Coward, Barry, *The Stuart Age: England, 1603–1714*, 3rd edn., Harlow: Longman Pearson, 2003.

Crawford, Patricia, 'Women's Published Writings 1600–1700' in Mary Prior (ed.), *Women in English Society, 1500–1800*, London and New York: Methuen, 1985, pp. 211–31.

'The Challenges to Patriarchalism: How Did The Revolution Affect Women?' in John Morrill (ed.), *Revolution and Restoration: England in the 1650s*, London: Collins and Brown, 1992, pp. 112–28.

Creaser, John, '"The Present Aid of this Occasion": The Setting of *Comus*' in David Lindley (ed.), *The Court Masque*, Manchester University Press, 1984, pp. 110–34.

Crouch, Kristin, '"The Silent Griefs Which Cut the Heart Strings"': John Ford's *The Broken Heart* in Performance' in Edward J. Esche (ed.), *Shakespeare and his Contemporaries in Performance*, Aldershot: Ashgate, 2000, pp. 261–74.

D'Monté, Rebecca, 'Mirroring Female Power: Separatist Spaces in the Plays of Margaret Cavendish, Duchess of Newcastle' in Rebecca D'Monté and Nicole Pohl (eds.), *Female Communities 1600–1800: Literary Visions and Cultural Realities*, Basingstoke: Macmillan, 2000, pp. 93–110.

Dart, Thurston, *The Interpretation of Music*, 1954; repr. London: Hutchinson, 1967.

Dash, Irene G., 'Single-Sex Retreats in Two Early Modern Dramas: *Love's Labor's Lost* and *The Convent of Pleasure*', SQ 47 (1996), 387–95.

Davidson, Clifford, 'Women and the Medieval Stage', *Women's Studies* 11 (1984), 99–113.

Davis, Natalie Zemon, 'Women On Top: Symbolic Sexual Inversion and Political Disorder in Early Modern Europe' in Barbara Babcock (ed.), *The Reversible World: Symbolic Inversion in Art and Society*, Ithaca, N.Y.: Cornell University Press, 1978, pp. 148–83.

Davidson, Peter and Thomas M. McCoog, SJ, 'Father Robert's Convert: The Private Catholicism of Anne of Denmark', *TLS*, 24 November 2000, 16–17.

Demaray, John G., *Milton and the Masque Tradition: The Early Poems, Arcades, and Comus*, Cambridge, Mass.: Harvard University Press, 1968.

Dyer, William D., 'Holding/Withholding Environments: A Psychoanalytic Approach to Ford's *The Broken Heart*', *ELR* 21 (1991), 401–24.

Edmond, Mary, *Rare Sir William Davenant*, Manchester University Press, 1987.

Erickson, Amy, *Women and Property in Early Modern England*, London and New York: Routledge, 1993.

Ewbank, Inga-Stina, '"These Pretty Devices": A Study of Masques in Plays' in T. J. B. Spencer and Stanley Wells (eds.), *A Book of Masques in Honour of Allardyce Nicoll*, Cambridge University Press, 1967, pp. 405–48.

Ewing, Elizabeth, *Dress and Undress: A History of Women's Underwear*, London: Batsford, 1978.

Ezell, Margaret, J. M., *The Patriarch's Wife: Literary Evidence and the History of the Family*, Chapel Hill and London: University of North Carolina Press, 1987.

 Writing Women's Literary History, Baltimore and London: Johns Hopkins University Press, 1993.

Farr, Dorothy, *John Ford and the Caroline Theatre*, London: Macmillan, 1979.

Fawcett, Mary Laughlin, '"Such Noise as I can Make": Chastity and Speech in *Othello* and *Comus*', *Renaissance Drama*, n.s. 16 (1985), 159–80.

Findlay, Alison, 'Playing the "Scene Self": Jane Cavendish and Elizabeth Brackley's *The Concealed Fancies* in Viviana Comensoli and Anne Russell (eds.), *Enacting Gender on the Renaissance Stage*, Urbana and Chicago: University of Illinois Press, 1998, pp. 154–76.

 and Stephanie Hodgson-Wright with Gweno Williams, *Women and Dramatic Production 1550–1700*, Harlow: Longman Pearson, 2000.

Finkelpearl, Philip J., 'The Authorship of the Anonymous "Coleorton" Masque of 1618', *Notes and Queries*, n.s. 40 (1993), 224–6.

 'The Faries' Farewell: *The Masque at Coleorton* (1618)', *Review of English Studies*, n.s. 46 (1995), 333–51.

Fitzmaurice, James, 'Fancy and the Family: Self-Characterizations of Margaret Cavendish', *Huntington Library Quarterly* 53 (1990), 198–209.

Fleming, Juliet, 'The Ladies' Man and the Age of Elizabeth' in James Grantham Turner (ed.), *Sexuality and Gender in Early Modern Europe: Institutions, Texts, Images*, Cambridge University Press, 1993, pp. 158–81.

Freud, Sigmund, *Collected Papers*, ed. James Strachey, 5 vols., London: The Hogarth Press and The Institute of Psycho-Analysis, 1950.

Gagen, Jean E., *The New Woman: Her Emergence in English Drama 1600–1730*, New York: Twayne, 1954.

Gallagher, Catherine, 'Embracing the Absolute: The Politics of the Female Subject in Seventeenth-Century England', *Genders* 1 (1988), 24–39.

Gilder, Rosamond, *Enter the Actress: The First Women in Theater*, New York: Theater Arts Books, 1931, p. 132.

Gless, Darryl J., 'Chapman's Ironic Ovid', *ELR* 9 (1979), 21–41.

Goldberg, Jonathan, *James I and the Politics of Literature: Jonson, Shakespeare, Donne, and their Contemporaries*, Baltimore and London: Johns Hopkins University Press, 1983.

'Fatherly Authority: The Politics of Stuart Family Images' in Margaret W. Ferguson, Maureen Quilligan and Nancy J. Vickers (eds.), *Rewriting the Renaissance: The Discourses of Sexual Difference in Early Modern Europe*, Chicago and London: University of Chicago Press, 1986, pp. 3–32.

Gordon, D. J., 'The Imagery of Ben Jonson's *Masques of Blacknesse and Beautie*' in Stephen Orgel, (ed.), *The Renaissance Imagination: Essays and Lectures by D. J. Gordon*, Berkeley, Los Angeles, and London: University of California Press, 1975.

Gossett, Suzanne, '"Man-Maid, Begone!": Women in Masques', *ELR* 18 (1988), 96–113.

Gough, Melinda J., '"Not as Myself": The Queen's Voice in *Tempe Restored*', *Modern Philology* 101 (2003), 48–67.

Grant, Douglas, *Margaret the First: A Biography of Margaret Cavendish, Duchess of Newcastle*, London: Hart-Davis, 1957.

Graves, Thornton Shirley, 'Women on the Pre-Restoration Stage', *Studies in Philology* 22 (1925), 184–97.

Green, Lucy, *Music, Gender, Education*, Cambridge University Press, 1997.

Greenblatt, Stephen, *Renaissance Self-Fashioning: From More to Shakespeare*, University of Chicago Press, 1980.

Greer, Germaine, *Slip-Shod Sibyls: Recognition, Rejection and the Woman Poet*, Harmondsworth: Penguin, 1995.

Foreward, *Women's Writing* 6 (1999), 3–4.

Griffey, Erin, 'Multum in Parvo: Portraits of Jeffrey Hudson, Court Dwarf to Henrietta Maria', *British Art Journal* 4 (2003), 39–53.

Gurr, Andrew, 'Elizabethan Action', *Studies in Philology* 63 (1966), 144–56.

'Singing Through the Chatter: Ford and Contemporary Theatrical Fashion' in Michael Neill (ed.), *John Ford: Critical Re-Visions*, Cambridge University Press, 1988, pp. 81–96.

The Shakespearean Stage, 1574–1642, 3rd edn., Cambridge University Press, 1992.

Hackett, Helen, *Virgin Mother, Maiden Queen: Elizabeth I and the Cult of the Virgin Mary*, Basingstoke: Macmillan, 1995.

Hall, Kim F., *Things of Darkness: Economies of Race and Gender in Early Modern England*, Ithaca, N.Y., and London: Cornell University Press, 1995.

Hammond, Nicholas, *Creative Tensions: An Introduction to Seventeenth-Century French Literature*, London: Duckworth, 1997.

Harbage, Alfred, *Cavalier Drama*, New York and London: Modern Language Association of America and Oxford University Press, 1936.

Harvey, Elizabeth D., *Ventriloquized Voices: Feminist Theory and English Renaissance Texts*, London and New York: Routledge, 1992.

Hawkins, Harriett, 'The Idea of a Theater in Jonson's *The New Inn*', *Renaissance Drama* 9 (1966), 205–26.

'Mortality, Morality, and Modernity in *The Broken Heart*: Some Dramatic and Critical Counter-Arguments', in Michael Neill (ed.), *John Ford: Critical Re-Visions*, Cambridge University Press, 1988, pp. 129–52.

Heilman, Robert B., 'The Perverse: An Aspect of Ford's Art' in Donald K. Anderson, Jr. (ed.), *Concord in Discord: The Plays of John Ford 1586–1986*, New York and London: AMS Press, 1986, pp. 27–48.

Heinemann, Margot, *Puritanism and Theatre: Thomas Middleton and Opposition Drama under the Early Stuarts*, Cambridge University Press, 1980.

Helms, Lorraine, 'Roaring Girls and Silent Women: The Politics of Androgyny on the Jacobean Stage', *Themes in Drama* 11 (1989), 59–73.

Higgins, Patricia, 'The Reactions of Women, With Special Reference to Women Petitioners' in Brian Manning (ed.), *Politics, Religion and the English Civil War*, London: Edward Arnold, 1973, pp. 179–222.

Hill, Christopher, 'Pottage for Freeborn Englishmen: Attitudes to Wage-Labour' in Hill, *Change and Continuity in Seventeenth-Century England*, 1974; rev. edn., New Haven and London: Yale University Press, 1991.

Liberty Against the Law: Some Seventeenth-Century Controversies, Harmondsworth: Allen Lane, Penguin Press, 1996.

Hobby, Elaine, *Virtue of Necessity: English Women's Writing 1649–88*, London: Virago Press, 1988.

Holland, Peter, *The Ornament of Action: Text and Performance in Restoration Comedy*, Cambridge University Press, 1979.

'Modality Ford's Strange Journeys', *TLS* 28 October 1994, 21.

Hopkins, Lisa, *John Ford's Political Theatre*, Manchester University Press, 1994.

The Female Hero in English Renaissance Tragedy, Basingstoke: Palgrave Macmillan, 2002.

Hotson, Leslie, *The Commonwealth and Restoration Stage*, Cambridge, Mass.: Harvard University Press, 1928.

Howe, Elizabeth, *The First English Actresses: Women and Drama 1660–1700*, Cambridge University Press, 1992.

Huebert, Ronald, *John Ford: English Baroque Dramatist*, Montreal and London: McGill-Queen's University Press, 1977.

Hutson, Lorna, *The Usurer's Daughter: Male Friendship and Fictions of Women in Sixteenth-Century England*, London and New York: Routledge, 1994.

'Rhetoric and the Body in *Twelfth Night*' in Stephen Orgel and Sean Keilen (eds.), *Shakespeare and Gender*, New York: Garland, 1999, pp. 148–82.

Jacquot, Jean, 'La Reine Henriette-Marie et L'Influence Française dans les Spectacles à la Court de Charles I', *Cahiers de l'Association Internationale des Études Françaises* 9 (1957), 128–60.

Jones, Ann Rosalind and Peter Stallybrass, *Renaissance Clothing and the Materials of Memory*, Cambridge University Press, 2000.

Jones, Kathleen, *A Glorious Fame: The Life of Margaret Cavendish, Duchess of Newcastle, 1623–1673*, London: Bloomsbury, 1988.

Kahn, Coppélia, 'The Absent Mother in *King Lear*' in Margaret Ferguson, Maureen Quilligan and Nancy J. Vickers (eds.), *Rewriting the Renaissance:*

The Discourses of Sexual Difference in Early Modern England, Chicago and London: University of Chicago Press, 1986, pp. 33–49.

Kastan, David Scott, 'Performances and Playbooks: The Closing of the Theatres and the Politics of Drama' in Kevin Sharpe and Steven N. Zwicker (eds.), *Reading, Society and Politics in Early Modern England*, Cambridge University Press, 2003, pp. 167–84.

Kaufmann, R. J., 'Ford's "Waste Land": *The Broken Heart*', *Renaissance Drama*, n.s. 3 (1970) 167–87.

Kermode, Frank, 'The Banquet of Sense' in Kermode, *Renaissance Essays: I Shakespeare, Spenser, Donne*, London: Routledge and Kegan Paul, 1971.

Kirsch, Arthur C., 'A Caroline Commentary on the Drama', *Modern Philology* 66 (1968–9), 256–61.

Knowles, James, 'WS MS', *TLS* 29 April 1988, 472, 485.

'"To Enlight the Darksome Night, Pale Cinthia Doth Arise": Anna of Denmark, Elizabeth I and the Images of Royalty' in Clare McManus (ed.), *Women and Culture at the Courts of the Stuart Queens*, Basingstoke: Palgrave Macmillan, 2003, pp. 21–48.

Larner, Christina, 'James VI and I and Witchcraft' in Alan G. R. Smith (ed.), *The Reign of James VI and I*, London: Macmillan, 1973.

Le Comte, Edward, *Milton and Sex*, London and Basingstoke: Macmillan, 1978.

Leapman, Michael, *Inigo: The Troubled Life of Inigo Jones, Architect of the English Renaissance*, London: Review, 2003.

Leech, Clifford, *John Ford*, Writers and their Work, London: Longmans, Green and Co., 1964.

'Private Performances and Academic Theatricals (excluding the academic stage) from 1650–1660', PhD thesis, University of Cambridge, 1967.

Leggatt, Alexander, *English Drama: Shakespeare to the Restoration 1590–1660*, London and New York: Longman, 1988.

Levi, Peter, *A Private Commission: New Verses by Shakespeare*, London: Macmillan, 1988.

Levin, Carole, '"We Princes, I Tell You, Are Set On Stages": Elizabeth I and Dramatic Self-Representation' in S. P. Cerasano and Marion Wynne-Davies (eds.), *Readings in Renaissance Women's Drama: Criticism, History, and Performance 1594–1998*, London and New York: Routledge, 1998, pp. 113–24.

Levin, Richard, *The Multiple Plot in English Renaissance Drama*, Chicago and London: University of Chicago Press, 1971.

Lewalski, Barbara K., *Writing Women in Jacobean England*, Cambridge, Mass., and London: Harvard University Press, 1993.

'Milton's *Comus* and the Politics of Masquing' in David Bevington and Peter Holbrook (eds.), *The Politics of the Stuart Court Masque*, Cambridge University Press, 1998, pp. 296–320.

The Life of John Milton, Oxford: Blackwell, 2000.

Lindley, David, *The Trials of Frances Howard: Fact and Fiction at the Court of King James*, London: Routledge, 1993.

'The Politics of Music in the Masque' in David Bevington and Peter Holbrook (eds.), *The Politics of the Stuart Court Masque*, Cambridge University Press, 1998, pp. 273–95.

Little, Ruth Marion, 'Rogues and Ravens: Ben Jonson and the Staging of Courtiership', PhD thesis, University of Cambridge, 1993.

Loewenstein, Joseph, *Responsive Readings: Versions of Echo in Pastoral, Epic, and the Jonsonian Masque*, New Haven and London: Yale University Press, 1984.

Loftis, John *et al.* (eds.), *The Revels History of Drama in English, V 1660–1750*, London: Methuen, 1976.

Lucow, Ben, *James Shirley*, Boston: Twayne, 1981.

Lynch, Kathleen M., *The Social Mode of Restoration Comedy*, 1926; repr. New York: Biblo and Tannen, 1965.

Maclean, Ian, *Woman Triumphant: Feminism in French Literature 1610–1652*, Oxford University Press, 1977.

The Renaissance Notion of Woman: A Study in the Fortunes of Scholasticism and Medical Science in European Intellectual Life, Cambridge University Press, 1980.

Madelaine, Richard, '"Sensationalism" and "Melodrama" in Ford's Plays' in Michael Neill (ed.), *John Ford: Critical Re-Visions*, Cambridge University Press, 1988, pp. 29-53.

McLaren, Margaret Anne, 'An Unknown Continent: Lady Mary Wroth's Forgotten Pastoral Drama, *Loves Victorie*' in S. P. Cerasano and Marion Wynne-Davies (eds.), *Readings in Renaissance Women's Drama*, London and New York: Routledge, 1998, pp. 219–33.

McLuskie, Kathleen, '"Language and Matter with a Fit of Mirth": Dramatic Construction in the Plays of John Ford' in Michael Neill (ed.), *John Ford: Critical Re-Visions*, Cambridge University Press, 1988, pp. 97–127.

Renaissance Dramatists, Feminist Readings, Hemel Hempstead: Harvester Wheatsheaf, 1989.

McManus, Clare, *Women on the Renaissance Stage: Anna of Denmark and Female Masquing in the Stuart Court 1590–1619*, Manchester University Press, 2002.

'Memorialising Anna of Denmark's Court: *Cupid's Banishment* at Greenwich Palace' in McManus (ed.), *Women and Culture at the Courts of the Stuart Queens*, Basingstoke: Palgrave Macmillan, 2003, pp. 81–99.

McMullan, Gordon, *The Politics of Unease in the Plays of John Fletcher*, Amherst: University of Massachusetts Press, 1994.

Mambretti, Catherine Cole, 'Orinda on the Restoration Stage', *Comparative Literature* 37 (1985), 233–51.

Mann, David, *The Elizabethan Player: Contemporary Stage Representations*, London and New York: Routledge, 1991.

Marcus, Leah S., 'John Milton's *Comus*' in Thomas N. Corns (ed.), *A Companion to Milton*, Oxford: Blackwell, 2001, pp. 232–45.

Masson, Georgina, *Queen Christina*, London: Secker and Warburg, 1968.

Masten, Jeffrey, *Collaboration, Authorship and Sexuality in Renaissance Drama*, Cambridge University Press, 1997.

Maurer, Margaret, 'Reading Ben Jonson's *Queens*' in Sheila Fisher and Janet E. Halley (eds.), *Seeking the Woman in Late Medieval and Renaissance Writings: Essays in Feminist Contextual Criticism*, Knoxville: University of Tennessee Press, 1989, pp. 233–63.

Maus, Katharine Eisaman, '"Playhouse Flesh and Blood": Sexual Ideology and the Restoration Actress', *ELH* 46 (1979), 595–617.

'A Womb of his Own: Male Renaissance Poets in the Female Body' in James Grantham Turner (ed.), *Sexuality and Gender in Early Modern Europe*, Cambridge University Press, 1993, pp. 266–88.

Meagher, John C., *Method and Meaning in Jonson's Masques*, Notre Dame, Ind.: University of Notre Dame Press, 1966.

Mendelson, Sara Heller, *The Mental World of Stuart Women: Three Case Studies*, Brighton: Harvester Press, 1987.

and Patricia Crawford, *Women in Early Modern England*, Oxford: Clarendon Press, 1998.

Millar, Oliver, *Van Dyck in England*, London: National Portrait Gallery, 1982.

Montrose, Louis Adrian, 'The Purpose of Playing: Reflections on a Shakespearean Anthropology', *Helios*, n.s. (1980), 51–74.

Morash, Christopher, *A History of the Irish Theatre 1601–2000*, Cambridge University Press, 2002.

Mulryne, Ronnie and Margaret Shewring, *This Golden Round: The Royal Shakespeare Company at the Swan*, Stratford-on-Avon: Mulryne and Shewring, 1989.

Mulvihill, Maureen E., 'A Feminist Link in the Old Boys' Network: The Cosseting of Katherine Philips' in Mary Anne Schofield and Cecilia Macheski (eds.), *Curtain Calls: British and American Women and the Theater, 1660–1820*, Athens: Ohio University Press, 1991, pp. 71–104.

Neely, Carol Thomas, '"Documents in Madness": Reading Madness and Gender in Shakespeare's Tragedies and Early Modern Culture' in Shirley Nelson Garner and Madelon Sprengnether (eds.), *Shakespearean Tragedy and Gender*, Bloomington: Indiana University Press, 1996, pp. 75–104.

Neill, Michael, 'Neo-Stoicism and Mannerism in the Drama of John Ford', PhD thesis, University of Cambridge, 1974.

'"Anticke Pageantrie": The Mannerist Art of *Perkin Warbeck*', *Renaissance Drama*, n.s. 7 (1976), 117–50.

'Ford's Unbroken Art: The Moral Design of *The Broken Heart*', *Modern Language Review* 75 (1980), 249–68.

'Monuments and Ruins as Symbols in *The Duchess of Malfi*', *Themes in Drama* 4 (1982), 71–87.

'What Strange Riddle's This?: Deciphering '*Tis Pity She's a Whore*' in Neill (ed.), *John Ford: Critical Re-Visions*, Cambridge University Press, 1988, pp. 153–79.

Issues of Death: Mortality and Identity in English Renaissance Tragedy, Oxford: Clarendon Press, 1997.

'"He That Thou Knowest Thine": Friendship and Service in *Hamlet*', in Richard Dutton and Jean E. Howard (eds.), *A Companion to Shakespeare's Works*, 4 vols., *Volume I: The Tragedies*, Malden, Mass.: Blackwell, 2003, pp. 319–38.

Nethercot, Arthur H., *Sir William D'Avenant: Poet Laureate and Playwright-Manager*, Chicago, 1938, repr. New York: Russell and Russell, 1966.

Newman, Karen, *Fashioning Femininity and English Renaissance Drama*, Chicago and London: University of Chicago Press, 1991.

Norbrook, David, 'The Reformation of the Masque' in David Lindley (ed.), *The Court Masque*, Manchester University Press, 1984, pp. 94–110.

Poetry and Politics in the English Renaissance, 1984; rev. edn., Oxford University Press, 2002.

Novy, Marianne, *Love's Argument: Gender Relations in Shakespeare*, Chapel Hill and London: University of North Carolina Press, 1984.

Oliphant, E. H. C., *The Plays of Beaumont and Fletcher: An Attempt to Determine Their Respective Shares and the Shares of Others*, New Haven, 1927; repr. New York: AMS Press, 1970.

Oman, Carola, *Henrietta Maria*, London: Hodder and Stoughton, 1936.

Opie, Brian, '"Being All One": Ford's Analysis of Love and Friendship in *Love's Sacrifice* and *The Ladies Triall*' in Michael Neill (ed.) *John Ford: Critical Re-Visions*, Cambridge University Press, 1988, pp. 233–60.

Orgel, Stephen, *The Jonsonian Masque*, Cambridge, Mass: Harvard University Press, 1965.

The Illusion of Power, Berkeley, Los Angeles and London: University of California Press, 1975.

'Jonson and the Amazons' in E. D. Harvey and K. Eisaman Maus (eds.), *Soliciting Interpretation: Literary Theory and Seventeenth-Century Poetry*, Chicago and London: University of Chicago Press, 1990, pp. 119–39.

Impersonations: The Performance of Gender in Shakespeare's England, Cambridge University Press, 1996.

'Marginal Jonson' in David Bevington and Peter Holbrook (eds.), *The Politics of the Stuart Court Masque*, Cambridge University Press, 1998, pp. 144–75.

'The Case for *Comus*', *Representations* 81 (2003), 31–45.

Ornstein, Robert, *The Moral Vision of Jacobean Tragedy*, Madison, WIS., and Milwaukee: University of Wisconsin Press, 1965.

Orrell, John, *The Theatres of Inigo Jones and John Webb*, Cambridge University Press, 1985.

Ostovich, Helen, 'Mistress and Maid: Women's Friendship in *The New Inn*', *Ben Jonson Journal* 4 (1997), 1–26.

Parker, Andrew and Eve Kosofsky Sedgwick (eds.), *Performativity and Performance*, New York and London: Routledge, 1995.

Parker, William Riley, *Milton: A Biography*, 2 vols., Oxford: Clarendon Press, 1968.

Parry, Graham, *The Golden Age Restor'd: The Culture of the Stuart Court, 1603–42*, Manchester University Press, 1981.

Paster, Gail Kern, *The Body Embarrassed: Drama and the Disciplines of Shames in Early Modern England*, Ithaca, N.Y.: Cornell University Press, 1993.

Pater, Walter, 'The School of Giorgione' (1877) in Adam Philips (ed.), *The Renaissance: Studies in Art and Poetry*, Oxford University Press, 1986.

Payne, Deborah, 'Patronage and the Dramatic Marketplace under Charles I and II', *The Year's Work in English Studies* 21 (1991), 137–52.

Payne, Linda R., 'Dramatic Dreamscape: Women's Dreams and Utopian Vision in the Works of Margaret Cavendish, Duchess of Newcastle' in Mary Anne Schofield and Cecilia Macheski (eds.), *Curtain Calls: British and American Women and the Theater, 1660–1820*, Athens: Ohio University Press, 1991, pp. 18–33.

Peacock, John, 'The French Element in Inigo Jones's Masques Designs' in David Lindley (ed.), *The Court Masque*, Manchester University Press, 1984, pp. 149–68.

Pearson, Jacqueline, *The Prostituted Muse: Images of Women and Women Dramatists 1642–1737*, Hemel Hempstead: Harvester Wheatsheaf, 1988.

Pechter, Edward, 'Why Should We Call Her Whore?: Bianca in *Othello*' in Jonathan Bate, Jill L. Levenson, and Dieter Mehl (eds.), *Shakespeare and the Twentieth Century*, Newark and London: Associated University Presses, 1998, pp. 364–77.

Pitcher, John, '"In those figures which they seeme": Samuel Daniel's *Tethys' Festival*' in David Lindley (ed.), *The Court Masque*, Manchester University Press, 1984, pp. 47–59.

Plowden, Alison, *Henrietta Maria: Charles I's Indomitable Queen*, Stroud: Sutton, 2001.

Pollack, Linda A., 'The Child in Time', review of Nicholas Orme, *Medieval Children*, *TLS*, 15 March 2002, 10.

Potter, Lois, *Secret Rites and Secret Writing: Royalist Literature 1641–1660*, Cambridge University Press, 1989.

Poynting, Sarah, '"In the Name of all the Sisters": Henrietta Maria's Notorious Whores' in Clare McManus (ed.), *Women and Culture at the Courts of the Stuart Queens*, Basingstoke: Palgrave Macmillan, 2003, pp. 163–85.

Prest, W. R., 'Law and Women's Rights in Early Modern England', *The Seventeenth Century* 6 (1991), 169–87.

Procter, J., '*The Queen's Arcadia* (1606) and *Hymen's Triumph* (1615): Samuel Daniel's Court Pastoral Plays' in J. Salmons and W. Moretti (eds.), *The Renaissance in Ferrara and its European Horizons*, Cardiff and Ravenna: University of Wales Press and M. Lapucci, 1984, pp. 83–109.

Purkiss, Diane, *The Witch in History: Early Modern and Twentieth-Century Representations*, London and New York: Routledge, 1996.

Raber, Karen, *Dramatic Difference: Gender, Class, and Genre in the Early Modern Closet Drama*, Newark and London: University of Delaware Press and Associated University Presses, 2001.

Randall, Dale B. J., *Winter Fruit: English Drama 1642–1660*, Lexington: University Press of Kentucky, 1995.

Ravelhofer, Barbara, 'Bureaucrats and Courtly Cross-dressers in the *Shrovetide Masque* and *The Shepherd's Paradise*', *ELR* 29 (1999), 75–96.

Reiss, Timothy J., 'Corneille and Cornelia: Reason, Violence, and the Cultural Status of the Feminine: Or, How a Dominant Discourse Recuperated and Subverted the Advance of Women', *Renaissance Drama*, n.s. 18 (1987), 3–41.

Relle, Eleanor Gwynne, 'Studies in the Presentation of Chastity, chiefly in post-Reformation English Literature, with particular reference to its ecclesiastical and political connotations and to Milton's treatment of the theme in *Comus*', PhD thesis, University of Cambridge, 1969.

Reynolds, Myra, *The Learned Lady in England from 1650 to 1760*, 1920; repr. Gloucester, M.A.: Peter Smith, 1964.

Richards, Kenneth, 'Queen Henrietta Maria as a Patron of the Drama', *Studia Neophilologica* 42 (1970), 9–24.

Riggs, David, *Ben Jonson: A Life*, Cambridge, M.A.: Harvard University Press, 1989.

Roberts, Josephine A., 'The Huntington Manuscript of Lady Mary Wroth's Play, *Loves Victorie*', *Huntington Library Quarterly* 46 (1983), 156–74.

Rose, Mary Beth, *The Expense of Spirit: Love and Sexuality in English Renaissance Drama*, Ithaca, N. Y., and London: Cornell University Press, 1988.

Rosenthal, Laura J., *Playwrights and Plagiarists in Early Modern England: Gender, Authorship, Literary Property*, Ithaca, N. Y., and London: Cornell University Press, 1996.

Rowe, Nick, '"My Best Patron": William Cavendish and Jonson's Caroline Dramas', *The Seventeenth Century* 9 (1994), 197–212.

Sanders, Julie, '"The Day's Sports Devised in the Inn": Jonson's *The New Inn* and Theatrical Politics', *Modern Language Review* 91 (1996), 545–60.

'"A Woman Write a Play!"': Jonsonian Strategies and the Dramatic Writings of Margaret Cavendish; or, Did the Duchess Feel the Anxiety of Influence?' in S. P. Cerasano and Marion Wynne-Davies (eds.), *Readings in Renaissance Women's Drama*, London and New York: Routledge, 1998, pp. 293–305.

Caroline Drama: The Plays of Massinger, Ford, Shirley, and Brome, Plymouth: Northcote House, 1999.

'"Twill Fit the Players Yet": Women and Theatre in Jonson's Late Plays' in Richard Cave, Elizabeth Schafer and Brian Woolland (eds.), *Ben Jonson and Theatre: Performance, Practice, Theory*, London and New York: Routledge, 1999, pp. 179–90.

'Caroline Salon Culture and Female Agency: The Countess of Carlisle, Henrietta Maria and Public Theatre', *Theatre Journal* 52 (2000), 449–64.

Introduction, *The New Inn*, *The Complete Works of Ben Jonson*, gen. ed. Martin Butler, forthcoming, Cambridge University Press.

Schwarz, Kathryn, *Tough Love: Amazon Encounters in the English Renaissance*, Durham and London: Duke University Press, 2000.

Schwoerer, Lois G., 'Women's Public Political Voice in England: 1640–1740' in Hilda L. Smith (ed.) *Women Writers and the Early Modern Political Tradition*, Cambridge University Press, 1998, pp. 56–74.

Shapiro, Michael, *Gender in Play on the Shakespearean Stage: Boy Heroines and Female Pages*, Ann Arbor: University of Michigan Press, 1994.

'The Introduction of Actresses in England: Delay or Defensiveness?' in Viviana Comensoli and Anne Russell (eds.), *Enacting Gender on the Renaissance Stage*, Urbana and Chicago: University of Illinois Press, 1998, pp. 77–200.

Sharpe, Kevin, *Criticism and Compliment: The Politics of Literature in the England of Charles I*, Cambridge University Press, 1987.

Shell, Alison, *Catholicism, Controversy and the English Literary Imagination, 1558–1660*, Cambridge University Press, 1999.

Shepherd, Simon, *Amazons and Warrior Women: Varieties of Feminism in Seventeenth-Century Drama*, Brighton: Harvester Press, 1981.

Shifflet, Andrew, '"How Many Virtues Must I Hate": Katherine Philips and the Politics of Clemency', *Studies in Philology* 94 (1997), 103–35.

Stoicism, Politics, and Literature in the Age of Milton, Cambridge University Press, 1998.

Shullenberger, William, 'Tragedy in Translation: The Lady's Echo Song', *ELR* 33 (2003), 403–23.

Smith, Nigel, *Literature and Revolution in England 1640–1660*, New Haven: Yale University Press, 1994.

Smuts, R. Malcolm, *Court Culture and the Origins of a Royalist Tradition in Early Stuart England*, Philadelphia: University of Pennsylvania Press, 1987.

Spink, Ian, *Henry Lawes: Cavalier Songwriter*, Oxford University Press, 2000.

Stallybrass, Peter, 'Patriarchal Territories: The Body Enclosed' in Margaret W. Ferguson, Maureen Quilligan and Nancy J. Vickers (eds.), *Rewriting the Renaissance: The Discourses of Sexual Difference in Early Modern Europe*, Chicago and London: University of Chicago Press, 1986, pp. 123–42.

Staves, Susan, *Players' Scepters: Fictions of Authority in the Restoration*, Lincoln: University of Nebraska Press, 1979.

Stavig, Mark, *John Ford and the Traditional Moral Order*, Madison, Milwaukee and London: University of Wisconsin Press, 1968.

Stokes, James, 'Women and Mimesis in Medieval and Renaissance Somerset (and Beyond)', *Comparative Drama* 27 (1993), 176–96.

Stone, Lawrence, *Road to Divorce: England 1530–1987*, Oxford University Press, 1990.

Straznicky, Marta, 'Reading the Stage: Margaret Cavendish and Commonwealth Closet Drama', *Criticism* 37 (1995), 355–90.

Stretton, Tim, *Women Waging Law in Elizabethan England*, Cambridge University Press, 1998.

'Women, Property and Law' in Anita Pacheca (ed.), *A Companion to Early Modern Women's Writing*, Oxford: Blackwell, 2002, pp. 40–57.

Strong, Roy, *Van Dyck: Charles I On Horseback*, London: Allen Lane, Penguin, 1972.

Summit, Jennifer, *Lost Property: The Woman Writer and English Literary History, 1380–1589*, University of Chicago Press, 2000.

Suzuki, Mihoko, *Subordinate Subjects: Gender, the Political Nation, and Literary Form in England, 1588–1688*, Aldershot: Ashgate, 2003.

Swift, Carolyn Ruth, 'Feminine Self-Definition in Lady Mary Wroth's *Love's Victorie* (c. 1621)', *ELR* 19 (1989), 171–88.

Thomas, David (ed.), *Theatre in Europe: A Documentary History, Restoration and Georgian England 1660–1788*, Cambridge University Press, 1989.

Thomas, Patrick, *Katherine Philips ('Orinda')*, Writers of Wales, Cardiff: University of Wales Press, 1988.

Tilley, Morris Palmer, *A Dictionary of the Proverbs in England in the Sixteenth and Seventeenth Centuries*, Ann Arbor: University of Michigan Press, 1950.

Tillyard, E. M. W., *Milton*, 1930; rev. edn., London: Chatto and Windus, 1966.

Tomlinson, Sophie, 'Too Theatrical?: Female Subjectivity in Caroline and Interregnum Drama', *Women's Writing* 6 (1999) 65–79.

'Theatrical Vibrancy on the Caroline Court Stage: *Tempe Restored* and *The Shepherds' Paradise*' in Clare McManus (ed.), *Women and Culture at the Courts of the Stuart Queens, 1603–42*, Basingstoke: Palgrave Macmillan, 2003, pp. 186–203.

Traub, Valerie, M. Lindsay Kaplan and Dympna Callaghan (eds.), *Feminist Readings of Early Modern Culture: Emerging Subjects*, Cambridge University Press, 1996.

The Renaissance of Lesbianism in Early Modern England, New York: Cambridge University Press, 2002.

Trease, Geoffrey, *Portrait of a Cavalier, William Cavendish, First Duke of Newcastle*, London: Macmillan, 1979.

Trubowitz, Rachel, 'The Reenchantment of Utopia and the Female Monarchical Self: Margaret Cavendish's *Blazing World*', *Tulsa Studies in Women's Literature* 11, (1992), 229–45.

Ure, Peter, 'Cult and Initiates in Ford's *Love's Sacrifice*' in J. C. Maxwell (ed.), *Elizabethan and Jacobean Drama*, Liverpool University Press, 1974, pp. 93–103.

Veevers, Erica, *Images of Love and Religion: Queen Henrietta Maria and Court Entertainments*, Cambridge University Press, 1989.

Wade, Mara R., 'The Queen's Courts: Anna of Denmark and her Royal Sisters – Cultural Agency at Four Northern European Courts in the Sixteenth and Seventeenth Centuries' in Clare McManus (ed.), *Women and Culture at the Courts of the Stuart Queens*, Basingstoke: Palgrave Macmillan, 2003, pp. 49–80.

Waith, Eugene M., *Ideas of Greatness: Heroic Drama in England*, London: Routledge and Kegan Paul, 1971.

Walker, Kim, *Women Writers of the English Renaissance*, New York: Twayne, 1996.

Waller, Gary, "Like One in a Gay Masque": The Sidney Cousins in the Theaters of Court and Country' in S. P. Cerasano and Marion Wynne-Davies (eds.), *Readings in Renaissance Women's Drama*, London and New York: Routledge, 1998, pp. 234–45.

Walls, Peter, *Music in the English Courtly Masque, 1604–1640*, Oxford: Clarendon Press, 1996.

Weaver, Elissa, 'Spiritual Fun: A Study of Sixteenth-Century Tuscan Convent Theatre' in Mary Beth Rose (ed.), *Women in the Middle Ages and the Renaissance: Literary and Historical Perspectives*, Syracuse, N.Y.: Syracuse University Press, 1986, pp. 173–205.

Weidemann, Heather, 'Theatricality and Female Identity in Mary Wroth's *Urania*' in Naomi J. Miller and Gary Waller (eds.), *Reading Mary Wroth: Representing Alternatives in Early Modern England*, Knoxville: University of Tennessee Press, 1991, pp. 191–209.

Welsford, Enid, *The Court Masque: A Study in the Relationship between Poetry and the Revels*, Cambridge University Press, 1927.

Wertheim, Albert, 'Games and Courtship in James Shirley's *Hyde Park*', *Anglia* 90 (1972), 71–91.

Wheelock, Arthur, 'The Queen, the Dwarf and the Court: Van Dyck and the Ideals of English Monarchy' in Hans Vlieghe (ed.), *Van Dyck 1599–1999: Conjectures and Refutations*, Turnhout: Brepols, 2001, pp. 151–66.

Whitaker, Katie, *Mad Madge: The Extraordinary Life of Margaret Cavendish, Duchess of Newcastle, the First Woman to Live by her Pen*, New York: Basic Books, 2002.

Williams, Gordon, *A Dictionary of Sexual Language and Imagery in Shakespeare and Stuart Literature*, 3 vols., London: Athlone Press, 1994.

Wilson, John Harold, *All the King's Ladies: Actresses of the Restoration*, Chicago University Press, 1958.

Wiseman, Susan, 'Gender and Status in Dramatic Discourse: Margaret Cavendish, Duchess of Newcastle' in Isobel Grundy and Susan Wiseman (eds.), *Women, Writing, History 1640–1740*, London: B. T. Batsford, 1992, pp. 159–177.

Drama and Politics in the English Civil War, Cambridge University Press, 1998.

'Margaret Cavendish among the Prophets: Performance Ideologies and Gender in and after the English Civil War', *Women's Writing* 6 (1999), 95–111.

Wood, Bruce and Andrew Pinnock, '"Unscarr'd by Turning Times"?: The Dating of *Dido and Aeneas*', *Early Music* 20 (1992), 373–90.

Wood, Julia K., 'William Lawes's Music for Plays' in Andrew Ashbee (ed.), *William Lawes: Essays on his Life, Time and Work*, Aldershot: Ashgate, 1998, pp. 11–67.

Wood, Tanya, 'The Fall and Rise of Absolutism: Margaret Cavendish's Manipulation of Masque Conventions in "The Claspe: *Fantasmes* Masque" and *The Blazing World*', *In-between* 9 (2000), 286–99.

'Margaret Cavendish, Duchess of Newcastle, *The Convent of Pleasure* (1668), Ending revised by her husband, the Duke of Newcastle' in Helen Ostovich and Elizabeth Sauer (eds.), *Reading Early Modern Women: An Anthology of*

Texts in Manuscript and Print, 1550–1700, New York and London: Routledge, 2004, pp. 435–7.

Woodbridge, Linda, *Women and the English Renaissance: Literature and the Nature of Womankind, 1540–1620*, Brighton: Harvester Press, 1984.

Wright, Louis B., 'The Reading of Plays During the Puritan Revolution', *Huntington Library Bulletin* 6 (1934), 73–108.

Wrightson, Keith, *English Society 1580–1680*, London: Hutchinson, 1982.

Wyke, Maria, *The Roman Mistress: Ancient and Modern Representations*, Oxford University Press, 2002.

Wynne-Davies, Marion, 'The Queen's Masque: Renaissance Women and the Seventeenth-Century Court Masque', in S. P. Cerasano and Marion Wynne-Davies (eds.), *Gloriana's Face: Women, Public and Private, in the English Renaissance*, New York and London: Harvester Wheatsheaf, 1992, pp. 79–104.

Yates, Frances A., *The French Academies of the Sixteenth Century*, London and Norwich: The Warburg Institute and Empire Press, 1947.

The Art of Memory, Harmondsworth: Penguin, 1966.

Index

288